Burning with Desire

THE MIT PRESS CAMBRIDGE, MASSACHUSETTS LONDON, ENGLAND

GEOFFREY BATCHEN

BURNING WITH DESIRE

THE CONCEPTION OF PHOTOGRAPHY

This book was set in Monotype Garamond and Engravers Gothic by Graphic Composition, Inc.

Printed and bound in the United States of America.

Library of Congress Cataloging-in-Publication Data

Batchen, Geoffrey.

 Burning with desire : the conception of photography / Geoffrey Batchen.

 p. cm.

 Includes index.

 ISBN 0-262-02427-6 (hardcover : alk. paper)

 1. Photography—History. 2. Photographic criticism. I. Title.

TR15.B37 1997

770'.9—DC21 97-4022

 CIP

CONTENTS

This book examines recent accounts of photography by way of a detailed analysis of the medium's conception. Its title, *Burning with Desire,* comes from a letter written by Louis Daguerre in 1828 in which he tells his partner Nicéphore Niépce that "I am burning with desire to see your experiments from nature." *Burning with Desire* also embodies a number of desires of its own. It presents a sympathetic but rigorous reading of one aspect of postmodern accounts of photography. At the same time, it tries to rewrite the traditional history of photography's origins. To this end, the book gathers a large amount of information about photography's earliest experimenters and their milieus. This information is incorporated into a mode of historical criticism informed by Michel Foucault's genealogy and Jacques Derrida's deconstruction. Above all, *Burning with Desire* sets out to show that history inhabits the present in very real ways; that the practice of history is always an exercise of power; that history *matters* (in all senses of this word). The reader will have to decide whether or not these various desires are fulfilled (and whether others, including some not recognized by the author, are broached).

The structure of this book is fairly straightforward, even if its conclusions are not. Chapter 1 examines what appear to be two opposing views of photography's historical and ontological identity. Many postmodern critics (including John Tagg, Allan Sekula, Victor Burgin, and Abigail Solomon-Godeau) argue that, because all meaning is determined by context, "photography as such" has no identity and photography's history has no unity. This view contrasts that of formalist critics (the prime example

is John Szarkowski) who identify and value photography according to its supposedly fundamental characteristics as a medium. Photography is thereby caught up in a struggle between those who identify it with culture and those who locate its inherent nature. But are the two approaches really as different as they appear?

Chapter 2 seeks a possible solution to the problem of photography's identity in the foundational story of the medium's origins. However, close analysis of this story reveals that at least twenty people from seven European countries entertained the idea of photography between about 1790 and 1839. Inspired by the work of Michel Foucault, the book shifts focus from the successful invention of photography to the onset of a desire to photograph. Particular attention is given to the general conditions that allowed anyone at all to conceive of a photography. This moves the history of its origins to the early years of the nineteenth century and raises questions about the significance of photography's *timing*.

Chapter 3 examines this in detail, looking at each of the aspirations (nature, landscape, mirror images, spontaneity) voiced by the twenty proto-photographers and revealing that every element of the desire to photograph was in deep crisis in the early nineteenth century. This crisis manifests itself in the discourse of the proto-photographers in a consistently paradoxical dynamic structuring their texts. In one brilliant stroke of language, the naming of photography reproduces the fascinating dilemma of its own "impossible" identity. Chapter 4 extends this analysis to include the various "first photographs" that have been posited as the origins of the medium.

These include such unlikely candidates as a woodcut by Albrecht Dürer, a painting by Joseph Wright of Derby, and some sketches by Henry Talbot, as well as early photographic efforts by Nicéphore Niépce, Louis Daguerre, and Hippolyte Bayard.

Everywhere we look, photography's origins are displaced by a troubling play of differences, by what Derrida has called the economy of *différance*. Where photography's contemporary commentators want to identify it with *either* nature *or* culture, the medium's earliest proponents offer a far more equivocal articulation that incorporates but declines to rest at either pole. Chapter 5 analyzes the consequences of this difference in approach, concluding with a brief discussion of the limitations of postmodern photographic theory. Despite undoubtedly powerful insights, postmodernism reproduces at every level of its operation the same logocentric economy that sustains not only formalism but also broader systems of oppression such as phallocentrism and ethnocentrism. The book concludes with an epitaph on recent anxieties regarding the digitally induced death of photography, arguing that this debate once again raises important questions about photography's identity.

This book's genesis dates back to about 1984, at which time I was a Rubinstein Fellow in the Independent Study Program of the Whitney Museum of American Art in New York. Inspired by scholars and artists of the caliber of Ron Clark, Yvonne Rainer, Martha Rosler, Benjamin Buchloh, and especially Craig Owens, I developed an interest in the relationship between postmodernism and the politics of photography. Faithful to the logic of postmodern criticism, I wanted to devise a way of talking about photography that was concerned not only with the representation of politics but also with the politics of photographic representation itself. The work of critics such as John Tagg, Allan Sekula, and Victor Burgin was an important precedent and provided an influential theoretical platform for my early thinking on this question. Even more important were classes on semiotics, Foucault, and Jacques Lacan taught by Elizabeth Grosz at the University of Sydney; her exceptional teaching confirmed that contemporary philosophy could indeed be useful to cultural criticism. The more I looked at the various questions that the postmodern poses for contemporary photography, the more I felt compelled to go back to the beginnings of both the photographic and the modern and to examine in detail the history of their simultaneous emergences as cultural entities.

This revised project soon turned into a doctoral dissertation titled "Photogram-matology: A Study in the History and Theory of Photography." After several false starts and bouts of rewriting, the dissertation was finally submitted to the University of Sydney in 1990. Thanks are due to my dissertation supervisor, Terry Smith, for his patient support and advice. I would also like to acknowledge the formative assistance of Anne-Marie Willis and the editorial suggestions of Mick Carter, each of whom worked as my acting supervisor at different times during the writing of the dissertation. Outside the university, Ian Burn's work with Australian art history provided an inspir-ing model of how to read pictures with the intelligence and close attention they deserve. My parents, David and Gillian Batchen, were generous with their encour-agement and support throughout this process.

Many people encouraged the completion of the dissertation and manuscript with criticisms, translation assistance, research material, and helpful references. These in-clude Vicki Kirby, Sue Best, Noel Gray, Mary Mackay, Tony Fry, Helen Grace, Julian Perfanis, Cathy Vasseleu, Marina Vloss, Hilda and Gail Tighe, Catriona Moore, Mal-colm Andrews, Nancy Keeler, Graham Howe, Helen Ennis, Kate Davidson, Ewa Kur-ilyk, Mike Weaver, Olav Westphalen, Alison Gingeras, Susan Schuppli, Joan Hostetler, Valerie Hazel, Douglas Nickel, Sheldon Nodelman, Evonne Levy, Katherine Ware, Becky Smith, Mary Warner Marien, Ed Dimendberg, Whitney Davis, Leigh Anne Lan-gwell, and Holland Gallup. Professor Richard Terdiman also assisted by naming me his research assistant for two quarters during 1988, thereby giving me access to the library facilities of the University of California at Santa Cruz. My initial research was also assisted by a Commonwealth Postgraduate Research Award granted in 1985 through the University of Sydney. The final revisions of the manuscript were facilitated by an Academic Senate Research Grant from the University of California at San Diego. This grant allowed me to employ the research services of Diana Reynolds; the images that appear in this book would not be there without her determined expertise. I also thank Tim Nohe for his invaluable assistance in preparing some of these images for publication. Larry Schaaf was particularly generous in providing me with illustrative material from his own collection.

During the writing of this book, a number of its arguments were published in various journals, usually in a fledgling and fragmentary form. I thank the editors and

publishers involved for their advice and support. They include Lorraine Kenny and Nadine McGann at *Afterimage,* Helen Grace at *West,* and Heinz Henisch, Mike Weaver, and Anne Hammond at *History of Photography.*

The eventual transformation from dissertation to book was facilitated by the helpful suggestions of my doctorate examiners, Hayden White and Victor Burgin of the University of California at Santa Cruz and Ross Gibson of the University of Technology, Sydney. The critical comments of the anonymous manuscript reviewers organized by MIT Press also contributed to this process. I thank my MIT Press editor Roger Conover and his assistant Daniele Levine for their encouragement and advice, Sandra Minkkinen for her editorial expertise, and Ori Kometani for her elegant design.

Finally, this book could not have been either begun or finished without the inspiration and intellectual and emotional support of Vicki Kirby. I gratefully dedicate it to her.

| 1 IDENTITY |

Henceforth, we must not only ask what is the "essence" of history, the historicity of history, but what is the "history" of "essence" in general? And if one wishes to mark a break between some "new concept of history" and the question of the essence of history (as with the concept that the essence regulates), the question of the history of essence and the history of the concept, finally the history of the meaning of Being, you have a measure of the work which remains to be done.

—Jacques Derrida, *Positions*[1]

P hotography's historians have long struggled to articulate the "being" of their subject. Indeed, the identity of photography—both as a system of representation and as a social phenomenon—has been a matter of contention ever since the medium's inception. But never has this debate been quite so vigorous as during the past two decades.

The 1970s saw photography achieve a new prominence within the Anglo-American art world. Faced with a faltering demand for painting and sculpture, the art market sought to revitalize itself by promoting the sale and collection of both historic and contemporary photographs.[2] This enterprise has generated the usual discourses associated with the commerce of connoisseurship, including a rewriting of photographic history to emphasize certain newly collectable commodities and the production of photographic publications and exhibitions concerned with promoting particular individual artists.

Photography also attracted some trenchant critical voices during this period. The early and mid-1970s saw the publication of such influential and provocative commentaries as John Berger's *Ways of Seeing* (1972), Susan Sontag's *On Photography* (1977, with the earliest essays appearing in the *New York Review of Books* in 1973), and Roland Barthes's *Image-Music-Text* (appearing in English in 1977 but reproducing essays on photography published in France as early as 1961).[3] Informed by the intellectual traditions of Marxism and semiology as well as the interests of their non-specialist audiences, each of these authors contributed to the development of what might be called a cultural anthropology of the photograph. Snapshots and advertising images were treated with the same critical rigor as art photographs, all seen as having something interesting to say about the nature of modern life.

This reinvigorated photographic discourse was soon incorporated into a wider critique of modern cultural and social systems that has come to be known as postmodernism.[4] In 1978, for example, the editors of the New York journal *October* (widely regarded as the flagship of American postmodern cultural criticism) published an editorial on the art market's reevaluation of the photograph. Contributing to "the embryonic enterprise of photographic theory," the editors argued that "we urgently need a radical sociology of photography to force upon us, to disclose to view, the structural and historical nature and implications of our present photographic revisionism."[5] Over the past twenty years, a number of important Anglo-American critics have

sought to provide photography with just such a "structural and historical" analysis. In the process, they have produced a revisionism and a way of thinking that are the principal subjects of this book.

PHOTOGRAPHIES

Although I use the term *postmodernism* here as a convenient rhetorical trope, postmodern criticism is by no means homogenous in outlook, having been informed by a variety of sometimes competing theoretical models (Marxism, feminism, psychoanalysis, semiotics). Nevertheless, a remarkably consistent view of the photograph has come to occupy the center stage of critical debate. Indeed, within a certain intellectual milieu, this view has become the dominant way of thinking about the medium. It is now ubiquitous in undergraduate and graduate classes on photographic history and criticism and is frequently reproduced in articles and books on the medium. A paragraph from the writing of English critic John Tagg neatly summarizes this viewpoint:

Photography as such has no identity. Its status as a technology varies with the power relations which invest it. Its nature as a practice depends on the institutions and agents which define it and set it to work. Its function as a mode of cultural production is tied to definite conditions of existence, and its products are meaningful and legible only within the particular currencies they have. Its history has no unity. It is a flickering across a field of institutional spaces. It is this field we must study, not photography as such.[6]

What exactly is being said here? To begin with, Tagg suggests that photography cannot be understood as having a static identity or singular cultural status. Photography is, he says, better regarded as a dispersed and dynamic field of technologies, practices, and images. The compliant ubiquity of this photographic field is such that it is indistinguishable from those institutions or discourses that choose to make use of it. Photography's history is, therefore, the collective and multifarious history of those same institutions and discourses. A history of police photography could not, for example, be separated from a history of the practices and institutions of criminology and the justice system. Hence it follows that photography has no coherent or unified history of its own other than as a selective documentation of its various uses and effects.

The meanings of any individual photograph are similarly contingent, being entirely dependent on the context in which that photograph finds itself at any given moment. A photograph can mean one thing in one context and something else entirely in another. The identity of a photograph is thereby equated not with some kind of inherent photographic qualities but with what that photograph actually does in the world. The crucial point is that photographs can never exist outside discourses or functions of one kind or another. There is never a neutral ground where the photograph is able to speak "of and for itself," where it can emit some essential, underlying "true" meaning. Tagg's whole argument is based on the presumption that photographs have no single true meanings.

Particularly influential for Tagg's conception of the photograph is the structuralist Marxism of French philosopher Louis Althusser, with its emphasis on the role of ideological apparatuses in the maintenance and reproduction of the capitalist system. This is clear in one of Tagg's early explanations of his approach to the study of photography.

What I am trying to stress here is the absolute continuity of the photograph's ideological existence with their existence as material objects whose "currency" and "value" arise in certain distinct and historically specific social practices and are ultimately a function of the state. . . .

While it is also used as a tool in the major educational, cultural and communications apparatuses, photography is itself an apparatus of ideological control under the central "harmonising" authority of the ideology of the class which, openly or through alliance, holds state power and wields the state apparatus.[7]

Although Tagg goes on in later articles to criticize the totalizing rigidity of this Althusserean model of political control, his concept of photography retains much of its basic outline. For Tagg, the meanings and values of any individual photograph continue to be entirely determined by its relationship to other, more powerful, social practices. And, as an apparatus of visual representation, photography remains before all else a tool for transporting ideology from one site to another. As he explains this process in his best known essay, "Power and Photography" (1980): "Like the state, the camera is never neutral. The representations it produces are highly coded, and the

power it wields is never its own. As a means of record, it arrives on the scene vested with a particular authority to arrest, picture and transform daily life; a power to see and record; a power of surveillance. . . . This is not the power of the camera but the power of the apparatuses of the local state which deploy it and guarantee the authority of the images it constructs."[8]

Despite a residual Althuserrean framework, Tagg's essay does provide a more complicated description of how this deployment occurs. The result is a pioneering effort to relate the work of French philosopher Michel Foucault to the history of photography. As Tagg explains, Foucault provided cultural critics with a concept of a dynamic "micro-physics" of power, of a "disciplinary power" that circulates within and through the very grain of the social body such that we find "a multiplication of the effects of power through the formation and accumulation of new forms of knowledge."[9] Following Foucault's lead, Tagg concentrates in this and later essays on the photographs used by that "disciplinary archipelago" of agencies and local apparatuses of the state involved in the circulation of power and knowledge. As an instrument of these agencies, photography exercises no power of its own. Consequently, Tagg's account of the political effects of photography focuses not on the medium itself but on the determining mechanisms of its historical frames, on "the ways in which photography has been historically implicated in the technology of power-knowledge."[10]

Building on Foucault's idea that "discourse constitutes its object," Tagg's essays consistently regard photography as an instrument that facilitates the imposition of power by those who have some (usually the agents of the state) on those who have none (usually already marginalized groups such as the working class, criminals, the insane, native peoples, ethnic subcultures, and so on). In Tagg's schema, photography is but a convenient conduit that enables these more or less powerless subjects to be represented by the forces of modern oppression as objects of knowledge, analysis, and control. Photography itself receives little attention in his analysis, precisely because he pointedly rejects the category of the "in-itself." Indeed, the assumption here is that, as a thing with no fixed identity or historical unity, photography potentially belongs to every institution and discipline *but its own*.

The basic tenets of Tagg's view of photography are repeated in the work of other contemporary writers on photography. We can also find it figured, for example, in the

essays of American photographer and critic Allan Sekula. But whereas Tagg's photo-criticism derives from a combination of Althusser and Foucault, Sekula reproduces a dialectical theory of the photograph informed primarily by the Marxism of Georg Lukács. As Sekula has described his own work:

I see my own critical project now as an attempt to understand the social character of "the traffic in photographs." Taken literally, this traffic involves the social production, circulation and reception of photographs in a society based on commodity production and exchange. Taken metaphorically, the notion of traffic suggests the peculiar way in which photographic meaning—and the very discourse of photography—is characterized by an incessant oscillation between what Lukács termed the "antinomies of bourgeois thought." This is always a movement between objectivism and subjectivism. [11]

Sekula regards the photograph as a mobile, contingent, and inherently social entity, an entity always caught between the twin ideological demands of aestheticism (or subjectivism) and scientism (objectivism). These contradictory demands are induced, he argues, by the "sustained crisis at the very center of bourgeois culture." This crisis is produced by the "threat and promise of the machine," a dialectic that bourgeois culture "continues to both resist and embrace." As Sekula would have it, "the fragmentary and mechanically derived photographic image is central to this attitude of crisis and ambivalence; the embracing issue is the nature of work and creativity under capitalism." [12]

For Sekula, the photograph appears to confirm the individual subjectivity of those pictured even as it reduces those subjects and their social relations to a visual thing, to a commodified object-image equivalent to all others. As a mechanical, seemingly neutral machinery of representation, informed by the empirical truth-values of positivism, the photograph makes this objectification appear natural and beyond question. However, the photograph's very objectivity can reveal class differences *as* different, as historical and *unnatural,* and therefore as potentially open to change. This capacity to both threaten and confirm the established order of capitalism is for Sekula the source of photography's fascination and social power.

For this reason, Sekula identifies photography as a practice uniquely placed to focus "the confidence and fears of an ascendant industrial bourgeoisie." [13] Note, for

example, Sekula's description of the 1955 "Family of Man" exhibition: "Here, yet again, are the twin ghosts that haunt the practice of photography; the voice of a reifying technocratic objectivism and the redemptive voice of a liberal subjectivism."[14] And his account of photography's mixed reception in 1839: "Photography promises an enhanced mastery of nature, but photography also threatens conflagration and anarchy, an incendiary leveling of the existing cultural order."[15] Sekula discovers a similar duality in the photographs produced by Canadian Leslie Shedden between 1948 and 1968, referring to their linkage of "the *instrumental realism* of the industrial photograph and the *sentimental realism* of the family photograph."[16] Most prominently, Sekula investigates various nineteenth-century photographs of the body and identifies "a fundamental tension develop[ing] between uses of photography that fulfill a bourgeois conception of the *self* and uses that seek to establish and delimit the terrain of the *other*."[17] In short, Sekula continually stresses that, when looking at photography, "we are confronting, then, a double system: a system of representation capable of functioning both *honorifically* and *repressively*."[18]

What enables this system to function duplicitously is the fact that the meaning of any particular photograph is ultimately a manifestation of the tensions within capitalism itself. Like Tagg, Sekula thinks of photography as the vehicle of larger outside forces and of photographic identity as something fundamentally contingent on these forces. Never neutral, the photograph always finds itself attached to a discourse (or, more accurately, a cacophony of competing discourses) that gives any individual photograph its meanings and social values.

Sekula rests this aspects of his theory of photography on the semiotics of the American nineteenth-century pragmatist philosopher Charles Sanders Peirce. Arguing that photographs are before all else *indexical signs,* Sekula projects the photograph as a type of representation linked by a relation of physical causality or connection to its objects. According to Sekula, "because of this indexical property, photographs are fundamentally grounded in contingency."[19] In other words, as an index the photograph is never itself but always, *by its very nature,* a tracing of something else.

Like Tagg and Sekula, British photographer and critic Victor Burgin has no time for those who seek a photographic "essence" or who concentrate on a narrow, art-historical account of photography and its development. Burgin is more interested in

approaching photography through its relation to "the general sphere of cultural production."[20] In that context, he argues that photography's primary characteristic is its capacity to produce and disseminate *meaning*. But the meanings of photographs are not determined by, or confined to, the pictures themselves, for meaning is continually being reproduced within the contexts in which these pictures appear. Already we note a familiar conception of the photograph, namely that "meaning is perpetually displaced from the *image* to the discursive formations which cross and contain it."[21] For Burgin, the object of photographic theory is not the photograph as such but rather the practices of signification that precede, surround, inform, and produce any photograph as meaningful. Photographic theory is but an "*emphasis* within a general history and theory of representations," just as any individual photograph is but an intersection within a complex and often invisible process of meaning production.[22]

The "photographic text," like any other, is the site of a complex "intertextuality," an overlapping series of previous texts "taken for granted" at a particular cultural and historical conjuncture. These prior texts, those presupposed *by the photograph, are autonomous; they serve a role in the actual text but do not appear in it, they are latent to the manifest text and may only be read across it "symptomatically." . . . The question of meaning therefore is constantly to be referred to the social and psychic formations of the author/reader.*[23]

Semiotics and psychoanalysis are two of the ways by which such formations might be articulated, and Burgin's work has been of central importance in bringing these modes of social analysis to bear on photography. He has been particularly concerned with photography's contribution to Western culture's nexus of power, desire, and representation, especially as it involves itself in the "unending process of *becoming*" enacted by the viewing subject.[24] Photographs are always catalysts for, and foci of, that desire invested in looking. As such, the experience of the photograph can be readily incorporated into a Lacanian theory of the subject. Referring to the emphasis placed on the look in Jacques Lacan's discussion of the imaginary, Burgin similarly defines the subjective effect of the camera as a (deceptive) "coherence founded in the unifying gaze of a unified, punctual, subject."[25] It follows that the camera's "laws of projection . . . place the subject as geometric point of origin of the scene in an imaginary relation-

ship with real space."[26] The implication is that all photographs obey these "laws" and have this "effect." "It is therefore important that photography theory take account of the production of this subject as the complex totality of its determinations are nuanced and constrained in their passage through and across photographs."[27]

Notice however that this version of photographic theory again displaces attention from the photograph itself (a category that Burgin has in any case already abandoned as antithetical to the semiotics of meaning production). Like the desiring subject he describes, Burgin looks through the photograph in search of something that necessarily has its origins elsewhere. For Burgin, photography is yet one more of desire's tantalizing "red herrings": "Fundamentally, it is the unconscious subject that desires. . . . But the conscious object of desire is always a red herring. The object is only the representative, in the real, of a psychical representative in the unconscious (Freud's 'ideational representative' of the instinct). In fact, desire *is* the instinct, as the Lacanians put it, 'alienated in a signifier'—the *trace* of a primal, *lost,* satisfaction. The real object . . . is *irretrievably* absent."[28]

I have only briefly sketched the theories of photography presented by these three writers. My account is necessarily reductive, leaving out many of the nuanced arguments, revisions, and extensive visual analyses that so animate their individual essays and (in the case of Sekula and Burgin) their photographic works. However, it does outline the development of a particular conception of photography that is now central to Anglo-American postmodern thinking in general.[29] To repeat Tagg's opening formulation, "Photography as such has no identity," and "Its history has no unity."

This view is hardly peculiar to Tagg, Sekula, and Burgin. One finds it reiterated in the work of any number of other contemporary photo-critics. Feminist scholar Abigail Solomon-Godeau, to take one example, also cogently argues against a notion of "photographic autonomy" in her 1991 collection of essays, *Photography at the Dock*. She marks her disquiet by the addition of inverted commas around the "disciplinary object 'photography'" whenever she has cause to refer to it. Stressing the "mutability of photographic meaning," she asserts that "the photograph is, before all and after all, a building block in a larger structure." Once again, she rejects the category of "the thing-itself" in relation to photography, except as it is "something dynamically produced in the act of representation and reception and already subject to the grids of meaning

imposed upon it by culture, history, language, and so forth." Accordingly, she says, "I would submit that the history of photography is not the history of remarkable men, much less a succession of remarkable pictures, but the history of photographic uses." Her essays ably examine a number of such uses, looking always for both specific "contextual determinations" of photographic meaning as well as the wider traversal of these meanings by "the lived experience of class, race, gender, and nationality." In short, for Solomon-Godeau photography is best understood as a "conduit" for much larger social and psychic forces. As she puts it, "In the final analysis, photography . . . is ever a hireling, ever the hired gun."[30]

We see in the work of these critics a general shift in analytic focus from image to frame, from questions of form and style (the rhetoric of art) to questions of function and use (the practice of politics). Having argued that photographic meaning is entirely mutable and contingent, these postmodern scholars also logically conclude that the medium can have no autonomous history or fixed identity. They argue that there can be *no such thing* as a singular photography at all, only discontinuous, myriad *photographies*.

PHOTOGRAPHY ITSELF

This view of photography directly responds to the dominant art-historical agenda of the sixties and seventies—in particular, to the style of criticism known as modernist formalism. Postmodernism has steadfastly opposed itself to the formalist agenda, seeing it as both intellectually fruitless and politically conservative.[31] As far as photography is concerned, this agenda was primarily disseminated in the late sixties and early seventies by writers such as André Bazin and curators such as John Szarkowski. However, in the United States formalism was already well established as a way of talking about art in general through the formidable advocacy of critic Clement Greenberg.

Greenberg's basic argument is now well known: in the modern era the traditional functions of art have been usurped (by photography among other things); to survive, art has had to establish its value as an irreplaceable vehicle of heightened experience within an otherwise alienating culture; to do so each art medium must determine, through a rigorous self-examination of its own operations and effects, those specific

qualities unique to itself. Although prefigured in earlier writings, this argument is most cogently outlined in Greenberg's 1961 essay "Modernist Painting."

The essence of Modernism lies, as I see it, in the use of the characteristic methods of a discipline to criticize the discipline itself—not in order to subvert it, but to entrench it more firmly in its area of competence. . . . The arts could save themselves from [a] leveling down [to the level of entertainment] only by demonstrating that the kind of experience they provided was valuable in its own right and not to be obtained from any other kind of activity. Each art had to effect this demonstration on its own account. What had to be exhibited and made explicit was that which was unique and irreducible not only in art in general, but also each particular art. Each art had to determine, through the operations peculiar to itself, the effects peculiar and exclusive to itself. . . . It quickly emerged that the unique and proper area of competence of each art coincided with all that was unique to the nature of its medium.[32]

Using Kant as a philosophical touchstone ("He was the first to criticize the means itself of criticism . . . Kant used logic to establish the limits of logic"), Greenberg sought to render the history of modernism as a continual search for each art form's fundamental, irreducible essence.[33] The essence of photography is difficult to define in these terms, given what Greenberg called "the transparency of the medium . . . [to the] extra-artistic, real-life meaning of things."[34] He was nevertheless willing, in a 1964 essay titled "Four Photographers," to point to pictures by Jean-Eugène-August Atget and Walker Evans that he considered "masterpieces of photography," arguing that "they have become masterpieces by transcending the documentary and conveying something that affects one more than mere knowledge could."[35]

Other formalist evaluations of photography have relied on similar arguments. In "The Ontology of the Photographic Image" (written in 1945 but first published in English in 1967), French film critic André Bazin promoted the need for a "true realism, the need that is to give significant expression to the world both concretely and in its essence."[36] For Bazin, photography's "essentially objective character," the singular quality distinguishing photography from painting, enabled it, above all other media, to achieve this "true realism": "The photographic image is the object itself, the object freed from the conditions of time and space that govern it. No matter how fuzzy,

distorted, or discolored, no matter how lacking in documentary value the image may be, it shares, by virtue of the very process of its becoming, the being of the model of which it is the reproduction; it *is* the model. . . . The photograph as such and the object itself share a common being."[37]

John Szarkowski's approach to photography is closer to that of Greenberg than of Bazin, although all three share a similar intellectual aspiration. Unlike postmodern critics, Szarkowski takes the position that "there really is such a thing as photography."[38] The problem is how to define exactly what this "thingness" is. In an interview recorded in 1978, he describes how in his practice as a curator at the Museum of Modern Art he has pursued "the general generic problem of what is this funny medium and what can you do with it and what are its potentials . . . how those energies are used to further explore the potentials of that line, that evolutionary line of the being . . . the truth . . . the great genetic pool of [photographic] possibilities."[39] In other words, Szarkowski finds himself, like the artists he favors, in continual pursuit of the essence of the photographic medium. As he puts it, "I think in photography the formalist approach is . . . concerned with trying to explore the intrinsic or prejudicial capacities of the medium as it is understood at that moment."[40]

Szarkowski's best known attempt to articulate this approach at the level of curatorial practice is his 1966 exhibition "The Photographer's Eye." In his own words, "*The Photographer's Eye* was an attempt to try to define certain issues, certain fundamental issues, that might begin to offer the armature for a credible vocabulary that really has to do with photography."[41] To that end, Szarkowski's catalogue essay argues that photography was not only "born whole" but represents a "radically new picture-making process."[42] This new and distinctive process is embodied in every one of photography's instances, whatever the skill or sensitivity (or lack of these same qualities) brought to the medium by its many practitioners. Szarkowski goes on to argue that those pictures that reflect, with "success," on the strangeness of their own process of production should be regarded as "significant beyond their limited intention." This explains why he has consistently included pictures by anonymous photographers in all of his large survey exhibitions, including his 1989 historical overview "Photography Until Now."[43] For Szarkowski's interest is not only in what artists have done with the medium but also in what can be learned in general from "*photography*—the great undifferentiated, homogenous whole of it." With that end in mind, he seeks out those photographs that,

consciously or otherwise, exhibit "anonymous and untraceable gifts from photography itself."[44]

In *The Photographer's Eye,* Szarkowski identifies five "concepts" that he claims are "peculiar to photography"; specifically "The Thing Itself, The Detail, The Frame, Time, and Vantage Point." Photographs were displayed in groups according to their presumed engagement with these "concepts," resulting in a kind of modernist history of photographic picture making remarkably reminiscent of that propagated by Greenberg for painting. As Szarkowski describes his chosen photographic pictures: "The vision they share belongs to no school or aesthetic theory, but to photography itself. The character of this vision was discovered by photographers at work, as their awareness of photography's potentials grew. If this is true, it should be possible to consider the history of the medium in terms of photographers' progressive awareness of characteristics and problems that have seemed inherent in the medium."[45]

In various exhibitions and texts, Szarkowski presents the history of photography as an inevitable progression toward self-knowledge. He is joined in this enterprise by many other scholars. Most histories of photography are in fact art histories, faithfully following in the ruts of Beaumont Newhall's influential *The History of Photography* (which was first published as an exhibition catalogue for the Museum of Modern Art in 1937).[46] In emphasizing art photography above all other genres and practices, these histories tend to privilege the most self-conscious photographs, those that appear to be in some way about their own processes of production. In this sense these histories—and I refer here to almost every recent publication that has attempted to cover the history of the medium—all contribute consciously or unconsciously to the general formalist project.[47]

Szarkowski makes the connection clear in the opening remarks to his 1989 exhibition catalogue for "Photography Until Now," arguing that art photography embodies the essence of all photography: "It is my hope that this approach will allow the art of photography to be seen not as a special case, peripheral to the larger story of the medium's broad concerns and instrumental functions, but rather, and simply, as that work that embodies the clearest, most eloquent expression of photography's historic and continuing search for a renewed and vital identity."[48] This same argument has also been made for particular aspects of photography's history. Many have linked Szarkowski's views, for example, to Peter Galassi's exhibition and catalogue, *Before Photogra-*

phy: Painting and the Invention of Photography, produced under the auspices of Szarkowski and the Museum of Modern Art in 1981.[49]

Galassi expresses the central revisionist premise of his exhibition in the following, now infamous, aphorism: "Photography was not a bastard left by science on the doorstep of art, but a legitimate child of the Western pictorial tradition."[50] More than this, Galassi is interested in locating photography within one particular pictorial tradition that makes its viewers "participants in the contingent experience of everyday life."[51] He identifies the expression of contingent experience with a certain attitude to picture making best represented by the landscape sketch genre that appeared around 1800. According to Galassi, this genre marks the "emergence of a new norm of pictorial coherence that made photography conceivable"; "the new attitude (and its pictorial expressions) had begun to develop before photography was invented"; "photography was born of this fundamental transformation in pictorial strategy."[52] He continues: "I have chosen ... to focus on that aspect of landscape painting that is the clearest (if ostensibly the most modest) symptom of the broad artistic transformation that catalyzed the invention of photography. The landscape sketches ... present a new and fundamentally modern pictorial syntax of immediate, synoptic perceptions and discontinuous forms. It is the syntax of an art devoted to the singular and contingent rather than the universal and stable. It is also the syntax of photography."[53]

One immediate effect of this argument, challenging though it is on other levels, is that it identifies both photography's "syntax" and its conceptual origins with an artistic rather than a social, intellectual, or political "transformation." In accordance with Szarkowski's privileging of the detail as one of photography's inherent characteristics, Galassi stresses photography's "intuitive," "arbitrary" framing of the world, resulting in pictures full of what he calls "discontinuous, unexpected forms." Moreover, he suggests that the production of this particular kind of modernist picturing is a consequence of "the camera's inability to compose"; that is, is a property inherent in the medium.[54]

Numerous critics have pointed out the artful convenience of Galassi's selection of both paintings and photographs in order that they comply with his argument's particular emphasis on the growing artistic desire to produce "pictures of bits." Important genres of photographic composition, such as daguerreotype portraiture, are almost

entirely absent from his exhibition. Similarly, he ignores the dominant and very conventional landscape school of painting of the early nineteenth century and the many monumental and similarly conventional landscape photographs produced by early practitioners. As Solomon-Godeau asserts:

Galassi can be justifiably accused of committing a tautology and of selecting only the evidence which matches his hypothesis . . . to provide an academic and scholarly justification for the curatorial preferences and critical apparatus of MoMA's Photography Department.[55]

"Before Photography" was thus constructed to provide precisely the thesis that the museum required: to wit, that the history of photography, essentially and ontologically, is not only engendered by art, but is in fact inseparable from it.[56]

All of this is undoubtedly true. Indeed, the postmodern critique of formalism is convincing on virtually all levels (and this book therefore takes it as a given). But this still leaves an important question unanswered. By what exactly is photography "engendered," if not by art (or, at least, by the Western picture-making tradition)? What is this thing we call photography?

It should be clear from my discussion thus far that recent approaches to photography all hinge on photography's historical and ontological identity, a matter that both postmodernists and formalists think they have somehow resolved. In a sense, the entire laborious argument between them reduces down to a single, deceptively simple question: Is photography to be identified with (its own) nature or with the culture that surrounds it? Both postmodernists and formalists presume to know what photography is (and what it isn't). Their argument is about the *location* of photography's identity, about its boundaries and limits, rather than about identity per se.

ORIGIN STORIES

In this context, it is interesting that Galassi has seen fit to provide his "photography" with something necessary to all identity claims—a location in time and space, a point of origin prior to which it had no identity, a *before* photography. This historical move,

this gesture to an originary moment of birth, is, as Jacques Derrida tells us, "not just *one* metaphysical gesture among others, it is *the* metaphysical exigency, that which has been the most constant, most profound and most potent."[57]

This is certainly the case with scholars concerned with the history and meanings of photography. Whatever the theoretical approach, photography's commentators inevitably find themselves having to say something about the medium's invention and its cause or causes. Indeed, the nature of photography's political and cultural identity is often explicitly equated with the nature of its origins. This, after all, is the use value of origin stories as a genre. They allow one the opportunity of, as Derrida puts it, "returning 'strategically,' ideally, to an origin or to a 'priority' held to be simple, intact, normal, pure, standard, self-identical, in order to then think in terms of derivation, complication, deterioration, accident, etc."[58] In other words, as a manifestation of "*the* metaphysical exigency," any given origin story distills its teller's approach to the practice of storytelling (the practice of thought, of history, of representation) in general.

As we've seen, Galassi locates the origins of photography in a specific shift in artistic aspiration that takes place within European culture in the late eighteenth and early nineteenth centuries. In *Photography Until Now,* Szarkowski is a little more circumspect, initially claiming no more than that "new possibilities" like photography arise from "a complex ecology of ideas and circumstance that includes the condition of the intellectual soil, the political climate, the state of technical competence, and the sophistication of the seed." He then goes on to suggest more concretely that "the invention of photography depended on the confluence of three streams of thought." The first two he identifies as optics and chemistry; "the third was the poetic idea that it might be possible to snatch from the very air a picture formed by the forces of nature."

With this conceptual architecture as his background, Szarkowski then goes on to sketch the same prehistory for photography that has been repeated in virtually every book published on the medium. He quickly traces the development of the camera obscura from the fifth century B.C. onward ("The camera is essential to the idea of photography"), mentions some eighteenth-century experiments on light-sensitive substances, and then draws attention to fifteenth-century Italy and the idea, made possible by perspective, that pictures might be "formed by the edges." In this way, Szarkowski is able to bring a broad sweep of history to focus on "the Western pictorial

tradition" and what both he and Galassi see as photography's most essential feature—the camera's ability to picture the world as a series of framed views (which Szarkowski calls "the idea of contingency"). However neither of these scholars addresses why this particular ability suddenly came to be privileged or why the "poetic" idea of photography emerged in the early nineteenth century and not before. Indeed, Szarkowski provocatively asserts that, on the evidence available, "photography was not invented to serve a clearly perceived need." It was instead, so it seems, the inevitable product of an artistic sensibility whose own origins lie in the fifteenth century. In other words, photography's identity is founded in history (or, at least, in art history).[59]

This equation of identity with history brings Szarkowski and Galassi a little closer to the views of those very postmodernists who so vehemently oppose them. For postmodernism would also locate photography's origins within history; it is just not always the same history as that favored by formalism. Victor Burgin, for example, provides photography with one origin story that closely resembles that of Szarkowski, arguing that "in its essential details the representational system of photography is identical with that of classical painting: both depend (the former directly, the latter indirectly) upon the camera obscura."[60]

Many other historians, John Tagg among them, have sought to equate photography's emergence with the concurrent development of particular social and political formations: "The incentive to develop the existing scientific and technical knowledge as a means of fixing the image of the camera obscura came . . . from the unprecedented demand for images among the newly dominant middle classes, at a stage of economic growth in Britain and France when organized industry was displacing traditional patterns of manufacture and laying the basis for a new social order."[61] The assumption that the invention of photography answered the demands of a newly dominant bourgeois ideology enables Tagg neatly to incorporate the medium's history into a class-based analysis of contemporary European society. Most importantly, it makes even photography's invention an unavoidably social and political phenomenon. This also suits the theoretical approach of Allan Sekula. Although avoiding the demand to define a specific point of origin (this would come dangerously close to the essentialism that his work claims to dispute), Sekula consistently equates photography's historical appearance with the modern development of the logic of capital: "Photography is funda-

mentally related in its normative way of depicting the world to an epistemology and an esthetics that are intrinsic to a system of commodity exchange."[62]

Already it is possible to note a strange congruence taking place within and among these various accounts of photography's origins. The formalists, supposedly concerned primarily with the essence of the photographic, find themselves building the foundation of this essence on history (on that which lies outside the photographic frame). Meanwhile, the postmodernists, supposedly opposed to any search for essence, find themselves seeking to identify photographic epistemologies and aesthetics that are "fundamental," "essential," and "intrinsic" (and so are presumably internal to each and every photograph).

Until this point my account has seemed quite straightforward. Schematic though it undoubtedly is, it nevertheless reveals the operation of what appear at first glance to be two diametrically opposed points of view. On one side are those who believe that photography has no singular identity because all identity is dependent on context. On the other are those who identify photography by defining and isolating its most essential attributes, whatever they may be. One group sees photography as an entirely cultural phenomenon. The other speaks in terms of photography's inherent nature as a medium. One approach regards photography as having no history of its own; the other happily provides an historical outline within which all photographs are thought to have a place determined in advance. One stresses mutability and contingency; the other points to eternal values. One is primarily interested in social practice and politics, the other in art and aesthetics. We could go on. The differences seem clear enough.

But are they? Is the difference between essentialist and antiessentialist theories of photography quite as marked as it appears? The postmodern critique of essence, for example, is the critique of identity "as such"; in this case, a critique of the formalist notion of photography as something unified and undifferentiated. Postmodernism wants to say that photography is nothing but difference and replace its singular identity with multiple photographies. But there is an irony in the orchestration of this oppositional logic. In postmodern criticism, the photograph still has an essence, but now it is found in the mutability of culture rather than in its presumed other—an immutable nature. In other words, the postmodern identification of photographies with a sphere of operations that is entirely cultural—the assumption that mutability "as such" can

be delimited even if identity "as such" cannot—is itself an essentializing gesture. Why, amid the general postmodern critique of binary structures, does this division between sameness and difference, nature and culture, substance and appearance, continue to be essentialized? Why, in short, assume that nature is frozen in place as the undifferentiated origin against which culture can secure its identity?

Already we begin to see the limitations of these prevailing ways of talking about photography. Despite appearances to the contrary, both share a presumption that, in the final analysis, photography's identity can be determined as a consequence of *either* nature *or* culture. The distinction between these two entities, more particularly the politics of the maintenance of all such distinctions, is left unquestioned. Thus the opposition between postmodernism and formalism is binary (each depends on defining itself as not-the-other, allowing neither to actually engage the logic of otherness itself). This oppositional structure is then repeated within the methodology each brings to photography, a problem to which I shall return. The point is that postmodernism and formalism, at least in their dominant photographic manifestations, both avoid coming to grips with the historical and ontological complexity of the very thing they claim to analyze.

This book aims to rearticulate something of that complexity. Following in the footsteps of the scholars discussed above, I will look for the identity of photography in the history of its origins. If nothing else, a repetition of this traditional gesture allows me to make a close, even rigorous examination of this most foundational of photographic stories. More than that, such an examination may help to determine photography's own determinations. Should the identity of photography be confined to the realm of nature or to that of culture? Or will we find that, wherever we look—at photographic theory or at the medium's history—any given foundation is continually being displaced by a dynamic and troubling play of differences? In this sense, the chapters that follow are not just about the arcane matter of photography's historical identity. They are also about questions of history and identity in general and perhaps even about the question of matter itself.

| 2 CONCEPTION |

M——y account of recent debates about photography has directed attention to the identity of the object under investigation. Traditionally, photography's commentators have been quick to rephrase this ontological question in terms of a historical one, that is, as a search for origins. "What is photography?" is all too readily transformed into "Where and when did photography begin?" Responses to this second question have been easier to formulate, relying as they do on concepts of history seldom closely examined and on evidence regarded as self-evident. Consequently, photography's historiography is generally comprised of a rapid movement from the difficulties of philosophical investigation to a simple and selective exposition of facts. By this means, a theoretically fragile edifice, that identity signaled by the word *photography,* has been erected on a rarely questioned foundation of endlessly repeated historical information.[1]

Before returning to the debate, we must address this rhetorical structure. The aim is not to reject it as incorrect but rather faithfully to follow the path of its own logic, to pursue photography to its moment of origin.

THE GREATEST MYSTERY

But when (or what) exactly was that moment? As soon as we ask such a question we can feel photography's historical foundations stir a little under our feet. For example, in the introduction to his authoritative tome *The Origins of Photography,* Helmut Gernsheim describes photography's origins in terms of a temporal conundrum which he regarded as "the greatest mystery in its history."

Considering that knowledge of the chemical as well as the optical principles of photography was fairly widespread following Schulze's experiment (in 1725) . . . the circumstance that photography was not invented earlier remains the greatest mystery in its history. . . . It had apparently never occurred to any of the multitude of artists of the seventeenth and eighteenth centuries who were in the habit of using the camera obscura to try to fix its image permanently.[2]

This question, a question of timing—and, as we shall eventually see, of truth, of appellation, of propriety, and of power—is one that has concerned almost all who

have written about the origins of photography. At its most vulgar, the question has taken the form of a sometimes acrimonious debate about the identity of photography's 'true' inventor. Frenchman Louis-Jacques-Mandé Daguerre was of course the one who enjoyed the honor and pecuniary benefits of being the first to have his process announced to the general public, initially in the Academie des Sciences on January 7, 1839 and then in the Chambre des Députés on June 15: "You all know, and some of you, Gentlemen, may have already had an opportunity of convincing yourselves of the fact, that, after fifteen years of expensive and persevering labor, Mr. Daguerre has at length succeeded in discovering a process to fix the different objects reflected in a camera obscura. . . . The method of Mr. Daguerre is of his own invention, and is distinct from that of his predecessor, in its course as well as in its effects."[3]

This last strategic aside suggests that the speaker already glimpsed something of the argument that would soon ensue as to the status of Daguerre's original partner in this project, Nicéphore Niépce. The tone of this argument is suggested in a small extract from Victor Fouque's 1867 tract, *The Truth concerning the Invention of Photography: Nicéphore Niépce, his Life, his Endeavours, his Works:* "open the biographies, the dictionaries, open most of the works treating on Photography, and you will read there that this wonderful art was invented by *Daguerre! . . .* In spite of all that has been said to the contrary, against the usurpation, in spite of all that has been written for more than a quarter of a century on photography and its real inventor, Joseph-Nicéphore Niépce, the error persists today."[4] No less insistent is Gernsheim's view: "In our opinion, Niépce alone deserves to be considered the true inventor of photography—a fact confirmed by our rediscovery of the world's first photograph which led us to a reassessment of his pioneer work."[5]

Niépce's ownership of the title of "true inventor" and Gernsheim's ownership of the "first photograph" would seem to put the issue beyond doubt, at least as far as Marcel Bovis, writing in 1986 in *A History of Photography,* is concerned: "The credit for the initial idea of photography must without question go to Nicéphore Niépce (and his brother Claude)."[6] Bovis, however, subtly shifts the emphasis away from the hunt for the first successful *maker* of a photograph to a more nebulous quarry—the first *thinker* of photography! For this there are also plenty of claimants and just as many determined advocates seeking kudos for being the discoverer of the first photo-

thinker. The Austrian historian Josef Maria Eder is among the best known of these advocates:

I pointed out as early as 1881 that we must consider as the first discoverer of the sensitiveness to light of the silver salts Johann Heinrich Schulze. . . . It follows that Schulze, a German, is to be credited with the invention of photography, which was pointed out for the first time by this author. . . . None of the modern authors seems to have known the work of Schulze, and the present writer was the first, basing his statement upon the study of the original sources, to point out the German scientist Schulze as the inventor of photography in its first inception."[7]

Eder equates the process of "discovery" with that of "invention," perhaps thereby confusing the accidental with the conscious and the chemistry necessary to the making of photographs with the actual *idea* of photography itself. As Lynn White Jr. has pointed out: "Here we are faced with a problem of critical method. Apples had been dropping from trees for a considerable period before Newton discovered gravity: we must distinguish cause from occasion."[8]

Nevertheless Eder's argument does at least add weight to Gernsheim's claim that the basic components of photography—the images formed by the camera obscura and the chemistry necessary to reproduce them—were both available in the 1720s, quite some time before the photograph was officially "invented" in 1839. Indeed, Eder's *History of Photography* takes considerable trouble to trace the development of photochemistry through the eighteenth century, detailing the various discoveries and experiments with light and silver compounds undertaken by, among others, Schulze (1727), Jean Hellot (1737), Beccarius (1757), William Lewis (1763), Joseph Priestley (1772), Torbern Olof Bergman (1776), Carl Wilhelm Scheele (1777), and Jean Senebier (1782). As Eder points out, there is a direct link between these discoveries and some of the earliest experiments toward a specifically photographic process.

The earliest publication of such experiments appeared in the first issue of the *Journals of the Royal Institution of Great Britain* in June 1802 under the title "An Account of a method of copying Paintings upon Glass, and of making Profiles, by the Agency of Light upon Nitrate of Silver. Invented by T. WEDGWOOD, Esq. With Observations by H. DAVY." This essay, one of forty-eight authored by Humphry Davy appearing in

this issue of the *Journals,* records various experiments undertaken by himself and Tom Wedgwood, son of the famous potter and industrialist. A few pertinent extracts follow:

White paper, or white leather, moistened with solution of nitrate of silver, undergoes no change when kept in a dark place; but on being exposed to the day light, it speedily changes colour, and, after passing through different shades of grey and brown, becomes at length nearly black. . . .

The condensation of these facts enables us readily to understand the method by which the outlines and shades of painting on glass may be copied, or profiles of figures procured, by the agency of light. . . . When the shadow of any figure is thrown upon the prepared surface, the part concealed by it remains white, and the other parts speedily become dark. . . .

The images formed by means of a camera obscura have been found too faint to produce, in any moderate time, an effect upon the nitrate of silver. To copy these images was the first object of Mr. Wedgwood in his researches on the subject, and for this purpose he first used the nitrate of silver, which was mentioned to him by a friend, as a substance very sensible to the influence of light; but all his numerous experiments as to their primary end proved unsuccessful.[9]

The exact date of these experiments remains uncertain. In a letter to a friend dated January 14, 1797, Wedgwood remarks that "this talent [for philosophical investigation], if I have it in any degree, I attribute to a spirit of accurate analysis acquired from the writings of Scheele and Bergmann [sic], and practiced in the operations of the laboratory."[10] Wedgwood's "talent" also undoubtedly benefited from the influence of his father. Not only was Josiah Wedgwood an enthusiastic experimental chemist himself, he also surrounded his family with the best scientific thinkers and most up-to-date library in Britain. In 1779 he had employed Joseph Priestley's assistant John Warltire to instruct his children in chemistry. Two years later he purchased the notebooks of Dr. William Lewis, who had earlier repeated and confirmed Schulze's experiments with the light sensitivity of silver compounds. The following year he even employed Lewis's assistant Alexander Chisholm as his secretary, and it seems likely that Chisholm also instructed Tom Wedgwood in chemistry. It is no surprise then to find references to both Scheele and Senebier in Wedgwood and Davy's *Account,* nor to find Wedgwood familiar with the properties of silver compounds.[11]

Davy was also expert in the experimental chemistry of his day. On March 11, 1801 he had been appointed assistant lecturer in chemistry at the Royal Institution in London as well as director of the laboratory. He had been working there only a few months before his employers asked him to prepare courses on "The Art of Dyeing" and "The Chemical Principles of the Art of Tanning." It is tempting to think that during the preparation for these courses, undertaken between July and September 1801, Davy took a (renewed?) interest in Wedgwood's experiments on printing images on "white leather, moistened with solution of nitrate of silver."

During his research, Davy may also have come across the earlier work of Elizabeth Fulhame in this same field. Having been encouraged by a meeting with Joseph Priestley in October 1793, Fulhame had published her book *With a View to a New Art of Dying and Painting* in the following year. Among other things, she suggested that maps could be made using silver inscribed by the action of light. Larry Schaaf has described her notion as "an essentially photographic process" and argued that this 1794 book be included among those important to the early history of photography.[12] The book was republished in Germany in 1798 and in the United States in 1810. More importantly, Fulhame's experiments were reviewed in three British magazines in 1795 and 1796 and mentioned in an article published in 1798 in *Philosophical Transactions* on "the chemical Properties that have been attributed to Light." This last article was written by one of Davy's patrons at the Royal Institution, Sir Benjamin Thompson, Count of Rumford. Fulhame was also one of only two researchers cited by John Herschel in his first paper on photography, published in March 1839. In his second footnote he refers readers to Count Rumford's 1798 report on her work.[13] Whether or not Fulhame had any direct influence on the idea of photography, her book is yet further evidence that the chemistry necessary to a photographic process was available and widely known for some time before 1839.

Unfortunately the only direct records we have of Davy's own photographic experiments are the references in his "Account." After detailing various experiments that Wedgwood (and he?) had carried out, Davy also mentions certain efforts of his own: "In following these processes, I have found, that the images of small objects, produced by means of the solar microscope, may be copied without difficulty on prepared paper. This will probably be a useful application of the method; that it may be employed

successfully however, it is necessary that the paper be placed at but a small distance from the lens." He then goes on to discuss the preparation of various possible solutions and their different responses to light, before concluding as follows: "Some experiments on this subject have been imagined, and an account of the results of them may possibly appear in a future number of the Journals. Nothing but a method of preventing the unshaded parts of the delineation from being coloured by exposure to the day is wanting, to render the process as useful as it is elegant."[14]

Unfortunately no accounts of further experiments were published, and Davy—always in a hurry—seems to have been distracted by other pressing concerns away from his pursuit of photography.

Important though this 1802 document undoubtedly is, it still does not explain either why it took so long to invent a workable photographic process or why such a process was conceived in the first place. And so we come back to the quest for the first idea of photography. As Henry Talbot argued in 1844, "The numerous researches which were afterwards made—whatever success may be thought to have attended them—cannot, I think, admit of a comparison with the value of the first and original idea."[15] Five years before, in his first publication on photography, Talbot had conceded that "it appears that the idea was originally started by Mr. Wedgwood."[16]

Many more recent historians have agreed. But when and under what circumstances did this idea arise? Some histories date Wedgwood's first experiments as early as 1790. In this year, having completed an excellent education, the nineteen-year-old Wedgwood began a series of experiments at his father's ceramics factory in Etruria, England. In November 1790, for example, he was reportedly experimenting with quicksilver and nitrate of silver, leading to his invention of "silvered ware" in about February 1791. His new process resulted in ceramic vessels that exhibited a pattern of silver on black earthenware bodies.[17] Wedgwood subsequently had two papers read before the Royal Society. The first of these, titled "Experiments and Observations on the production of Light from different bodies by heat and attrition," was communicated to the Society by Sir Joseph Banks on December 22, 1791. However neither this paper nor its later companion make any mention of photographic experiments or discoveries. Although obviously occupied at this time with experiments and speculations about the relations of silver compounds, light, heat, and the fixing of images,



Wedgwood apparently undertook no work toward a specifically photographic process in 1790.

Apart from the "Account" of 1802, we have only one other relatively detailed report of Wedgwood's photographic experiments. In December 1799 the already distinguished English surgeon Anthony Carlisle, who was to become famous six months later for his own experiments with electricity, was introduced to Wedgwood's close friend Samuel Taylor Coleridge by Davy. The three men apparently enjoyed a vigorous discussion about Locke, Newton, and pain, among other diverse topics. Perhaps Davy was also instrumental in bringing together Carlisle and Wedgwood at around this time. In any case, in a letter to the editor of *The Mechanics' Magazine* dated January 30, 1839, just five days after Talbot's photogenic drawings had been exhibited for the first time, Carlisle wrote about participating in similar experiments with Wedgwood "about forty years ago":

At the evening meeting holden at the Royal Institution on Friday last, several specimens of shaded impressions were exhibited, produced by the new French Camera. The outlines, as well as the interior forms of the objects, were faintly pictured, and hence the application of this method of impressing accurate design may become disregarded after public curiosity subsides.

Having, about forty years ago, made several experiments with my lamented friend, Mr. Thomas Wedgwood, to obtain and fix the shadows of objects by exposing the figures painted on glass, to fall upon a flat surface of shamoy leather wetted with nitrate of silver, and fixed in a case made for a stuffed bird, we obtained a temporary image or copy of the figure on the surface of the leather, which, however, was soon obscured by the effects of light. It would be serviceable to men of research if failing experiments were more often published, because the repetition of them would be thus prevented. The new method of depicting by a camera, promises to be valuable for obtaining exact representations of fixed and still objects, although at present they seem only to possess the correct elements for a finished drawing.

Few artists of competent skill addict themselves to drawing natural objects, although the value of such designs should be faithfully correct, and the new instrument and new method are well suited to those purposes.[18]

Carlisle's reminiscence lends weight to the notion that Wedgwood undertook at least some of his photographic experiments in the latter part of 1800. We know, for

example, that Wedgwood himself was almost constantly traveling between January and June 1800 and then between November 1800 and August 1802, with only occasional periods of rest in London. However one of those rest periods fell between November 17, 1800 and the first week of December. He could well have used this time to undertake experiments at the facilities of the Royal Institution. Moreover, a letter written to Tom Wedgwood by his fellow intellectual and former housemate John Leslie on November 18 of that year contains a sentence that neatly corresponds to Carlisle's description of Wedgwood's experimental apparatus. "A few days ago I left at York Street an object-glass and some thin cylinders for the solar microscope, and half a dozen bits of painted glass which will, I think, suit you. I have more pieces, which you may have at any time."[19]

Leslie's reference in the same line to both the pieces of painted glass and a solar microscope suggests that, like Davy, Wedgwood may have used such an instrument to project his "shadows" on the moistened leather in the bird case. Such images could of course have been made as contact prints, but Carlisle specifically mentions that the leather is "fixed" in place, a precaution that implies the use of some sort of projection process. Of course, Davy had already written that Wedgwood's first attempts were made using a camera obscura, an instrument that Carlisle does not mention in his letter. So Wedgwood's earliest attempts may well have preceded both their friendship and the 1800 date. Whatever the exact timing, Wedgwood's experiments obviously took place between about 1790 and 1802 and are usually regarded as the first to have photography as their principal object.

The claims made for Wedgwood as first photographer, like those for Schulze, assume that the inaugural idea of photography must be marked by some definite evidence of a technological struggle in its direction. But what of those ideas that are no more than ideas? Could not photography have been imagined in some earlier, idle moment of speculation by a creative but not necessarily technological mind? Georges Potonniée's *The History of the Discovery of Photography* speculates that "the first idea of photography seems to have been discerned by some in a work written by the Norman, Tiphaigne de La Roche, about the middle of the eighteenth century."[20]

This work, an allegorical novel called *Giphantie* written in 1760 and rediscovered for photo-history by Mayer and Peirson in 1862, has often had its "photographic" portion reproduced.[21] Tiphaigne likens a large hall to a camera obscura, the walls of

which carry a "painting" that faithfully replicates, in all of its color and movement, an agitated seascape. Certain "elementary spirits" were able to "fix these passing images" on a piece of material soaked in a "very subtle substance," resulting in a permanent image "much more precious than anyone can produce, and so perfect that time cannot destroy it."[22]

Potonniée, who identified Niépce as first inventor, was not particularly impressed with this passage, despite its remarkable rhetorical proximity to the photographic process. Pointing to the problem of retrospective interpretation, he rather disdainfully regarded Tiphaigne's descriptions as no more than "a naive and popular dream": "Some historians look upon this mass of fantasies as a divination of genius, and the description as anticipating photography. I must refuse to see in it as much as this. . . . It was only chance which made his dreams so curious. . . . No, Giphantie did not forecast photography! Moreover, instead of having aided whatever led to its discovery, it is photography which discovered the simple novel and rescued it from oblivion."[23]

Dream it may have been, but was it a popular dream as Potonniée suggests? For what is striking about both Tiphaigne's novel and Schulze's earlier experiments is that they represent two of the very few recorded instances of pre-nineteenth-century imaginings that even *approximate* the idea of photography. Much more impressive in this regard is the vast *absence* of similar talk during the centuries prior to 1800. Indeed the historical record reveals that only at the end of the eighteenth century did speculations of this kind become frequent and widespread.

Compare, for example, the paucity of pre-nineteenth-century evidence with that multitude of would-be photographers industriously speculating, experimenting, and claiming successful results throughout the early part of the nineteenth century. I have already mentioned the experiments of Wedgwood, Carlisle, and Davy. Davy's coeditor of the *Journals of the Royal Institution,* Thomas Young, is one contemporary scholar who obviously took note of the "Account." In 1803 he tested his theories of light using the same setup described by Davy: "I threw this image on paper dipped in a solution of nitrate of silver, placed at a distance of nine inches from the microscope."[24] However, Young makes no mention of wanting to make the resulting "dark rings" permanent, an aspiration that many have seen as an essential component of any *photographic* process.

The aspiration for permanence looms large, for example, in the writings and experiments of Joseph-Nicéphore Niépce and his brother Claude. Pierre Harmant has

claimed that they first had the idea of photography in 1797 or 1798, although the evidence for this date is unconvincing.[25] More persuasive is the statement that appeared in Daguerre's 1839 publication *An Historical and Descriptive Account of the Daguerréotype and the Diorama:* "M. Niépce was engaged, since 1814, in endeavouring to fix the images of the camera obscura."[26] The Niépce brothers' earliest experiments concentrated on the automatic copying of engravings, having been inspired by the introduction of lithography into France in 1802 (and more especially by the establishment of the first successful lithographic premises in Paris in 1813). However, by 1824 Claude (who had left their home in Chalon-sur-Saône in 1816, eventually moving to England) signaled a definite shift in his brother's ambition: "I see that you . . . are determined, my dear friend, to occupy yourself principally with views of landscape in preference to copying paintings."[27] Having in 1816 made some early attempts with paper soaked in silver chloride, Nicéphore concentrated his later efforts on making heliographs, as he called them, using pewter plates coated with a light-sensitive bitumen solution. The earliest extant example, a barely legible image showing a view from the window of this studio, dates from about June 1827.

The year before Louis Daguerre had contacted Niépce with an offer to collaborate on any future photographic experiments. Daguerre, already famous as a designer for the Paris Opera and a coinventor of the Diorama, had apparently been making his own fledgling attempts at a photographic process since 1824. The strength of his motivation is conveyed in a story repeated by Helmut Gernsheim:

Obsessed by this idea, Daguerre equipped a laboratory at the Diorama near the Place de la Republique in Paris, and there for several years he carried out mysterious experiments, shutting himself in his workroom for days on end. The famous chemist J. B. Dumas relates (in The Illustrated London News *of July 26, 1851) that Madame Daguerre consulted him one day in 1827 as to whether or not he thought it possible that her husband would be able to fix the images of the camera. "He is always at the thought; he cannot sleep at night for it. I am afraid he is out of his mind; do you, as a man of science, think it can ever be done, or is he mad?"*[28]

By 1838, five years after Nicéphore's death and following a premature announcement of success in 1835, Daguerre was able to announce the invention of a workable process that he modestly called daguerreotype: "It consists in the spontaneous repro-

duction of the images of nature received in the camera obscura, not with their colors, but with very fine gradation of tones."[29] This announcement, officially endorsed by various French notables in January 1839, immediately induced a number of other people to come forward and claim that they too had been thinking of or experimenting toward a photographic process.

The most famous of these is William Henry Fox Talbot, an English scholar, experimental scientist, and natural philosopher. Talbot quickly arranged for a few samples of his "photogenic drawings" to be shown at a meeting of the Royal Institution on January 25, 1839 and followed this a week later with a reading of his paper on the process involved. Some historians have favored Talbot's claims over all others because he eventually introduced the paper-based negative-positive system still in use today. Also, unlike Daguerre, Talbot left numerous notes and essays about his photographic experiments and a quite specific account of the onset of the idea of photography. The latter forms part of his "Brief Historical Sketch of the Invention of the Art," published with his photographically illustrated book *The Pencil of Nature* in 1844. Some pertinent extracts follow:

It may be proper to preface these specimens of a new Art by a brief account of the circumstances which preceded and led to the discovery of it. And these were nearly as follows.

One of the first days of the month of October 1833, I was amusing myself on the lovely shores of the Lake of Como, in Italy, taking sketches with Wollaston's Camera Lucida, or rather I should say, attempting to take them: but with the smallest possible amount of success. . . .

I then thought of trying again a method which I had tried many years before. This method was, to take a Camera Obscura, and to throw the image of the objects on a piece of transparent tracing paper laid on a pane of glass in the focus of the instrument. . . .

Such, then, was the method which I proposed to try again, and to endeavour, as before, to trace with my pencil the outlines of the scenery depicted on the paper. And this led me to reflect on the inimitable beauty of the pictures of nature's painting which the glass lens of the Camera throws upon the paper in its focus—fairy pictures, creations of a moment, and destined as rapidly to fade away.

It was during these thoughts that the idea occurred to me . . . how charming it would be if it were possible to cause these natural images to imprint themselves durably, and remain fixed upon

the paper![30]

Already then, a number of names could be put forward as the "true" inventor of the idea of photography—Fulhame (1794), Wedgwood (c. 1800), the Niépce brothers (1814), Daguerre (1824), and Talbot (1833). But this list has still only scratched the surface. Pierre Harmant, for example, has put together a surprisingly crowded register of all who came forward after Daguerre's 1839 announcement to claim the honor of being photography's first inventor.

Twenty-four persons claimed to have been the inventor of photography as from 1839 and can be grouped thus: Seven Frenchmen: Niépce, Bayard, Daguerre, J-B Dumas, Desmarets, Vérignon, Lassaigne; six Englishmen: Talbot, the Rev. J. B. Reade, Herschel, Fyfe, Mungo Ponton (to the English section of this list there should perhaps be added a mysterious ecclesiastic who goes under the pseudonym of Clericus); six Germans: Steinheil, Kobell, Breyer, Hoffmeister, von Wunsch, Liepmann; an American: Samuel F. B. Morse; a Spaniard: Zapetti; a Norwegian: Winther; a Swiss: Gerber, and finally a Brazilian: Hercules Florence. Quite a list for a single discovery in so short a time![31]

Quite a List

Quite a list indeed! Its multitude alone would seem to mock the efforts of those historians who continue to squabble over which of *them* was the first to discover the one, true inventor of photography. As we have seen, this is invariably an argument as much about virility and paternity as about history, as much about the legitimacy of both photographer and historian as heroic primogenitors as about the timing of the birth itself.[32] (Thus the claim made for Henry Talbot, for example, is not that he was the first, because he plainly wasn't, but that he was the most fertile, that he was no less than the "father" of photography.)[33] In this the historians of photography have followed the lead of those early photographers about whom they write; witness *their* triumphant cries of discovery, *their* hasty insistence on restrictive patents, and *their* self-righteous anger when their claims were challenged during subsequent court cases.[34]

However I am not particularly concerned here with continuing this familiar photographic history of masters and their unruly offspring. For all its heat, the argument has thrown only a small amount of light on the timing of photography's origin. I therefore suggest a slightly different approach to the question. This approach incorporates

some aspects of Michel Foucault's archaeological method, which has critically engaged traditional historical ideas of invention and beginnings:[35] "Archaeology is not in search of inventions; and it remains unmoved at the moment (a very moving one, I admit) when for the first time someone was sure of some truth; it does not try to restore the light of those joyful mornings. But neither is it concerned with the average phenomena of opinion, with the dull grey of what everyone at a particular period might repeat. What it seeks . . . is not to draw up a list of founding saints; it is to uncover the regularity of a discursive practice."[36]

Following Foucault, our investigation of photography's timing will henceforth shift emphasis from that traditional economy of originality and priority to the appearance of a "regular" discursive practice for which photography seems to be the desired object. The invention of photography is thereby assumed to coincide as much with its conceptual and metaphoric as with its technological production. Accordingly I will ask not just who invented photography but rather at what moment in history did the *desire* to photograph emerge and begin insistently to manifest itself? In other words, at what moment did photography shift from an occasional, isolated, individual fantasy to a demonstrably widespread, social *imperative?*

With this question in mind, another list of names and dates merits investigation. We might begin with Harmant's list of twenty-four claimants. Upon further examination of this list, Harmant concluded that "of these, four only had solutions which were truly original."[37] However, originality is not particularly pertinent to an investigation of the desire to photograph. After all, the mythopoetic significance of the discourse in general is at issue, rather than the historical accuracy or import of individual texts or claimants. Originality of method, accuracy of chemical formulas, success or failure—these need not be taken as crucial factors in this investigation. More important, who showed evidence, written or otherwise, of *wanting* to photograph, even before Daguerre and Talbot had in fact made such a thing possible? And when did this evidence appear with sufficient regularity and internal consistency to be described in Foucault's terms as a "discursive practice?"

To keep the list within manageable proportions, I will retain only the requirement of relative independence; it is already clear that when the idea of photography was made public in 1839 it inspired a barrage of imitations and improvements, and, within a short time, an army of practitioners in every corner of the globe. Indeed, as

Theodore Maurisset, *La Daguerréotypomanie*, 1840. Lithograph. Collection of the J. Paul Getty Museum, Malibu, California

early as June 8, 1839, the English journal *The Athenaeum* was complaining that "hardly a day passes that we do not receive letters respecting some imagined discovery or improvement in the art of photogenic drawing."[38]

In some ways of course, the speed and enthusiasm of this response is as important a marker of photography's timing as the earlier moment of its first emergence as an idea. Indeed, that the new invention was received with such rapture and attention (rather than indifference and silence) suggests that photography was an invention whose time had well and truly come.[39] Among those who enthusiastically took up the idea of photography were respected scientists and scholars like Jean Baptiste Dumas, Paul Desmarets, Vérignon, Jean Lassaigne, Joseph Reade, John Herschel, Frederike Wilhelmine von Wunsch, Andrew Fyfe, Mungo Ponton, Clericus, John Draper, Albrecht Breyer, Jakob Liepmann, Hans Thøger Winther, Carl Steinheil, and Franz von Kobell. Even though many of these post-invention experimenters and letter writers were important to the future development of photography as a technology and a practice, it seems clear that each of them only began his or her experiments after first hearing of the initial successes of either Daguerre or Talbot. Thus, as far as the emergence of a photo-desire is concerned, they might be said to represent no more than, as Foucault ungenerously puts it, "the dull grey of what everyone at a particular period might repeat." My revised list includes only those who, before hearing of the work of Talbot or Daguerre, felt the hitherto strange and unfamiliar desire to have images formed by light automatically fix themselves.

Having said this, I must admit that claims of total independence are difficult to guarantee. Between 1802 and 1828, for example, the pioneering article by Wedgwood and Davy was reprinted or summarized in at least fifteen different publications in England, Italy, Switzerland, the Netherlands, the United States, Germany, and France.[40] Similarly, rumors of Daguerre's experiments had circulated in Paris and beyond since at least 1836 and possibly from 1824 onward.[41] Certainly a number of French journalists and artists indicated that they had heard of Daguerre's aspirations before his official announcement in 1839. In this context, and given that my principal interest here is in the discourse of the proto-photographers rather than in their honesty, one or two unlikely claimants have to be given the benefit of the doubt.

One such claimant is Henry Brougham. In his three-volume posthumously published autobiography of 1871, *The Life and Times of Henry, Lord Brougham, written by him-*

self, Brougham wrote that he engaged in some "experiments upon light and colours" during the years 1794–95 (when he was sixteen years of age). He had, he tells us, included a discussion of his experiments in a paper offered to the Royal Society in 1795. Most of the paper, his first in natural philosophy, was published in the society's *Philosophical Transactions* (no. 86) of 1796 under the title "Experiments and Observations on the Inflection, Reflection, and Colours of Light." The published paper attempted to discover analogies between the bending of light within bodies (refraction or, in the eighteenth-century term, refrangibility) and the bending of light outside bodies (reflection and diffraction or, in Brougham's terminology, flexion). But, as Brougham tells us in his autobiography, some parts of the paper, specifically those subtitled "Queries" (by which he meant conjectures or speculations), were never published.

The paper was very courteously received; but Sir Charles Blagden, the Secretary, desired parts to be left out in the notes or queries as belonging rather to the arts than to the sciences. This was very unfortunate; because, I having observed the effect of a small hole in the window-shutter of a darkened room, when a view is formed on white paper of the external objects, I had suggested that if that view is formed, not on paper, but on ivory rubbed with nitrate of silver, the picture would become permanent, and I had suggested improvements in drawing, founded upon this fact. Now this is the origin of photography; and had the note containing the suggestion in 1795 appeared, in all probability it would have set others on the examination of the subject and have given us photography half a century earlier than we have had it.[42]

The American painter and inventor of the telegraph, Samuel Morse, also remembered undertaking some quasi-photographic experiments well before hearing of Daguerre's and Talbot's efforts. While promoting his own invention, Morse had met with Daguerre in Paris on March 7, 1839. During the meeting he viewed some of the Frenchman's daguerreotype images, and on March 9 he wrote back to his brothers in New York:

You have perhaps heard of the Daguerrotipe [sic], so called from the discoverer, M. Daguerre. It is one of the most beautiful discoveries of the age. I don't know if you recollect some experiments of mine in New Haven, many years ago, when I had my painting-room next to Professor Silliman's— experiments to ascertain if it were possible to fix the image of the camera obscura. *I was able to*

produce different degrees of shade on paper, dipped into a solution of nitrate of silver, by means of different degrees of light; but, finding that light produced dark, and dark light, I presumed the production of a true image to be impracticable, and gave up the attempt.[43]

Many of photography's historians have taken this letter, which was published in the *New York Observer* on May 18, 1839, to mean that Morse undertook these experiments while studying chemistry under Professor Benjamin Silliman at Yale between 1808 and 1810. This assumption is reinforced by the recollections of an artist from Savannah, Georgia, named Richard W. Habersham. Habersham had been a roommate of Morse's in Paris in 1832, having arrived in that city the year before to join the atelier of Baron Gros. Morse was apparently happy to confide in his new companion, although Habersham's later memory of their conversations does not appear entirely trustworthy.

I have forgot to mention that one day, while in the Rue Surenne, I was studying from my own face reflected in a glass, as is often done by young artists, when I remarked how grand it would be if we could invent a method of fixing the image on the mirror. Professor Morse replied that he had thought of it while a pupil at Yale, and that Professor Silliman (I think) and himself had tried it with a wash of nitrate of silver on a piece of paper, but that, unfortunately, it made the lights dark and the shadows light, but that if they could be reversed, we should have a facsimile like India-ink drawings. Had they thought of using glass, as is now done, the daguerreotype would have been perhaps anticipated—certainly the photograph.[44]

Interesting that Habersham also is eager, at least in retrospect, to join his name to those who felt the desire to photograph before Daguerre and Talbot made its fulfillment possible. However Habersham's account is so similar in phrasing to the published 1839 letter written by Morse himself ("finding that light produced dark, and dark light") that one has to presume that the Georgian based his own recollection on a rereading of it. Notice that Habersham remembers Morse saying that he first had the idea of photography while a pupil at Yale but not that his actual experiments were carried out there as well. This bring us back to Morse's specific reference in the 1839 letter to his "painting-room next to Professor Silliman's."

After leaving Yale in 1810 Morse had begun working toward a career as a professional painter. Having befriended Washington Allston, he moved to London in July 1811 and studied there until October 1815. Upon his return to the United States, Morse struggled to establish himself in the American art scene and moved about a great deal. By the spring of 1821, however, Morse was back in New Haven, living with his wife and child, his mother and father, and his two brothers in a house in Temple Street and trying to earn a living as a portrait painter. As his biographer Carleton Mabee recounts:

He went on with his painting of portraits even while dreaming of painting in West's and Allston's grand manner. For four hundred dollars he had made a portable wooden house, a painting room, he called it, which could be attached to the family house or moved into the garden at will. There he not only painted but worked on his new invention, a marble-carving machine, designed like many similar inventions of the period to make copies of statues by machine rather than chisel. . . . The Morse home throbbed with need, creative force, and ambition.[45]

In 1825, the same year Morse left New Haven to live in New York, he painted a portrait of a man who was, according to Mabee, his "neighbor"—none other than his teacher of fifteen years before, Benjamin Silliman. Morse and Silliman, who had met Davy and who was familiar with the chemistry necessary to any photographic process, had been neighbors ever since Morse had returned in 1821.[46] They often undertook experiments together, both in chemistry and with the galvanic pile. A letter from Morse's wife, dated November 24, 1821 and sent to him in Washington, states that she will "send him the Camera-obscura."[47]

With these various fragments of documentary and biographical evidence in hand, we can now return to Morse's letter of March 1839 and better interpret his phrase "many years ago." All of the clues isolated here could relate to one of two possible periods, 1809–1810 or 1821–22. All but one, that is—the reference Morse makes to his painting room. The painting room could only be the one built in 1821 next to the property of his neighbor and friend Silliman. Of course, Morse may well have first conceived and even experimented with photographic images in 1809–10 and then repeated these experiments in a more systematic fashion a decade later. But, the weight

of the other evidence—his intense friendship with Silliman in the 1820s, his active involvement in experimentation and invention at this time, the sharing of a house with his brothers between 1821 and 1823, the availability of a camera obscura and the necessary chemicals, his reference to New Haven rather than to Yale—together with the painting room suggests that it is probably around this later time that Morse undertook his first photographic experiments.[48]

Morse was not the only American who claimed to have felt the desire to photograph at around this time. In 1849 Henry Hunt Snelling published his *The History and Practice of the Art of Photography*, and the first chapter discusses the reminiscences of photographer and painter James Miles Wattles as exemplary of "the innate genius of American minds." Snelling recounted that "as early as 1828" Wattles had "his attention drawn to the subject of Photography, or as he termed it 'Solar picture drawing.'" Wattles in 1828 was a sixteen-year-old student of the Parisian artist Charles-Alexandre Lesueur at the utopian New Harmony School in Indiana. He recalled to Snelling that he had then made attempts to "save" the pictures made by a camera obscura; his parents had apparently "laughed at him" and "bade him attend to his studies and let such moonshine thoughts alone." Wattles goes on to describe his attempts as follows:

In my first effort to effect the desired object, they were feeble indeed, and owing to my limited knowledge of chemistry—wholly acquired by questioning my teachers—I met with repeated failures; but following them up with a determined spirit, I at last produced, what I thought very fair samples—but to proceed to my experiments.

I first dipped a quarter sheet of thin white writing paper in a weak solution of caustic (as I then called it) and dried it in an empty box, to keep it in the dark; when dry, I placed it in the camera and watched it with great patience for nearly an hour, without producing any visible result; evidently from the solution being to [sic] weak. I then soaked the same piece of paper in a solution of common potash, and then again in caustic water a little stronger than the first, and when dry placed it in the camera. In about forty-five minutes I plainly perceived the effect, in the gradual darkening of various parts of the view, which was the old stone fort in the rear of the school garden, with the trees, fence etc. I then became convinced of the practicability of producing beautiful solar pictures in this way; but alas my pictures vanished and with it, all—no not all—my hopes. With renewed determination I began again.[49]

There is no other record of Wattles's efforts. However we do know of at least one or two other experimenters who claimed to have attempted photography in the 1820s. A French architect named A. H. E. (Eugène) Hubert, his attention drawn to the claims made by Daguerre in 1835, sent in a sarcastic reply to the same paper titled "M. Daguerre, the camera obscura, and the drawings which make themselves" (published in *Journal des Artistes* on September 11, 1836). The article reveals a fair amount of knowledge of both the difficulties and the technical requirements of the photographic process on which Daguerre was then working, suggesting that Hubert also had undertaken some experiments in this direction. And indeed he says as much in his text:

The researches which I have made on this subject seven or eight years ago, and of which I have spoken to several chemists and artists, make me think that even if we assume that a substance more sensitive than chloride of silver has been discovered, one would still have great difficulty in obtaining the most perfect of all drawings: for if we assume taking in the camera obscura image of a plaster cast lit up in bright sunshine and set against a dark background, and even if we assume placing the camera obscura and the object to be copied on the same turntable and rotate it according to the sun's movement in order that the shadows should remain unchanged, and even if we assume that an almost instantaneous discoloration would not be necessary, this would still be a far cry from copying portraits and landscapes, which have by no means the brightness of plaster exposed to sunlight.

I repeat, I so much doubt M. Daguerre's anticipated results that I find myself almost tempted to announce that I, too, have discovered a process, the possibility of which has recently been questioned in the Journal des Artistes—a process, namely, for obtaining the most perfect of portraits, by means of a chemical composition which fixes them in the mirror at the moment one looks at oneself![50]

Despite the implied criticisms, Hubert went on to become Daguerre's main assistant in the latter's efforts to perfect his metal-based photographic process. In June 1840 (the year of his death), Hubert even published an unsigned pamphlet dedicated to the daguerreotype process, *Le Daguerréotype considéré sous un point de vue artistique, mécanique et pittoresque, par le amateur* (*The Daguerreotype regarded from the viewpoint of art, mechanics and picturesqueness, for the amateur*), with a brief final section devoted to paper photography. Interestingly, in this last section he pointed to another Frenchman, Hippolyte Bayard, as the main hope for the future of the difficult paper-based process.[51]

This same Bayard, in October 1840, claimed through a note written on the back of one of his direct positive paper photographs to have been working on his own unique process for "about three years." Bayard, an employee of the Ministry of Finance in Paris, attempted to have his invention recognized by the French authorities throughout 1839 and 1840, eventually persuading the Académie Royale des Beaux-Arts to commission a report on his efforts. It is notable that the 1837 date later claimed by Bayard is not mentioned in the *Rapport sur les dessins produits par le procédé de M. Bayard* (*Report on the drawings produced by M. Bayard's process*) submitted by a committee of eleven on November 2, 1839. This report stresses instead the importance of February 5, 1839, the date of Bayard's first satisfactory results. However, the report does suggest that, at the very least, the desire to photograph had been a concern of Bayard's for some time: "M. Bayard appears to have been, during virtually the whole course of his life, preoccupied with a fixed idea, that of producing drawings with the aid of light, a light that plays upon bodies in varying intensities such that they are endowed with a more or less lifelike sensitivity."[52]

Not all of these pre-1839 experimenters lived in Europe or the United States. Hercules Florence, for example, was a French-born artist and inventor living in Campinas, Brazil (population 6,700) during the 1830s. In 1870 he claimed that "in 1832, without even thinking about it in advance, the idea of printing with sunlight came to me." His surviving drawings and manuscripts, dated from 1829 to 1837, seem to confirm this claim. Following some experiments with contact stencil printing in 1829 (which he called *poligraphie*), Florence moved on to address his enquiring mind to the images produced by the camera obscura: "In this year 1832, on August 15, while strolling on my verandah, an idea came to me that perhaps it is possible to capture images in a camera obscura by means of a substance which changes color through the action of light. This is my own idea because not the slightest indication of it ever reached me from elsewhere."

An entry of January 20, 1833 in Florence's notebooks describes his first photographic experiment. Using a camera obscura with an added lens and a sheet of paper soaked in silver nitrate, he took a four-hour exposure and obtained an image of the view from his window in which he could see the neighboring roofs and part of the sky. He also referred to later photographs of the facade of a local jail, a statue of Lafayette,

and further views from his window. At one point he practiced the contact printing of drawings on glass. He later mentioned that he began his experiments "seven years before I knew that there were other people developing the same research and being more successful than I." Nevertheless, in an article published in 1839 he stated that "I will not dispute my discovery with anyone because two people can have the same idea."

In one manuscript, entitled "L'Ami des Arts livre a lui-meme ou Recherches et decouvertes sur differents sujets nouveaux" and dated 1837, Florence recorded the following observations:

The action of the light drew for me the objects in the camera obscura, fixing the big shapes and accentuating contrasts, but with the imperfection that the lighter parts become darker and vice-versa. In spite of the fact that this is the way to obtain drawings made by nature and not by our hands, putting aside its actual precariousness, is this new fact in the Arts, not really interesting? Isn't it deserving of perfection? Haven't I initiated the more than wonderful art of designing any object, and capturing a view, without having the trouble of doing it myself?

Florence did however concede that photographic printing had some initial disadvantages compared to his *poligraphie* system.

Photography is really inferior to the other printing process because of the inconveniences I have just mentioned, but it is superior to them since it does not employ any of the expensive apparatus like the others do. It can be generalised as simple as writing, and having a glass plate near means it becomes equally simple. The traveller, the merchant, the poet, the painter, the teacher and the non-talented one will always make use of it. A happy idea, a well thought plan, which for so many reasons was kept with their authors in forgetfulness, can then be distributed, although in limited number, among friends that will enjoy them. This art has its price, its "sui generis" advantages, and after all, it was not said that it will never be improved.[53]

It is worth mentioning one or two more of these early photographic experimenters, if only to reinforce how widespread such experiments were in the years before 1839. Both J. M. Eder and Pierre Harmant, for example, mention the Reverend Philipp Hoffmeister, a German clergyman, as a "minor" contender in the debate as to the first

inventor. Hoffmeister claimed in his autobiography of 1863 to be the "inventor of photography," citing as evidence an article he had written, "Von den Grenzen der Holzschneidekunst, sowie auch einige Worte über schwartze Bilder" (Concerning the borders of wood engraving, as well as a few words regarding black pictures) published in 1834 in *Allgemeiner Anzeiger und Nationalzeitung der Deutschen*. He stated there: "Permit the undersigned, Hoffmeister, to give a few hints how by sunlight even paintings and copper engravings may be produced. Everybody knows how some . . . colors are bleached by sunlight; imagine then a board painted with such a color, upon which certain objects throw a shadow, and expose the board to the solar rays; soon a monochromatic painting will appear, which needs only to be varnished to be made permanent."

What should we make of this modest piece of speculation, written five years before Daguerre and Talbot made such reveries common? As a piece of scientific record it probably has little value, but as a signifier of the desire to photograph it is of far more interest. Unwittingly, Eder and Harmant made this clear, even as they rushed to condemn Hoffmeister's text as unworthy of attention. "Personally, I believe the cited statement of Hoffmeister to be more the expression of an ideal wish than the result of experiments," commented Eder. "This author did nothing but voice a dream, which was shared by any number of his contemporaries, viz to record the pictures of the camera obscura and to make copies of the results. His description is not a scientific one and, like many others, he had confused desire and reality," wrote Harmant.[54]

Another claimant to the invention of photography was Friedrich Gerber, a Swiss veterinary surgeon and professor at Berne University. On February 2, 1839 he announced in the *Schweizerischer Beobachter* that he had, several years earlier, succeeded in fixing the images of the camera obscura. Gerber claimed that his process "did not fear comparison" with that of Daguerre.[55] He stated moreover that he had demonstrated his invention to a group of prominent friends in 1837, including Professor Volmar and his brother, as well as the lithographer Wagner, the "Dozent" Marti and Carl Vogt. This invention consisted, he said, of fixing the images of illuminated objects in the camera obscura on white paper coated with silver salts, obtaining the images according to nature with regard to light and shade, and making any desired number of copies from a specially produced picture by another process on the same principles. Gerber mentioned that he and Professor Volmar had intended to undertake some further ex-

periments with the process but were handicapped by lack of time and an imperfect camera obscura. He did not provide the method by which he fixed his images. He did offer, however, to give "all the necessary information to any art-lover with the necessary time and means, and perhaps also chemical knowledge, who seriously intends to advance this entertaining and useful art by continued experiments."[56]

Interestingly, an anonymous person wrote to a rival newspaper, the *Allgemeine Schweizer-Zeitung,* on February 9, claiming that neither Gerber nor Daguerre were the first to make pictures by light, this having been done previously by Dr. (Thomas) Young in England and "Nips" (Niépce) in France. Moreover, this surprisingly knowledgeable person (perhaps one of Gerber's "friends?") claimed in a later issue (February 16) that the only pictures of Gerber's that he had seen were "excellent copies of small birds' feathers which no artist could have painted better, and which were produced by laying the feathers on the prepared paper."[57] Gerber replied in the *Schweizer Beobachter* on February 23, saying that he unconditionally withdrew any claims to being the first to come up with the idea of having images make themselves by means of light but that he was the first to have obtained enlarged photographic images of microscopic objects, presumably using the solar microscope. He also insisted that his method had been devised completely independently of the experiments of others.

In 1840 Gerber published a *Handbuch der Allgemeinen Anatonomie* (*Handbook of General Anatomy*) illustrated with lithographs. In his foreword, written in January 1839, Gerber explained that the lithographs were poor representations of the real thing, which could be accurately copied only by the process invented by him in 1836, "by means of which images of microscopic objects were drawn by the delicate hand of Nature herself in the solar microscope. However, this art is not yet suitable for a popular work."[58]

Nevertheless, Gernsheim claims that another book published in 1840, *Le premier livre imprimé par le soleil* by Boscawen Ibbetson, an album of contact prints of ferns, grasses, and flowers, used "the independently invented process of Friedrich Gerber of Berne, published in January 1839, when Ibbetson was residing in Berne."[59] We have no further records of Gerber's photographic experiments. No doubt, after the announcement of Daguerre's and Talbot's processes and the skepticism of his anonymous protagonist, he chose to address his energies to other problems.

Quite independently of Morse and Wattles, yet another American, professor of chemistry and natural philosophy John William Draper, also experimented with photographic processes prior to 1839. Following Daguerre's announcement in that year, Draper met Morse in New York, and the two of them made a number of daguerreotypes and in 1840 even opened a portrait studio together. However, Draper had wanted to make photographs for some time before this date. In 1858 he recalled that in 1835 he had, like Thomas Young before him, attempted to register a chemical reaction by focusing a cone of light on sensitive paper. Around this time he obviously also became acquainted with the earlier efforts of Wedgwood and Davy, replicating and expanding on their experiments as early as 1836.

For years before either Daguerre or Talbot had published anything on the subject, I had been in the habit of using sensitive paper for investigations of this kind. . . . The difficulty at this time was to fix the impressions. I had long known what had been done in the copying of objects by Wedgewood [sic] and Davy, had amused myself with repeating some of their old experiments, and had even unsuccessfully tried the use of hyposulphite of soda, having learnt its properties in relation to the chloride of silver from Herschel's experiments, but abandoned it because I found it removed the black as well as the white parts.[60]

Spain also claimed a pre-1839 would-be photographer. Pierre Harmant reiterated sections of an article apparently written in 1903 by Francesco Alcántara in the *Madrid Científico* claiming that an obscure Spanish painter from Saragossa called José Ramos Zapetti had in 1837 managed to fix the image in a camera obscura. This image apparently showed a figure and a part of his studio, appearing as a series of dark lines on a bright sheet of copper. According to this same article, "He could now do without a model or a lay figure and was going to give the whole world the benefit of his discovery, and more especially his companions the artists."[61]

The article is quoted in more detail in the 1983 Spanish publication *Historia de la fotografía,* written by Marie-Loup Sougez. Sougez reports that Alcántara had found some references to Zapetti's experiments in the memoir of another painter, Vicente Poleró. According to Alcántara, this claimed that Zapetti, who was otherwise poor, most valued

a cupboard full of bottles and small jars of liquids, giving the environment a certain laboratory atmosphere. His classmates called him names because every time they visited they found him occupied with his experiments. This is according to Federico de Madrazo and Carlos Rivera, who give many details about this. Ramos assured them as many times as they met that soon he would let them know about the admirable results obtained with his camera obscura, results which would be beneficial to all and especially to his friends the artists, with their models and casts.

On a day appointed beforehand, Dr. Carlos and Dr. Frederico were astounded to see, reproduced on a bright copper sheet, a figure and part of the studio, shown to them with great joy by Ramos Zapetti just as he had promised. This was an accomplishment much celebrated by these artists. Someone proposed to acquire the invention, but Ramos did not accept. Some two years later, the invention of Daguerre was made public.[62]

Nor does the cavalcade of experimenters end there. Other claimants, for example, point not to experimental successes and failures but to their (of course quite unprovable) production of ideas and desires. Vernon Heath, a successful English commercial photographer, reports in his *Recollections* (1892), that he was in his youth "accustomed to sketch a great deal out of doors, devoting myself chiefly to water-colour landscape work, using as a help the camera lucida invented by Dr. Wollaston." The camera lucida, a prism device that merged scene and paper on the retina, thus allowing the draftsman to trace one directly upon the other, was patented in 1807. While undertaking such a sketch Heath wrote he felt his first murmurings of the desire to photograph.

Harking back so far as the year 1837, I find that I was accustomed to sketch a great deal out of doors, devoting myself chiefly to water-colour landscape work, using as a help the camera lucida invented by Dr. Wollaston. This is an instrument having an adjustable glass prism, by means of which objects are represented (true to colour and proportions) on a sheet of paper lying horizontally to it; so that an accurate drawing can be made of them, even by those little accustomed to the use of the pencil, and a practical knowledge of perspective is acquired, not easily attained without some such assistance.

This was a period long previous to the discovery of photography. How often, though, when using my camera lucida, and looking at the brilliant and distinct picture its prism had formed on

the paper beneath it—how often did I wonder whether, within the realms of chemical science, there existed means by which the picture as I saw it could be retained and made lasting! Day after day I thought and dwelt upon this, as others no doubt had done before me, until at last there came one eventful Friday evening. On the 25th of January, 1839, I went to the Royal Institution to hear a discourse by Dr. Brand. At its close Professor Faraday came to the lecture-table, and, to my intense gratification and surprise, announced the two discoveries—the Daguerreotype and Mr. Fox Talbot's invention, then called "photogenic drawing."

Mr. Faraday invited his audience to inspect the specimens displayed in the library of the Institution, and I, being one of those who did so, saw realised that which my camera lucida had so often led me to speculate upon, and from that moment I was, in heart and spirit, a disciple of the new science—photography.[63]

THE PROTO-PHOTOGRAPHERS

Here then is the roll call, undoubtedly still selective and somewhat speculative, of those who practiced, recorded, or subsequently claimed for themselves a precocious onset of the desire to photograph: Henry Brougham (England, 1794), Elizabeth Fulhame (England, 1794), Tom Wedgwood (England, c. 1800), Anthony Carlisle (England, 1800), Humphry Davy (England, c. 1801–2), Nicéphore and Claude Niépce (France, 1814), Samuel Morse (United States, 1821), Louis Daguerre (France, 1824), Eugène Hubert (France, c. 1828), James Wattles (United States, 1828), Hercules Florence (France/Brazil, 1832), Richard Habersham (United States, 1832), Henry Talbot (England, 1833), Philipp Hoffmeister (Germany, 1834), Friedrich Gerber (Switzerland, 1836), John Draper (United States, 1836), Vernon Heath (England, 1837), Hippolyte Bayard (France, 1837), and José Ramos Zapetti (Spain, 1837).

These we could call the proto-photographers. As authors and experimenters they produced a voluminous collection of aspirations for which some sort of photography was in each case the desired object. Given the selective nature of history's memory, one could reasonably assume that this list still represents only a small portion of those who actually aspired to photography before 1839. Fragmentary evidence indicates that many other unnamed people shared the desires of the proto-photographers but were, for one reason or another, discouraged from either announcing or continu-

ing with their speculations. Talbot for example mentions one in his *Some Account of the Art of Photogenic Drawing,* published in January 1839.

I have been informed by a scientific friend that this unfavourable result of Mr. WEDGWOOD's *and Sir* HUMPHRY DAVY's *experiments, was the chief cause which discouraged him from following up with perseverance the idea which he had also entertained of fixing the beautiful images of the* camera obscura. *And no doubt, when so distinguished an experimenter as Sir* HUMPHRY DAVY *announced "that all experiments had proved unsuccessful," such a statement was calculated materially to discourage further inquiry.*[64]

As if to confirm Talbot's story, *The Literary Gazette* published a letter on February 9, 1839 in which the author claimed that he and two friends had devised a method similar to Talbot's some thirty years previously but had been unable to convert the negative they obtained into a positive print such that "the effects produced were . . . true."[65] A story published in *Chambers' Edinburgh Journal* on October 19, 1839, also suggests a widespread interest in photographic experimentation among an anonymous general public well before Talbot and Daguerre had identified such experiments with their proper names and legal patents.

We have ourselves a somewhat remarkable fact respecting photography to communicate to the public. Since the subject came into notice in Britain, a young Scotch barrister of our acquaintance has brought to us a number of specimens of the art, executed by himself and his young companions, fifteen years ago, when they were attending the grammar-school of Aberdeen. Photography, which has since become the subject of so much interest and so much discussion among grave men, was then and there practiced merely as one of the ordinary amusements of the boys, a sheet of paper covered with nitrate of silver, and then held up to a sun-lit window with a leaf or feather or picture before it, being the whole mystery of the process. Our young friend has no recollection of its being considered as any thing either new or wonderful: it simply ranked amongst the other amusements which boys in a great school hand down from one to another. The specimens exactly resemble those which have been exhibited during the last few months before our scientific societies, but are of course very different from the exquisite productions of M. Daguerre, as described by Sir John Robison.[66]

Having faithfully followed this trail of claimants and memoirs, we are now left with an undoubtedly incomplete but still representative listing of people who claimed or demonstrably exhibited photo-prophetic aspirations before 1839. In each case, some sort of photographic process emerged as their object of desire, sometimes literally so. We see Niépce for example writing in 1824 to his brother saying "I have the satisfaction of being able to announce to you at last that with the perfected processes I have succeeded in getting a picture from nature as good as I could desire." He wrote in 1827 to Daguerre "in order to respond to the *desire* which you have been good enough to express" (his emphasis); Daguerre replied in the following year that "I cannot hide the fact that I am burning with desire to see your experiments from nature."[67] On other occasions we must seek evidence of this same desire in the experiments that these various people undertook, the images they were moved to make, or in the choice of objects they sought to represent—invariably landscapes, the objects of nature, and/or the images found in the mirror of the camera obscura. This desire also manifests itself as certain concepts and metaphors or even within the very economy of language used by the proto-photographers to describe their imagined or still-fledgling processes. Any further analysis of the desire to photograph must therefore take each of these elements into account.

However, at this stage I am principally concerned with photography's timing rather than with its possible meanings. This chapter has, for the first time in the history of photography's historiography, brought together all of the known proto-photographers and their various accounts. It should already be clear that the discursive desire that I have described as photo-prophetic coincides with a quite singular moment in Western history. This is the crucial fact of my argument: the desire to photograph only appears as a regular discourse at a particular time and place. One infers that it was only possible to think "photography" at this specific historical conjuncture, that photography as a concept has an identifiable historical and cultural specificity. From a virtual dearth of signs of a desire to photograph in the eighteenth century or earlier, the historical archive reveals the onset only in the late eighteenth and early nineteenth centuries of a rapidly growing, widely dispersed, and increasingly urgent need for that which was to become photography.

It should also be clear that the desire to photograph was a product of Western culture rather than of some isolated individual genius. This in turn raises questions

about the nature of this desire, about both its production and its expression. We have to account not just for the unconscious or conscious actions of one or two gifted individuals but for the yearnings of an entire social body. In doing so, we have to go beyond the clichés that too quickly concede that "photography was in the air" (What was that "air?" How was it constituted? Where exactly was photography located in it?) or that allow that individuals like Daguerre or Talbot were the personifications of their age (Who isn't?). We instead have to articulate a moment of origin that produced these individuals even as they reproduced it through their various thoughts and actions.

Clearly by the 1830s the momentum of the desire to photograph was evident among an intelligentsia scattered throughout Europe and its colonial outposts (England, United States, France, Germany, Brazil, Spain, Switzerland). Indeed, by 1839 the desire to photograph was apparently so well established that Frenchman François Arago could in that year confidently assume to speak for all when he claimed that "everyone who has admired these images (produced in a camera obscura) will have felt regret that they could not be rendered permanent."[68] Later in the same year, Arago was again moved to declare that "there is no one, who, after having observed the nicety of the outlines, the correctness of shape and colour, together with that of the shade and light of the images represented by this instrument, has not greatly regretted that they should not be preserved of *their own accord;* no one that has not ardently desired the discovery of some means to fix them on the focal screen."[69]

"There is no-one who has not ardently desired some means to fix images of *their own accord.*" Arago's assumption that this once novel desire is now a universal imperative brings us directly back to the question posed in my first quotation from Gernsheim. Why should the ardent desire that Arago describes above have arisen at this particular time, rather than at some prior or subsequent moment in the long history of European uses of the camera obscura, or indeed in the long history of European image making in general? Given that a basic knowledge of the existence of light-sensitive chemicals had been popularly available since the 1720s, why does the concept of and desire to *photograph* only begin to emerge around 1800 and not before? It seems a simple, almost trivial, question, yet this matter of timing is absolutely crucial as far as the *meaning* of photography's conception is concerned. This, at any rate, is what I will be arguing in my next few chapters.

| 3 DESIRE |

What is found at the historical beginning of things is not the inviolable identity of their origin; it is the dissension of other things. It is disparity.

—Michel Foucault, "Nietzsche, Genealogy, History," in *Language, Counter-Memory, Practice*[1]

A——s we have seen, the desire to photograph was felt by a wide range of individuals in a number of different countries during the thirty years prior to the actual introduction of a marketable photography in 1839. This desire is relatively recent: its discursive traces only began to appear in Europe in the late eighteenth century, from whence it steadily increased in insistence and dispersal up until photography's public disclosure and commercialization in the 1830s. I have thus established the historical and cultural specificity of the emergence of this latent desire that came to be called photography. However, the precise morphological coordinates of this desire have yet to be determined. Before returning again to the question of origins, and with it the theoretical problem of photography's identity, we must examine in more detail the desire to photograph as it was actually represented by those I have called the proto-photographers.

From Henry Brougham to Louis Daguerre, photography's many inventors described their aspirations in a remarkably uniform fashion. Almost all spoke of wanting to devise a means by which nature, especially those views of it found in the back of a camera obscura, could be made to represent itself automatically. Daguerre's description, first published in September 1839, is one of the most definitive: "This process consists of the spontaneous reproduction of the images of nature reflected by means of the Camera Obscura, not in their own colors, but with a remarkable delicacy of gradation of tints."[2] A few months earlier, Talbot had published an equally carefully considered wording of his invention: "Some Account of the Art of Photogenic Drawing, or, The Process by Which Natural Objects May Be Made to Delineate Themselves without the Aid of the Artist's Pencil."[3]

Views (of landscape), the objects of nature, the images found in the camera obscura, spontaneous reproduction—these appear to be the principal fixations of what was in most cases a still-latent photographic desire. Landscape, nature, camera image, spontaneity—the words are clear enough, but what do they mean? What does it mean in the years between 1790 and 1839 to express a desire to have an otherwise fleeting picture of nature fix itself within the confines of a camera obscura? A closer examination of each of these elements, of their meanings at this time, and of the way they were actually represented by the various proto-photographers, may at least provide a slightly firmer outline of this desire that was to eventually manifest itself as photography.

The aim of such an investigation is not to uncover the truth of these pioneer's intentions. Indeed, we may well discover that the desire to photograph exceeded the limits of its recipients' own consciousness or understanding. We will look instead for what Foucault called "a *positive unconscious* of knowledge," for an ordering of thought at "a level that eludes the consciousness of the scientist and yet is part of scientific discourse."[4] We are attempting to make visible the conditions of possibility that might allow photography to be conceived when it was; to reveal the economy of metaphors that, in the years around 1800, could bring a concept like "photography" into the European imaginary. It is, in short, a task similar to that described by Foucault: "My problem was to ascertain the sets of transformations in the regime of discourses necessary and sufficient for people to use these words rather than those, a particular type of discourse rather than some other type, for people to be able to look at things from such and such an angle and not some other one."[5]

IMAGES OF NATURE

As Raymond Williams tells us, nature is "perhaps the most complex word in the language. . . . Any full history of the uses of nature would be a history of a large part of human thought."[6] This is particularly so when one looks at the nature of the late eighteenth and early nineteenth centuries. On the one hand this figure lies at the heart of all epistemological debate and inquiry during this period, as the popularity of natural philosophy, the name then given to such inquiry, suggests. Yet during this same period nature assumed an increasingly problematic and uncertain place within language, ultimately leading both to its own transformation as a sign and to the general disintegration of natural philosophy as a coherent discipline.

When looking at the function of the word *nature* from around 1800 on, we must remember that fields of study that in modern times have for the sake of convenience been divided into science, art, and literature were, in this era, indivisible and often embodied in one person and one text.[7] Henry Talbot, for example, was a world authority in what we would now separate into botany, mathematics, philology, linguistics, chemistry, and optics, as well as being an amateur poet and artist, an inventor, and a politician. A similar mixture of art and science (or at least of artistic aspiration and

technological invention) can be found in the lives of many other photographic pioneers. It is thus no surprise that, while the word *nature* is ubiquitous within the discourses of all proto-photographers, its meanings and functions within that discourse remain surprisingly elusive and uncertain.

Before looking at the specifics, I must briefly sketch something of the term's history just before and during the period in question. Nature, human nature, the nature of things—these were the constant and interrelated concerns of natural philosophy throughout the eighteenth century. As English poet James Thompson put it during the first half of that century, "I know of no subject more elevating, more amusing, more ready to awake the poetical enthusiasm, the philosophical reflexion and the moral sentiment, than the works of Nature."[8] But what exactly was the nature to which Thompson referred with such adoration?

It was, first and foremost, a divine nature, orderly and harmonious, and originally set in motion by none other than the Great Creator Himself. In *The Order of Things,* Foucault describes this Enlightenment period as setting itself the project of discovering a universal method of analyzing the works of nature. A method was sought that would reflect the presumed order of the world by relentlessly organizing its signs and representations according to that same order. Foucault refers to a number of exemplary projects from this period that set out to provide this exhaustive ordering of the world, including the concept of "one 'chain of universal being'" propagated by the Swedish natural philosopher Carl von Linné (1707–1778), better known as Linnaeus.[9]

Foucault pinpoints two key conceptual tools that underpinned this worldview. One was the tabula rasa, a comparative framework within and upon which things could be distributed according to a network of identities and differences such that they were simultaneously separated and united. The other was the notion that representation itself was something preestablished, reliable, neutral, and transparent to its object. As Foucault puts it, "The limit of knowledge would be the perfect transparency of representations to the signs by which they are ordered."[10]

The invention of visual aids like the telescope and microscope had done nothing to induce a new or revised vision of this world. They instead seemed to confirm that nature's order, shown by Newton to also have a mathematical basis, extended both to the celestial universe and to life in miniature. Marjorie Nicolson has described the

influence of these optical instruments on concepts of nature as follows: "The new Deity is, in the first place, the Divine Artist, who draws in little as exquisitely as in large. . . . God alone may rejoice in an Art which is as perfect as Nature; for . . . 'Nature is the Art of God.'"[11] Any small discrepancies or curiosities within Nature's plenitude were regarded not as fatal flaws within this reading but as signs of God's mysterious ways, of an order operating beyond the ken of mortal beings.[12]

However, at a certain point in history this view of nature, together with the Linnaean tabula rasa, suffered a profound internal crisis of confidence. During the period in question, the speculations of European thinkers as diverse as Lamarck and Lyell, Goethe and Erasmus Darwin, Kant and Hegel, Coleridge and Constable, contributed to its complete transformation. From a stable clockwork entity produced by a single act of divine creation, nature came to be seen as an unruly, living, and active organism with a prolonged and continuing history.[13] Indeed nature became synonymous with the rapid expansion of time itself.

One has to remember that in the early eighteenth century nature was still regarded as having only relatively recently come into being. A contemporary of Isaac Newton's, John Lightfoot of Cambridge University, made a number of careful calculations based on his biblical studies and announced, quite seriously, that the earth had been created at 9:00 A.M. on October 23, 4004 B.C.[14] Thus, the inhabitants of seventeenth-century paintings by an artist such as Claude Lorrain, invariably shown surrounded by appropriately tranquil and ordered pastoral landscapes, are assumed to occupy the static and eternal horizon of the present. This is a nature that is neither young nor old—it just is.

By 1778, however, the French naturalist Buffon was giving the earth a history of approximately 74,047 years. In the same year paintings of an erupting Mount Vesuvius were being exhibited in England by a close associate of the Wedgwood family, Joseph Wright of Derby. Such paintings were not only a study of the sublime as geological marvel but also a commentary on nature as a work in continual and sometimes violent progress. The early nineteenth century saw the presumed age of the earth continue to increase in exponential leaps and bounds, from tens of thousands to millions of years. To take but one example of the effects of this change in perspective, the study of geological formations was henceforth displaced from the ambit of theology to that of history, and thus from a biblical to an evolutionary style of discourse.

In this general context the English poet Samuel Taylor Coleridge, who called himself "an Eye-servant of the Goddess Nature," was moved to speak of this same divinity as "an ever industrious Penelope for ever unravelling what she had woven, for ever weaving what she had unravelled."[15] His phrasing here adapts the words of Johann Herder, one indication of the growing influence of German philosophy on his thought at this time.[16] Although Coleridge's thinking may at first appear to have been extreme, his close relationship with Humphry Davy and Tom Wedgwood, and his later friendship with Samuel Morse, make his concept of nature worthy of particular attention.

Indeed, so intimate was Coleridge with Wedgwood and Davy that it seems more than likely that he would have taken part in any photographic experiments they undertook. Certainly he would have discussed with them the scientific and philosophical implications of their work. Coleridge and Wedgwood had first met in 1797, on or about September 15. They quickly became firm friends and, more importantly, intellectual colleagues. On June 16, 1798, for example, Coleridge wrote that "The Wedgwoods received me with joy & affection. I have been metaphysicing so long & so closely with T. Wedgwood that I am a *caput mortuum,* mere lees & residuum."[17] Coleridge is describing his post-Wedgwood self in this passage as a "dead head," a term used in alchemy and chemistry to refer to the residue left after distillation. So, in describing his relationship with Wedgwood, Coleridge here aptly intertwines references to both philosophy and chemistry.

Wedgwood and his brother almost immediately became Coleridge's patrons, making it financially possible for the poet to visit Germany between September 1798 and June 1799. While there he studied the German idealist philosophy of Kant, Fichte, Schelling, and others at firsthand. We can safely assume that he shared this new way of thinking with the family that had made its acquisition possible. In fact, between 1797 and Tom Wedgwood's death in 1805, he and Coleridge had frequent discussions about philosophy and its relationship to vision, touch, and psychology.

Coleridge was also very close to Humphry Davy, taking part in his experiments with nitrous oxide at the Pneumatic Institute in 1800 and in January 1802 attending Davy's lectures on general chemistry at the Royal Institute, reportedly to "increase his stock of metaphors."[18] In December 1799 Davy introduced Coleridge to Anthony Carlisle, the same year in which the English surgeon later claimed to have assisted

Wedgwood in some photographic experiments. It therefore seems unlikely that Coleridge would not also have been familiar with these same experiments.

Samuel Morse also knew Coleridge well, especially between 1812 and 1815 when the American was studying painting in London. As Morse later recalled: "When [Charles] Leslie and I were studying under Allston, Coleridge was a frequent, almost daily, visitor to our studio. For our entertainment while painting, we used to arrange in advance some question in which we were interested, and propound it to Coleridge upon his coming in. This was quite sufficient, and never failed to start him off on a monologue to which we could listen with pleasure and profit throughout the entire sitting."[19]

Beyond this direct contact with some of the proto-photographers, Coleridge's thinking in the years around 1800 is exemplary of the more general shifts then transforming European epistemology as a whole. Drawing on a complex mix of Herder, Schelling, Steffens, Fichte, and Kant, as well as a variety of contemporary English thinkers, Coleridge saw the goal of all artistic endeavor as an effort "to make the external internal, the internal external, to make Nature thought and thought Nature."[20] His is a dynamic and interactive nature in which neither subject nor object, viewer or viewed, are passive and divided. They are instead, "identical, each involving, and supposing the other."[21] When mounting such arguments about nature, Coleridge turned first to the word itself, insisting that (as the future participle of the Latin verb *nasci,* "to be born") it is simultaneously a verb and a noun; "*Natura,* that which is about to be born, that which is always *becoming.*" Thus, for him, nature is "the term in which we comprehend all things that are representable in the forms of time and space, and subjected to the relations of cause and effect: and the cause of the existence of which, therefore, is to be sought for perpetually in something antecedent."[22]

In accordance with his interest in German *Naturphilosophie*, Coleridge conceived nature in terms of a universe continually being composed and decomposed by means of a web of polar forces, "two forces of one power."[23] He therefore welcomed Davy's youthful pronouncement in 1799 on the common identity of electricity and chemical attractions and Davy's early hypothesis "that there is only one power in the world of the senses."[24] As a consequence of this line of thinking, Coleridge was anxious to posit an interactive and constitutive relation between nature and culture (as embodied in the

observer), a relation again in keeping with his concept of the magnet metaphor: "even as the centrifugal power supposes the centripetal, or as the two opposite poles constitute each other, and are the constituent acts of one and the same power in the magnet."[25]

Much more could be said about the views of nature propagated by Coleridge, surely one of the most complex and fascinating of English intellectuals. The important point here is that Coleridge's early writings are exemplary of a more general shift from an eighteenth century to a modern view of nature. At the very time that photography was being conceived, nature had become irrevocably tied to human subjectivity; its representation was no longer an act of passive and adoring contemplation but an active and constitutive mode of (self-)consciousness. Nature and culture were interconstitutive entities. And although Coleridge was undoubtedly a maverick thinker, his ideas point to concerns that occupied all around him, including such influential Romantic poets as William Wordsworth, John Keats, and Percy Bysshe Shelley.[26]

It is no surprise that the Romantic poets were obsessed with nature, but part of this obsession had to do with their recognition of the impossibility of either reconciling or separating nature from its other, culture. A similar uncertainty appears in the discourses of the proto-photographers. However, as with the Romantic poets, this in no way lessened the wonder and respect that the idea of nature induced in them. As Talbot made clear in a paper published in February 1840, photography itself was regarded as but one more marvelous effect and confirmation of natural laws. It was no less than an act of "natural magic": "You make the powers of nature work for you, and no wonder that your work is well and quickly done. ... There is something in this rapidity and perfection of execution, which is very wonderful. But after all, what is Nature, but one great field of wonders past our comprehension? Those, indeed, which are of everyday occurrence, do not habitually strike us, on account of their familiarity, but they are not the less on that account essential portions of the same wonderful Whole."[27]

How then did the proto-photographers relate their projected inventions to this Nature, this "wonderful Whole?" Some, like Niépce, wrote their desire as "the copying of views from nature" or in terms of "a faithful image of nature." Daguerre spoke more ambiguously of "the spontaneous reproduction of the images of nature received

in the camera obscura" and then of "the spontaneous reproduction of the images of nature reflected by means of the Camera Obscura." Florence sought "drawings made by nature" while Talbot described his process as "Photogenic Drawing or Nature Painted by Herself."

Read collectively, these phrases certainly acknowledge the crucial role that nature was thought to play in photography. At the same time they reveal a noticeable uncertainty as to what exactly this role entails. Is nature painted by photography or being induced to paint herself? Is she produced by or a producer of photography? This question haunts almost all descriptions of photography produced by the three men most readily identified with its invention—Niépce, Daguerre, and Talbot.

In 1826 Nicéphore Niépce had attempted to resolve any initial uncertainties about the object of his experiments by coining a generic word for the whole process— *héliographie* or "sun-writing/drawing." He thereby placed his invention into the same genealogical family as lithography, a word introduced in about 1805 to describe Aloys Senefelder's 1796 invention. Lithography was the system of reproduction that had inspired the Niépce brothers' earliest attempts at making light-induced images. At the same time, by naming the process after the sun, Niépce aptly referred to the importance of light to its action while incorporating a key metaphor for God's divine power and benevolence. In this way, Niépce's term neatly summarized his actual process while conjuring a long lineage of theological and classical associations.

He continued to use the term in private correspondence as well as on public occasions. He presented his *Notice sur l'héliographie* to the Royal Society in December 1827, for example, with a note appended to the title to say that "I believe I may be allowed to give this name to the object of my researches, until a more exact term may be found."[28] Although he obviously believed that *héliographie* was only a provisional term, he was still using it in November 1829, when he prepared a synopsis titled "On Heliography, or a method of automatically fixing by the action of light the image formed in the camera obscura." On the basis of this synopsis, Niépce's process is also referred to as *héliographie* in Daguerre's "Account" of September 1839, as well as in most subsequent histories.[29]

Yet we know that Niépce was not fully satisfied with this name, apparently never believing it to be a sufficiently exact term for his process. This is demonstrated by the

game with Greek compounds that he employed in 1832, the year before he died, as a means of coming up with a more suitable name. He presumably chose Greek because it was at the time the language of science and especially of the natural sciences. As it happens, *hélio,* or for that matter any other signifier for "light," is notably absent from Niépce's preliminary list of seven potential components. It is also absent from the twenty suffixes and prefixes that he eventually shuffled around his page, although *graphé* (which he himself translated as "writing; painting; picture") is among them.

The very contrariness of the individual word-signs he played with ("nature, itself, writing, painting, picture, sign, imprint, trace, image, effigy, model, figure, representation, description, portrait, show, representing, showing, true, real") suggests his conceptual dilemma. No wonder then that he marked his resulting compounds with the apologetic interpolation "roughly." Was he to describe his process, at this stage still little more than an exciting idea, "painting by nature herself" or "true copy from nature," "to show nature herself" or "real nature?" His attention eventually focused exclusively on the word *phusis* or "nature," this becoming the fundamental component in each of his final four compounds—*Physaute, Phusaute* (Nature herself), *Autophuse, Autophyse* (copy by Nature).

Obviously, for Niépce, nature was central to photography, but he could never resolve with any precision how to articulate the relationship between the two. In his note this conceptual hesitation is reproduced at the level of nomenclature itself. Rather than replace *héliographie* with another single word, he could never bring himself to make a final decision. He left instead a contradictory set of pairs (nature or her copy, representation or reality?). It is as if, to his mind, the nature of photography itself could only be properly represented by way of a sustained paradox.[30]

A similar paradox animates Daguerre's writing on photography. Strangely, we have very little written by Daguerre himself on the inspiration behind his photographic experiments and none of his early notes or experiments to examine for clues. A number of his contemporaries remembered Daguerre's desire to photograph as a "madness" or sickness. Certainly, the fifteen years he spent struggling to bring his process to fruition suggests he was in the grip of a powerful obsession. And, as with Niépce, nature was key in his own descriptions of this obsession.

His first letter to Niépce, sent in 1826, claimed that "for a long time I, too, have been seeking the impossible," and Niépce agreed (in his letter of June 4, 1827) that

3.1 Nicéphore Niépce, *Notebook page: Autophuse/Autophyse*, 1832. Pen on Paper. Russian Academy of Sciences, Saint Petersburg. Reproduction courtesy of Larry Schaaf

they were "occupying ourselves with the same object."[31] Their letters usually referred to this impossible but desired object as "views from Nature." In Niépce's 1827 *Notice sur l'héliographie,* the author mentioned that Daguerre regarded the process as "eminently suitable for rendering all the delicate tones of Nature."[32] Indeed, Daguerre consistently discounted Niépce's initial experiments with a technique to copy engravings automatically and urged him to concentrate instead on producing camera pictures "from" nature.

Thus when Daguerre published his subscription broadsheet in late 1838, he described his own process as "the spontaneous reproduction of the images of nature received in the camera obscura" and spoke throughout of delivering to buyers "the effects of nature," of "a perfect image of nature" and of "the imprint of nature."[33] Here again then Daguerre faced a quandary. Did his process actively make an image of nature or merely make it possible for her to "imprint" an image of herself? Like Niépce before him, Daguerre solved his conceptual dilemma with a construction of language that paradoxically doubled back on itself, thus allowing him to posit a nature somehow both drawn and drawing, reproduced and reproducing. As he put it in his concluding remark: "In conclusion, the DAGUERREOTYPE is not merely an instrument which serves to draw Nature; on the contrary it is a chemical and physical process which gives her the power to reproduce herself."[34]

As a prominent scientist and scholar, Henry Talbot was well aware of the latest speculations about the "nature of Nature." Among his earliest photographic images were contact prints ("copies" as he called them) of leaves and flowers, a choice that suited his own interest in botany as well as his expressed desire to apprehend "the true law of nature which they [his photographs] express."[35] However, like Niépce and Daguerre, Talbot seemed to find it difficult to articulate exactly how this "true law" operated in relation to photography.

His *Some Account of the Art of Photogenic Drawing* (1839) described his process as one that "renders" or "imitates" its botanical specimens "with the utmost truth and fidelity." At another point he told readers about making photographic representations of his house: "And this building I believe to be the first that was ever known *to have drawn its own picture."* Photography, he explained, results in "pictures" or "drawings" that are "effected" or "impressed" by the "boundless powers of natural chemistry." It

William Henry Fox Talbot, *Linen*, 1835. Photogenic drawing negative. Collection of the J. Paul Getty Museum, Malibu, California

is a way of letting "Nature substitute her own inimitable pencil" for that of the artist. At the same time, he recounted the story of observers unable to tell the difference between his picture of lace and the piece of lace itself, a story that seems unconsciously to mirror his own linguistic uncertainty about the relationship between image and referent. By what mode of inscription did nature reproduce herself as a photographic image? Talbot's constant change of verb ("renders, imitates, drawing, effected, impressed") suggests that he was not entirely certain himself.[36]

This uncertainty is clearly reiterated in his less public notes and letters. On January 25, 1839, the week before his *Account* was read to the Royal Society, Talbot wrote to his friend and future collaborator John Herschel about his "new Art of Design"—about, that is, "the possibility of fixing upon paper the image formed by a Camera Obscura, or rather, I should say, causing it to *fix itself.*"[37] On March 3 he jotted down the potentially theological phrase "Words of Light" while composing yet another equivocal description of the relationship between photography and nature; his process is, he mused, "Nature magnified by Herself, or, Nature's Marvels 'And look thro' Nature up to Nature's God.'"[38] On March 26 Talbot wrote a similarly confused letter to fellow botanist Sir William Hooker, suggesting that they work together on a publication "with photographic plates, 100 copies to be struck off, or whatever one may call it, taken off, the objects."[39] The consistent deployment of such equivocal phrasing suggests that Talbot was still unable to describe in words the relationship between photographs and the nature that generated them.

Talbot's irresolution takes us back to his choice of title for the crucial 1839 paper to the Royal Society. In a draft version he had called it "Photogenic Drawing or Nature Painted by Herself." His final title is no more resolved. The paper was headed "Some Account of the Art of Photogenic Drawing." However, perhaps suspecting that an invented word like "photogenic" (once again a compound formed from two Greek words; *phos* or "light," and *genesis* or "produced") would require some further explanation, Talbot added another clarifying phrase: "or, The Process by Which Natural Objects May Be made to Delineate Themselves without the Aid of the Artist's Pencil."[40] Photography, he wrote, is both a mode of drawing and a system of representation in which no drawing takes place. In this convoluted formulation, nature is simultaneously active and passive, just as photography itself is simultaneously natural and cultural.

Taken as a whole, this description neatly embodies the conceptual paradox that pervades the discourse of all proto-photographers.

Each case examined here attempted to maintain a dynamic reflexive movement at the level of language that comes to rest at neither of the two defining poles. Consider the concept-metaphor each conjured up in these ambiguous words and phrases: a mode of representation that is simultaneously active and passive, that draws nature while allowing her to draw herself, that both reflects and constitutes its object, that undoes the distinction between copy and original, that partakes equally of the realms of nature and culture. Photography, whatever it was, obviously posed a dilemma for its inventors that was as much philosophical and conceptual as scientific. Everyone was sure that nature was central to his idea of photography, but no one was quite sure what nature was or how to describe her "mode of existence." In short, at the very moment photography was conceived, nature, its central element, was a decidedly unresolved concept.

VIEWS OF LANDSCAPE

Frequently, although not always, references to nature in the discourse of the proto-photographers were articulated in terms of landscape; that is, as one quite particular mode of *picturing* nature. For many of these pioneers, landscape not only represented the principal pictorial aspiration for their latent process but provided much of the conceptual and technical language used to describe its expected products. Whether landscape figured in their discourse as picture, concept, or vocabulary, it invariably fit within the framework provided by the aesthetic theory known as the picturesque.

The picturesque, Europe's primary theorization of landscape during the eighteenth and early nineteenth centuries, provided its adherents with a widely recognized set of conventions and aesthetic standards by which to make and judge landscape images. It also provided a popular philosophical context within which larger questions of representation could be conceived and disputed. It is hardly surprising to find the picturesque inhabiting the discourse of the proto-photographers. Any educated person would have been familiar with its basic precepts and most of photography's inventors were very well educated indeed. In addition, most of photography's pioneers were ei-

ther amateur or professional artists; thus the picturesque was one of their regular tools of trade.

Against this background, it is no accident that we find picturesque terms like *view, effect,* or *prospect* appearing in their writings or that we see landscape posited as a central aspiration for their photographic experiments. But even when landscape is not specifically mentioned, the almost invariable use of a camera obscura by the proto-photographers suggest an interest in its representation. The facilitation of landscape drawing was, after all, this instrument's principal artistic function. The use of a camera obscura to aid one's drawing also tended to presume a picturesque rendering of the scene in question, for the camera provided the tight framing and fixed viewing position required by this particular arrangement of aesthetic conventions.

But how central was the picturesque to the experimental thinking of the proto-photographers and to the reordering of European knowledge that made it possible even to conceive of a "photography?" A brief examination of its place in the photo-graphic activities of Niépce, Daguerre, and Talbot may provide the beginnings of an answer. It is notable that Nicéphore Niépce, for example, chose a consistent designa-tion to distinguish his "photographic" experiments from those concerned only with the photomechanical copying of engravings. Georges Potonniée traced the use of this particular designation:

Niépce always called these images by a peculiar name, he named them "points de vue." We find this term "points de vue" used for our present word "photographs" in his letters to his son Isidore, to his brother Claude, to the engraver Lemaître, to his partner Daguerre, etc. His correspondents, in turn, use the same term when replying: the letters of July 19, 1822, February 24, and September 3, 1824, May 26, 1826 and February 2, June 4, July 24, and September 4, 1827, August 20, 1828, Octo-ber 4, and 12, 1829. The same term, with its precise significance, is found again in the "Notice" written by the inventor on December 8, 1827 for the Royal Society of London and in the letter written on December 5, 1829 to his associate Daguerre. Everywhere the difference between "points de vue" and "copies de gravures" is emphasized.[41]

Niépce apparently always used the picturesque phrase *points de vue* to designate the images he hoped to produce in his camera. Indeed, when speaking of his brother's

"desired end" in 1824, Claude Niépce noted that "you are determined, my dear friend, to occupy yourself principally with views of landscape in preference to copying paintings."[42] In September of that year Nicéphore was able to report back that "I have succeeded in getting a picture from nature [*point de vue*] as good as I could desire."[43] By about June 1827 Niépce had produced his earliest extant heliograph, a courtyard scene taken from his studio window. In an earlier letter to Daguerre, dated June 4, 1827, Niépce apologized for his lack of recent results: "I shall take them up again today because the countryside is in the full splendor of its attire and I shall devote myself exclusively to the copying of views from nature [*points de vue*]."[44] With this constant emphasis in mind the second paragraph of Niépce and Daguerre's "Provisional Agreement" of December 1829 asserts that "Monsieur Niépce has made certain researches with the purpose of fixing by a new method, without the aid of a draughtsman, the views of nature."[45]

This was an aim with which Daguerre would have had considerable sympathy. In 1801, at the age of fourteen, he had been apprenticed to an architect in Orléans and spent much of his teenage years sketching landscapes. Between 1807 and 1816 he worked as an assistant to Pierre Prévost, helping to paint the large historical vistas for which the latter became famous. Even Jacques-Louis David admired them, supposedly remarking to some students, "Really, one has to come here to study Nature!"[46] Daguerre went on occasionally to exhibit paintings in the annual Salon, usually of architectural ruins set amid gloomy landscapes. He also contributed ten drawings to the monumental *Voyages pittoresques et romantiques en l'ancienne France,* a twenty-six-volume work that appeared in numerous parts between 1820 and 1878. Having made his reputation as a master of trompe l'oeil scenery designs for the theater, Daguerre then went on to employ this skill to good effect in his diorama paintings. These paintings, consisting primarily of landscape scenes, used every available convention of the sublime and the picturesque to achieve the dramatic visual effects that Daguerre and his patrons desired. They were, as one spectator remarked, "an extraordinary mixture of art and nature, producing the most astonishing effect."[47] In 1839 Daguerre would claim that the daguerreotype could deliver these same "effects" to its practitioners.

Although by no means as expert in the ways of the picturesque as Daguerre, Henry Talbot was equally steeped in its methods and iconography. He was, for ex-

ample, first taken to see a panorama at the impressionable age of eight and exclaimed to his mother that it was "exactly like nature."[48] After an extensive education, including some instruction in the fine arts, Talbot moved into Lacock Abbey in 1826. Two years before he had praised the "view from the top of Bowden hill," although he also complained that the "fine old pile" of the abbey had been "defaced with *modern* windows irregularly placed."[49] This appreciation of views, of buildings as signifiers of history, and of the aesthetics of regularity are all drawn from picturesque theory.

Talbot could hardly escape this theory. His strong-willed mother was a notorious practitioner of the picturesque, reportedly "constantly adjusting the landscape to her taste."[50] This was a taste that Talbot obviously shared. In 1826 he visited Corfu and on April 16 wrote back to his mother and described what he had seen: "I wish Claude were here to take a view for me, from the lighthouse of Zante at sunset. I never saw so perfect a view, for generally in real views, something is too much or too little, but with this view the most critical judgement must be contented. The same view looks nothing in the morning when the light falls the wrong way."[51]

After 1839 Talbot frequently went in search of such picturesque views for his photographs, referred readers to the picturesque features of particular images, gave instructions on how to take pictures of landscape and "external nature," and promoted the use of his photographic process by tourists and travelers. This promotion was inspired no doubt by his own experience in 1833 while on a honeymoon trip to Lake Geneva. There, in the midst of an unsuccessful attempt to draw a picturesque view using a camera lucida, Talbot later claimed to feel his first pangs of the desire to photograph. Thus, in his own narrative of invention, the picturesque figures as a powerful point of origin, supposedly inspiring his thoughts of photography by the frustrating absence of a properly drawn composition on the page before him.

What did it mean to aspire to the production of picturesque effects in the decades around 1800? The Reverend William Gilpin was the picturesque's most persistent and influential exponent, publishing numerous illustrated travel books on the subject, many of which were reissued and translated into French and German. In his first writings on the subject in 1768, Gilpin had described the picturesque as "expressive of that peculiar kind of beauty which *is agreeable in a picture*."[52] By 1792 Gilpin had slightly redefined his concept of the picturesque, bringing it more in tune with a ro-

mantic sensibility. He now described it in terms of a judicious conjunction of opposites: "By enriching the parts of a united whole with roughness, you obtain the combined idea of simplicity and variety, from whence results the picturesque."[53] It is worth noting that Gilpin's concept of the picturesque in this, his last book on the subject, does not involve a harmonious resolution of constituent parts but rather a strategic maintenance of visual disjunctions. It is also important to note that the picturesque is here projected in terms of an effect on the mind produced by his "combined idea" and not as a particular style of picture making or genre of subject matter.

However, in practice this didn't preclude Gilpin from projecting landscape as the central concern of the picturesque. Indeed, Gilpin's formulations were so popular that those who could afford to do so would troop around Britain and the continent looking for views of nature that looked like landscape pictures, for scenes that confirmed a picturesque aesthetic. Beauty spots these were called, the precursors to the postcard views we seek out today. Sketches were often made at these spots as memories of the experience. Indeed, one irony of Gilpin's promotion of the picturesque was that while promoting an ideal style of landscape he encouraged many more people to get out into the European countryside and to observe and draw it for themselves. When nature proved a little recalcitrant, machines were sometimes employed to bring a more picturesque order to what was seen by the naked eye. The camera obscura was one popular device used for this purpose. However in many cases this instrument was replaced by more portable machines for seeing, such as the camera lucida (invented in 1801) or the Claude glass.

This last instrument, a tinted convex mirror, was commonly used to produce a stable, reflected image of landscape reminiscent of the paintings of Claude Lorrain: "The blackened mirror gave a rather weak reflection, so that the prominent features of the scene were stressed at the expense of the detail, while the colours were also toned down nearer to those found in actual varnished paintings."[54] Travelers would hold the glass in their hand so as to see a reversed image of the landscape positioned behind their back. As one tourist recalled, "my Convex Mirror brought every scene within the compass of a picture."[55] This made the device particularly useful for composing picturesque versions of the landscape. The curved surface of the mirror allowed one, for example, to bend framing trees so that they more obviously cupped a particu-

lar view. It also provided an enhanced pictorial integrity such that one could hold a simultaneous focus on both foreground and distance. As Gilpin described this preferred state, "In the minute exhibitions of the convex-mirror, composition, forms, and colours are brought closer together; and the eye examines the general effect, the forms of the objects, and the beauty of the tints, in one complex view."[56]

The pictorial properties that Gilpin admired in his Claude glass—the ability to reduce all things to a visual equivalence—are strikingly similar to those that would later be found in the photograph. No wonder that Sir John Robison, secretary and a fellow of the Royal Society of Edinburgh, referred to the glass while trying in August 1839 to describe his first sight of a daguerreotype: "The best idea I can give of the effect produced is, by saying that it is nearly the same as that of views taken by reflection in a black mirror."[57]

In Gilpin's terms, tourist sketches, whether made with the glass or without, were but pictures of a nature, which was already a series of pictures. He made this clear in his *Observations . . . on . . . the Mountains, and Lakes of Cumberland, and Westmoreland*:

As we stood under *the beetling cliffs on each side, they were too near for inspection: their harsh features wanted softening; but we had noble views of them all in order, both in* prospect *and* retrospect. *Not only the design, and composition, but the very strokes of nature's pencil might be traced through the whole scene; every fractured rock, and every hanging shrub which adorned it, was brought within the compass of the eye: each touch so careless, and yet so determined: so wildly irregular; yet all conducting to one whole.*[58]

In the context of such thinking aesthetes like Arthur Young (1741–1820) surveyed the Swiss Alps in his *Travels in France and Italy* and declared with satisfaction that "in several places the view is picturesque and pleasing: enclosures seem hung against the mountain sides as a picture is suspended to the wall of a room."[59] In 1788 Gilpin's son wrote to his father in similar terms following a visit to Borrowdale in the Lake District. Like Young, Gilpin junior wrote without apparent irony as if his view of the countryside and its representation as pictures were two indivisible and equivalent activities. "It gave me . . . a very singular pleasure to see your system of effects so compleatly [sic] confirmed as it was by the observations of that day—wherever I turned my eyes, I beheld a drawing of yours."[60]

On the basis of this apparent conjunction of nature, picture, and eye—later to be emulated in the invention of the camera lucida—Rosalind Krauss has defined the picturesque as a "beautifully circular" relationship between nature and art, original and copy.[61] She posits this definition in the context of a larger argument concerning an avant-garde modernism invested in the "myth" of originality. Looking back to the origins of modernism, she points out that "the ever-present reality of the copy as the *underlying condition of the original* was much closer to the surface of consciousness in the early years of the nineteenth century than it would later be permitted to be."[62]

For it is perfectly obvious that through the action of the picturesque the very notion of landscape is constructed as a second term of which the first is a representation. Landscape becomes a reduplication of a picture which preceded it. . . .

The singular *and the* formulaic *or repetitive may be semantically opposed, but they are nonetheless conditions of each other: the two logical halves of the concept* landscape. *The priorness and repetition of pictures is necessary to the singularity of the picturesque, because for the beholder singularity depends on being recognized as such, a recognition made possible only by a prior example.*[63]

It is no surprise then to find that, for the eighteenth-century viewer, nature was always already a picture in waiting, with God as its divine artist. As Carl Barbier argues, Gilpin believed that "nature as a divine work of art is placed above human works of art," a comparison only possible because he assumes that both obey common "artistic" principles.[64] The picturesque system of judicious selection and combination—amounting to a systematic process of aesthetic ordering—merely emulated those principles of order that nature herself was thought to practice (but that her vast scale had sometimes made ambiguous and difficult to discern). Indeed, wealthy proponents of the picturesque, like Talbot's mother, employed landscape designers to transform their grounds into a series of "views," thus forcing nature to look more like a picture, to look more ideal.[65] As Gilpin explained: "Nature is always great in design; but unequal in composition. . . . Nature gives us the material of landscape; woods, rivers, lakes, trees, ground, and mountains: but leaves us to work them up into pictures, as our fancy leads. . . . I am so attached to my picturesque rules, that if nature gets it wrong, I cannot help putting her right. . . . The picture is not so much the *ultimate end,*

as it is the *medium*, through which the ravishing scenes of nature are excited in the imagination."[66]

Although nature remains the archetype for Gilpin, it is as an ideal model of the creative process rather than as a specific object or a given arrangement of forms that an artist should mechanically copy. The artist's canvas, page, or mind's eye is therefore the aesthetic equivalent of the Linnaean table while the artist is but a natural philosopher seeking to make visible a system of divine order that is always already there. In that sense, the artist or viewer merely plays the role of a conduit between nature (God) and image. In terms of epistemology, picturesque landscape and nature are of one and the same order of knowledge—in the words of Foucault, they are taken to be signs "perfectly transparent to one another."

This, at any rate, was Gilpin's rhetorical ideal for the picturesque. However, his own preference for the conventions of the sublime, together with the way in which the picturesque was actually formulated—as an ennobling and pleasurable effect on the mind—tended to undercut its rationalist imperative. This is particularly so late in the century when, as we saw in Coleridge's formulations, mind came to be regarded as something constitutive of the self rather than simply reflective of the outside world. Even Gilpin conceded that in the picturesque the imagination must be allowed to rule the eye: "The learned eye, versed equally in nature, and art, easily compares the picture with it's [sic] archetype: and when it finds the characteristic touches of nature, the imagination immediately takes fire; and glows with a thousand beautiful ideas, *suggested* only on the canvas."[67]

In the light of such sentiments some critics have argued that the picturesque served as a transition between a rationalist comprehension of nature and a romanticism based more on subjective and emotional responses.[68] Examples of this shift in conception include the notable dispute in the 1790s between Uvedale Price and Richard Payne Knight "on whether the picturesque defines real properties of natural objects or whether it is a mode of vision abstracted from the senses and pertaining exclusively to painting."[69] In a similar vein, Coleridge asked himself, while looking at a view, "how much of this sense of endless variety in Identity was Nature's—how much the living organ's."[70] As a consequence of this kind of questioning the picturesque itself—that discourse so important to the vocabulary of a desire to photograph—had become, by the end of the eighteenth century, a somewhat "unstable term."[71]

The writings of Richard Payne Knight, in particular his *Analytical Inquiry into the Principles of Taste* of 1805, are commonly cited as exemplary of this instability. Some short extracts follow:

This very relation to painting, expressed in the word picturesque, is that which affords the whole pleasure derived from association; which can, therefore, only be felt by persons, who have conversant ideas to associate; that is, by persons in a certain degree conversant with that art. Such persons, being in the habit of viewing, and receiving pleasure from fine pictures, will naturally feel pleasure in viewing those objects in nature, which have called forth those powers of imitation. . . . The objects recall to the mind the imitations . . . and these again recall to the mind the objects themselves, and show them through an improved medium—that of the feeling and discernment of a great artist.[72]

The spectator, having his mind enriched with the embellishments of the painter and the poet, applies them, by the spontaneous association of ideas, to the natural objects presented to his eye, which thus acquire ideal and imaginary beauties; that is, beauties, which are not felt by the organic sense of vision; but by the intellect and imagination through that sense.[73]

Knight understood the picturesque to be a circular economy of pleasurable memories with their source in the minds of persons already "in a certain degree conversant with . . . fine pictures." He confirmed the picturesque's pictorial qualities with reference to the inescapable history of its name, the sign it had taken up within language. This attention to the opacity of language is one clue to the modern tenor of his outlook. Another is the fact that the economy he described depends on a knowing subject who acts within the system as an agent, rather than as a transparent conduit.

This picturesque, the one that coincided with the advent of the desire to photograph, is therefore caught up in a discourse of critical self-reflexivity. Moreover, and most importantly, it is a model of representation depending on having a certain self-conscious being as its trope. A new kind of personage is being described, a figure who looks with discernment while simultaneously being constituted as *discerning* by "the habit of viewing." Knight articulated, in other words, a different kind of viewer of landscape—a being who is for the first time both the subject and the object of representation.

By around 1800 landscape was no longer directly preordained by God but recognized as a specifically human construction. Moreover, its relation to nature had become decidedly distanced; picturesque landscape was apparently but one of many orders of knowledge able to be fashioned from the natural world. Indeed nature as an originary source was removed from the equation almost entirely. According to Knight the picturesque was essentially a set of relations between one class of imitation and another, with nature acting only as a prompt for the transfer of associational memories always originating elsewhere. The picturesque became a practice in which the distinction between representation and referent dissolved into an endless circuit of representations and representations of representations. Most importantly, the point of contact between these various representations was not the tabula rasa of the Enlightenment but rather the sensitized mind's eye of the individual human subject, a subject who views and, in viewing, constitutes both image and self.

IMAGES FORMED BY MEANS OF A CAMERA OBSCURA

The camera obscura looms large in traditional historical accounts of photography's invention. And with good reason. Almost every one of the proto-photographers, including Brougham, Wedgwood, Niépce, Morse, Daguerre, Hubert, Talbot, Wattles, Bayard, Florence, and Zapetti, spoke of their desire to photograph primarily in relation to the image formed within a camera obscura. Yet once again, most histories of photography pay relatively little attention to the various possible meanings of this key rhetorical figure.

The camera obscura had been used by artists for several centuries, but until the eighteenth century it remained a relatively large and clumsy drawing apparatus. During the course of this same century the camera gradually became smaller and hence more portable, eventually being carried around in the hands or, in some models, collapsed into a book-shaped carrying case. This allowed the use of the camera indicated in Jurriaen Andriessen's sketch from about 1810: a man, standing casually with one leg crossed over the other, looks at the view through his window with a handheld camera obscura (fig. 3.3). Here we see someone who looks through his camera's viewfinder for no other purpose than the sheer pleasure of doing so—nor did the potential pleasure

3.3 Jurraien Andriessen, *Artist with a Camera Obscura*, c. 1810. Pen and wash drawing. Koninlkijk Oudheidkundig Genootschap (Rijksmuseum), Amsterdam

end there. The addition in 1812 of a refined lens system devised by Wollaston greatly enhanced the camera's ability to focus light onto its internal mirror and ground glass drawing surface, and thus increased its usefulness as a sketching and, eventually, a photographic instrument.

Ever since the publication of Newton's *Opticks* in 1704, the themes of light, color, and optics had been central to both aesthetic and scientific enquiry throughout Europe. Newton, regarded as an intellectual hero throughout the eighteenth century, had opened his book with a description of a room-sized camera obscura and its optical effects.[74] Thus it was logical that the "Proem" to Erasmus Darwin's 1789 poem *The Loves of the Plants* would emphasize its claim to be "pure description" by conjuring this same metaphor. "Lo, here a CAMERA OBSCURA is presented to thy view, in which are lights and shades dancing on a whited canvas, and magnified into apparent life!"[75]

Darwin here drew an analogy between the camera and a poem, between a supposedly mechanical mode of looking and a text replete with suggestive (but not necessarily "realist") literary devices and conventions. In keeping with the triad vision-knowledge-language that dominated eighteenth-century thinking, Darwin argued elsewhere that poetry should be as direct a manner of expression as possible. This meant the extensive use of visual similes and pictorial language (*ut pictura poesis*).[76] In this context, Darwin did not assume that the view provided by the camera obscura gave access to an entirely unmediated "real" of the kind that positivists would later claim as photography's preserve; it provided instead a "pictorial" way of seeing. Indeed, one reason that the camera obscura was so popular with prephotographic artists was that it automatically *modified* the scene it reflected, stressing tonal masses and compressing forms in a manner complementary to picturesque taste.[77] According to Knight, for example, "as the field of vision is confined, [Nature] Shews all its parts collected to the mind."[78]

Jean Hagstrum has made a similar point about the Claude glass in his book *The Sister Arts,* at the same time extending this argument to include the mirror or "looking glass" in general.

"Mirror" was used to suggest not only the exact rendition of reality in art but also the idealization of reality. . . . Because the mirror suggests both faithful realism and stylized idealism (the two large

aspects of nature and art in our period), it is a revealing symbol of contemporary aesthetic thought. In pictorialism it is a linking metaphor that brings the two sister arts together, and its use was often a sign of the presence of the pictorialist tradition in criticism and poetry. But the term is useful in still another way: it helps us detect not only the presence but also the nature of artistic idealization as the eighteenth century conceived it.

If art is said to hold up a mirror to nature, the metaphor cannot, even in a context of idealization, legitimately describe a Neoplatonic process. The Claude glass, for example, reproduced nature that was idealized and corrected but that remained nature still. In this respect neoclassical general nature differs from the Neoplatonic ideal.[79]

It would appear from all of these accounts that, by the late eighteenth century, the mirror was no longer seen as a guarantee of unmediated reality. It was instead taken as a metaphor for a dynamic enfoldment of opposites, a movement that incorporates without synthesizing the conceptual poles nature-culture, real-ideal, general-particular, science-art, object-subject, reflection-expression.[80]

It should not be assumed from the above discussions that the interest in optical instruments like the camera obscura was entirely confined to the disciplines of poetry and picture making. On the contrary, such instruments were often considered aids to "natural and experimental philosophy." For this reason much of the uncertainty and argument surrounding natural philosophy and other branches of knowledge around 1800 also informed attitudes to the image found in the mirror of the camera obscura. Significant evidence of this lies, for example, in the writings of the proto-photographers.

On March 12, 1816, Nicéphore Niépce wrote to his brother Claude about his photographic activities and in particular about making a camera: "I used some of the time while here in making a kind of artificial eye, which is nothing but a small box six inches square; the box will be equipped with a tube that can be lengthened and will carry a lenticular glass. This apparatus is necessary in order to properly complete my process."[81] In another letter to his brother, dated May 5, 1816, Nicéphore referred again to his camera, although this time specifically to his camera lens (his *objectif*), as an "artificial eye."[82] Talbot echoed this in *The Pencil of Nature* (1844–46): "to use a metaphor we have already employed, the eye of the camera."[83] Jean Baptiste Biot also

praised Daguerre for providing science with an "artificial retina" in his speech of January 7, 1839.[84] The analogy of camera and eye has a long history in European intellectual discourse, figuring prominently in the writing of such luminaries as Leonardo, Kepler, Descartes, Locke, and Newton, to name only a few. By the eighteenth century, the camera obscura had become both a dominant metaphor for human vision and a crucial and ubiquitous representation of the relation of a perceiving subject to an external world. In this representation, subject and world were understood as pregiven, separate, and distinct entities. Consequently the act of seeing was passively transparent to the world being seen and in that sense sundered from the physical body of the observer. The optical geometry at the heart of the camera obscura, at once ideal and natural, was taken as an empirical confirmation of the truth of its Enlightenment worldview.

However, as Jonathan Crary has demonstrated in *Techniques of the Observer,* around 1800 a "vast systematic rupture" in the history of vision marked the end of the camera obscura as the dominant paradigm of knowledge and truth: "The collapse of the camera obscura as a model for the status of the observer was part of a much larger process of modernization, even as the camera obscura itself was an element of an earlier modernity. By the early 1800s, however, the rigidity of the camera obscura, its linear optical system, its fixed positions, its categorical distinction between inside and outside, its identification of perception and object, were all too inflexible and unwieldy for the needs of the new century."[85] Crary pursues this line of argument by examining the implications of the writings of scholars like Goethe and Hegel, the work of a number of physiologists, and the contemporary development of various optical devices. He examines, for example, Goethe's use of the familiar camera obscura metaphor in his *Color Theory* (1810). Goethe described a spectator looking fixedly at the circle of light admitted into a room-sized camera and then closing off the light source and observing only the changing colors left floating on the dazzled retina of his or her eye. Crary argues that, in suggesting this last action, Goethe "abruptly and stunningly abandons the order of the camera obscura":

Goethe's instruction to seal the hole announces a disordering and negation of the camera obscura as both an optical system and epistemological principle. The closing off of the opening dissolves the distinction between inner and outer space on which the very functioning of the camera (as paradigm and apparatus) depended. But it is now not simply a question of an observer repositioned in a sealed

interior to view its particular contents; the optical experience described here by Goethe presents a notion of vision which the classical model was incapable of encompassing. . . . The corporeal subjectivity of the observer, which was a priori *excluded from the camera obscura, suddenly becomes the site on which an observer is possible.*[86]

We also have a firsthand account of an interest in the strange physiological workings of the eye from one of photography's inventors. On November 1, 1818, Henry Talbot wrote to his mother from Cambridge to complain of his increasing short sightedness: "I have been reading books on the structure of the eye, in order to find out the cause: and have arrived at the learned conclusion, that it is owing to want of due tension in the ligamentum éclaire. It occurred to me the other day, that if I was to press my eye gently with my finger, it would render the vision distinct, and upon trial I found that this was actually the case. The distinctness however is not quite as great as can be obtained by the use of a glass."[87] Crary calls this ocular self-consciousness "a key delineation of subjective vision, a post-Kantian notion that is both a product and constituent of modernity."[88]

It is a moment when the visible escapes from the timeless incorporeal order of the camera obscura and becomes lodged in another apparatus, within the unstable physiology and temporality of the human body. . . . As observation is increasingly tied to the body in the early nineteenth century, temporality and vision become inseparable. The shifting processes of one's own subjectivity experienced in time became synonymous with the act of seeing, dissolving the Cartesian ideal of an observer completely focused on an object.[89]

It is no accident that the actual physiology of the eye had also recently become a matter of concern, displacing this organ's assumed passivity and suggesting its active involvement in what we see and how we see it. As a consequence, sight was no longer to be unproblematically trusted. Once regarded as a predictably mechanical means of reflection, around 1800 the eye became instead a troublesome and elusive complex of anatomical relationships. As Crary describes this shift, "The discourse of dioptrics, of the transparency of mechanical optical systems in the seventeenth and eighteenth centuries, has given way to a mapping of the human eye as a productive territory with varying zones of efficiency and aptitude."[90] He continues: "The real importance of

physiology lay in the fact that it became the arena for new types of epistemological reflection that depended on new knowledge about the eye and processes of vision. Physiology at this moment of the nineteenth century is one of those sciences that stand for the rupture that Foucault poses between the eighteenth and nineteenth centuries, in which man emerges as a being in whom the transcendent is mapped onto the empirical."[91]

The meanings of the camera obscura, and of mirrors more generally, were undergoing a profound questioning around 1800. References to the camera's mirror image in the early nineteenth century did not simply posit a direct mimetic reflection of an outside world. The camera remained a convenient analogy for vision and its representation, but these were now problems, not givens. Scholars were forced to address a newly uncertain relationship between observer and observed and to incorporate within their work both the unpredictability of the flesh and the exigencies of time.

William Cowper, for example, appears to repeat the familiar camera obscura analogy in his 1785 poem entitled "The Task." However, his familiar metaphor is tied to this new problem of faithfully representing what one sees in the face of passing time:

To arrest the fleeting images that fill
The mirror of the mind, and hold them fast,
And force them sit, till he has pencilled off
A faithful likeness of the forms he views.[92]

In 1817 Coleridge also used such a figure, a temporal camera, to describe his poetic ideal: "creation rather than painting, or if painting, yet such, and with such co-presence of the whole picture flash'd at once upon the eye, as the sun paints in a camera obscura."[93] In the 1820s another English poet, John Clare, spoke in similar terms of "an instrument . . . which he had fashiond [sic] that was to take landscapes almost by itself." However, despite his own best efforts the pencil drawings obtained using this instrument were "but poor shadows of the original & the sun with its instantaneous sketches made better figures of the objects in their shadows."[94]

This exploration of the relationship between time and mirror image also appeared in the work of less accomplished poets. Talbot, for example, made extensive use of this metaphor in his prophetic poem "The Magic Mirror," published in 1830 in his *Legendary Tales in Verse and Prose*.[95] Fourteen years later, in 1844, Talbot reminisced in the introduction to another of his books, *The Pencil of Nature,* about how the idea of photography first came to him in 1833 while he was trying to use a camera lucida on the shores of Lake Como in Italy. His failure to master this difficult instrument led him to think back to earlier, equally frustrating, attempts at making landscape sketches with the mirrored camera obscura. Once again the transience of the shimmering, unsteady images made by this instrument—"fairy pictures, creations of a moment, and destined as rapidly to fade away"—bothered him most. "It was during these thoughts that the idea occurred to me . . . how charming it would be if it were possible to cause these natural images to imprint themselves durably, and remain fixed upon the paper! . . . Such was the idea that came into my mind. Whether it had ever occurred to me before amid floating philosophic visions, I know not, though I rather think it must have done so, because on this occasion it struck me so forcibly."[96]

Talbot's 1830 poem indeed seems to be one of those "floating philosophic visions" to which he refers. In a heavy-handed variation of Pandora's box, Talbot's verse tells of a young girl named Bertha who is bequeathed a castle by her dying father on the understanding that she will not look into a veiled mirror hanging on the wall. True to the fate of her sex, she is of course unable to overcome the temptation to draw back the curtain and gaze upon the "fatal glass."

What show'd the Mirror? In an azure sky
The Sun was shining, calm and brilliantly,
And on as sweet a Vale he pour'd his beam
As ever smiled in youthful poet's dream:
With murmur soft, a hundred mazy rills
In silver tracks meander'd down the hills
And fed a crystal Lake, whose gentle shore
Was grassy bank with dark woods shadow'd o'er.

Alas, this pleasant picturesque scene with all of its lovely details was no sooner exposed to the light of day than it began to tarnish and change character.

In rapture o'er the mirror Bertha hung,
And pleased her fancy stray'd those scenes among;
But, as she gazed, a dimness seem'd to steal
O'er the bright glass, and slowly to conceal
The distant hills: then rolling up the vale
Shrouded it o'er with Vapours wan and pale.
The Lake, the Mountains, fade in mist away,
And lurid Darkness overspreads the day.

Bertha's problem with the permanence of her image was, in a few short years, to dismay many pioneer proto-photographers as well (Talbot included). However, time and mortality were not the only issues explored through references to the mirror metaphor. M. H. Abrams has indicated in his influential book *The Mirror and the Lamp* just how central this particular metaphor was to literature and art, particularly during the transitional period from which the desire to photograph emerged. As Abrams explains the situation, a radical shift occurred around 1800 from rhetorical figures of reflection to ones of projection, from passivity to activity, and from imitation to expression. "The title of the book identifies two common and antithetic metaphors of mind, one comparing the mind to a reflector of external objects, the other to a radiant projector which makes a contribution to the objects it perceives."[97]

Abrams sees Coleridge and Wordsworth as exemplary figures in this transformation of the mirror metaphor. As he points out, in their work in particular the mere seeing of a mirror image was no longer a guarantee of a transparent or reflective relationship between perceiver and perceived: "The analogies of mind in the writings of both Wordsworth and Coleridge show a radical transformation. Varied as these are, they usually agree in picturing the mind in perception as active rather than inertly receptive, and as contributing to the world in the very process of perceiving the world."[98] The mirror theme recurs in the notes and poems of both writers. Speaking for example of Wordsworth's 1798 poem "There was a Boy," Stephen Spector claims that "Words-

worth pictures a world of possibly infinite interconnection between the mind, nature, and the divine—each behaving as if it were a mirror imaging other mirrors."[99] Almost thirty years later, in a notebook entry dated February 21, 1825, Coleridge mused about his own ideal mind-image, what else but "a Self-conscious Looking-glass": "I have often amused my self with the thought of a Self-conscious Looking-glass, and the various metaphorical applications of such a fancy—and this morning, it struck across the Eolian Harp of my Brain that there was something pleasing and emblematic (of what I did not distinctly make out) in two such Looking-glasses fronting, each seeing the other in itself, and itself in the other."[100]

Coleridge was close to three of the proto-photographers and was particularly friendly with Tom Wedgwood. Coleridge wrote to his wife on November 16, 1802, only a few months after the appearance of Davy's article in the *Journals of the Royal Institution,* to tell her about his ongoing travels through South Wales with his companion Tom Wedgwood.

He will be out all the mornings—the evenings we chat, discuss, or I read to him. To me he is a delightful & instructive Companion. He possesses the finest, *the* subtlest *mind and taste, I have ever yet met with.—His mind resembles that miniature Sun seen, as you look thro' a Holly Bush, as I have described it in my Three Graves:*

A small blue Sun! and it has got
A perfect Glory too!
Ten thousand Hairs of color'd Light,
Make up a Glory gay & bright,
Round that small orb so blue![101]

Wedgwood's biographer R. B. Litchfield, writing about "the first photographer" in 1903, added a footnote to his quotation from this letter to express his puzzlement at Coleridge's intended meaning.

The exact point of the comparison of Tom Wedgwood's mind to the "small blue sun" is not very evident. The quotation of the context may make it clearer. The scene in the poem is an arbour-like nook in a woody dell, wherein three people are resting and talking on a sunny morning:

The sun peeps through the close thick leaves,

See, dearest Ellen! See!

'Tis in the leaves, a little sun,

No bigger than your 'ee;

A small blue sun! and it has got

A perfect glory too!

Ten thousand hairs of colour'd light," &c.

I imagine that the simile is meant to emphasise, as it were, his underlining the words "subtlest," "finest," "A small blue sun" became in later editions "a tiny sun."[102]

Litchfield fails to recognize that Coleridge was playfully using a classical allusion to compare Wedgwood's mind both to a sun projecting light and to the workings of a camera obscura. He compares Wedgwood's mind, in other words, to both a mirror and a lamp. In the fourth century B.C., Aristotle had noted the natural occurrence of crescent-shaped images of the sun on the ground below a leafy tree, caused, he surmised, by light filtering through the small spaces between the leaves.[103] Aristotle's discussion of the camera obscura was certainly familiar to scholars of the classics during the eighteenth and nineteenth centuries (if not to biographers in the twentieth). Coleridge had, for example, used the same figure to good effect in an earlier poem, "This Lime-Tree Bower My Prison" (1797–1800). So Coleridge referred to the camera in his letter of 1802, but, in the context of Davy's recent publication and his own close relationship with both Davy and Wedgwood, it could hardly be a reference to the simple drawing instrument so beloved in the eighteenth century. What could it be but the photographic camera that he now has in (Wedgwood's) mind?

The analogy is telling for a history of photography's conception. In one of Coleridge's notebook entries he referred to his own mind as an "Eolian harp." This is yet another mirror analogy, the Eolian or Aeolian harp referring to a lute positioned so as to be played by any passing breeze. It is, in other words, an audible mirror of nature, an instrument that simultaneously reflects and projects sound. In the 1795 poem *The Eolian Harp,* Coleridge even speculated that "all of animated nature" was "but organic Harps diversely framed."[104] In this same poem, Coleridge described the overall phe-

nomenon in terms of "a light in sound, and sound-like power in light," an equation in keeping with his idealist view of nature as well as with a latent wave theory of light. As a figure of speech, it also allowed Coleridge to articulate his growing speculations about the interactive relation between nature and the viewing subject.

According to Abrams, Coleridge, Wordsworth, and Shelley were among those who went on to use the image of the wind harp as "a construct for the mind in perception as well as for the poetic mind in composition." Abrams reads the use of the harp in the poetry of the Romantic poets as signifying "a bilateral transaction, a give-and-take, between mind and external object."[105] This was certainly Coleridge's view after his return from Germany in 1798. In his marginal notes to Kant's *Critique of Pure Reason* he declared that "the mind does not resemble an Aeolian harp . . . but rather as far as objects are concerned a violin or other instrument of few strings yet vast compass, played on by a musician of Genius."[106] His refiguring of the perceiving mind as something as much active as inertly reflective coincided with his extensive critique of Enlightenment philosophy. In a series of long letters to Tom Wedgwood's brother Josiah, written in February 1801, Coleridge argued that Locke and Descartes "held precisely the same opinions concerning the original Sources of our Ideas" and that Locke's "Innate Ideas were Men of Straw."[107]

These letters were written in response to Tom Wedgwood's speculations on "the relations of Thoughts to Things." No doubt their discussions of these issues continued during their journey together in November of 1802. In the previous year, 1801, Coleridge had also begun a critical study of Newton's *Opticks* (a book that opened with the figure of a camera obscura). As Coleridge confided to his friend Thomas Poole in a letter of March 23, 1801, this study of Newton was preempted by his own prejudices against the presumptions invested in such a figure: "I am exceedingly delighted with the beauty & neatness of his experiments, & with the accuracy of his *immediate* Deductions from them—but the opinions founded on these Deductions, and indeed his whole Theory is, I am persuaded, so exceedingly superficial as without impropriety to be deemed false. Newton was a mere materialist—*Mind* in his system is always passive—a lazy Looker-on on an external World. . . . Any system built on the passiveness of the mind must be false, as a system."[108]

With this as background we can return to Coleridge's description of Wedgwood's mind as a camera and see that he could not possibly have been referring to the passive

instrument of Newton and Locke. Indeed, Wedgwood's photographic experiments, in which the mirrored image visibly projects itself onto a surface, must have confirmed the validity of Coleridge's newly fashioned mind metaphor. Wedgwood himself could hardly have been unfamiliar with Coleridge's rhetorical transformation of the camera obscura into an active projection of the world it receives. To repeat my point, the camera whose images were the "first object" of Wedgwood's desire was not the same instrument that had so preoccupied artists in previous centuries. Wedgwood's camera was instead a figure undergoing a profound transformation, a mutation that was to see it reemerge as a peculiarly modern rhetorical trope. This new trope appears in the discourse of the desire to photograph, with all of its troubling intonations of a change in subjectivity and its apparent questioning of the dualist certainties of its Cartesian predecessor.

SPONTANEOUS REPRODUCTION

The dynamic economy of expression that I have identified with the discourse produced by the proto-photographers could also be said to represent, even to reproduce, a new understanding of space and time. This manifests itself in a number of ways. Daguerre, for example, claimed with considerable flourish that his process was capable of "spontaneous reproduction," a phrase that in the early nineteenth century often indicated chemical or physical changes that appeared to have no external cause. Niépce had also used the words *spontaneous reproduction* in his earlier accounts of *héliographie,* suggesting the importance of this property to both men's perception of photography's identity. To describe photography as spontaneous was to claim that it proceeded entirely from natural impulse, which seems at variance with the preponderance of chemical manipulation and equipment necessary to processes like the daguerreotype. What is interesting then is not so much the achievement of spontaneity as the desire for the natural that Niépce and Daguerre's phrase suggests. This also focuses attention on how time is figured within the conception of photography.

We have already seen that time is important in a number of the discourses from which emerged the desire to photograph. Talbot, having explored some aspects of the temporal in his 1830 poem *The Magic Mirror,* directly addressed this same theme in his

earliest publication on photography, "Some Account of the Art of Photogenic Drawing" (January 1839). Referring to Wedgwood and Davy's failure to find a way to stop the images they produced from fading away or "becoming entirely dark," Talbot announced to his listeners that he had discovered "a method of overcoming this difficulty," of "*fixing* the image." He went on to explain that two different objects, one intricate in its details and one not, take the same amount of time to be rendered photographically. "The one of these takes no more time to execute than the other; for the object which would take the most skillful artist days or weeks of labour to trace or to copy, is effected by the boundless powers of natural chemistry in the space of a few seconds."

Never quite able to decide whether the origins of photography lay in nature or in culture (notice how his own photograms include both botanical specimens and samples of lace and handwriting), Talbot later conjured yet another descriptive phrase that contains elements of each: "the art of fixing a shadow." He further elaborated: "The most transitory of things, a shadow, the proverbial emblem of all that is fleeting and momentary, may be fettered by the spells of our '*natural magic,*' and may be fixed for ever in the position which it seemed only destined for a single instant to occupy. . . . Such is the fact, that we may receive on paper the fleeting shadow, arrest it there and in the space of a single minute fix it there so firmly as to be no more capable of change."[109]

Many themes mentioned in this quotation have been rehearsed earlier in my argument. It is worth noting in particular that Talbot spoke of photography here not in terms of the image that it might produce but as a possible resolution of his frustration with space-time itself. In this one passage where he decisively abandoned empirical science in favor of poetic metaphor, Talbot spoke of the new medium as a peculiar articulation of temporal and spatial coordinates. Photography is apparently a process in which "position" is "occupied" for a "single instant," where "fleeting" time is "arrested" in the "space of a single minute." It seems that he was able to describe the identity of photography only by harnessing together a whole series of binaries: art and shadows, the natural and magic, the momentary and the forever, the fleeting and the fettered, the fixed and that which is capable of change. Photography was, for Talbot, the desire for an impossible conjunction of transience and fixity. More than that, it was an emblematic something/sometime, a "space of a single minute" in which space *becomes* time, and time space.

Talbot further elaborated the relationship between photography and time in his 1844 publication *The Pencil of Nature*. His very first image, a view titled *Part of Queen's College, Oxford,* is accompanied by a commentary in which Talbot pointed out that "this building presents on its surface the most evident marks of the injuries of time and weather."[110] As Hubertus von Amelunxen has remarked, Talbot continued to stress time in many more of these commentaries; indeed Talbot's "use of temporal adverbs" is so extensive that "chronology becomes chronoscopy."[111]

The Pencil of Nature *derives the uniqueness of its form and content from the traces of a perception that announces itself as new and that is predominantly based in its being vis a vis the fourth dimension, time. Immediacy and simultaneity are temporal characteristics, as perception and aesthetic experience are an expression of an awareness of time and space. The experience of time in the animated traversal of space, in a movement that distances even as we approach, means that the viewing subject experiences itself in history.*[112]

Photography's peculiar temporal characteristics, in particular its ability to bring past and present together in one visual experience, were also noticed by contemporary journalists. A number used the term *necromancy* (communication with the dead) to describe the actions of both Daguerre's and Talbot's processes. In March 1839, for example, the English periodical *The Spectator* said the daguerreotype was apparently "like some marvel of a fairy tale or delusion of necromancy."[113] Referring to Talbot's publication of *The Pencil of Nature, The Athenaeum* called it "a wonderful illustration of modern necromancy."[114] An earlier review in this same journal, published on February 22, 1845, also noted photography's engagement with time, commenting that "photography has already enabled us to hand down to future ages a picture of the sunshine of yesterday."[115] Photography provided a visual memory of the past, a history of what has come before and with it a prophecy of future changes.

In this sense, photography seems to offer a temporal experience significantly different from that provided by previous media. Speaking strictly in terms of chronometry, a painting or drawing is marked first and foremost by the painstaking time invested in its production by the artist concerned. We read that expenditure of time in the picture's elaborately inscribed surface, thus leaving the object or scene represented

within the picture frame to inhabit its own internal time zone. As Talbot pointed out in his *Account,* a photograph explicitly directs attention to the temporal implications of its own process of representation. It depicts a set of objects in fixed spatial relations at a given moment in real time. It fixes in place that moment lived before the camera, a moment external to the picture's own compositional organization of temporal coordinates. Talbot concluded that the primary subject of every photograph was therefore time itself.

But what kind of time is it? The photograph presumes to capture, as if in a vertical archaeological slice, a single, transient moment from a linear progressive movement made up of a numberless sequence of just such moments. Photography apparently figures time itself as a progressive linear movement from past to future. The present during which we look at the photographic image is but a staging point, a hallucinatory hovering that imbricates *both* past and future. In this paradoxical play between a synchronic and diachronic notation of time, photography reiterates what Hayden White has called a peculiarly modern time anxiety.[116] As Linda Nochlin describes the situation, "Time is seen as the arrester of significance not—as in traditional art—the medium in which it unfolds."[117]

The expression of this time anxiety was by no means confined to the discourse of the proto-photographers. As early as 1782 William Gilpin expressed vexation at not having the means to capture adequately the fleeting visual sensations of a river journey. In his *Observations on the River Wye,* he made the following comment: "Many of the objects, which had floated so rapidly past us, if we had had time to examine them, would have given us sublime, and beautiful hints in landscape: some of them seemed even well combined, and ready prepared for the pencil: but in so quick a succession, one blotted out another."[118]

Gilpin sometimes made use of his Claude Glass momentarily to alleviate this problem. In this passage from 1791, for example, he yearned for the ability to make his glass "fix" its transient reflected image: "In a chaise particularly the exhibitions of the convex-mirror are amusing. We are rapidly carried from one object to another. A succession of high-coloured pictures is continually gliding before the eye. They are like the visions of the imagination; or the brilliant landscapes of a dream. Forms, and colours in brightest array, fleet before us; and if the transient glance of a good composi-

tion happen to unite with them, we should give any price to fix and appropriate the scene."[119]

In normal circumstances, the Claude glass necessitated a certain stop-start progress on the part of the aesthete seeking picturesque views. Once again visible space is space is measured through a temporal spacing. Each change in the view offered by the glass is a visual marker of the time taken to move a few paces from the previous view. Rosalind Krauss remarks on a similar staccato quality in Gilpin's writings. He consistently presents, she says, "the notion of singularity as the perceptual-empirical unity of a moment of time coalesced in the experience of a subject."

Gilpin's Observations on Cumberland and Westmorland *addresses this question of singularity by making it a function of the beholder and the array of singular moments of his perception. The landscape's singularity is thus not something which a bit of topography does or does not possess; it is rather a function of the images it figures forth at any moment in time and the way these pictures register in the imagination. . . . The landscape is not static but constantly recomposing itself into different, separate, or singular pictures.*[120]

However, from the 1790s on neither the Claude glass, nor the older camera obscura, nor the new camera lucida satisfied the frustrations and yearnings engendered by by the temporal demands of picturesque representation. Gilpin's use of the word *fix* is striking in this context. In picturesque parlance it normally referred to the delineation by sketch or watercolor of the image reflected on retina, mirror, screen, or paper. At a certain point we encounter the idea, so preposterous that it can barely be spoken, of the image retaining or fixing itself. According to historian Malcolm Andrews, the widespread use at this time of such a word as "fix" indicates a "predatory, acquisitive instinct," a "figurative sense of appropriation" that "leads in one direction to landscape as a commodity." At the same time, he suggests, such terms represent a prevailing need to give "stability" to new experiences, and this at a time when traditional notions of space and time, as well as landscape, were being called into question.[121]

This questioning was very much informed by what Kant called the "Copernican revolution" offered by German idealist philosophy. Embodied in a series of debates between Kant and successors like Fichte, Schelling, and Hegel, this philosophy empha-

sized the role of the human subject as both knower and active constituent of knowledge. Space and time were particularly important to this type of thinking. Kant, for example, posited space and time as a priori or transcendental structures "spontaneously" triggered in the mind of the individual subject by stimuli from the external world. Space and time are therefore neither things nor relations of things but the two forms of human sensibility and thereby the dual condition of all cognitive experience.[122]

Here then is another source of Coleridge's rejection of the camera obscura model of the human mind. It has already been noted that in 1798 Coleridge was able to study German philosophy firsthand as a consequence of the financial security promised by the Wedgwood brothers' generous annuity. Indeed, it is often said that Coleridge introduced such philosophy, more particularly a selective conglomeration of the work of Kant, Fichte, and Schelling, into English aesthetic discourse. However Coleridge was not alone in finding such thinking attractive. Before working at the Royal Institution, Humphry Davy had, between October 1799 and February 1801, been an assistant at the Pneumatic Institute in Bristol (where he gained some notoriety for his experiments with the effects of nitrous oxide).[123] His employer, Dr. Thomas Beddoes, possessed a fluent reading knowledge of German and was at this time apparently looking into the possibilities offered by Kant's philosophy. This, when taken in conjunction with Davy's close friendship with Coleridge, has led historians like Trevor Levere to equate Davy's thinking at this time with a "post-Kantian idealistic dynamism."[124] Davy's brother claims that Humphry was reading about Kant as early as 1796, the same year that the first English account of the German philosopher's work appeared in London—F. A. Nitsch's *A General and Introductory View of Professor Kant's Principles concerning Man, the World and the Deity*.[125] Nitsch's book was soon followed by other publications, and German idealism of one form or another became part of the currency of early nineteenth-century English philosophical debate.

We find evidence of this debate in how Coleridge in 1803 attempted to address the discrepancy between the passing of time and the demands of representation:

Thursday Morning, 40 minutes past One o'clock—a perfect calm—now & then a breeze shakes the heads of the two Poplars, [& disturbs] the murmur of the moonlight Greta, then in almost

a direct Line from the moon to me is all silver—Motion and Wrinkle & light—& under the
arch of the Bridge a wave ever & anon leaps up in Light . . . silver mirror/gleaming of moonlight
Reeds beyond—as the moon sets the water from Silver becomes a rich yellow.—Sadly do I need to
have my Imagination enriched with appropriate Images for Shapes—/Read Architecture, &
Icthyology—[126]

Coleridge tried to solve his dilemma with a stream of fragmented metaphoric phrases, unimpeded by the restraints of grammar or coherent narrative. It was a quest, as Ross Gibson puts it, "to capture the instant of perception." According to Gibson, "the problem is that the moment passes faster than words can cohere."[127] This problem continued to occupy Coleridge's thoughts. The poet told friends, for example, that he was particularly interested in how certain psychic processes such as dreams and opium reveries allow the observer to experience "a transmutation of the succession of Time into juxtaposition of Space."[128] A few years later, in 1816, Coleridge coined a word that aptly describes the property he sought—"tautegorical." The term described "the translucence of the Eternal through and in the Temporal" or, as the *Oxford English Dictionary* puts it, "expressing the same subject but with a difference," the difference that comes with time.[129]

One person who shared Coleridge's concern with such issues was Tom Wedgwood. Wedgwood had himself visited Germany in 1796, accompanied by his friend John Leslie; in fact, Coleridge's later trip followed the same route. No doubt Coleridge and Wedgwood spent some time comparing their experiences. They also often discussed related philosophical issues. I have already suggested that they discussed Wedgwood's photographic experiments during a trip taken together in 1802. It appears that they also touched on the question of time itself. Indeed, in one letter written during this trip, Coleridge described the whole experience in temporal terms remarkably reminiscent of those associated with the photographic: "For the last five months of my Life I seem to have annihilated the present Tense with regard to place—you can never say, where is he?—but only—where was he? where will he be?"[130]

Ample evidence shows that Coleridge and Wedgwood also often discussed the work of Kant and other German idealist philosophers. In a notebook entry dated December 1803, Coleridge paraphrased and discussed Kant's *Grundlegung zur Metaphysik*

der Sitten (1797 edition). In the midst of this discussion, Coleridge interpolated "Remember T. Wedgwood, as we were sitting together in the Coach/& forever are loving to look at Children/Vide Schiller." Coleridge referred here to the two men's mutual interest in the psychology and perceptual skills of children, by way of a rhetorical gesture toward Schiller's *Über naïve und sentimentalische Dichtung* (1795).[131]

This interest had taken on a particular focus two years before. In early 1801 Tom's brother Josiah referred to Tom's ardent theorizing, saying that "the subjects cleared are no less than Time, Space, and Motion; and Mackintosh and Sharp think a metaphysical revolution likely to follow."[132] Coleridge was also familiar with Tom's philosophical speculations along these lines. On February 13, 1801 he described them: "I take T. Wedgwood's own opinion, his own convictions, as STRONG presumptions that he has fallen on some very valuable Truths—some he stated but only in short hints to me/ & I guess from these, that they have been noticed before, & set forth by Kant in part & in part by Lambert. . . . I have been myself thinking with the most intense energy on similar subjects/ I shall shortly communicate the result of my Thoughts to the Wedgwoods."[133] Despite the enthusiasm of various friends, one of whom had promised to publish Wedgwood's theories under the title *Time and Space,* only one fragment ever appeared. Titled "An Enquiry into the Origin of our Notion of Distance" (and compiled posthumously by friends from Wedgwood's notes), the article, which Eliza Meteyard describes as "a somewhat feeble attempt to replace the Berkeleian theory of optical distance by the more objective ideas of Reid, of whom Wedgwood was an ardent admirer," was published in 1817 in the *Journal of Science and Arts* edited by the Royal Institution of Great Britain.[134] The article primarily compares sight and touch in relation to the perception of distance. As Wedgwood argued, "When we have learned by touch the real magnitude of an object, the visual or apparent magnitude becomes only a sign which instantly suggests the tactual magnitude." This idea places Wedgwood's thinking within an ongoing philosophical argument about the relations of the senses whose participants also included Descartes, Locke, Berkeley, Diderot, Buffon, Condillac, Reid, Kant, and Brown.[135] Not surprisingly, Coleridge was also interested in this issue. As Coburn remarks, from November 1800 on, in Coleridge's notebooks "observations and experiments in touch and vision are often associated with Tom Wedgwood."[136]

Among the other concerns of Wedgwood's article are the "inadequacy of language ... to description," the "correction of visual appearances by notions derived from appearance," and the distinction between "two acts or states of mind, called perception and idea." The essay also indicates Wedgwood's interest in experiments based on bodily experience and in children's responses to stimuli: "Perception becomes a language of which the chief use is to excite the correspondent series of thought, and the senses are seldom intensely and long employed but in the examination of new objects. The far greater part of what is supposed to be perception is only the body of ideas which a perception has awakened."[137] Wedgwood's arguments seem to draw on both Reid and the associationism of Archibald Alison's *Essays on the Nature and Principles of Taste* (1790); however they also correspond to certain Kantian concepts. Whatever their exact derivation, at the very moment Wedgwood's speculations encompassed the idea of photography, he was also intimately caught up in an idealist-inspired reconsideration of space, time, perception, and subjectivity. No wonder Coleridge felt able to describe Wedgwood in 1809 not just as a departed friend but as one who "added a fine and ever-wakeful sense of beauty to the most patient accuracy in experimental philosophy and the profounder researches of metaphysical science."[138]

Time and representation were also comprehensively explored by certain painters during this period. In 1833, for example, English painter John Constable published a book on landscape painting in which he claimed that his own pictures were "taken from real places ... the effects of light and shadow being transcripts only of such as occurred at the time of being taken." He continued: "In some of these subjects of Landscape an attempt has been made to arrest the more abrupt and transient appearance of the CHIAR'OSCURO IN NATURE; to shew its effect in the most striking manner, to give 'to one brief moment caught from fleeting time' a lasting and sober existence, and to render permanent many of those splendid but evanescent Exhibitions, which are ever occurring in the changes of external Nature."[139] It is interesting to compare Constable's aspirations with those of the French landscape painter Jean-Baptiste-Camille Corot (1796–1875). Corot reportedly advised painters to "surrender to the initial impression and if you have really been touched, the sincerity of your emotion will move others ... (choose your motifs) not for their sentimental implications or their symbolic content, but only for what they are, as seen from a distance, caught in

an instant, bearing the stamp of time."[140] As Peter Galassi has pointed out, a number of painters in the late eighteenth and early nineteenth centuries, including Corot, Constable, and Pierre-Henri de Valenciennes, began to produce self-consciously quick sketches designed to capture nothing more than transient effects of light and atmosphere.[141] Some of Constable's earliest plein-air sketches of weather were produced during a tour of the Lake District in 1806, following virtually the same route suggested by his family's copy of William Gilpin's guide to the region's landscape. Indeed it has been suggested that the growing popularity of the quick sketch owed much to picturesque theory, acting as the visual equivalents of Gilpin's diaristic word-pictures. Such sketches were also a provocative instance of *non finito,* of an image simultaneously fixed in place while still overtly in the midst of a process of completion.[142]

Anxious to put into practice the conviction that "painting is a science," Constable took care during the 1820s to inscribe his frequent studies of clouds with quite particular information about the time and conditions that accompanied their production. One 1821 study, for example, has the following details written on its back; "Hampstead/Sept 11 1821 10 to 11 Morning/Clouds silvery grey on warm ground/ Light wind to the S.W./fine all day—but rain/in the night following."[143] Constable's systematic exercise confirmed his conviction that "no two days are alike, not even two hours; neither were there two leaves alike since the creation of the world."[144] In short, time and the appearance of things were now to be regarded as entirely interdependent.[145] More than that, in Constable's work the body of the observer is built into the picture's very existence. Constable's sketch represents not a "God's eye view" of a generic nature but a particular scene witnessed by a particular person at a particular place and time, under particular conditions. In that sense, it is as much a study of the temporal exigencies of human observation, and thus of human subjectivity, as a picture of a cloudy sky.

Constable's studies from the 1820s became an archive from which he could borrow when painting the moody skies of his studio landscapes, pictures that, unlike the sketches, were meant for public exhibition. Contemporary observers found these finished paintings somewhat awkward precisely because they juxtaposed, without the balm of pictorial resolution, time-specific weather effects and more traditional signifiers of the timeless moral philosophy that high art was still supposed to exemplify. Ann

Bermingham has argued that both the cloud studies and the "finished" landscapes share a strategically schizophrenic character. She suggests that Constable adopted a sketchlike application of paint because it "functions as evidence of both a naturalistic observation and a subjective response": "Its dual signification works to collapse the distinction between Constable and the landscape which he paints. . . . The goal he set himself at this time [the 1820s] was to make his landscapes the sign of both nature and human nature, of both optical sensation and emotional response. . . . The sky becomes both a signified and a signifier, both the thing represented and the thing which represents, both the natural 'element' and the 'chief organ of sentiment.'"[146]

TRANSMUTATIONS

Culture and nature, transience and fixity, space and time, subject and object—each example cited above articulates these opposing pairs in the same act of representation. From this epistemological dilemma also emerged the desire to photograph. At issue was not just the theorization and depiction of nature, landscape, reflection, or the passing of time but, more fundamentally, the nature of representation and the constitution of existence itself. It is yet further evidence that the period between about 1790 and 1839 was marked by a turbulent phase of scientific and philosophical speculation, of which photography was but one residual effect. Indeed the conjunction of frustrations and aspirations that I have characterized as a "desire to photograph" obviously long precedes, and extends well beyond, the announcement of a photographic apparatus in 1839.

I have set out to look specifically at the meanings of the words and practices actually used by the proto-photographers to articulate *their* aspirations and latent desires. At this stage two main conclusions could be drawn from my examination of their discourse and its historical context. First, each of the concept-metaphors in which they collectively invested their desire to photograph—nature, landscape, camera obscura, spontaneity—was undergoing a radical and dislocating transmutation during the period in which the proto-photographers wrote. This involved the general refiguring of prevailing relationships between knowledge and subjectivity, as well as the reconceptualization of representation and its metaphysical implications.

The second and related conclusion is that this dislocation is manifest not only in their choice of metaphors but also at the level of the discursive text itself: hence the recurrence of a movement back and forth between two conceptual poles, or, alternatively, of a paradoxical doubling within the compass of a single term or passage of speech. In each case we find not so much a resolution or reconciling synthesis of two options as a dynamic, even contradictory, incorporation of both. Thus the latent desire to photograph could only be expressed somewhat provisionally, as a mode of hesitation and equivocation. In Coleridge's terms, photography was conceived as a becoming rather than a thing, a verb as much as a noun. And, as the various debates around nature, landscape, the camera obscura, and space-time attest, this economy of hesitations produced no less than a newly embodied subject, which in its formation as *doublet* entailed both photographer and photographed, without remaining completely faithful to either.

This same dynamic is reproduced in the word *photography* itself. Despite a bevy of other contenders, this term was proposed as early as 1834 by Hercules Florence and was then independently coined by English, French, and German commentators in February 1839.[147] A compound of two Greek components—*phos* (light) and *graphie* (writing, drawing, and delineation)—photography is significant on a number of levels. As a word, it posits a paradoxical coalition of "light" (sun, God, nature) and "writing" (history, humankind, culture), an impossible binary opposition "fixed" in uneasy conjunction only by the artifice of language.[148] This linguistic construction, replete with the magnetic tension of two in one (a tension writ large in the daguerreotype, which is of course simultaneously a negative and a positive), sidesteps the necessity of deciding to which sphere photography should be consigned. Indeed, as the maintenance of disjunction, photography gives neither the resolution of a third term suspended "between" nature and culture nor the equally convenient irresolution of a perpetual undecidability. Uncertain of its own identity, photography defers instead to the presumed self-presence of its two constituents.

Both of these were in transitional crisis at the moment of photography's linguistic construction. The corpuscular theory of light proposed by Newton in the eighteenth century was by 1839 being replaced by the wave theory developed by Thomas Young in England and Augustin Fresnel in France. The result was a widespread inco-

herence in contemporary discussions of light and its properties.[149] Writing was also undergoing a radical transformation, being refigured as a cultural and historical rather than a natural or God-given phenomenon.[150] No wonder then that photography's nomenclature divided nature from culture even while putting this same hyphenation under erasure. "Photo-Graphy" marked not only the interval between two things but also the operation of continually setting those things aside. As Derrida describes such an operation, "It marks what is set aside from itself, what interrupts every self-identity, every punctual assemblage of the self, every self-homogeneity, self-interiority."[151]

Indeed, if we look closely at the texture of photography's parts, we find them constituted by an infinite partitioning of a sort that unravels all borders and all identities. The *Oxford English Dictionary,* for example, traces the etymology of the Greek suffix *graphy* to an "abstract noun of action or function."[152] In other words, *graphy* can be read as either active or passive (either and therefore never simply one or the other). Operating simultaneously as verb and noun, this writing produces while being produced, inscribes even as it is inscribed. Here, in one brilliant stroke of language, the naming of photography replicates the fascinating dilemma of its own impossible historical and epistemological identity.

began this book with a discussion of recent debates about the identity of photography, then shifted to the question of photography's historical origins. The search for these origins led from the 1839 announcements in France and England to the earlier emergence of an unmistakable desire to photograph within European cultural discourse in general during the years around 1800. This desire was inspired by and invested in various concepts (nature, landscape, camera, time) themselves undergoing a profound crisis of identity at this same time. However, still to be investigated are the pictorial manifestations of this desire, the many "first photographs" produced or imagined by the proto-photographers in the years before 1839. These may well offer as much insight into the desire to photograph (and thus into photography's identity) as the previously examined speculative and explanatory texts.

Photography's historians have argued as much about the first photograph as they have about the first photographer. Where the exact timing of the idea of photography remains frustratingly elusive, actual pictures promise a more stable point of origin on which to build a coherent history of the medium. Strangely, despite (or perhaps because of) this need, historians have offered very little detailed analysis of the images at issue. I will now seek to redress this omission. However, I will not attempt to establish which image is indeed the first true photograph (this whole book questions such efforts). Rather, I will once again address the mythopoetic significance of photographic origin stories as a genre. For this reason, I will consider a number of images not normally thought to be photographic as central to any serious investigation of photography's historical identity.

Draftsman Drawing a Nude

First published in 1986, *A History of Photography: Social and Cultural Perspectives* is in many ways typical of recent historical accounts of photography's origins.[1] Edited by French historians Jean-Claude Lemagny and André Rouillé, the book brings together essays by numerous European and American writers in an effort to address precisely the problem outlined in my opening chapter: defining photography within boundaries set by opposing formalist and postmodern concerns. Lemagny's introduction explains why he sees a need to bring together both "a history *through* photography" and a his-

tory in which "*photography would have to reflect on itself.*" He argues, in fact, for some sort of balance of the two approaches, "a central position."

Taken together, technical definition and aesthetic value confer unity upon photography. Without these, it becomes fragmented into as many different sectors as it has uses: information, fashion, leisure, and so on. Silver salts and a questioning of the works through the works themselves: these constitute the two points of anchorage that can prevent photography from fragmenting into a multitude of tiny parasitical stories. . . . As far as possible, we have aimed to keep everything in view, concentrating simultaneously upon both sides of the story: on the one hand, photography seeking its own internal coherence; *on the other,* photography dependent on everything that surrounds it.[2]

Bernard Marbot's opening chapter, "Towards the Discovery (before 1839)," in keeping with his editors' pluralist aims, traces photography's prehistory by encompassing general social, cultural, and technological developments as well as the efforts of individual inventors such as Niépce, Wedgwood, Daguerre, and Talbot. To this end, Marbot faithfully reproduces many images found in earlier histories of photography's invention, including both Niépce's "only print from nature," a heliographic view from his studio window, and Talbot's "oldest known negative," showing a window in Lacock Abbey. However the oldest image of any sort reproduced here happens to be a wood engraving by the German artist Albrecht Dürer (1471–1528), identified by the caption "Italian method for drawing a subject according to the principle of linear perspective" (also sometimes more simply known as *Draftsman drawing a nude*).[3]

Although never discussed in Marbot's accompanying text, Dürer's image is there of course to signify the invention during the Italian Renaissance of that monocular system of perspective destined, three centuries later, to be embodied in photography. Virtually every commentator on photography, whether formalist or postmodern, has regarded the invention of perspective as one of the key events in the medium's history. In *Before Photography* for example, Peter Galassi declares that "the ultimate origins of photography—both technical and aesthetic—lie in the fifteenth-century invention of linear perspective."[4] Victor Burgin similarly suggests that perspective represents the "essential details" of photography as a representational system.[5]

What are these details presumed to be? Monocular perspective allows a geometric and therefore idealized space to be pictured on a two-dimensional plane, with the regulating coordinates of this space centering on a single point of vision (the *punto di fuga* or "point of flight," later called the "vanishing point"). Perspective is, in other words, a homogenizing system of representation constructed around a given point of origin—the eye of an individual human observer. This system also implies a boundary between this eye and what is seen, a clear separation of observing subject and observed object. As Christian Metz has described it, the vanishing point of monocular perspective "inscribes an empty emplacement for the spectator-subject, an all-powerful position which is that of God himself, or more broadly of some ultimate signified."[6] So this 1986 reincarnation of *Draftsman drawing a nude* (fig. 4.1) is asked to carry a heavy load within the pages of *A History of Photography*. As the earliest image reproduced in the book, Dürer's engraving is presented to readers as the first photographic image (or at least as the archetypal proto-photograph). It therefore represents the ontological as well as the historical origins of photography.

The rendering in question is a woodcut first published in 1538 (ten years after Dürer's death and thirteen years after it was originally drawn) in *Unterweysung der Messung (Instruction in the Art of Measuring)*, a text explicitly designed to introduce the methods and possibilities of Italian perspective to a Northern European audience. It shows a draftsman in the process of drawing a naked woman. The woman reclines on a table in an unusually awkward position such that her partly opened legs have become the focus of the draftsman's gaze. Her left hand reaches across with a drape to mask her genital area, simultaneously emphasizing the immodesty of her position. Her supine state is repeated in the horizontal forms of the undulating landscape seen through the window behind her. She is separated from the draftsman by a gridded screen, an Albertian "window" that is the measuring instrument of the perspective drawing she is about to become. The draftsman's eye never wavers from her, being fixed both to the horizon line and to the phallic pinnacle of a miniature obelisk that stands on the table before him. Only his hand prepares to move, ready to commit her sexual identity to representation, to geometric order, to a perspectival unity absolutely centered by and on the masculine eye.

Perspective as an all-encompassing masculine order: Is this then the message of Dürer's print? At first glance it seems to confirm the subject-object opposition said to

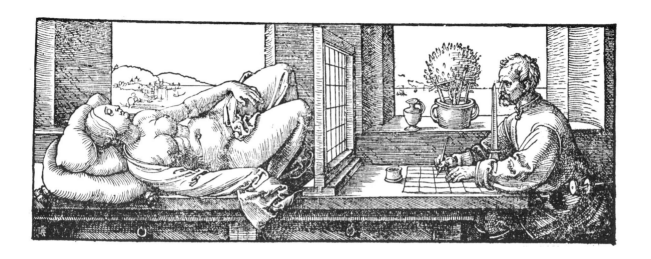

4.1 Albrecht Dürer, *Draftsman drawing a nude*, c. 1525. Woodcut. Kupferstichkabinett Staatliche Museen zu Berlin, Preußischer Kulturbesitz

be inherent to perspective (here reproduced as an opposition of masculine/feminine as well as of viewer/viewed).[7] But what of that which here escapes this binary order? The "awful void" of female sexuality for example, the mapping of which would appear to be the principal object of the draftsman's desire, seems to be denied the imperative of his gaze by that strategically placed drape. He will draw her anyway of course, but she has already refused the certainty of his figuring, already frustrated any marking of his gridded page beyond a reiteration of her presumed lack.

And what of the position of the spectator (here made synonymous—by way of a shared system of perspective—with that of the artist Dürer himself)? Although the woodcut is symmetrical, we find ourselves standing somewhere outside yet still within the draftsman's immediate space of representation, at about the point of intersection where the screen divides the sexes. In the influential *Della Pittura* (1435), Alberti had written of the artist's "window" as a usefully practical metaphor. He conjured, therefore, a device that must somehow be transparent but also, if it is to be drawn on, opaque. In another section of his treatise, Alberti felt the need, perspective apparently proving a rather slippery concept, to posit another of these concrete metaphors. "Let us use this intersection, that is the veil," he says. "Nothing can be found, so I think, which is more useful than that veil which among my friends I call an intersection."[8] Like his window, the veil is a figure of speech that destabilizes any simple oppositional structure—it suggests something that simultaneously allows and denies the gaze, depending on which side of its surface the viewer is positioned.

Dürer's rendition seems to take Alberti's ambiguous figures of speech at their word. As spectators we are positioned in the space between masculine subject and feminine object, but a little to his side of it—her side after all appears to be the space of the unrepresentable. For she does not occupy a rational space at all (she is not "in" perspective); from our point of view her body assumes an impossible, non-Albertian, medieval morphology. (As William Ivins has pointed out, Dürer's "various figures . . . frequently have nothing to do with one another and exist in different spaces.")[9]

The viewer's eye is positioned on the same level as that of the draftsman (although our point of focus is not the phallus but rather beyond it, to an infinite horizon—to a point that is also a line). Like him we are unable to glimpse beyond the woman's drapes. Dürer had written that *perspectiva* was a Latin word that meant "*a Seeing-through.*"[10] However, in this case he gave viewers an angle of vision that ensured

that they would be unable to see through the draftsman's window; it may appear transparent to the draftsman but for us it retains a mirrorlike opacity. Can the draftsman see anything beyond the reflection of his own desire? Can we? What we *are* able to see on "our" side of the screen is a potted shrub—yet another phallic protuberance—sitting on the large Italianate windowsill next to the draftsman. Could this sample of topiarian art, its foliage constrained by yet exceeding the strictures of its framework of sticks, be a microcosm of perspective at work? We spectators are asked to identify with the draftsman's project then, but also with his dilemma, with the impossibility of his (and perspective's) call to order and transparency, of his desire for a total homogeneity. No wonder the draftsman's page remains blank, his hand hesitating to make the first mark. For this image speaks as much about the deferral of perspective's desire as it does about its potential articulation as/of difference.

Leaving aside the intentions of its original maker (which are largely irrelevant to its place within the history of photography), Dürer's woodcut can today be read as a telling critique of perspectival representation itself, of its constitutive power but also of its residual failure to "fix" its object firmly in place. It also undermines any claims perspective might have to naturalness; Dürer's representation makes it plain that perspective is an Italian, rather than a universal, way of seeing. In the same vein, this image could be taken as an unusually incisive reading of photographic seeing that recognizes that certain historical, cultural, and sexual differences necessarily inhabit the very grain of its existence as a concept-metaphor, as a desire, and as a practice.

This is a (vanishing) point worth repeating (even as it endlessly repeats itself). Dürer's woodcut, in its contemporary manifestation as both the first photograph and the "essential details" (Burgin's phrase) of photography in general, reveals a complex meditation on the very metaphysics that make such claims possible. For this woodcut also represents perspectival representation at work representing itself. A drawing about drawing (about drawing drawing itself), it represents perspective's "geometric point of origin" (and photography's "ultimate origins") not as a stable location but as an endless play of deferral and difference, an articulation of a *spacing* as much as of space.[11] Thus *A History of Photography*'s rendering of photography's origins is also something of a rending of that same origin, a theme to which we will continually return throughout this chapter.

Histories of photography are unable to reproduce any of Tom Wedgwood's "first photographs," none having survived beyond the moment of their initial manufacture. Indeed Wedgwood's failure to make his images permanent is still sometimes taken as reason enough to exclude his and Humphry Davy's names from the list of photography's inventors. However what is striking about Davy's *Account* of 1802 is that he and Wedgwood fully articulated photography (as it much later came to be called) despite their inability to make their images permanent. In five short pages they in fact described an impressive range of photographic ideas and applications.[12]

Wedgwood apparently began by attempting to capture the image formed by the camera obscura and only subsequently moved on to the problem of copying existing images. The two experimenters attempted to copy paintings on glass (such as those used for projection devices) and "profiles of figures" (perhaps a reference to silhouette portraits). They also made contact prints using leaves and insect wings as well as engraved prints. Their friend Anthony Carlisle recalled in 1839 that he had undertaken several experiments with Wedgwood in about 1799 "to obtain and fix the shadows of objects by exposing the figures painted on glass, to fall upon a flat surface of shamoy leather wetted with nitrate of silver, and fixed in a case made for a stuffed bird."[13] Davy also wrote that he himself made images of small objects using a solar microscope and "prepared paper."

Amid these creative variations on the basic idea, the two also undertook numerous comparative experiments using different materials, solutions, and processes. They exposed both white paper and white leather moistened with a solution of nitrate of silver in direct sunlight and then in shade, as well as under red, yellow, green, blue, and violet glass. They tried, unsuccessfully, to remove the delineations so produced with both water and soapy water and attempted, equally unsuccessfully, to prevent further development by covering the image with a thin coat of varnish. Davy also experimented with different solutions of nitrate and water and with muriate of silver (a chloride that he found less suited to the task than the nitrate). He even gave practical advice about how best to apply the resulting solution to one's paper or leather. Finally, he not only recognized the lack of image permanency as a problem but also suggested a

plausible theoretical answer to it—on which subject "some experiments have been imagined" (although, it seems, never undertaken).

So, thirty-seven years before Daguerre and Talbot announced their own discoveries to the world, the *Account* supplied many elements of the concept of photography: an image is induced and/or projected by light and made automatically to delineate itself on a prepared surface. But the *Account* gave no further insight into the thinking behind this concept. Why, after centuries of silence regarding this particular quest, did Wedgwood suddenly desire to fix the image seen in his camera obscura? What meanings can we attach to such a desire? And what, in particular, does Wedgwood's career as a picture maker tell us about the conceptual economy of the desire to photograph?

One picture associated with Wedgwood might begin to answer such questions. Asked directly about the possible origin of a desire to photograph, Victor Burgin has argued that "the origin of photography is identical with the origin of painting, with the origin of any desire for the image." He then refers specifically to Pliny's famous myth about the potter's daughter who outlines the shadow of her departing lover on a wall as a means of remembering him. Burgin proposes that this mythical origin of painting reminds us that "the origin of the graphic image is in the portrait, and that the origin of the portrait is in the desire for protection against the loss of the object, and the loss of identity." By means of this "psychic historiography" (as he calls it), Burgin describes a psychoanalytic notion of desire as a continual repression of and substitution for lack or loss and then equates this desire, both literally and figuratively, with the narrative of photography's conception.

In effect, this makes the desire to photograph but one instance of a more general desiring economy common to all times and places and therefore transcending historical and cultural difference. In other words, Burgin replaces one originary essence, "photography in itself," with another, "desire in itself." This is certainly a suggestive move (and one that his own work has explored in some detail). However, this psychoanalytic version of photography's origins still does not account for the specificity of the timing, the morphology, or the cultural focus of the desire to photograph as represented by the efforts of Wedgwood, Davy, and all other early nineteenth-century experimenters.[14]

Burgin's account does draw attention to a painting not previously included in discussions of Wedgwood's photographic thinking. The painting was one of a number

commissioned by Tom's father Josiah (1730–1795) in the 1770s and eighties. Josiah significantly influenced the activities and aspirations of his son. Apart from three years at Edinburgh University, the Wedgwood sons were largely educated at home under the close supervision of their father.[15] There they were taught every imaginable subject, from languages to physical education. They were also introduced to the study and practice of picture making. Tom, for example, was already a skillful draftsman at the age of sixteen, having received perspective drawing lessons from George Stubbs in 1780 and more general artistic instruction from the painter Henry Webber (who had been recommended to Josiah by Sir Joshua Reynolds). Josiah also employed several artists (among whom was John Flaxman) to produce designs for his pottery business and commissioned or purchased a number of paintings in the 1780s from Joseph Wright of Derby, an English painter well known for his luminous depictions of scenes from industry and science.

In September 1778 a portrait by Wright of Wedgwood's three sons conducting an experiment to produce "fixable air" was discussed but never painted.[16] Another painting, one of two family portraits commissioned from George Stubbs in 1779, showed a similar scene.[17] Josiah continued to negotiate with Joseph Wright about the possibility of commissioning a number of other paintings. One major work that was eventually completed was *The Corinthian Maid* (fig. 4.2), painted between about 1782 and 1785 but much discussed by artist and patron from 1778 on. Tom was fourteen when the painting was finally delivered to the family home. The picture is interesting in the present context because of its theme—none other than Pliny's account of the origin of painting.

Robert Rosenblum has provided a short but useful history of depictions of the origin of painting in the history of European art.[18] He points out that the story of the Corinthian maid was seldom illustrated before the 1770s but enjoyed considerable popularity from this time until the 1820s, after which it again fell out of fashion. This period of popularity coincided with the development of "automatic" portrait technologies such as the silhouette machine and the physionotrace (one French print of the theme was even given the title *L'origine de la peinture, ou Les portraits à la mode*). The popularity of this theme also neatly coincided with the first conceptions of and experiments toward photography.[19]

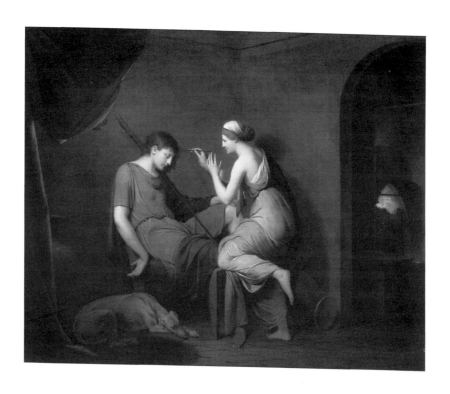

4.2 Joseph Wright of Derby, *The Corinthian Maid*, 1783–84. Oil on canvas. National Gallery of Art, Washington, Paul Mellon Collection

This subject would have particularly appealed to Josiah Wedgwood because the Corinthian maid was described as the daughter of a potter, with Pliny telling how this potter later modeled and baked the resulting silhouette in clay. Wright's painting eventually included a glowing potter's kiln and various ceramic vases, a tangential reference to the Wedgwood factory at Etruria. The painting managed to associate the production of ceramics with neoclassical tradition and taste while appealing to the popular virtue of fidelity. From Wright's point of view it allowed him to continue his celebration of modern industrial processes as well as his exploration of the pictorial representation of artificial light.

Wright's particular interpretation of Pliny's story was inspired by contemporary literature. In 1784 he wrote to his friend the poet William Hayley to confirm that "I have painted my picture from your Idea." Six years before, Hayley had published a poem about the "soft Corinthian maid" entitled *An Essay on Painting*. After recounting how the maid, knowing of her lover's imminent departure, "long'd to keep his image in her view," Hayley concluded with these telling lines:

Thus from thy power, inspiring LOVE, *we trace*
The modell'd image, and the pencil'd face![20]

So far, the "idea" expressed by Wright's painting does indeed seem to be one in which representation of any kind (the theme incorporates the origins of drawing, painting, and designing, as well as ceramic casting) is born of a perennial desire to substitute an image for an anticipated loss. But given that it has also been posited as/at the origin of the desire to photograph, what more does this painting have to say about the nature of such a desire?

French philosopher Jacques Derrida has discussed some of the implications of the story of the Corinthian maid in a number of different contexts. He reminds us in *Of Grammatology,* for example, that Jean-Jacques Rousseau conjured this mythical event in his *Essay on the Origin of Languages,* written between 1749 and 1763.[21] It appears as early as Rousseau's fourth paragraph, a prelude to his influential investigations of the origin of both language and music. "Love, it is said, was the inventor of drawing. It might also have invented speech, though less happily."[22] With this analogy in place, Rousseau concluded that a passion beyond need—in other words, desire—is the ori-

ginary cause of language, indeed of all communication: "Man's first motives for speaking were of the passions."[23]

This may seem to be drifting rather far from Wright's painting of *The Corinthian Maid*—until one remembers that Wright, prompted by Hayley, had originally proposed to Josiah Wedgwood that he paint a companion piece to the *Maid* on the theme of *The Origin of Music.* In the very same years that he made this proposal, he was painting his celebrated portrait of Brooke Boothby, the English publisher of Rousseau's autobiographical *Dialogues.* Boothby, shown lying in a wood with a manuscript marked with Rousseau's name curled up in his hand, was an associate of Erasmus Darwin's, a close friend of the Wedgwood family.[24] It seems very likely that Rousseau's thinking was familiar to both Wright and the Wedgwoods.

Like Burgin, Rousseau gestured to the image of the Corinthian maid to put desire at the origin. Driven by a natural (read "essential") passion, the maid demonstrates her emotion in a silent gesture, in a touching that is also a seeing. Her gesture is an immediate (photo-graphic) sign, a spontaneous (because passionate) tracing of the illuminated projection of her lover's body on a receptive surface. This gesture, through her stylus, maintains a physical continuity between the desiring body of the person who traces and the image of the other. But before this gesture is desire itself. For Rousseau, as for Burgin, desire comes before any representation, any convention, any social formation (culture, history): It is what makes representation possible and necessary.

This, as Derrida outlines in detail in *Of Grammatology,* is just one of many hierarchical binaries structuring Rousseau's argument. Rousseau's preference for speech over writing (with its implicit corollary of nature over culture, originary expression over re-presentation) is the most notorious of these binaries, but they appear in many other forms as well. Faithfully following every nuance of Rousseau's own writing, Derrida reveals that the *Essay*'s argument continually contradicts itself. Wherever it wants to posit an originary pure speech, Derrida finds a writing always already there. Derrida's point is not that writing comes before speech but that Rousseau's "speech" is also a writing, and his writing a speech. This calls for a reconsideration of all arguments based on priority. No wonder Rousseau was unable to decide the "difficult problem" of what comes first, "the existence of society to the invention of language, or the invention of language to the establishment of society."[25]

In each case, we find at the origin what Derrida calls (picking up on a word Rousseau uses frequently himself) the logic of the supplement, and with it "an infinite chain, ineluctably multiplying the supplementary mediations that produce the sense of the very thing they defer: the mirage of the thing itself, of immediate presence, of originary perception."[26] Given that the supplement refuses a position of exteriority to this chain, Derrida warns that "in spite of certain appearances, the locating of the word *supplement* is here not at all psychoanalytical."[27] Thus, even if we accept with Burgin that Wright's *The Corinthian Maid* can be taken as a photograph (a memory inscription) of the origin of Tom Wedgwood's desire to photograph, we are looking at a desiring that comes neither before nor after this origin because it resides both inside and outside any delimitable moment in time.

Derrida continues his discussions of the origin of painting in the context of his own semiautobiographical speculations on a link between self-portraiture and blindness. These speculations appear in his 1990 catalogue essay for a Louvre exhibition entitled "Mémoires d'aveugle: L'autoportrait et autres ruines" ("Memoirs of the Blind: The Self-Portrait and Other Ruins"). Derrida points out that in order to draw something the artist must momentarily turn away from the thing to be drawn in order to put pencil to paper. Thus an unsightedness, a blindness, is the very condition of the act of drawing. Moreover, the artist is doubly blinded, because the drawing instrument itself then comes between the artist's eye and the line being drawn. Drawing is always done from memory. It is an act of blindness, a gesture in the dark. This conundrum, Derrida suggests, is recognized by all artists who seek to represent this same act's purported origins.

The origin of drawing and the origin of painting give rise to many representations that substitute memory for perception. First, because they are representations, next because in addition they often draw on an exemplary story (the one of Dibutades, the young Corinthian lover who carries the name of her father, a potter of Sycione), and finally because that story connects the origin of graphic representation to the absence or invisibility of the model. Dibutades cannot see her lover, either because she turns her back to him, more steadfast than Orpheus, or because he turns his back to her. Their glances cannot meet in either case (as in the example of Dibutades ou l'origine du Dessin, *by J. B. Suvée): it is as if the condition for drawing is to be unable to see, as if you can draw only if you do not see. So drawing appears as a declaration of love directed or ordered by the invisibility of the*

other, or maybe it's that drawing can be born only when the other is hidden from the gaze. When Dibutades, her hand sometimes guided by Cupid (a Love who sees and who therefore isn't blindfolded in this case), traces a shadow or silhouette on the surface of a wall or veil—making a skiagraphia *or shadow writing—she invents a certain art of blindness. Perception has its origin in remembrance. She writes, therefore her love is already nostalgic. Detached from the actual moment of perception, cast by the same thing that it divides, a shadow is simultaneously a memory, and the stick of Dibutades a blind person's cane.*[28]

In Wright's version of *The Corinthian Maid,* the male lover is asleep and therefore without the power of sight. However, the maid is positioned so as to be able to see both his head and shadow as she draws (although, because he is leaving, both will soon of course be no longer visible to her). In any event, love remains her primary motivation, and, as everyone knows, love is blind. Note the coincidence of the maid's inauguration of *skiagraphia* and Talbot's choice of the same word in his first attempt to name photography (he referred to "the Photogenic or Sciagraphic process" in a notebook entry dated February 28, 1835). Wright's painting also reiterates a message apparent in Dürer's rendering of perspective: any origin is always already marked by a play of sexual and other differences.[29]

One reviewer of Derrida's exhibition and catalogue points out that "he insists that during the act of drawing the artist 'has seen' and 'will see' but 'presently does not see.'"[30] One wonders if Wedgwood, Talbot, and Daguerre pondered this same conundrum while making their images. It certainly struck one journalist as he watched Daguerre demonstrate his process in September 1839: "The director (for I cannot call him the operator) cannot see by the plate how the process goes on, experience alone can tell him how to judge as to the advancement which the action of light has made."[31] The photographer points his camera at a scene and removes the lens cap for a certain duration; only later, after development, will he see exactly what the camera has seen. Thus this first daguerreotypist has seen and will see the scene being imaged, but during the extended moment of photographing he does not see it. He photographs blind, from memory.

Never able to induce a photographic image in the camera obscura, Wedgwood turned instead to contact prints of various kinds. As in *The Corinthian Maid,* a faithful image only came with touch. He placed objects directly on a material made sensitive

to the difference between the presence and absence of light. In other words, an image was produced only because of this material's receptivity. In Wedgwood's contact prints, objects had to be removed before their photographic trace (the tracing of a difference) could be seen. Like the maid's repetition of her lover's shadow, the trace marked what was set aside from itself. It marked the space between the object and its image but also the movement (the spacing) of the object's placement and removal.

In this case, the movement that made photography possible had continually to reenact itself. Never fixable, Wedgwood's photographs hovered briefly between life and death before succumbing to their own will to develop. Perversely, the very light needed to make and see them proved fatal to their continued visibility. In a sense, Wedgwood and Davy's struggle to overcome this shortcoming was a struggle with mortality itself. Their photographs were truly palimpsests, an absent inscription that is also present (at least in memory), a presence (a blackened surface) inhabited by absence. In Derrida's terms, these "ruined" photographs, themselves an absent presence within the history of photography, represent the inescapable play of difference that inhabits every point of origin, including photography's own: "In the beginning, at the origin, there was ruin. At the origin comes ruin; ruin comes to the origin, it is what first comes and happens to the origin, in the beginning."[32]

Paysage (View from a Window)

Claude and Nicéphore Niépce left a number of images that could claim to be their "first photographs." The Niépce brothers' earliest attempts at making light-induced images were inspired by lithography. Accordingly, from 1814 on they worked toward reproducing existing engravings. These were made transparent by the application of wax or oil, then placed in the sun on stones or other surfaces coated with a variety of light-sensitive varnishes. The result was a reversed contact print of the original engraved image on the prepared surface. In July 1822 Nicéphore succeeded in making such a heliographic copy of an engraving of Pope Pius VII on glass coated with bitumen. Over the next five years a number of other engravings were similarly copied, most onto copper or pewter plates. Those that have survived include *Le Cardinal Georges d'Amboise* (1826–27), *Paysage d'après Claude Lorrain* (1826), *Le Christ portant sa croix* (1825–27), *La Sainte Famille* (1826–27), *Un Grec et une Grecque, Moine accompagnant*

un jeune homme, and *Le jouer de cartes.*[33] Particularly interesting is Niépce's heliographic copy of Daguerre's lithograph for the stage set of *Elodie.* However the heliograph of a profile portrait of *Le Cardinal Georges d'Amboise* (fig. 4.3), a minister in the court of Louis XII, is most frequently published in histories of photography. In this case, Niépce soaked the plate in acid and then had it further etched with acid by Augustin Lemaître, a professional engraver. A number of faint but recognizable paper proofs of the print were pulled from the plate, proving the potential of this method for automatically reproducing existing images.

Note the eclectic selection of engravings that Niépce chose to test his process. Portraits, landscapes, religious subjects, and genre scenes were all employed in more or less equal numbers; indeed, it seems as if any available picture would do. The process of reproduction mattered to Niépce, not the subject matter. This was reiterated in a number of exchanges between Niépce and Daguerre about the desirability of multiplicity. On February 2, 1827 Niépce wrote to Lemaître about Daguerre's approaches to him, reporting that Daguerre had denigrated Niépce's own efforts at photogravure. Daguerre had apparently claimed that "he had made researches with another application, tending more towards perfection than to multiplicity."[34] In the *Memoir* of December 8, 1827 Niépce repeated Daguerre's own evaluation of this "other application," "which has not, it is true, the advantage of being able to multiply the product, but he regards it as eminently proper for rendering all the details of nature."[35] On June 4, 1827 Niépce had sent a heliogravure and paper proof of *La Sainte Famille* (The Holy Family) to Daguerre to demonstrate his process. In the accompanying letter he clarified that he conceived all of his heliographs, whether copies of existing engravings or copies of "views from nature," as but the first step toward an etching and multiple reproduction process.

This is not one of my recent results but dates from last spring; since then I have been diverted from my researches by other matters. I shall resume them today, now that the country is in its full splendor, and shall devote myself exclusively to copying views from nature. There is no doubt that this offers the more interesting results, but I am fully aware of the difficulties which it will present in engraving. The enterprise is beyond my powers, and my ambition is limited to being able to show by more or less satisfactory results the possibility of complete success if a skilful and practised hand in the process of aquatinta would subsequently co-operate in this work.[36]

Nicéphore Niépce, *Portrait of Cardinal d'Amboise*, 1826. Paper print from heliograph. Gernsheim Collection, Harry Ransom Humanities Research Center, The University of Texas at Austin

As this letter suggests, Niépce certainly regarded his attempts at "views from nature" as the "more interesting" experiments, even though they employed the same basic chemistry and method already outlined. In an earlier letter to Lemaître, dated February 2, 1827 and accompanied by five helio-engraved plates, Niépce mentioned, "I am busy principally at present, Monsieur, with engraving a view from nature, using the newly perfected camera."[37] Lemaître replied that "I look forward to seeing your examples of images from nature, because this discovery seems most extraordinary to me and at first incomprehensible."[38] This same distinction, the difference between a representation of the real (nature) and a representation of what is already a representation (an engraving), has also transfixed photography's historians, leading them to downplay Niépce's heliogravure contact prints in favor of his images "from nature." Although made by virtually identical chemical processes, only these latter images made with a camera have been classified as potential first photographs in most histories.

The first image reproduced, for example, in Claude Nori's *French Photography: From its Origins to the Present* is a camera picture credited to Joseph Nicéphore Niépce, titled *Still life* and dated 1822.[39] In *The Origins of Photography* Gernsheim reproduces this same image but identifies its source as an 1891 photo-engraving titled *Table prepared for a meal* (fig. 4.4).[40] This engraving, purporting to be of a heliograph on glass, was first reproduced in A. Davanne's 1893 *Conférences Publiques sur la Photographie,* where it was claimed to have been made by Nicéphore Niépce in "1823 or 1825."[41] The image shows a table covered in a tablecloth and laid out as if for a simple meal with crockery, cutlery, and a vase of flowers. Although he included it in the section of the book dealing with Niépce, Gernsheim disputes both its date (which he puts at c. 1829) and its authorship (which he ascribes either to Daguerre or to Nicéphore's cousin Abel Niépce de Saint-Victor). The original object was smashed in 1909 and only its mysterious ghost remains to haunt the history of photography's origins.

Apart from Nori, virtually every history of photography reproduces another image by Nicéphore Niépce as the world's first photograph. It is usually titled *View from the window at Le Gras* or, in French histories, *Paysage à Saint-Loup de Varennes* (fig. 4.5). According to Helmut Gernsheim, this 16.5-by-20.5-centimeter image was probably made sometime between June 4 and July 18, 1827.[42] It presents a view from Niépce's studio window, looking out over a courtyard and buildings. From his correspondence,

4.4 Photographer unknown, *Table prepared for a meal*, date unknown. Reproduction from photo engraving in A. Davanne & Maurice Bucquet, *Le Musée restrospectif de la photographie a l'Exposition Universele de 1900* (Paris, 1903). Société Française de Photographie, Paris

it is clear that Niépce had been attempting to make similar views since about April 1816, with varying degrees of success. On May 5, 1816, for example, he reported to his brother that, having pointed his camera obscura out the window of his studio, "I saw on the white paper all that part of the birdhouse that is seen from the window and a faint image of the casement, which was less illuminated than the exterior objects."[43] This describes the basic elements of what can be seen of the surviving 1827 heliograph and suggests that Niépce made this image over and over again. How often he must have looked at and for it! Its "magical" reappearance on paper, glass, copper, zinc, or pewter became his template of heliography at work, the standard effect by which photography was to be recognized as such.[44]

The 1827 image was made using a pewter plate coated with a solution of bitumen of Judea, exposed for over eight hours in a camera fitted with a biconvex lens, then washed with a solvent (oil of lavender and white petroleum) to remove those parts of the bitumen not hardened by light. The details of the resulting image are difficult to make out. However, its general subject matter and symmetrical composition at least confirm Niépce's stated interest in capturing views of landscape. The picture is framed on the left by the loft of his pigeon house and on the right by a wing of the house. In the center is the sloping roof of a barn, with the top of a pear tree rising above it. Although it is not very exciting to look at, everyone who studies the history of photography is familiar with this image. With Gernsheim calling it "the world's earliest, and the inventor's sole surviving photograph from nature," it is an undisputed icon.[45]

In an article published in 1977 Gernsheim tells how he and his wife Alison rediscovered this sacred object in 1952. It had been lying in a trunk in England, forgotten until their inquiries had drawn attention to its existence. On February 15, 1952 Helmut held the long-missing heliograph for the first time. "Only a historian can understand my feeling at that moment. I had reached the goal of my research and held the foundation stone of photography in my hand." The problem was that this "foundation stone" proved almost impossible to reproduce photographically. The photograph that he himself took of it turned out to be no more than a reflection of the front of his own camera (a mirroring of his own photogenic desire). After the *Times* and the National Gallery in London had also tried and failed to get a satisfactory reproduction, Gernsheim solicited the help of the Kodak Research Laboratory. After three weeks of trials, this laboratory produced what Gernsheim describes as a "greatly distorted image . . .

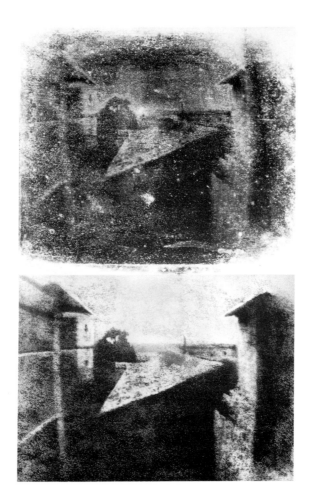

| 4.5 | Nicéphore Niépce, *View from the window at Le Gras*, 1827. Bitumen of Judea on tin plate. Gernsheim Collection, Harry Ransom Humanities Research Center, The University of Texas at Austin. Reproduction by Kodak Research Laboratory, England (March 20, 1952)

| 4.6 | Nicéphore Niépce, *View from the window at Le Gras*, 1827. Retouched reproduction of heliograph (watercolor on gelatine silver print). Gernsheim Collection, Harry Ransom Humanities Research Center, The University of Texas at Austin

[which] in no way corresponded with the original . . . a travesty of the truth." Accordingly, Gernsheim then spent two days touching up this copy print with watercolor, eliminating "hundreds of light spots and blotches" and giving the image a "pointillistic effect" that he admits is "completely alien to the medium." Although he confesses that his painted reproduction "was only an approximation of the original," he reassures readers that it "comes rather close to the drawing I had made a month before any reproduction existed." [46] Gernsheim went on to reproduce this watercolor approximation in *The Photographic Journal* in 1952; it appears as "the world's earliest photograph" in his *The Origins of Photography* (1982). The same reproduction and claim also appear in a vast number of more recent histories of photography. [47]

Here we have another one of those peculiar twists of photographic history. The image that is everywhere propagated as the first photograph, as the foundation stone of photography's history, as the origin of the medium, is in fact a painting after a drawing! The much touted first photograph turns out to be a representation of a representation and therefore, according to photo-history's own definition, not a photograph at all. We have instead a painted version of a reproduction that itself "in no way corresponded with the original." It seems that wherever we look for photography's bottom line, we face this strange economy of deferral, an origin always preceded by another, more original, but never-quite-present photographic instance.

Still Life

About twenty daguerreotypes by Louis Daguerre have survived to the present day, with another seventeen or so mentioned in 1839 by the press or other witnesses. In late 1838 Daguerre himself claimed that he would have "40–50 pictures" ready for an exhibition scheduled to open on January 15 of the following year. The exhibition never took place, and unfortunately, although reportedly saved from the Diorama fire of March 8, 1839, Daguerre's earlier experiments and notes have not come to light. Nevertheless, a fair amount of evidence indicates Daguerre's aspirations as a photographer.

As with Niépce's choice of engravings, Daguerre's work as a daguerreotypist suggests that he was never preoccupied by a single photographic subject. On the con-

trary, he seems to have attempted as wide a range of genres as possible. His photographs include a number of still lifes (composed of casts of sculptures and architectural details, engravings, relief panels, carpets, fossil shells, and other items), several scenes showing buildings (Notre-Dame, the Tuileries, the Palais Royal, the Quai Voltaire) or city streets (especially the view from his studio window), a number of portraits (the earliest taken in 1841), an only partially successful attempt to photograph the moon, and, in one recorded case, an image of a spider taken through a microscope.[48] This eclecticism is matched by the range of pictures that he proposed in his various publications. In his premature announcement of 1835, for example, he claimed to have "discovered a means of receiving on a plate of his own preparation the images produced by the camera obscura, so that a portrait, a landscape, a view of any kind . . . *leaves its imprint* there."[49] In his 1838 subscription brochure he was equally expansive, pointing out that his discovery is "capable of innumerable applications" and mentioning "the most detailed views, the most picturesque scenery." Obviously speaking to what he hoped would be wealthy investors, he suggested that people take views of their "castle or country-house" and was daring enough to predict that "even portraits will be made."[50]

Of all of these pictorial aspirations, landscape alone never fell within the compass of his own camera. Landscape, and this of course meant picturesque landscape, nevertheless continued to be an ideal for his photographic process. Daguerre's seventy-nine-page instructional *Account,* published in Paris in September 1839, includes six engraved plates detailing how a daguerreotype is to be made. The last contains a figure described as "la plaque de l'épreuve" (the drawing plate), in other words a daguerreotype in the making.[51] The image shown on this mythical plate is a landscape scene, its receding foreground neatly framed by foliage in the prescribed picturesque manner. Ironically enough, this is precisely the kind of scene that one almost never sees in daguerreotypes, certainly not in any examples made by Daguerre himself.

Of the various daguerreotypes by Daguerre that do survive, one in particular is often reproduced in histories of photography as the earliest extant example, as Daguerre's first photograph. Dated 1837, this full-plate daguerreotype is usually titled *Still life* or *The artist's studio* (or, in one intriguing instance, *Intérieur d'un Cabinet Curiosité*) (fig. 4.7).[52] Although frequently published, the image has attracted little close analysis.

4.7 Louis Daguerre, *Still life*, 1837. Daguerreotype. Société Française de Photographie, Paris

It pictures a segment of what must be Daguerre's own studio, showing a section of wall and bench (or perhaps a window ledge) cluttered with various objects typically found in such places. These include the following: plaster casts of the heads of two putti or cupids, complete with small wings; a carved relief panel of a naked nymph holding a branch with one hand and a large paddle with the other, attended by a cupid and with a foot resting on one of two overturned vessels disgorging liquid; a cast of a ram or goat's head hanging on the wall; another cast of what appears to be a sheep's head; a corked wine flask covered in wicker, hanging from the wall by a thin strap; an ornately framed picture of a woman, probably an engraving or lithograph; two hanging pieces of cloth; a shallow bowl and several other small implements sitting on the bench. Each object is shown in tantalizing detail, with the disposition of light producing an aesthetic chiaroscuro. How then are we to read this conglomeration, beyond its ability to demonstrate what the newly perfected process could achieve?

The bas-relief in Daguerre's image recalls the style and iconography of the sixteenth-century French sculptor Jean Goujon, especially the series of five water nymphs carved for the Fountain of the Innocents in about 1547. This fountain was erected at a corner of the Rue Saint-Denis for Henry II's triumphal entry into Paris in 1549. Goujon went on, between 1548 and 1562, to contribute a significant amount of carving to the facade and interior of the Louvre.[53] By the early nineteenth century Goujon was regarded as one of the masters of a French Renaissance, which itself had come to be considered the pinnacle of French artistic achievement. In 1820 three of the bas-reliefs from the fountain's base were replaced by copies and the original panels moved to the Louvre. Although similar to these, the panel that appears (inverted) in Daguerre's image is actually a close copy of another bas-relief representing the same theme, a limestone carving held by the Louvre but whose attribution to Goujon is now disputed. This work, of a *divinité fluvial* (*Water nymph*) (fig. 4.8) clutching some bullrushes along with her oar, has been traced back to the collection of a Monsieur Daval, a "merchant of curiosities." It was acquired by Alexandre Lenoir for the Museum of French Monuments in the early nineteenth century before making its way to the Louvre. According to Pierre du Colombier, one of Goujon's biographers, many copies were made of this particular panel. In casting doubt on its attribution to Goujon, Colombier suggests that the panel itself may have been modeled after an engraving.

After Jean Goujon, *Nymphe fluviale*, date unknown. Stone relief panel. Musée du Louvre, Paris

Whatever its origins, this sort of nymph was, claims Colombier, a very popular image during the romantic era.[54]

This becomes relevant to the present discussion when one realizes that Daguerre at some point presented his *Still life* image, complete with its sidelong reference to Goujon and the Louvre, to Alphonse de Cailleux, who in 1836 had been appointed adjunct director of this same museum. Could Daguerre, in making this particular image, have been deliberately courting the attention and recognition of the artistic and political power brokers of his time?[55]

Julia Ballerini has also pointed to the association of wine and women in Daguerre's arrangement, its hedonist theme reinforced by the presence of the ram, "a common sign of the male ardent, vital force that reassures the return of the regenerative cycle in spring." Whether by accident or intention, "In its doubling of past/present joined with symbols of love and sensuality this picture more than hints at a continuing pagan image of sexuality and reproduction." Similar arrangements of sculptural reproductions inhabit other examples of Daguerre's pictures, as they do early photographs by Eugène Hubert, Hippolyte Bayard, and Henry Talbot. Ballerini points to a historical context in which increasing numbers of people, including Daguerre and Bayard, were being displaced from the provinces to the city, with all of the dislocating social and personal effects such moves entail. With this in mind, she proposes a general narrative frame for these early still lifes. "Again and again these first photographs staged scenarios concerning ancestry, both personal and social, a theme that integrated them into the mainstream of contemporary debates around the positioning and significance of both an individual and a collective lineage in a new era of changing sociopolitical structures."[56]

Be that as it may, Daguerre's earliest extant daguerreotype also demonstrates the potential usefulness of daguerreotypy to professional artists like himself. As a source of faithful copies of the classical canon, it amply illustrates the claim made in his own subscription brochure that "it will also give a new impulse to the arts, and far from damaging those who practise them, it will prove a great boon to them."[57] Successfully mimicking an already established genre of art practice, these still lifes (and Daguerre made at least eleven of them) perhaps even imply that photography itself was capable of artistic expression. More than that, however, Daguerre presented this image (to an

art museum no less) as a demonstration of daguerreotypy as a whole; on the back of the plate is inscribed "épreuve ayant servi à constater la découverte du Daguerréotype, offerte à Monsieur de Cailleux par son très devoué serviteur Daguerre" (proof [as in engraver's trial impression] having served to verify the discovery of Daguerreotype, offered to M. de Cailleux by his very devoted servant Daguerre).[58] *Still life,* then, is a manifesto of photography intended to certify its conceptual and pictorial identity. As such, Daguerre's image once again represents photography as a reproduction of what are all already reproductions (in the case of the bas-relief, perhaps even a reproduction of a three-dimensional copy of an engraving after a sculpture by Goujon). Photographs, this image seems to be saying, are the equivalent of those fossilized shells lined up in another of Daguerre's early efforts at still life: precise but fragmentary impressions supplied by a nature already at one remove from itself.[59]

Daguerre produced one other type of daguerreotype image a number of times. In about 1838 he made two views of the Boulevard du Temple from the window of his studio in the Diorama building, one at eight in the morning and the other at about midday. These were later sent to Ludwig I of Bavaria, having been described by their maker in now familiar terms: "épreuve ayant servi à constater la découverte du Daguerréotype, offertes à sa Majesté le Roi de Bavière par son très humble et très obéissant serviteur Daguerre."[60] Daguerre made at least one more of these same views of the Boulevard du Temple, this time taken late in the afternoon and showing horses that have moved during the exposure. Early in 1839 he repeated the exercise in another location. A journalist writing for *The Spectator* reported in the February 2, 1839 issue that Daguerre made views of the Luxor obelisk in the Place de la Concorde by morning, noon, and evening light.[61] Around the same time he also took a series of views of the Tuileries Palace, "taken at three different times of the day in the summer: in the morning at five, in the afternoon at two, and at sundown."[62] Daguerre was apparently interested (as were Bayard and Talbot, who also made multiple versions of the same object under different lighting conditions) not just in capturing a particular view but in representing photography as a peculiar articulation of time itself.

Time had of course long been a central problem for all experimenting with photography. As Comte Tannegui Duchâtel, the Minister of the Interior, explained in his speech of June 15, 1839 to the Chamber of Deputies, "The possibility of fixing tran-

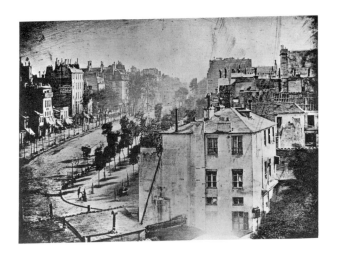

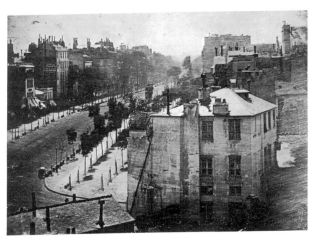

siently the objects reflected in a camera obscura, was ascertained as early as the last century."[63] However it wasn't until the efforts of Niépce and Daguerre that this transience could be fixed permanently, that the inexorable passing of time could be stopped in its tracks. In fact, as journalists were quick to point out, the actual passing of time was one thing that Daguerre could not reproduce on any one of his otherwise marvelous photographic plates; "Motion escapes him, or leaves only indefinite and vague traces":[64] "Nature in motion cannot be represented. . . . In one of the views of the boulevards of which I have spoken, all that was walking or moving does not appear in the picture; of two horses of a hackney coach on the stand, one unfortunately moved its head during the exposure and so the animal appears without a head in the picture."[65] Samuel Morse, commenting on his own viewing of one of Daguerre's photographs of the Boulevard du Temple, affirmed this limitation: "Objects moving are not impressed. The boulevard, so constantly filled with a moving throng of pedestrians and carriages, was perfectly solitary, except an individual who was having his boots brushed. His feet were compelled, of course, to be stationary for some time, one being on the box of the bootblack, and the other on the ground. Consequently, his boots and legs are well defined, but he is without body or head, because these were in motion."[66]

The daguerreotype's inability to represent motion was a direct result of the extended exposure time necessary to make a successful photograph. For while photographs may have been "spontaneous," they were by no means immediate. In June 1840 a rough table of exposure times prepared by Daguerre's assistant Hubert was published, and these times ranged, depending on the season and quality of light, from four and a half to sixty minutes (and, Hubert warned, even "this last is often not sufficient").[67] The year before, on September 7, Daguerre had given his first public demonstrations of the daguerreotype process, making several pictures of the Louvre with exposure times of between thirteen and twenty minutes.[68] His earlier series of views of the Boulevard du Temple, the Tuileries, and the Place de la Concorde further indicated the connection between appearance, exposure time, and time of day. These series not only calibrated the passing of time in the form of changing shadows and degrees of legibility but presented time itself as a linear sequence of discrete but related moments. Daguerre showed, in other words, that photography was able to bring the present and the past together in the one viewing experience, that photography could fold time back on itself.

One of these photographs, mentioned by Morse and usually titled simply *Boulevard du Temple* (1839), is commonly referred to as the first to show a human being.[69]

This claim, which invariably centers on the standing man, conveniently ignores the fact that the photo actually shows two people, the bending boot black and his standing customer. More than the first photo to show people, it is also the first to illustrate both labor and class difference, and in a particularly graphic fashion (standing middle/ upper-class being served by kneeling worker). Given the political turmoil that beset Paris in the nineteenth century, this image therefore continues to have a considerable historical resonance, albeit a resonance rarely mentioned by photography's various historians.

According to many historians, photography was born of the apparently coinciding demands of science and art for a transparent and unmediating form of representation. The daguerreotype is often mentioned as exemplifying this demand. It is certainly true that when daguerreotypes were first shown to the public in 1839, their ability faithfully to reproduce detail and accurately to replicate how things looked to the eye was greeted with the highest acclaim. Samuel Morse emphasized this quality on first sighting some of Daguerre's images on March 7, 1839.

They are produced on a metallic surface, the principal pieces, about seven inches by five, and they resemble acquatint engravings, for they are in simple chiaro-oscuro and not in colors. But the exquisite minuteness of the delineation cannot be conceived. No painting or engraving ever approached it. For example: in a view up the street a distant sign would be perceived, and the eye could just discern that there were lines of letters upon it, but so minute as not to be read with the naked eye. By the assistance of a powerful lens, which magnified fifty times, applied to the delineation, every letter was clearly and distinctly legible, and so also were the minutest breaks and lines in the walls of the buildings and the pavements of the streets. The effect of the lens upon the picture was in a great degree like that of the telescope in nature. . . .

The impressions of interior views are Rembrandt perfected. One of Mr. D's plates is an impression of a spider. The spider was not bigger than the head of a large pin, but the image, magnified by the solar microscope to the size of the palm of the hand, having been impressed on the plate, and examined through a lens, was further magnified, and showed a minuteness of organization hitherto not seen to exist. You perceive how this discovery is, therefore, about to open a new field of research

in the depths of microscopic Nature. We are soon to see if the minute has discoverable limits. The naturalist is to have a new kingdom to explore, as much beyond the microscope as the microscope is beyond the naked eye.[70]

Morse, who, like most proto-photographers, was caught between abiding interests in art and science, here reached for examples from both areas to articulate his view of the daguerreotype image. Thus he compared it to the pictorial qualities of Rembrandt and the acquatint on one hand and to the views of nature provided by a microscope and telescope on the other. At the same time he claimed that, having aspects of both, photography offers more than either. Although unable to reproduce color, the unprecedented detail captured in the image obviously impresses him most.

François Arago spoke in similar terms of "plates on which the image is reproduced down to the most minute details with unbelievable exactitude and finesse" but which still look like "an acquatint engraving" in terms of their tonal variations of black, white, and gray.[71] So it is with all initial descriptions of the daguerreotype. The process is praised for providing a precise facsimile of nature, but the inherent inexactitude of that facsimile—its similarity of appearance to tonal prints, its lack of color, its inability to cope with movement—is also noted. Even when journalists cried with rhetorical flourish that daguerreotypes were "nature itself," they clearly recognized these images as no more than *pictures* of nature, even if remarkably truthful ones. The *Gazette de France* summed up the popular reaction when it proclaimed that "the effects of this new process have some resemblance to line engraving and mezzotinto, but are much nearer the latter: as for truth, they surpass everything."[72]

Such comments were of course proffered in the same decade that saw the publication of Auguste Comte's first important works on positivism, in particular his *Cours de philosophie positive* (1830–42). Although not without internal inconsistencies, positivism promoted what Comte called a "mechanical conception of general phenomena" in everything from science to social life.[73] Positivism in its simplest form argued that "all we can know of reality is what we can observe or can legitimately deduce from what we observe."[74] In one form or another, positivism came to dominate scientific thinking in the mid- and later nineteenth century and continues to inflect attitudes to photography to the present day.[75]

The obvious question must be addressed: Did a positivist desire inhabit the frustrations and aspirations of the proto-photographers in the decades before 1839 and thus lead them inexorably to photography? Can we find in the thinking of someone like Daguerre the confident certainty of positivist purpose expressed by Hippolyte Taine in the 1860s? "I wish to reproduce things as they are or as they would be even if I myself did not exist."[76]

If they did, they never said as much. Indeed, as we have already seen, the proto-photographers produced some strangely equivocal descriptions of their invention's relationship to nature and "the real." Why this equivocation, given that most of them were experienced scientists, familiar with empirical method and no doubt conversant with general positivist principles? If they were driven by a positivist desire for untrammeled objectivity, as certain historians claim, why didn't these proto-photographers take the opportunity to say as much? Could it be that an unproblematized positivism is something we desire more than they did, something that only retrospectively appears important in the emergence of a desire to photograph? No doubt photography did eventually become a popular metaphor for the possibility of a positivist view of the world. However, at least at the time of photography's conception, this view remained somewhat confused and contradictory. This would seem to be borne out by the argument of one recent historian of photographic technology.

Significantly, some of the pioneers of photography were simultaneously in both the Romantic and positivist camp. How is this possible? They were epistemological positivists and ontological Romantics. The positivist scientists were empiricists in the methods of acquiring knowledge, but often they were unable to shed their Romantic views of nature: 1) seeing the world composed of forces that were interrelated and ultimately unified; and 2) seeing the world not as a static entity that was only once created but as an evolving, changing, and continuously created entity. Therefore, photography was born in a context of the Romantic's virtual worship of nature. At the same time, the photographic records became the epitome of the positivists's detailed, objective record.[77]

Some historians speak of photography's invention not only in terms of scientific positivism but also as the product of an artistic realism; together these are supposed to be the twin forces behind photography's conception. One historian who places par-

ticular emphasis on the second of these factors is Janet Buerger. She argues that the daguerreotype is, in an "ontological" sense, a direct product of Daguerre's desire for a totally convincing illusion of nature, a realism most clearly prefigured in his work on the Diorama.

Much of the most sophisticated writing on photography has stressed the idea of an ontological specificity in the medium. . . . The more fundamental aspect of photography—the classic side of photography's "ontology"—was its illusion of nature, and the true antecedent of the photographic image in this regard, Daguerre's Diorama. . . . It is clear from reviews that they (the Dioramas) represented not Romanticism but Realism, not painterly academicism or bravura unto itself, but a goal of complete illusion. . . . The daguerreotype, with its distillation of volumetric (apparently cubic) illusion—completely unlike that of early paper photography, which was tied reluctantly to its interfering surface—was the sequel to the Diorama. . . . It was Daguerre's attempt to perfect his duplication of the illusion of nature that brought him to seek a way to fix the image of the camera obscura. . . . The result of Daguerre's research into fixing the image of the camera permanently was the daguerreotype.[78]

On first reading, her argument seems persuasive. Daguerre chose to insert the first public announcement of his photographic experiments amid a review of his Diorama painting *The Valley of Goldau* in the *Journal des Artistes* in 1835. In this announcement Daguerre described his process as capable of "the most perfect of drawings," a capability that led him to claim that "physical science has, perhaps, never offered such a marvel."[79] How does this description, divided yet again between science and art, compare to the Diorama? In the 1822 promotional brochure for this popular attraction, *Notice explicative des tableaux exposés au Diorama,* Daguerre and his coinventor Charles Marie Bouton described their aspirations in terms that lean toward the artistic or at least the phenomenological: "Means should be found of imitating aspects of nature as presented to our sight, that is to say, with all the changes brought by time, wind, light, atmosphere."[80]

In the Diorama the viewer sat on a platform that slowly moved from one side to another, so that different views of the same painted scene could appear gradually to reveal themselves. These views, painted on translucent cloth, were further enhanced

by special lighting. It was somewhat like viewing a sequence of paintings of the same piece of landscape at different times of the day and under different atmospheric conditions. The invention of the Diorama (which opened in Paris on July 11, 1822) followed on spectacular and popular predecessors like Philip Jacob de Loutherbourg's Eidophusikon (opened in 1781) and Robert Parker's Panorama (patented as "La nature à coup d'oeil" in 1787).[81] Daguerre and Bouton had both worked on Pierre Prévost's version of the Panorama in Paris, Bouton between 1800 and 1812 and Daguerre from 1807 until 1816. By 1822 Daguerre was famous for his innovative and illusionistic lighting as a stage designer in the theater and opera. He was also a professional painter, primarily of romantic, moody landscapes inhabited by ruined churches. The Diorama allowed him to develop these various skills to a new height, with visitors wondering at the changing naturalistic scenes laid before them.

The most striking effect is the change of light. From a calm, soft, delicious, serene day in summer, the horizon gradually changes, becoming more and more overcast, until a darkness, not the effect of night, but evidently of approaching storm—a murky, tempestuous blackness—discolors every object, making us listen almost for the thunder which is to growl in the distance, or fancy we feel the large drops, the avant-couriers of the shower. This change of light upon the lake (which occupies a considerable portion of the picture) is very beautifully contrived. The warm reflection of the sunny sky recedes by degrees, and the advancing dark shadow runs across the water—chasing, as it were, the former bright effect before it. At the same time, the small rivulets show with a glassy black effect among the underwood; new pools appear which, in the sunshine, were not visible; and the snow mountains in the distance are seen more distinctly in the gloom. The whole thing is nature itself.[82]

It is also worth repeating the impressions of another proto-photographer, Nicéphore Niépce, who visited Daguerre in Paris in September 1827 and was taken by his host to see the Diorama. On September 2 and 3 he wrote to his son Isidore as follows:

I have had many and very long interviews with M. Daguerre. He came to see us yesterday. His visit lasted for three hours . . . and the conversation on the subject which interests us is really endless. . . . I have seen nothing here that has struck me more or given me more pleasure than the Diorama. We were taken round by M. Daguerre, and could study at our ease the magnificent pictures exhibited

there. The interior view of St Peter's, Rome, by M. Bouton, is certainly an admirable work and produces the most complete illusion. But nothing could be better than the two views painted by M. Daguerre: one of Edinburgh taken by moonlight during a fire, the other of a Swiss village showing a wide road, facing a prodigiously high mountain covered with eternal snow. These representations are so true, down to the smallest details, that one really believes one sees rural and wild nature, with all the fascination that the charm of colour and the magic of chiaroscuro can produce. The illusion is so great, even, that one is tempted to leave one's box to go over the plain and climb to the top of the mountain. There is not, I assure you, the least exaggeration on my part, the objects being, or at least appearing, the natural size.[83]

Interestingly, in his *Notice de l'Héliographie* of November 24, 1829, Niépce returned to the "effects" of the Diorama to describe one result of his heliographic process. "In one of these experiments, the light, having acted with less intensity, uncovered the varnish in such a manner that the gradations of tones showed more clearly so that the impression seen by transmission reproduced, up to a certain point, the well known effects of the Diorama."[84]

Almost all commentators on the Diorama marveled at the illusion of reality that it achieved, with visitors often unable to distinguish between the paintings and the room in which they were sitting. This encouraged Daguerre to strive at one point for an even greater verisimilitude. "He executed a View of Mont Blanc complete with a real chalet, barn, outhouses, and live goat eating hay which he had imported specially from Switzerland. But it was not a success; the actual objects killed rather than nourished the illusion."[85]

Janet Buerger would identify this grand illusionism with "not Romanticism but Realism," thus conjuring two of the most slippery and abused terms in the art-historical lexicon. In her book *Realism,* for example, Linda Nochlin criticizes a view that is strikingly reminiscent of precisely that propagated by Buerger: "The commonplace notion that Realism is a 'styleless' or transparent style, a mere simulacrum or mirror image of visual reality, is another barrier to its understanding as an historical and stylistic phenomenon. This is a gross simplification, for Realism was no more a mere mirror of reality than any other style and its relation qua style to phenomenal data—the *donnée*—is as complex and difficult as that of Romanticism, the Baroque or Mannerism."[86]

To compare daguerreotypes to the Realist paintings of Courbet, a form of nineteenth-century abuse repeated as fact by Buerger, is to misunderstand the aspirations of both Courbet (who strove for a form of materialist social reality often couched in allegorical terms) and Daguerre.[87] Look, for example, at how Daguerre himself described the processes of the Diorama in his *Account* of 1839 (writing after his invention of the daguerreotype).

These processes have been principally developed in the pictures representing the Midnight Mass, the Conflagration in the Valley of Goldau, the Temple of Solomon, and the Cathedral of St. Mary at Montreal. All these pictures have been represented with effects of day and night. To these effects, decomposition of forms are added, by means of which, in the Midnight Mass, for instance, figures appear where chairs were seen just before, or, in the Valley of Goldau, huge rocks rolling over the precipice replace the beautiful and picturesque aspect of the valley.

Having proffered this description, Daguerre went on to discuss the painting and lighting techniques that provided these desired effects. He concluded:

We may even venture to assert it to be physically demonstrated that a picture cannot be the same at all hours of the day. This perhaps, is one of the causes which contribute to render good painting so difficult to execute and so difficult to appreciate. Painters led into error by the changes which take place between morning and evening in the appearance of their pictures, falsely attribute these alterations to a variation in their manner of seeing, and colour falsely, while in reality the change is in medium—in the light.[88]

Note the points of significance for Daguerre—landscape (the subject of almost all of the Diorama paintings), a dramatic shift in scene from the beautiful and the picturesque to the awesome and the sublime, the representation of temporal change, the treachery of mere appearance, and the constitutive effects of light. These interests undoubtedly inflected his concurrent obsession with photography (interests directly reproduced in his Boulevard du Temple and Place de la Concorde series), but they have little to do with the Realism of Courbet or the transparent access to the real desired by the positivists. Indeed, if one wanted to relate the desires manifested in the Diorama to a moment in art history one would do better to look at the work of Constable and

Turner in the 1820s and 1830s. Here the contingency of appearance, and therefore the instability of our visual access to reality, is explored. Daguerre's Diorama was primarily a commercial venture, with entertainment as its aim, and as such it called on the proven, popular conventions of his time—specifically the pictorial clichés of the picturesque and the sublime. It gave pleasure by allowing spectators to recognize an imagined and largely imaginary landscape; when it truly tried to imitate reality it quickly lost the interest of its customers.

Constable was one contemporary of Daguerre who recognized this difference in aim. He wrote to a friend after a viewing of the London Diorama in 1823: "It is in part a transparency. The spectator is in a dark chamber, and it is very pleasing and has great illusion. It is without the pale of the art, because its object is deception. The art pleases by reminding not by deceiving. The place was filled with foreigners, and I seemed to be in a cage of magpies."[89]

The concern for effects continued in Daguerre's descriptions of the daguerreotype. Thus in his 1838 promotional broadsheet, Daguerre emphasized the "rapidity, sharpness of the image, delicate gradation of the tones, and above all, the perfection of the details" obtainable through the daguerreotype but described his original goal as the ability to correctly "render the effects of nature." Having associated his own desire with the achievement of certain pictorial qualities ("effects" being part of picturesque parlance) he was nevertheless anxious to stress that the daguerreotype was "capable of innumerable applications," both in the arts and the sciences. Detail he claimed for photography, but reality he left to others.[90] In this sense, Buerger's interest in establishing a photographic ontology leads her to underestimate not only the subtleties of Daguerre's own language but also the aspirations of the other, mainly paper-based, proto-photographers. Realism of the kind she seeks within the desire to photograph is a feature neither of the Diorama nor of any of these other discourses.

Electromagnets

As with Daguerre, there is considerable uncertainty concerning the timing and identity of Henry Talbot's first photograph. In his "Brief Historical Sketch of the Invention of the Art," published in 1844 as an introduction to *The Pencil of Nature,* Talbot dated his

own conception of photography to October 1833. It was then, while taking sketches of Lake Como with a camera lucida, that a novel idea occurred to him: "How charming it would be if it were possible to cause these natural images to imprint themselves durably, and remain fixed upon the paper!"[91] So, his first *imagined* photographs were landscapes, similar to the picturesque examples that he was then producing with pencil and paper.

He followed this initial inspiration with a number of practical experiments, beginning in the spring of 1834 with contact prints of "leaves, lace, and other flat objects of complicated forms and outlines." At virtually the same time he attempted his first pictures with a camera obscura, using a building as his chosen subject. In his 1839 paper *Some Account of the Art of Photogenic Drawing* Talbot gave an even more extensive list of possible applications. He mentioned, for example, his own attempts to make photographs of "flowers and leaves" ("the first kind of objects which I attempted to copy"), "outline portraits or *silhouettes*," "paintings on glass," "the beautiful picture which the solar microscope produces," "architecture, landscape, and external nature," "statues and bas-reliefs," and "drawings or engravings."[92]

To the pictures outlined in these 1839 and 1844 accounts we can add his own earlier correspondence. The first mention of Talbot's photographs came in a letter to him from his sister-in-law Laura Mundy, dated December 12, 1834. She thanked him for "sending me such beautiful shadows, the little drawing I think quite lovely, that & the verses particularly excite my admiration."[93] It seems that Talbot was already making contact prints of pieces of text, as well as of botanical specimens. Between 1833 and 1836 there were intermittent references in his notebooks to chemical experiments with a "secret writing" process.[94] In a note dated only "April 3," Talbot had the words themselves enact their identity as a temporal play of absence and presence: "Concealed at first at last I appear."[95] A number of historians have noted that the oldest of Talbot's surviving photographs is an image of his own handwriting. Dated June 20, 1835, it self-consciously repeats the basic units of writing itself—the twenty-six letters of the English alphabet.[96] Talbot himself later recalled experimenting in the autumn of 1834 with a means of making photogenic contact prints of "etchings on copperplate," including "among other views . . . one of the city of Geneva . . . which we saw from our window" and "copies of any writing."[97] However, the earliest extant example of this

4.11 William Henry Fox Talbot, *Lacock Abbey roofline*, 1835. Photogenic drawing. Collection of the J. Paul Getty Museum, Malibu, California

William Henry Fox Talbot, *Botanical specimen,* c. 1835. Photogenic drawing negative. Science and Society Picture Library, Science Museum, London

| 4.13 | William Henry Fox Talbot, *June 20th 183(?)5 written with a pencil of Tin, Lacock Abbey Wilts. abcdefghijklmnopqrstuvwxyz* 1835 (?) photogenic drawing. The Smithsonian Institution. Reproduction courtesy of Anthony Burnett-Brown

Latticed Window
(with the Camera Obscura)
August 1835

When first made, the squares
of glass about 200 in number
could be counted, with help
of a lens.

4.14 | William Henry Fox Talbot, *Latticed window (with the camera obscura)*, August 1835. Photogenic drawing negative. Science and Society Picture Library, Science Museum, London

writing is, like Niépce's famous heliograph, almost illegible. This is presumably why the earliest photographs reproduced in Larry Schaaf's otherwise thorough 1992 book on Talbot, *Out of the Shadows,* are four images that the author dates at 1835 or circa 1835: two photogenic drawing negatives, one a copy of a print of a child and dog and the other an image of the stained-glass window in the great hall of Lacock Abbey; another negative contact print of a botanical specimen; and the famous "earliest surviving" negative from August 1835 of the latticed window of Lacock Abbey, taken with a camera obscura.[98]

Once again this cavalcade of images suggests that Talbot had no one subject in mind as the principal pictorial aspiration of photography. On the contrary he was, like Daguerre, anxious to promote the infinite variety of possible uses to which photography could be put. This was, for example, the primary idea behind his publication of *The Pencil of Nature* between 1844 and 1846. Nevertheless, it would be a mistake to imagine that Talbot's production of images was ever simply arbitrary or accidental. On the contrary, it is becoming increasingly clear that he was an intelligent and sophisticated image maker, well versed in literary and artistic matters and anxious to demonstrate this knowledge through his pictures. As British critic and historian Ian Jeffrey suggests, "His pictures are not simple representations of nature arbitrarily alighted on, but compositions and assemblages chosen and constructed according to a markedly regular pattern. . . . The point about Talbot's work, of course, is that it declares itself as artefact. The unmistakable subject in most of his calotypes is nothing more than the photograph itself as a means of representing. They might be called exemplary photographs in that they declare their own premises."[99]

With this in mind, we might turn to two images by Talbot reproduced in Schaaf's book but never discussed by him, or indeed by any other photo-historian. One of these is dated earlier than any of the images hitherto listed as Talbot's oldest extant photograph. The image appears in a notebook entry from February 28, 1835, on the very page on which Talbot first recorded his concept of a negative-positive "Photogenic or Sciagraphic process." At the top of this page a diagram represents two facing magnets and the force field created between them. Under the diagram Talbot wrote (with his note on photography following immediately below): "Piston is attached to the piece A. Elastic substances are not necessary to enable the piston to recover its former posi-

method of testing the force of attraction in different parts of a magnet bar, by attaching a flat small disk prior to an elastic wire, and drawing how far it requires to be stretched before the disk separates. Afterwards determine by exp: how many grains will stretch the wire to the same length.

magnet [diagram] magnet

Piston is attached to the piece A. Elastic substances are not necessary to enable the piston to recover its former position, as the magnets are to act alternately.

In the Photogenic or Sciagraphic process, if the paper is transparent, the first drawing may serve as an object, to produce a second drawing, in which the lights and shadows would be reversed. If an object, as a flower, be strongly illuminated, & its image formed by a camera obscura, perhaps a drawing might be effected of it, in which case not its outline merely would be obtained, but other details of it. For this purpose concentrated solar rays might be thrown on it: but best employ only violet light because we want chemical rays and not heating rays, lest the flower should be scorched by their intensity. My large concave mirror might be covered with plate glass washed over with blue gum or resin. Perhaps ammonia & copper might be made to unite with water and gum, so as to remain transparent when dry: if not, it might be used in a viscid state prepared between 2 plates of glass — At any rate the rays might be intercepted by a small blue glass nearing the focus.

4.15 William Henry Fox Talbot, *Notebook M, folio 90, entry number 141*, 28 February (?) 1835. Pen on paper. Lacock Abbey Collection, National Trust, Fox Talbot Museum

4.16 William Henry Fox Talbot, *Notebook P*, entry for 23 September 1839. Pen on paper. Science and Society Picture Library, Science Museum, London

tion, and the magnets are to act alternately. In the Photogenic or Sciagraphic process, if the paper is transparent, the first drawing may serve as an object, to produce a second drawing, in which the lights and shadows would be reversed."[100]

A coincidence perhaps? What then are we to make of another of these notebook entries, this time dated September 23, 1839 and titled "New Art Nature's Pencil No. 1," followed by a discussion of ways to improve the daguerreotype process. This page not only includes Talbot's first musings about a possible title for his 1844 book *The Pencil of Nature* but also the Latin inscription that he did eventually use on its title page. Immediately underneath these words, without explanation, Talbot drew two diagrams of what he identified in a note as a spring-mounted "compound horseshoe electromagnet."[101]

In short, on the two occasions where Talbot specifically meditated in his own notebooks on a way to describe the conceptual identity of photography, he sketched, whether deliberately or absentmindedly, the functioning of a magnet. Could we therefore take these drawings to be about or even *of* photogenic drawing itself? Appearing where otherwise a photograph might have been appended (as they were in John Herschel's 1839 notebooks), Talbot's unconscious subject could be, as Jeffrey puts it, "nothing more than the photograph itself as a means of representing."

Interestingly, Reece Jenkins has argued that the metaphor of the electromagnet played a crucial role in both the development of a romantic worldview and the conception of photography.

For example, the discovery of current electricity in the 1790s prompted considerable experimental activity. The polar conception of positive and negative electricity as well as polarity in the magnet reinforced the Romantic conception of nature as composed of opposite forces. The magnet was a particularly powerful metaphor in the Romantic view because it consists of opposite poles that are unified or inseparable. . . . Such Romantic views permeated Germany in the 1790s, spread to England and France, and continued well into the 19th century, influencing literature, the arts, philosophy, and science. . . . It is then not surprising that early photography adopted both the conception and the terminology "positive" and "negative" for photographs.[102]

Coleridge was one associated with photography's conception who embraced this kind of thinking. Drawing on his interest in German idealist philosophy, he made nu-

merous references to both real and metaphoric magnets, concluding that "every power in nature and in spirit must evolve an opposite as the sole means and condition of its manifestation: and all opposition is a tendency to re-union."[103] This romantic interest in electricity and magnetism was stimulated not only by philosophy and discoveries in science but also by the popularity of mesmerism. In a dissertation written in 1766, Franz Mesmer had propounded the widely accepted theory that a "subtle fluid ... pervades the universe, and associates all things together in mutual intercourse and harmony."[104] This fluid was regarded as related to magnetism, and Mesmer therefore made use of magnets in his medical practice, leading to what were claimed to be miraculous cures. He developed a theory of "animal magnetism" that was to have considerable currency throughout Europe in the early nineteenth century (including the publication in France of Pététin's *Electricité Animale* in 1808 and Deleuze's *Histoire Critique du Magnétisme Animal* in 1812). One of the stranger effects of this magnetism was that when concentrated it supposedly enabled patients to see through opaque surfaces, so-called eyeless vision. Coleridge, Shelley, and Hegel were among those familiar with the theory and its purported effects.[105]

Indeed the early conceptions of nature held by both Coleridge and his friend Humphry Davy neatly correspond with Mesmer's idea of a "universal magnetic fluid." In 1796, for example, Davy argued that "far from being conscious of the existence of matter, we are only conscious of the active powers of some being. By discovering the ratio between the attraction and repulsion of external things and our organs, we should discover philosophy."[106] In *Affinity and Matter* Trevor Levere argues that such statements were also influenced by Davy's contact in the years around 1800 with the work of Kant and Friedrich von Schelling. Compare Davy's statements, for example, to Schelling's view, published in 1799, "that magnetic, electrical, chemical, and finally even organic phenomena would be interwoven into one great association . . . [which] extends over the whole of nature . . . without doubt only a single force in its various guises is manifest in light, electricity, and so forth."[107]

Davy soon became famous for inducing electrolytic decomposition using a voltaic pile and in November 1820 had a paper read before the Royal Society titled "On the magnetic phenomena produced by electricity." Shortly after Volta's announcement in 1800 of his invention of the electric pile, William Nicholson and Anthony Carlisle

(who later claimed to have assisted Wedgwood with his photographic experiments in this same year) used it to decompose water and on May 2 discovered that hydrogen and oxygen evolved separately at the two electrodes. Even though some experimenters, Davy for example, later expressed reservations about the supposition that "all the phenomena of nature are supposed to depend on the dynamic system, or the equilibrium and opposition of antagonist powers," this idea nevertheless continued to influence English thinking.[108]

In any case, the idea had an influential English precedent. Newton's *Opticks* (1704) also contained some discussion of the conjunction of "active forces" in nature, including the thought that all phenomena might be caused by a combination of attractive and repulsive forces. This caused considerable debate among his successors, especially as regards the "ether" that was considered to be the vehicle for these forces.[109] Newton even offered a rather vague idea of light particles as small magnets with privileged poles or points to explain the principles of reflection and refraction. Talbot's close friend and fellow photographic experimenter, John Herschel, described this idea (in *A Preliminary Discourse on the Study of Natural Philosophy* of 1830) as follows: "The simplest way in which the reader may conceive this hypothesis, is to regard every particle of light as a sort of little magnet revolving rapidly about its own centre while it advances in its course, and thus alternately presenting its attractive and repulsive pole, so that when it arrives at the surface of a body with its repulsive pole foremost, it is repelled and reflected; and when the contrary attracted, so as to enter the surface."[110]

In the context of this debate, and this "hypothesis," Henry Brougham undertook research in 1794–95 on the refraction and reflection of light (a phenomenon analogous to attraction and repulsion), which led to his photographic speculations. Other proto-photographers also took an interest in the strange forces evidenced in electricity and magnets. Between 1790 and 1793 Tom Wedgwood had shared a house in Etruria with John Leslie, during which time Leslie conducted a number of experiments with static electricity. In 1794 Leslie published a review of G. C. Morgan's *Lectures on Electricity* in the *Monthly Review* in which he discussed "the phenomena of gravitation and magnetism" in relation to accepted theories of "electric fluid."[111] Samuel Morse also had a long and active interest in electromagnetism, beginning in 1809 while he was a student at Yale and especially evident in 1821–22 when he was experimenting with magnetism

and the galvanic pile as well as with photography. This resulted in his conception and invention of the electromagnetic telegraph in the 1830s. John Herschel in 1840 borrowed the terms *positive* and *negative* from the science of electromagnetism to describe paper-based photography's binary character.

However, the most persistent and significant manifestations of this interest in electricity and magnetism lie in the work of Henry Talbot. In 1825 Talbot spent several weeks working at the Paris Observatory with its director François Arago and while there "conducted magnetic experiments" and "discussed the rival corpuscular-undulatory theories of light and the polarization of light."[112] Arago in 1820 had discovered that a wire carrying a current of electricity "develops the magnetic virtue" and for that reason attracts iron filings.[113] Talbot went on to experiment with electric batteries from at least 1826 on and in 1852 applied for a patent for a linear electric motor composed of a large number of electromagnets arranged in a line with their pole faces uppermost—in short, a traveling magnetic field.[114] So the bipolar identity of electromagnetic power was familiar to him; perhaps, as with so many other scholars of his generation, it even exemplified an imagined arrangement of forces central to his thinking about nature and her processes—including the process of photography.

This speculation would make an apt caption for one particular portrait of Michael Faraday, an albumen print taken by British photographers Maull and Polyblank in about 1856 (fig. 4.17). Faraday, between 1813 and 1821 an assistant of Davy and someone with whom Talbot had conducted joint experiments as early as 1827, announced the invention of "photogenic drawing" to the three hundred assembled members of the Royal Institution (including Talbot's fellow proto-photographers Brougham, Carlisle, and Heath) on January 25, 1839. Faraday was also present at the reading of Talbot's paper "Some Account of Photogenic Drawing" at the Royal Society's meeting on January 31. He was of course a noted experimenter in his own right, having long been preoccupied with the various implications of electricity. From 1822 he had studied the problem of converting magnetism into electricity, announcing his discovery of electromagnetic induction on November 24, 1831 to international acclaim. So it is altogether appropriate that this portrait from the mid-1850s should honor Faraday's achievements in this field by having him hold aloft a single bar magnet, grasped in the center so that its two poles are clearly visible. But, in the context of our

4.17 Maull & Polyblank, *Portrait of Michael Faraday*, c. 1856. Albumen print. Gernsheim Collection, Harry Ransom Humanities Research Center, The University of Texas at Austin

present discussion of first photographs, it might be equally appropriate to wonder if his gesture can also now be read as an unintended commentary on the conceptual economy of the desire to photograph itself.

LE NOYÉ

The Frenchman Hippolyte Bayard was one of the most sophisticated and adventurous of photography's early practitioners, producing an incredible variety of photographic images during the 1840s and after. Most interesting is his obsession with making self-portraits: he produced at least twenty in diverse poses and settings. However, Bayard practiced almost every genre of photograph that we know today, from journalism to still life, from portraiture to science, from architecture to landscape, in these first few years of the medium's existence.[115]

Despite this burst of creativity, and his role as a founding member and long-serving secretary of the Société Française de Photographie, Bayard felt that he was never given his full due as an independent inventor of photography. On February 5, 1839, only a month after Arago's first announcement regarding Daguerre's process, Bayard was able to show the physicist César Desprets some paper negatives that he had made himself. Bayard's own notebook indicates that he had undertaken his first attempts on January 20, well before the details of either Daguerre's or Talbot's methods had been revealed. By March 20 he was able to present examples of his own unique process of making camera-induced direct positives (*l'effet positif*) to the lithographer Pierre-Louis-Henri Grévedon. By July 14 (Bastille Day), he was sufficiently expert to put thirty of these on exhibit in aid of earthquake victims in Martinique. One critic described them as displaying "an exquisite fineness, a harmony of softness of light that painting will never attain."[116] Twelve years later, in 1851, Francis Wey recalled these images, the first by Bayard to be publicly exhibited, in equally glowing terms: "One contemplates these direct positives as if through a fine curtain of mist. Very finished and accomplished, they unite the impression of reality with the fantasy of dreams: light grazes and shadow caresses them. The daylight itself seems fantastic and the peculiar sobriety of the effect renders them monumental. . . . Air plays on these images with so much transparency and envelops the foregrounds so completely that the images appear at once distant and complete."[117]

In June 1839, Bayard was awarded six hundred francs by the Minister of the Interior to buy some improved camera equipment. Nevertheless, compared to the honor and rewards that had been accorded Daguerre, Bayard attracted relatively little recognition from the authorities. Having a number of artist friends, he appealed to the Académie des Beaux-Arts, which in turn commissioned a report on his process and its history. Compiled by a committee of eleven, the report, submitted on November 2, 1839, praised the potential of his pictures but failed to establish Bayard's precedence over Daguerre as far as the invention of photography was concerned.

Six days after this report arrived, Bayard sent a letter and two photographs (made with a camera obscura on October 24 after an exposure of eighteen minutes) to the Académie des Sciences, once again attempting to draw attention to his discoveries. However, having officially allied themselves with the daguerreotype, none of these institutions was interested in actively supporting the claims of others. Throughout 1840 Bayard continued to agitate for recognition, despite being faced not only with the continued acclamation for Daguerre but also with the counterclaims of other inventors. In November of that year the Académie des Beaux-Arts appealed to the government on his behalf, but to no avail. It is in this general context that Bayard set out to produce an image that specifically addressed the situation in which he found himself. The three photographs that resulted from this effort offer a meta-commentary on the desire to photograph as intriguing and sophisticated as any of the words or pictures we have already encountered. Indeed, in many ways his images aptly summarize all that has been said up to this point.

In October 1840 Bayard produced three variations on the same strange composition, each now known as *Le Noyé* (*Self-portrait as a drowned man*) (figs. 4.18–4.20). The systematic repetition of the image, with only small variations between each version, suggests the quite deliberate and thoughtful way in which it was designed. In each picture we see the same naked male body sitting awkwardly on a bench, with back propped up against a wall so that the head and chest turn almost entirely toward us. The eyes are closed; the arms crossed; and the lower torso wrapped in drapery. In keeping with Bayard's association with the Académie des Beaux-Arts, his image overtly refers to classical tradition, specifically to the relief figures seen in sculptural friezes and antique gemstones. This artistic tone is enhanced by the addition of various props; a large straw hat, a ceramic vase, and a small plaster statuette of a crouching nymph.

4 . 18 Hippolyte Bayard, *Le Noyé (Self-portrait as a drowned man)*, 18 October 1840. Direct positive print. Société Française de Photographie, Paris (#24.6)

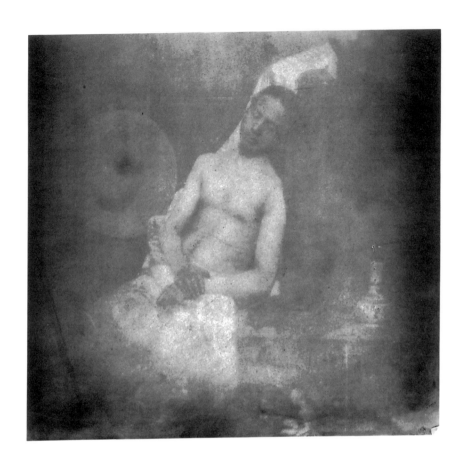

4.19 Hippolyte Bayard, *Le Noyé (Self-portrait as a drowned man)*, 18 October 1840. Direct positive print. Société Française de Photographie, Paris (#24.282)

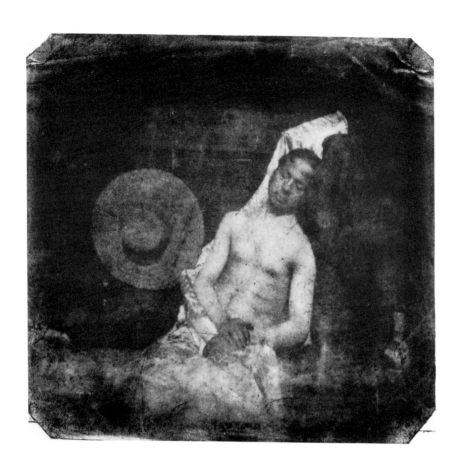

| 4.20 | Hippolyte Bayard, *Le Noyé (Self-portrait as a drowned man)*, 18 October 1840. Direct positive print. Société Française de Photographie, Paris (#24.269)

Bayard reportedly owned about forty of these statuettes and made numerous photographs of them in various carefully orchestrated arrangements. He often photographed himself surrounded by them, with the sculptural figurines set up in elaborate compositions on the roof of the Ministry of Finance where he worked. However, they also appear in pictures he made of the interior of his own home. Posing as "a thing among things," in one self-portrait (fig. 4.21) Bayard self-consciously put himself in a place occupied in another photograph by a statuette of Antinous, the beautiful young boy of Roman legend who, it is said, drowned himself in order to prolong the life of his lover, the emperor Hadrian.[118] This sense of pose and performance was no doubt informed by Bayard's intense interest in theater and the Comédie-Française (fig. 4.22). More than that, according to Julia Ballerini, "Bayard's impostures speak to the very condition of the plaster cast and miniaturized reproduction, that of im-posture: the making of a replica, a secondhand construction, a substitute, not the 'real thing.'"[119]

Bayard's other favored mise-en-scène for photography was his garden, and the hat that appears in *Le Noyé* appears in a number of the self-portraits that he made there. Indeed, in one image of this garden from around 1842 the hat simply hangs on a wooden lattice, facing us crown first like a metonym for the photographer himself. This same photograph, known simply as *Jardin* (Garden), also features the ceramic vase seen in *Le Noyé*. The vase's white body is decorated with a floral pattern and features an unusual tripartite spoutlike protrusion. This same vase, obviously significant for Bayard, makes further appearances in *Atelier de Bayard* [Bayard's Studio] (1845–47) and, filled with flowers, in *Portrait au bouquet* (Portrait with bouquet of flowers), *Bouquet aux dahlias* (Bouquet of dahlias), *Nature mort aux dahlias, grappe des raisins et poire* (Still Life with dahlias, grapes, and pear), and *Trois vases aux bouquets* (Three vases with flowers) (all 1840s).[120] In *Le Noyé* the vase sits on the same level as the naked man, neatly filling a void on the right-hand side of the picture. The straw hat fills another void. Its placement to the body's right emphasizes the solidity of the wall and therefore the shallowness of the pictorial space. It also acts as an impromptu sundial, recording in projected shadow the slight movement of the sun between the three exposures.[121]

At first glance Bayard's image can be read as a lighthearted joke on prevailing romantic taste in general, especially its propensity for images of death, including suicides, shipwrecks, and drownings. It has also often been mentioned that the pose that

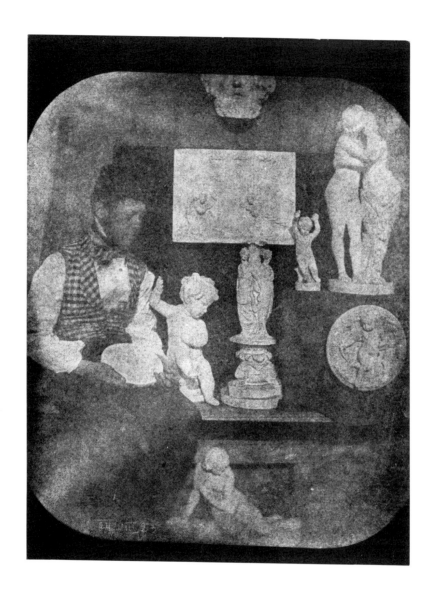

Hippolyte Bayard, *Bayard surrounded by statues*, 1845–48. Positive print. Société Française de Photographie, Paris

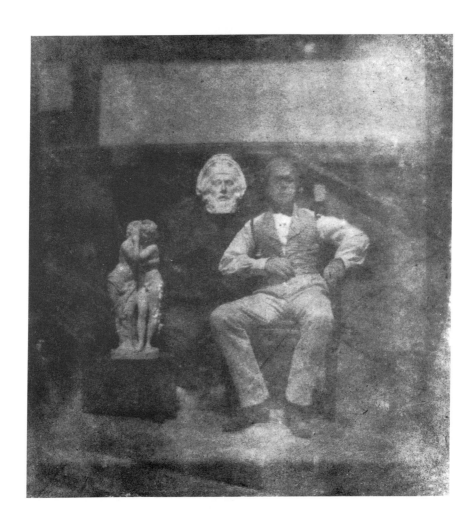

Hippolyte Bayard, *Self-portrait of Bayard, with a statue and a "mask,"* c. 1839–40. Direct positive print. Société Française de Photographie, Paris

4.23 Hippolyte Bayard, *Garden*, c. 1847–50. Direct positive print. Société Française de Photographie, Paris

Bayard adopts in this image cleverly parodies Jacques-Louis David's famous 1793 painting *Death of Marat* (fig. 4.24).[122] David's image, not shown in public in Paris since February 1795 (although well known through engravings), was a carefully calculated memorial to a radical activist seen by fellow Jacobins as having died for a noble and revolutionary cause. The painting combines a classical tableau with a contemporary event, and the ideal with trompe l'oeil realism, transforming the dead Marat into an iconic figure who is part antique and part Christian, but all martyr.[123] No commentators on the Bayard image have thought to mention that, at the time it was made, Marat was still an important figure as the translator of the current French edition of Newton's *Opticks*. A photographic repetition of Marat's death in 1840 might well be taken as a metaphor for the demise of the corpuscular theory of light associated with Newtonian science (which by then had been replaced by the "wave theory" of Fresnel and Young).

Without discounting the reference to *Death of Marat,* the design of Bayard's image even more strongly recalls David's lost memorial to another revolutionary martyr to liberty, Lepeletier de Saint-Fargeau. Now largely forgotten, Michel Lepeletier was a liberal aristocrat assassinated in 1793 as a consequence of his enthusiastic support for the French Revolution and his vote for the execution of the king. The design of David's painting, which was paraded with and then hung as a pendant to *Death of Marat* in the assembly hall of the Convention between November 1793 and February 1795, has only survived in the engravings of others. These engravings show a body, lying half-draped in a very similar pose to that adopted by Bayard, with a sword hanging overhead by a hair. The sword pierces a piece of paper with writing on it (saying, according to Delécluze, "I vote for the Tyrant's death") while its tip drips blood onto the body below.[124]

Another anonymous engraving shows Lepeletier's funeral, also designed by David, in which the martyr's body was crowned with a wreath and laid in state on a pedestal in the Place de Vendôme that had once borne a statue of Louis XIV.[125] David also called for the state to commission a sculpture of Lepeletier in this same reclining pose. The Bayard image, as a direct positive print, is an inverted mirror image of his original pose; what appears to be his right hand is in fact his left, and so on. Thus any resemblance to David's painting of Lepeletier would have to have been carefully calculated prior to the making of the photograph itself. David's two martyrs were also

represented as mirror images of each other, a configuration that would have been quite apparent when they were paraded and hung together in 1793. This mirroring would of course have been replicated as Bayard lay there on his couch (just as the two martyrs had lain in state during their funeral celebrations) for twenty minutes or so in 1840, facing his own inverted image in the back of the camera.

Bayard's attempt to associate himself with these celebrated martyrs was no doubt meant ironically, a tongue-in-cheek appropriation of the great David to his cause that artist friends like the caricaturist Gavarni would have appreciated and enjoyed. At the same time, this deliberate reference to revolutionary ideals and assassinations in the midst of a tumultuous period in French politics (a coup was attempted earlier this same year, and Adolphe Thiers, the prime minister, was pressured into resigning just three days after Bayard made *Le Noyé*) could be seen as a more dangerously subversive comment on the competence of the current government and perhaps even on the legitimacy of France's reigning citizen-king Louis-Philippe.

Both of David's paintings had incorporated a piece of writing relating to the circumstances of each martyr's death. Bayard parodied this element as well, including a handwritten text (fig. 4.26) on the back of one of the *Self-portraits* (fig. 4.20). One must presume from this placement that the print, which measures 19.2 by 18.8 centimeters, was meant to be handled rather than hung on a wall (and indeed, there is no record of any of these images being exhibited at this time). Bayard's text playfully elaborates on the theme of his image and does so, in the tradition of David's paintings, by having his martyr speak to us from beyond the grave.

The corpse which you see here is that of M. Bayard, inventor of the process that you have just seen, or the marvellous results of which you are soon going to see. To my knowledge, this ingenious and indefatigable researcher has been working for about three years to perfect his invention.

The Academy, the King and all those who have seen his pictures, that he himself found imperfect, have admired them as you do at this moment. This has brought him much honour but has not yielded him a single farthing. The government, having given too much to M. Daguerre, said it could do nothing for M. Bayard and the unhappy man drowned himself. Oh! The fickleness of human affairs! Artists, scholars, journalists were occupied with him for a long time, but here he has been at the morgue for several days, and no-one has recognized or claimed him. Ladies and Gentlemen, you'd

Jacques-Louis David, *The Death of Marat*, 1793. Oil on canvas. Musée Royaux des Beaux-Arts, Brussels

| 4.25 | Anatole Devosge, *Drawing after David's Lepeletier de Saint-Fargeau on his deathbed*, c. 1793. Pencil on paper. Musée des Beaux-Arts, Dijon

Le cadavre du Monsieur que vous voyez ci-derrière est celui de
M. Bayard, inventeur du procédé dont vous venez de voir, ou dont
vous allez voir les merveilleux résultats. À ma connaissance il
y a à peu près trois ans que cet ingénieux et infatigable
chercheur s'occupait de perfectionner son invention.

L'Académie, le Roi et tous ceux qui ont vu ses dessins,
qu'il trouvait imparfaits, les ont admirés comme vous les admirez
en ce moment. Cela lui a fait beaucoup d'honneur et ne lui a pas
valu un liard. Le Gouvernement qui avait beaucoup trop donné
à M. Daguerre a dit ne pouvoir rien faire pour M. Bayard
et le malheureux s'est noyé. Oh! Instabilité des choses humaines!
Les artistes, les savants, les journaux se sont occupés de lui
pendant longtemps et aujourd'hui qu'il y a plusieurs jours qu'il
est exposé à la Morgue personne ne l'a encore reconnu, ni
réclamé. Messieurs et Dames passons à d'autres, de crainte
que votre odorat ne soit affecté, car la figure du Monsieur
et ses mains commencent à pourrir, comme vous pouvez le
remarquer.

18 Octobre 1840.

4.26 Hippolyte Bayard, Text on reverse of *Le Noyé (Self-portrait as a drowned man)*, 18 October 1840. Direct positive print. Société Française de Photographie, Paris (#24.269)

better pass along for fear of offending your sense of smell, for as you can observe, the face and hands of the gentleman are beginning to decay.

H. B. 18 October 1840

So now we have the full story, or at least the complete script. The body we see before us belongs to a character known as H. B., a man who is now dead, having in despair committed suicide by drowning. Apparently this is a photographer who has literally succumbed to photography, destined to return forever with the news that he died at his own hand for having invented the very medium that allows his return. Thus the author of this text enjoys an unenviable immortality, the zombie existence of the living dead.

But even this unhappy state of affairs cannot prevent him from leaving us with a joke. It is, as it happens, a joke about photography itself and thus about the making of the very image that we hold. The text refers viewers to the color of H. B.'s face and hands, taking their darkness of color as a signifier of his rotting flesh and warning of the smell.[126] In fact, as a keen gardener Bayard has probably been out in the sun and got a little sunburned wherever his skin was exposed. Insensitive to the difference between sunburn and decay, his direct positive process has printed red skin as black, a circumstance that Bayard cleverly turns to his advantage. The joke draws attention to photography's trickery as a mere illusion of the real, as well as to the artifice of the actual text and image we are seeing. It also points to human skin as a potentially "photographic" surface; perhaps there is even a memory of those sun-stenciled apples that a later historian would posit as the initial inspiration of Bayard's desire to photograph.[127]

So here we have an extraordinary text, perhaps one of the most extraordinary in photographic history. Moreover, in the brilliant combination of this text with this image, Bayard managed to produce a single work that is explicitly all about the practice and implications of photographic representation in general. By undermining the veracity of the photographic image on its reverse, his text seems deliberately to call into doubt the assumed distinction between the literal and the figurative. For in the play he engineered here between text and image, everything is enmeshed with its other.

The photograph itself continues this theme. For Bayard chose to portray himself (and not only in this example) with his eyes closed—that is, as blind. Thus he asked us to see him as someone who does not see; as his own photographer, he saw himself as he could never (his eyes being closed) see himself. In the 1990 catalogue essay for the Louvre, Jacques Derrida suggested that the subtitle of all drawings of the blind, as well as of all self-portraits, should be "the origin of drawing." [128] We might make the same claim for this pioneering "photogenic drawing" (as Bayard called it).

In this context, we might also read into Bayard's imaging of the origin of photography something of Derrida's commentary on representation in general, in which representation is assumed to be a complicitous entanglement of sight and blindness, absence and presence, life and death, construction and ruin. Notice again that Bayard poses as an object—a corpse/sculpture/painting/still life (*nature morte*)—in order to become a subject worthy of our (and the state's) attention and recognition. Nowhere does he attempt to present photography as an analogue of "real life"; indeed, quite the opposite (here there is nothing but representation and representations of representations). We might, for example, now return to the hat on the wall and see it not only as a metonymic repetition of Bayard himself but as a metaphoric eye that mirrors the lens of the camera. Thus in Bayard's image he is continuously photographing himself photographing himself (such that the photograph's point of origin becomes quite ungraspable). [129]

Here, speaking at photography's origins, speaking *as* photography's origin, Bayard opens a discourse on photography and death, on photography *as* death, that has continued in our own century with Walter Benjamin and Roland Barthes, among others. Eduardo Cadava, for example, describes Benjamin's analysis of the photograph in terms that could as easily have been directed at Bayard's *Le Noyé*.

Death, both the word and the event, is a photograph, a photograph that photographs itself—a photograph that comes as a suspension of reality and its referents. As Benjamin suggests . . . the photograph, like the souvenir, is the corpse of an experience. A photograph therefore speaks as death, as the trace of what passes into history. I, the photograph, the spaced out limit between life and death, I, the photograph, am death. Yet, speaking as death, the photograph can be neither death nor itself. At once dead and alive, it opens the possibility of our being in time. [130]

Bayard's image likewise speaks through its interchange of text and simulated corpse of a theatrical double death, of a movement back and forth between the ecstacy of discovery (the sort of climactic pleasure that the French aptly call *le petit mort*) and the desolation and ruin of the undiscovered. Speaking simultaneously in past, present, and future tenses, *Le Noyé* presents Bayard as both subject and object of the photograph, as acting even while acted upon, as a representation that is also real, as self and other, present and absent, dead but also alive, as nature and culture (nature and *nature morte*)—simultaneously both . . . and for that very reason never simply one or the other. *Le Noyé* is, in other words, an involution that rewrites the identity of all these crucial terms. In short, Bayard's image represents a meta-discourse on the identity of photography that repeats and vigorously underlines that same paradoxical tropos that we have witnessed time and time again in the textual and pictorial discourses of his fellow proto-photographers.

Remember that we are talking here about a work made in October 1840, a little over a year after the medium was first made available to its delighted but bewildered public. Turning repeatedly on the rhetorical figure of a fake death, *Le Noyé* engineers a space of uncertainty, a strategic hesitation, a troubling movement back and forth within the very grain of photography's logic. In this sense, Bayard's ghost haunts not only photography but also the whole of Western metaphysics.

| 5 METHOD |

NOTHING—NO PRESENT AND IN-
DIFFERENT BEING . . . PRECEDES

DIFFÉRANCE AND SPACING.

—JACQUES DERRIDA, *POSITIONS*[1]

T his book began with a brief discussion of certain recent Anglo-American accounts of photography. These accounts propose that the meanings and values of any individual photograph are entirely determined by its context, by the operations of the culture that surrounds and informs it. Being wholly compliant with those operations, photography potentially belongs to every institution and discipline but itself. Given that photography has neither a singular identity nor a unified history, these critics argue, a "photography as such" can be no more than a misleading fiction. This argument was propagated in the late 1970s and 1980s as a postmodern counterdiscourse to the formalist vision of photography that, then as now, dominates how photographs are discussed in most art museums and historical texts. Formalist criticism seeks photography's most fundamental characteristics as a medium and thereby articulates the essential "photographicness" of each and every photograph. Thus, from a formalist perspective photography does indeed have a singular, inherent identity, the very "photography as such" that postmodernism denies.

In this sense, it appears that these two views are diametrically opposed. However, as I suggested above, these methodologies share some common approaches to the crucial question of photography's identity. Both, for example, equate the origins of that identity with the unfolding of history (social history on one hand and art history on the other). More importantly, both presume that photography's identity can indeed be delimited, that photography is ultimately secured within the boundaries of *either* nature *or* culture.

I have shown that this presumption is at odds with the discourse on photography's identity produced by those responsible for its conception. Based on their own speculations and actions, the proto-photographers did not seem to have a single subject or purpose in mind as the end product of their experimental undertakings; nor were they able to confidently articulate the identity of what they did produce. Unable to decide quite what photography is or how it does what it does, each proto-photographer began by referring to more familiar figures—nature, landscape, camera images, time, viewing subject. But the status of each of these figures (they are of course entirely imbricated with one another) was itself uncertain in the early nineteenth century. None of them had a stable identity either. No wonder that photography's inventors had such difficulty placing their conception.

This difficulty was reproduced at the level of language. As we have seen, the inventors' own descriptions of photography carefully avoid any stable definition, endlessly turning back on themselves in a perverse rhetoric of circular negation. Niépce could not decide between *physaute* (nature herself) or *autophuse* (copy by nature)—that is, between nature and her representation—as an appropriate name for his process. Daguerre claimed, quite paradoxically, that the daguerreotype drew nature while allowing her to draw herself. Talbot spoke in similar terms of an "art" that somehow both is and is not a process of drawing. Not content with this designation, he went on to describe photography as an effort to capture both eternity and transience in the same representation, such that time becomes space, and space time. In other words, where postmodern and formalist commentators want to locate photography within either culture or nature, the discourse of the proto-photographers consistently disrupts the very binary logic that underlies all such choices.

Postmodernists and formalists want to identify photography with a single generative source (*either* culture *or* nature, *either* context *or* essence, *either* the outside *or* the inside). The discourse of the proto-photographers, by contrast, presents their invention as a *differential economy of relations* that completely confuses these categories. As a consequence, none of the elements in the pairs remains either autonomous or simply opposed to its other. Although metaphors of both culture and nature figure prominently in the thinking of the proto-photographers, neither rests as the "origin" of the photographic process. Each is instead deployed in a strangely disjunctive relationship to its other, such that photography (the very word repeats this dilemma) becomes the movement of something continually being divided against itself. Thus, according to its makers' own descriptions, photography is a set of relations that carries within itself the trace of a perennial alterity.

Some might say that the equivocal wordings of the proto-photographers are simply a product of their ignorance or naïveté. These pioneers hesitated to describe what they did not understand or had not yet fully experienced. According to this argument, these hesitations resulted in an awkwardness of expression evidenced as much in the clumsiness of their language as in the "primitiveness" of their images. Photography's inventors just did not know what they were talking about. Such criticisms fail to recognize what this book has tried to make clear: there is no more a primitive photography

than there is a primitive language. The proto-photographers approached photography's identity from within the traditions of natural philosophy, and as sophisticated philosophical thinkers and experienced artists proffered their various words and images. Anyone who considers Talbot a naive writer or Bayard an unthoughtful picture maker has simply not looked at their work closely enough.

In any case, this is not an argument about consciousness, about what the proto-photographers really thought or intended. It is about the possibility raised by both postmodernists and formalists, the possibility of finding the ontology of photography's identity in the convolutions of its own history. This account has concentrated on the history of photography's origins, a key trope in this, as in any debate about identity. We have found that the same economy evident in the words and pictures of the proto-photographers is reproduced within the larger historical discourse that attends photography's origins. Wherever we have looked, we have found these origins caught up in a perverse movement of displacement and deferral. Every foundational point of origin that photography's historians posited—temporal, authorial, conceptual, textual, or pictorial—has depended on another absent but supposedly more originary moment.

PHOTOGRAPHY AND DIFFERANCE

No wonder that Jacques Derrida describes all such moments *as* moment, as a dynamic that inevitably turns in, on, and around its own fulcrum. As he points out, there is always difference at the origin—even at the origin of difference itself: "In this play of representation, the point of origin becomes ungraspable. There are things like reflecting pools, and images, an infinite reference from one to the other, but no longer a source, a spring. There is no longer a simple origin. For what is reflected is split *in itself* and not only as an addition to itself or its image. The reflection, the image, the double, splits what it doubles. The origin of the speculation becomes a difference."[2]

This deserves further elaboration. Derrida's work engages a Western metaphysics organized around a hierarchy of dichotomies such that certain states of being are privileged over others. In any given pair of supposed opposites (culture/nature, man/woman, white/black, presence/absence, and so on), one term is considered the

negative, derivative, or corrupted version of the other. By the same token, one term is always given priority, whether temporal or qualitative (or both), over the other. Although this privilege can shift back and forth between the terms, one is always assumed to come first. As Derrida points out, this logocentrism is much more than an abstract philosophical foible; it is an inescapable politics, an order of subordination, that inhabits every thought and action that our culture undertakes.

We have already encountered any number of such dichotomies in our examination of the discourse that surrounds and informs the conception of photography. The nature/culture opposition is perhaps the most obvious, appearing at the center of the thinking of both proto-photographers and postmodern/formalist critics (note how this last pairing represents a logocentric opposition in its own right). Indeed, photography is consistently positioned by its commentators within some sort of play between activity and passivity, presence and absence, time and space, fixity and transiency, observer and observed, real and representation, original and imitation, identity and difference—and the list could go on. Derrida's critique of this last opposition is one of his most famous and has often been elucidated in introductions to his work.[3] Arguing that all identity is always already divided by differences (for nothing is ever simply present, referring only to itself), he introduces a silent but visible change in the word difference itself. In French, *différance* simultaneously contains within its neographism the activities of differing and deferring, a distancing acted out temporally as well as spatially. While exceeding its components, "differance" (to translate Derrida's gesture into English) marks a "sameness which is not identical," the repressed and unacknowledged condition of possibility for both difference *and* identity. As Derrida writes, "Differance produces what it forbids, making possible the very thing that it makes impossible."[4]

Derrida brings this deconstructive economy, this differance, to any binary opposition, in the sense that his reading exacerbates into visibility what is already there. "The reading must always aim at a certain relationship, unperceived by the writer, between what he commands and what he does not command of the patterns of the language that he uses."[5] "Photography" is one such pattern of language, an undecidable marking of the kind "that can no longer be included within philosophical (binary) opposition, but which, however, inhabit[s] philosophical opposition, resisting and dis-

organizing it, *without ever* constituting a third term."[6] Derrida's practice is not interested in resolving this oppositional logic. His neologisms (of which differance is only one) do not privilege one of the two opposing options, nor do they proffer a bridging or synthetic amalgamation of them both. Like the photography presented in this book, these neologisms instead upset the stability of the political economy that sustains the whole system. Neither simply culture nor nature, yet encompassing both, photography embodies precisely the bewildering spatial and temporal play that Derrida reproduces throughout his work. "Nothing, neither among the elements nor within the system, is anywhere ever simply present or absent. There are only, everywhere, differences and traces of traces."[7]

This play animates every aspect of photography's history. My own account has sought to displace the traditional origin story centered on 1839 and the introduction of photography into the marketplace and replace it with another, the discursive formation of a *desire to photograph* within the European epistemological field of the late eighteenth and early nineteenth centuries. This shift of analytical focus certainly has its momentary advantages, if only in raising serious questions about what is proper to both "photography" and "history." But it also leaves a number of historical dilemmas and methodological problems still to be addressed.

We might begin with the timing of photography's conception. It has been noted that photography—or at least the desire to have images spontaneously inscribe themselves on a light-sensitive surface—was described by at least twenty different persons residing in seven countries between about 1790 and 1839. This desire's appearance as discourse almost always preceded and exceeded the scientific expertise needed to bring it to fruition. Virtually every account of photography's conception begins with an "impossible" idea, which is then slowly and sometimes haphazardly pursued in the face of constant scientific difficulties and uncertainties. Despite plenty of opportunities, there are no episodes in which this idea arose directly from scientific experiment and discovery itself.[8] This suggests that a linear, percussive, evolutionary, cause-and-effect model of historical progress, with science (or for that matter, art) as some sort of "first cause," is just not appropriate to the facts of photography's conception. More on that later.

Although my account has paid unusually close attention to the ways in which the various proto-photographers expressed their aspirations, no one of these figures has

been accorded privileged treatment. No one person has been designated photography's "true" inventor. In fact, given the dispersed geography of its conception, photography appears to have emerged as the embodiment of certain arrangements of Western knowledge rather than as a creative "idea" or technological "discovery" traceable to the actions of any particular individual. Photography, it seems, was a product of (and contributor to) certain shifts and changes within the fabric of European culture as a whole. Thus a beginning once thought to be fixed and dependable is now revealed as a problematic field of mutable historical differences.

This still leaves us with the problem of how to designate this phenomenon that I have called the "desire to photograph." For my account has extended well beyond the actions of the proto-photographers to include the aspirations and practices of representative figures such as poet Samuel Taylor Coleridge, painter John Constable, and aesthete Richard Payne Knight, as well as more general developments in a number of aspects of the arts and sciences in the years around 1800. Obviously not all of these developments directly related to the invention of a photographic apparatus or to the perfection of a photographic science, but all of them exhibit that disruptive play of a differance within and between nature and culture, real and representation, fixity and transience, observing subject and observed object. In this sense, the desire to photograph encompasses much more than the invention of a photographic apparatus. It represents, in microcosm, the deconstructive dynamic of an entire epistemology. Yet this desiring economy is no photo-zeitgeist, no originary "spirit of the age." For differance obstinately refuses the mantle of origin, whatever its guise. As Derrida insists: "This does not mean that the *différance* that produces differences is somehow before them, in a simple and unmodified—in-different—present. *Différance* is the non-full, non-simple, structured and differentiating origin of differences. Thus the name 'origin' no longer suits it." [9]

This also distinguishes the desire to photograph from the desire-itself posited by psychoanalysis. Psychoanalysis describes desire in terms of a universal and fundamental lack in the being of the individual subject. Desire, born in the gap between need and demand, continually drives this subject to seek an object of some sort to complete what is in fact an unfillable absence. Although certainly not irrelevant to discussions of photography, this psychoanalytic notion doesn't seem adequate to the

historical dimensions of the desire outlined here. What can it tell us about a desire that so suddenly manifests itself within such a broad spectrum of European culture? How can it help us account for the historical, cultural, and morphological specificity of this particular desire, the desire to photograph?

Perhaps a more useful way to think such a desire is by way of what Foucault calls "a *positive unconscious* of knowledge: a level that eludes the consciousness of the scientist and yet is part of scientific discourse."[10] This kind of intervention is in line with the "archaeological" enterprise that Foucault describes in *The Order of Things:* "What I am attempting to bring to light is the epistemological field, the episteme in which knowledge, envisaged apart from all criteria having reference to its rational value or to its objective form, grounds its positivity and thereby manifests a history which is not that of its growing perfection, but rather that of its conditions of possibility."[11] This stress on a "positivity" that lies simultaneously inside and outside consciousness is informed by a Nietzschean philosophical tradition and by what Foucault elsewhere calls a "tactical engagement" with those "who would subjugate the multiplicity of desire to the twofold law of structure and lack."[12] He writes these last words in support of the rhyzomatic reading of desire found in the work of Gilles Deleuze and Félix Guattari. In *Anti-Oedipus,* for example, these authors speak of wanting to "introduce production into desire, and conversely, desire into production":[13] "If desire produces, its product is real. . . . Desire does not lack anything; it does not lack its object. . . . Desire and its object are one and the same thing. . . . Desire is not bolstered by needs, but rather the contrary; needs are derived from desire: they are counterproducts within the real that desire produces."[14]

As with Derrida's differance, this "productive" desire upsets the usual temporal and spatial order that could say with confidence, "This comes before that." My own shift of analysis from 1839 to the earlier desire to photograph at one level obeys this traditional logic of priority, merely revising the usual historical account to place the desire to photograph before the invention of photography and 1800 before 1839. However this shift from invention to desire also opens up the whole question of temporality. For example, we must ask whether the desire to photograph simply preceded photography or whether photography was in fact always already there.

This complex question leads straight back to the argument between postmodernism and formalism with which we began. Following the logic of differance, in one

sense photography has indeed always been; there has never not been a photography. What is photosynthesis, after all, but an organic world of light writing? No wonder the whole history of Western philosophy has engaged light and the metaphor of the sun; as Derrida has suggested, Western thinking is itself a form of photology.[15] With this in mind, Eduardo Cadava points out: "There has never been a time without the photograph, without the residue and writing of light. If in the beginning we find the Word, this Word has always been a Word of light—the 'let there be light' without which there would be no history."[16]

Photography (the writing of light) is the condition of possibility of its own history, of any history whatsoever. How then do we explain the fact that the discursive desire that I have described as photo-prophetic coincides with a quite singular moment in Western culture? This appears to be a contradiction (but, I would argue, an enabling one) in my own account. For, in the face of a traditional history that posits photography as an imminence, an ideal necessity, within European culture ever since the Renaissance, I have continually emphasized that the desire to photograph only appears as a regular discourse at a particular time and place. Following centuries of silence, only from the 1790s do we find growing and unequivocal evidence of a widespread desire to have images spontaneously inscribe themselves. Only then do we witness a regular discursive practice in which the presumed differences between nature and its representation, fixity and transience, time and space, observer and observed are simultaneously called into serious question. Clearly it was only possible to think "photography" at this specific historical conjuncture; photography as a conceptual economy thus has an identifiable historical and cultural specificity. This is why the principal question of previous chapters has been not "Who invented photography?" but rather "Within which specific dynamic of cultural/social forces was it possible for photography to be thought by *anybody?*"

This takes us back to the historical dilemma posed by Helmut Gernsheim. Why did no previous artists or philosophers speculate about the possibility of one day fixing the images they saw in their camera obscuras? How do we explain the suddenness of photography's discursive appearance, given the concept's investment in mechanisms such as the camera and light-sensitive chemistry, both of which considerably predate it? How can we write a history that acknowledges photography's continuity with natural philosophy and various traditions of picture making (including Renaissance per-

spective) while taking into account its equally undoubted *difference,* both temporal and conceptual, from these same traditions?

CONTINUITY/DISCONTINUITY

How indeed? In a notorious division, Foucault claims that his own historical inquiry "has revealed two great discontinuities in the episteme of Western culture: the first inaugurates the Classical age (roughly half-way through the seventeenth century) and the second, at the beginning of the nineteenth century, marks the beginning of the modern age."[17] On the evidence presented in previous chapters, the emergence of the desire to photograph neatly coincided with the second of these supposed discontinuities. The observation that the beginnings of photography paralleled the beginnings of the modern age does not at first seem particularly original or even useful. After all, every orthodox history of ideas recognizes the years around 1800 to be significant. The French Revolution of 1789 is a reference point common to most histories of the beginnings of the modern period; this one event is often projected as the catalyst for the tumultuous changes that shortly occurred throughout Europe. Similarly, even the most conservative historian of photography would agree that the medium's invention and dissemination were closely tied to the advent of modernity and its particular economic, social, and cultural developments in the early nineteenth century.

However, Foucault claims rather more for his model of periodization than the usual textbook division between one historical epoch and the next. Paradoxically, his own notion of a discontinuity between Classical and modern insists on both their continuity with each other and the radical difference between the two.

The order on the basis of which we think today does not have the same mode of being as that of the Classical thinkers. Despite the impression we may have of an almost uninterrupted development of the European ratio from the Renaissance to our own day . . . all this quasi-continuity on the level of ideas and themes is doubtless only a surface appearance; on the archaeological level, we see that the system of positivities was transformed in a wholesale fashion at the end of the eighteenth and beginning of the nineteenth century. Not that reason made any progress: it was simply that the mode of being of things, and of the order that divided them up before presenting them to the understanding, was profoundly altered.[18]

In a more fundamental fashion, and at the level where acquired knowledge is rooted in its positivity, the event concerns, not the objects aimed at, analysed, and explained in knowledge, not even the manner of knowing them or rationalizing them, but the relation of representation to that which is posited in it. . . . What came into being . . . is a miniscule but absolutely essential displacement, which toppled the whole of Western thought.[19]

Such claims demonstrate the most provocative aspect of Foucault's method, his engagement with what Michel De Certeau euphemistically calls "the equivocal nature of historical continuity."[20] Rather than tracing a continuous linear evolution of ideas that lead neatly from one era to the next and inevitably find their apex in the present, Foucault stresses instead history's apparent moments of rupture and discontinuity. He notes the *lack* of correspondence between, for example, natural history and biology, or general grammar and philology.[21] His work therefore concentrates on what traditional histories have tended to ignore, "the fact that within the space of a few years a culture sometimes ceases to think as it had been thinking up till then and begins to think other things in a new way."[22]

Philology, biology, and political economy were established, not in the places formerly occupied by general grammar, natural history, *and the* analysis of wealth, *but in an area where those forms of knowledge did not exist, in the space they left blank, in the deep gaps that separated their broad theoretical segments and that were filled with the murmur of the ontological continuum. The object of knowledge in the nineteenth century is formed in the very place where the Classical plenitude of being has fallen silent.*[23]

Foucault describes in this slide from classical to modern no less than " a general transformation of relations"[24] such that, as De Certeau recognizes, "the same words and the same ideas are often reused, but they no longer have the same meaning, they are no longer thought and organized in the same way."[25] According to Foucault, new forms of knowledge, such as photography, inscribe themselves in the space left blank by their (non)predecessors. Thus the cameras of John Locke and Tom Wedgwood can be the same but different, equivalent as optical instruments but representing radically different worldviews (which in turn means that they are also radically different optical instruments). This troubling archaeological notion of historical change allows Fou-

cault to speak of a general transformation, "certainly one of the most radical that ever occurred in Western culture"[26] yet to claim that "below the level of identities and differences there is the foundation provided by continuities, resemblances, repetitions, and natural criss-crossings."[27]

Here is an expression of the complex character of Foucauldian (and photography's) history, a perverse complicity of continuity and resemblance with its supposed opposite, discontinuity and difference.[28] For the second of these couplets is only recognizable in terms of its distinction from the first, a reciprocity that, according to its own logic, is an impossibility. Thus, a Foucauldian history of photography does not so much replace the idea of continuity with that of discontinuity as problematize the assumed distinction between the two.[29] At the heart of both Foucault's method and photography's historical identity is once again this tantalizing undecidability, this play of a difference that is always differing from itself.

A life that is also a death, a presence inhabited by absence: photography's genealogy repeats the strange identity of each of its individual instances. As we have seen, the central concerns of the proto-photographers—nature, landscape, camera images, time, subjectivity—were in a state of considerable crisis during the early nineteenth century. Perhaps photography could only be conceived at a moment when classical and modern epistemes were folding over and into each other. In other words, photography's birth pangs coincided with a movement that involved both the demise of the premodern and the invention of a peculiarly modern arrangement of knowledges; the appearance of one was only made possible through the erasure of the other. Photography's historical emergence is therefore perhaps best described as a palimpsest, as an event that inscribes itself within the space simultaneously marked and left blank by the sudden collapse of natural philosophy and its Enlightenment worldview.

As palimpsest, photography's historical identity recalls Derrida's treatment of Freud's work in "Freud and the Scene of Writing."[30] In *The Interpretation of Dreams* (1900) Freud suggested, for the purpose of some preliminary remarks on the psyche, that "we should picture the instrument which carries out our mental functions as resembling a compound microscope or a photographic apparatus, or something of the kind."[31] In 1925, in "Note upon the 'Mystic Writing-Pad'," Freud proposed another working model. In this instance the earlier photographic apparatus was replaced by a writing machine, a *Wunderblock*. "If we imagine one hand writing upon the surface of

the mystic writing-pad while another periodically raises its covering sheet from the wax slab, we shall have a concrete representation of the way in which I tried to picture the functioning of the perceptual apparatus of our mind."[32]

We might immediately note that Freud retained a quasi-photographic model of the mind when he imagined the unconscious as comprised of hieroglyphs, that is, secretive pictographic imprints on a sensitized psyche. Indeed, his description of the *Wunderblock* as two hands, one writing as the other erases, calls to mind Bayard, Niépce, Talbot, and Daguerre's renditions of photography as a process whereby nature is perennially drawn even while it draws itself. Thus could it be said that in the shift from optical instrument to mystic writing pad, Freud merely replaced one photographic metaphor with another.[33]

Derrida argues that Freud saw the psyche as inhabited by "a radical alterity," a *sous rature* (literally, "under erasure") that could equally be taken as *writing* (as indeed it soon became in Freud's own developing schema of metaphors). Freud conceived the perceptive surface of the psyche, for example, as both marked and unaltered, as both breached and virgin, as a discontinuous unfolding of space and time best defined, in Derrida's terms, as *spacing* ("neither space nor time . . . the impossibility for an identity to be closed on itself, on the inside of its proper interiority, or on its coincidence with itself").[34] Indeed at the very heart of the *Wunderblock* is a surface tracery of inscriptions, a web of erasures that makes any writing possible. "What we think of as 'perception' is always already an inscription. . . . In fact, Freud speculates that the very mansion of presence, the perceiving self, is shaped by absence, and—writing."[35] Thus when Derrida claims that "there is nothing outside of the text" he once again breaches the assumption that representation and real, psyche and body can ever be simply separated or distinguished.[36] To this end he takes Freud's photographic writing-machine literally, as an argument that both body and psyche are entirely implicated in the intertextual play of concrete metaphor, such that "we are written only as we write."[37]

POSTMODERNISM AND PHOTOGRAPHY

My own methodological weave of archaeology/genealogy and deconstruction brings us back to postmodernism and its view of photography's historical and political identity.[38] We might begin with the relationship that postmodernism posits between pho-

tography and power. Despite protestations to the contrary, postmodernists tend to maintain an entirely instrumental view of photography. For them, photography is a mere vehicle for the transfer of power from one place to another. Photography has no power of its own. It is instead temporarily vested with the power of the apparatuses that deploy it.

This explains why John Tagg, for example, is content to write throughout his essays of photography being brought to sites of power, of photography accruing power, of discovering how power touches photography, of the complicity of photography with power. The very wording of these phrases separates photography from power. Power is conceived as an autonomous entity, as a "burden" (with the moral implications that this word carries in its wake) that can be possessed and passed around. Notably absent from Tagg's work is an appreciation of how Foucault's description of power reinscribes it as a shifting set of relationships productively inhabiting all aspects and members of social life. Although Tagg is frequently concerned with bodies that are being subjected to photography, he never deals with the production of actual bodies. He presumes that photography's "subject" is a production *effect* of ideology, a state of consciousness inscribed over an existing biological body. Body and mind, biology and culture are again regarded as separate entities, with the subject always preexisting its embrace by the photographic apparatus. By neglecting to address the material production of the subject as body, Tagg limits the effects of power to the realm of what previously would have been called the ideological—to "new kinds of knowledge," to "domains of objects, institutions of language, rituals of truth."[39]

There are two major problems with this view of power: first, it is at odds with the theory of power offered by Foucault himself. For Foucault, modern power functions not only as a tool of the state apparatus but also as a network of circulating forces, an economy of relations such that "individuals are the vehicles of power, not its points of application."[40] This is why he is interested in discovering "how it is that subjects are gradually, progressively, really and materially constituted through a multiplicity of organisms, forces, energies, materials, desires, thoughts, etc."[41] He continues, "What I want to show is how power relations can materially penetrate the body in depth, without depending even on the subject's own representations. If power takes hold on the body, this isn't through its having first to be interiorised in people's consciousness."[42]

Foucault's most famous effort in this direction involved his 1976 book, published in English as *The History of Sexuality: An Introduction*. Faced with the apparent opposition of sex (the real thing) and sexuality (the discourse on sex), with one seeming clearly to come before the other, he ends up not only reversing the terms of debate but also questioning their separability. "So we must not refer a history of sexuality to the agency of sex; but rather show how 'sex' is historically subordinate to sexuality. We must not place sex on the side of reality, and sexuality on that of confused ideas and illusions; sexuality is a very real historical formation; it is what gives rise to the notion of sex, as a speculative element necessary to its operation."[43]

The second consequence of Tagg's view is that it sets up a logic of priority in which power always precedes photography, having its ultimate source in the apparatuses of the state. The implication is that real power, the power of the state, comes before its representation, whether through photography or any other cultural medium. As Derrida suggests in his discussions on the history of writing, this base-superstructure model of power has some important consequences: "Fostering the belief that writing *befalls* power . . . that it can ally itself to power, can prolong it by complementing it, or can serve it, the question suggests that writing can *come* to power or power to writing. It excludes in advance the identification of writing *as* power or the recognition of power from the onset of writing. . . . Writing does not come to power. It is there beforehand, it partakes of and is made of it. . . . The question also led to the singular abstraction: *power, writing*."[44]

Is there anything about the history of photography's emergence that might allow us to speak not just of "photography and power" but of "photography *as* power?" Can we speak of another of these "singular abstractions": *photopower?* Foucault's work certainly makes clear that any regimentation of what can and cannot be thought at a given moment in history (this is his stated "problem" in *The Order of Things*) is as much a question of power as it is of knowledge. "The exercise of power perpetually creates knowledge and conversely knowledge constantly induces effects of power."[45] Accordingly, his oxymoronic concept of desire as a *"positive unconscious* of knowledge" is soon replaced, via Nietzsche, by the phrase *will to power*. Through this notion of a will to power Foucault subsequently investigates the emergence in the years around 1800 of a variety of heterogeneous social apparatuses (to which we have now added photography).

I understand by the term "apparatus" a sort of—shall we say—formation which has as its major function at a given moment that of responding to an urgent need. The apparatus thus has a dominant strategic function. . . . The apparatus is thus always inscribed in a play of power, but it is always linked to certain coordinates of knowledge which issue from it but, to an equal degree, condition it. This is what the apparatus consists in: strategies of relations of forces supporting, and supported by, types of knowledge.[46]

Foucault's discussion of the panopticon, that now notorious system of social control and incarceration first proposed by Jeremy Bentham in 1791 (a conception that also coincided with that of photography), is particularly interesting in this context. For this apparatus, like photography and as another of its French appelations suggests (*appareil:* apparatus, camera), operates according to a certain system of relations between a light source, a focusing cell, and a directed looking. However I raise Foucault's discussion here not to suggest a relationship between photography and the panopticon based on an architectural resemblance between camera and cell, as if one machine is in any simple way a miniature version of the other. Rather, we need to examine the extent to which they might correspond as systems of power, the extent to which they share and constitute a peculiarly modern configuration of power-knowledge-subject.

Many critics assume the panopticon to be a "static, spatial structure" designed to allow an oppressive surveillance of those without power by those who have it.[47] However, Foucault's reading is more complex. He reiterates Bentham's own point that as the prisoner never knows when he is actually being watched, he must assume that it is always so; thus the prisoner necessarily surveys and disciplines himself. He becomes the instrument of his own subjection. As far as the exercise of power is concerned, the prisoner is always caught in an uncertain but productive space of hesitation between tower and cell. He is both the prisoner and the one who imprisons (and therefore not simply either). As Foucault puts it, "He who is subjected to a field of visibility, and who knows it, assumes responsibility for the constraints of power; he makes them play spontaneously upon himself; he inscribes in himself the power relation in which he simultaneously plays both roles; he becomes the principle of his own subjection."[48]

The subject constituted as the locus of disciplinary power, a being positioned as simultaneously subject and object of that power, resembles the "strange empirico-

transcendental doublet" that Foucault in *The Order of Things* had identified with the emergence of the modern episteme.[49] According to Foucault, in the years around 1800, "Man appears in his ambiguous position as an object of knowledge and as a subject that knows: enslaved sovereign, observed spectator."[50] He continues: "Man has not been able to describe himself as a configuration in the episteme without thought at the same time discovering, both in itself and outside itself, at its borders yet also in its very warp and woof, an element of darkness, an apparently inert density in which it is embedded, an unthought which it contains entirely, yet in which it is also caught."[51]

A being that is both in itself and outside itself, the self beside/in the other, an identical newness, "an unthought which it contains entirely, yet in which it is also caught." Foucault's phraseology recalls that of writers like Coleridge, Knight, Niépce, Daguerre, and Talbot and the discursive figures of nature, landscape, and camera in the years around 1800. Photography, these incubating discourses suggest, simultaneously depends on and produces this new economy of power-knowledge-subject, this continually divided or doubled mode of being. Looking again at the circumlocutions that characterize these proto-photographic texts and their metaphors, they appear to apprehend their own cultural parameters almost exactly as Foucault describes them. Once again we confront a Foucauldian conundrum: "a task that consists of not—of no longer—treating discourses as groups of signs (signifying elements referring to contents or representations) but as practices that systematically form the objects of which they speak."[52] As Foucault insists:

In the descriptions for which I have attempted to provide a theory, there can be no question of interpreting discourse with a view to writing a history of the referent. . . . [W]hat we are concerned with here is not to neutralize discourse, to make it the sign of something else, and to pierce through its density in order to reach what remains silently anterior to it, but on the contrary to maintain it in its consistency, to make it emerge in its own complexity. . . . To substitute for the enigmatic treasure of "things" anterior to discourse, the regular formation of objects that emerge only in discourse. To define these objects without reference to the ground, the foundation of things, but by relating them to the body of rules that enable them to form as objects of a discourse and thus constitute the conditions of their historical appearance.[53]

This line of thought, with its troubling of the traditional relationship of discourse and referent, of historical appearance and those things anterior to it, recalls another important commentary on photography. In a 1964 essay titled "Rhetoric of the Image," French critic Roland Barthes describes the photograph as a perverse enfoldment of denotation within connotation, as a system of meaning torn internally between culture and nature. Seeking a semiology of the photographic image (and with it an "ontology of the process of signification"), Barthes is "brought up against the paradox . . . of a message without a code."[54] This, he says, constitutes the "real unreality" of the photograph. The entanglement of one with its other (the coded with the uncoded, the real with the unreal) recurs in Barthes's last series of extended reflections on photography, published in 1980 under the title *Camera Lucida*.[55] This time he orchestrates his analysis of individual photographs by recourse to another pair of binary terms, *studium* and *punctum,* an artifice which allows him to distinguish between a given photograph's communal and private meanings. Once again, however, he finds it difficult to maintain the difference between the two. This is particularly clear when he brings these binaries to bear on his discussion of photography in general.

In an earlier book, *The Pleasure of the Text* (1973), Barthes again structures his discussion around a binary distinction (in this instance, between two opposing orders of pleasure he calls *plaisir* and *jouissance*). At the same time, he advises his readers that the erotic is best sought in "intermittence," in the flash "between two edges, the staging of an appearance-as-disappearance."[56] In *Camera Lucida* his analysis privileges a photograph of his mother taken in a conservatory when she was five years old. He refers to this photograph frequently but never reproduces it for his readers, despite the fact that he believes that "something like an essence of the Photograph floated in this particular picture."[57] He thus stages photography's essence as another of these tantalizing flashes of appearance-as-disappearance, as yet another paradoxical play of absence within presence, blindness in insight.

Nor does the paradox of photography's identity end there. In "Rhetoric of the Image," Barthes describes the introduction of photography into human history as an event of revolutionary proportions: "The type of consciousness the photograph involves is indeed truly unprecedented, since it establishes not a consciousness of the

being-there of the thing (which any copy could provoke) but an awareness of its having-been-there. What we have is a new space-time category: spatial immediacy and temporal anteriority, the photograph being an illogical conjunction between the here-now and the there-then." [58]

He repeats this idea in *Camera Lucida*. When looking at the image of his mother as a child and thinking of her recent death, Barthes laments the "anterior future" tense that he finds in this and all other photographs. Pondering an 1865 portrait of a condemned man, Barthes similarly observes that the subject depicted there is both dead and is going to die. "I read at the same time: This will be and this has been. ... The photograph tells me death in the future. ... Whether or not the subject is already dead, every photograph is this catastrophe." [59] The catastrophe is heightened by his awareness of the "stigmatum" of the having-been-there of the thing photographed. For him, photography's identity lies in the photograph's impossible but axiomatic articulation of time and history, in its simultaneous presentation of life and death. According to Barthes, then, the reality offered by the photograph is not that of truth-to-appearance but rather of truth-to-presence, a matter of being (of something's irrefutable place in space/time) rather than resemblance.

As Derrida quickly recognizes, Barthes's consistent collapsing of binary terms is the key move in his rewriting of photography.

*For above all, and in the first place, this apparent opposition (*studium/punctum*) does not forbid but, on the contrary, facilitates a certain* composition *between the two concepts. What is to be understood by composition? Two things which compose together. First, separated by an insuperable limit, the two concepts exchange compromises; they compose together, the one* with *the other, and we will later recognize in this a* metonymic *operation; the "subtle beyond" of the* punctum, *the un-coded beyond, composes with the "always coded" of the* studium. *It belongs to it without belonging to it and is unlocatable in it; it never inscribes itself in the homogeneous objectivity of the framed space but instead inhabits, or rather haunts it: "it is an addition* [supplément]: *it is what I add to the photograph and* what is none the less already there." *... Neither life nor death, it is the haunting of the one by the other. ... Ghosts: the concept of the other in the same, the* punctum *in the* studium, *the dead other alive in me. This concept of the photograph* photographs *all conceptual oppositions, it traces a relationship of haunting which perhaps is constitutive of all logics.* [60]

The failure to recognize this same haunting, and to transform it into an enabling politics, ultimately limits the prevailing Anglo-American view of photography. Postmodern criticism would simply reverse a given economy of oppositions and thus move from one side of a duality to the other. It wants to say, not photography but photographies; not nature but culture; not autonomy but context; not the "thing-itself" but discourse; not sameness but difference; not essentialism but antiessentialism. Most importantly, postmodernism comes down on the side of photography and power, not photography *as* power. As a consequence, photography continues to be conceived as an inconsequential vehicle or passage for "real" powers that always originate elsewhere.

One can already see a number of problems with this instrumental communication-model conception of photography. It neatly parallels, for example, phallocentrism's figuring of woman as a mere passage between man's body and that of "his" offspring, as if her materiality is of no account. Indeed, the postmodern conception of photography described above maintains the binary structure of logocentrism in all of its many manifestations, despite the early and frequent references to Derrida's critique of this logocentrism that appear in writings by Victor Burgin and, more recently, by John Tagg as well. Notwithstanding the deployment of a certain amount of poststructuralist rhetoric, contemporary photographic criticism remains bound to a structuralist mode of thinking, with its phallanx of unacknowledged binary oppositions. Indeed, these oppositions are the very foundation on which a postmodern theory of photography's identity has been erected. Thus, to disturb the self-certainty of this binary composure is to undermine not only postmodernism's concept of a "photography that is not one" but also its assumed political progressiveness.

Representation/Real

When it comes right down to it, all of these oppositions reiterate a familiar distinction, the presumed divide between representation and the real. Allan Sekula, for example, refers to C. S. Peirce's semiotic schema when defining photographs as "physical traces of their objects," as signs having an *indexical* relationship to the world they represent. Indeed, according to Sekula, "because of this indexical property, photographs are fundamentally grounded in contingency."[61] For Sekula, Peirce's schema also provides a

"fundamental ground" for his own theory of photography; apparently indexicality is the only thing about photography that is *not* contingent. As Sekula would have it, "everything else, everything beyond the imprinting of a trace, is up for grabs."[62] But what is the status of any ground that is in permanent contradiction with itself, that is apparently both contingent and not contingent?

Sekula attempts to clarify matters by carefully distinguishing indexical signs from their other, the class of signs known as symbols. "Symbols, on the other hand, signify by virtue of conventions or rules."[63] Photography is a type of representation operating, at least in the first instance ("fundamentally"), before any conventions or rules. In coming to this conclusion, Sekula refers to Rosalind Krauss's influential writings about the index. In her two-part "Notes on the Index" (1977), Krauss argues that the contact print or photogram "only forces, or makes explicit, what is the case of *all* photography."[64] Having already enlisted Lacan to establish an opposition between the symbolic (where, she claims, language presents the subject "with an historical framework pre-existent to its own being," "forming a connection between objects and their meaning") and the imaginary (a state in which the subject is "disengaged from the conditions of history"), Krauss equates photography firmly with the latter. "Its power is as an index and its meaning resides in those modes of identification which are associated with the Imaginary."[65]

Krauss reiterates the point when she repeats Barthes's aphorism "message without a code," not as a puzzling paradox but as a description of "the inherent features of the photograph," as evidence of the "fundamentally uncoded nature of the photographic image."[66]

It is the order of the natural world that imprints itself on the photographic emulsion and subsequently on the photographic print. This quality of transfer or trace gives to the photograph its documentary status, its undeniable veracity. But at the same time this veracity is beyond the reach of those possible internal adjustments which are the necessary property of language. The connective tissue binding the objects contained by the photograph is that of the world itself, rather than that of a cultural system.[67]

So photography "traces" the order of nature ("the world itself"), not that of culture. And it does so without the internal adjustments, the mediating play of codes,

that is apparently the sole preserve of language. However, Krauss's argument depends on a notion of language's fixed relationship to the world itself that, unlike Sekula, she will later refute. "An analogy we could make here is to the color spectrum which language arbitrarily divides up into a set of discontinuous terms—the names of hues. In order for language to exist, the natural order must be segmented into mutually exclusive units."[68] In her 1980 essay "In the Name of Picasso," Krauss mounts a vigorous critique of this same nominalism, and with it the primacy she had previously given to a natural order preceding language. Activating the work of Ferdinand de Saussure, she stresses that the sign is a substitute for an always absent referent, such that absence is "the very condition of the representability of the sign."[69] Accordingly, she now describes the notion of the sign-as-label as a "perversion."[70] Repeating Saussure's dictum that "in language there are only differences without positive terms," she presents the early collage practice of Braque and Picasso as one antidote to modernism's search for "perceptual plenitude and unimpeachable self-presence." For Krauss, cubist collage is a proto-postmodern example of a "representation of representation."[71] Where modernism remains invested in the originary presence of "objects of vision," collage sets up "discourse in place of presence, a discourse founded on a buried origin."[72]

Krauss continues this line of argument in her subsequent discussions of photography, beginning with her 1981 essay "The Photographic Conditions of Surrealism." Once again she claims that "technically and semiologically speaking" the photograph is an index, "a kind of deposit of the real itself."[73] However, some photography, and especially that produced by the surrealists in the 1920s and thirties, has apparently been able to employ specific strategies (which, referring to Derrida, Krauss describes using words such as supplement, *en abyme,* invagination, spacing, doubling, writing) that constitute *"reality as representation."*[74]

The manipulations wrought by the surrealist photographers—the spacings and doublings—are intended to register the spacings and doublings of that very reality of which this photograph is merely the faithful trace. In this way the photographic medium is exploited to produce a paradox: the paradox of reality constituted as sign—or presence transformed into absence, into representation, into spacing into writing. . . . Reality was both extended and replaced or supplanted by that master supplement which is writing: the paradoxical writing of the photograph.[75]

By bringing Derrida to surrealism, Krauss provides photocriticism with a suggestive analogy between the photograph and a kind of *writing*. Nevertheless, in other respects her account retains a traditional notion of photography similar to that outlined by Sekula. Reality continues to precede a photography that is "merely" its "faithful trace." Photography is the indexical deposit of a real that it may mimic but of which it is never itself a part.[76]

Some of the theoretical and political consequences of this view of photography appear in Sekula's criticism. Although Sekula recognizes the discursively mediated character of social life (as in, for example, his accounts of the naturalization of the cultural), he continues to reproduce this differential as an ordered system of binary oppositions or contradictory negations (object-subject, self-other, appearance-substance, bourgeois-proletariat). As a consequence, he maintains a division between, for example, nature and culture (as in his distinction between index and symbol) in a way that inflects his whole project. Rather than examining the manner in which each necessarily inhabits the other, he clings to the possibility of a reversal of terms and a resolutive telos based on noncontradiction. Thus his sometimes emancipatory tone ("Therein lies a promise and a hope for the future") tends to equate photography with the false consciousness of mere appearance and to oppose it to the hidden substance of humanity's real social relations.[77] His criticism always wants to make present an absent, true presence, not to problematize the very categories of absence and presence themselves. No wonder that in his article on "The Body and the Archive," the body, unlike the archive, remains unproblematic. It is seemingly the ground, the existing reality, upon which an instrumental photography lavishes its unwelcome attentions.[78] The photograph is once again no more than a transparent vehicle for the oppressive discourses of the state. Its relationship to power, contradictory or otherwise, is tied to its particular function or use, not to its own identity as a historical (and therefore political) practice of representation.

Sekula's reference to the index and Peircean semiotics provides a theoretical justification for maintaining a division between photography and the real. However, things are not so clear cut in Peirce's own writings. Derrida points out that, like Barthes, Peirce "complies with two apparently incompatible exigencies" and warns that it would be a mistake to "sacrifice one for the other."[79] To summarize Derrida's argument, Peircean semiotics depends on a nonsymbolic logic even while recognizing

that such a logic is itself a semiotic field of symbols. Thus, "No ground of nonsignifi-cation . . . stretches out to give it foundation under the play and the coming into being of signs." In other words, Peirce's work in fact never allows us to presume that there is a real world, an ultimate foundation, that somehow precedes or exists outside of representation. Real and representation, world and sign, must, in line with Peirce's own argument, always already inhabit each other.

According to Derrida, by maintaining this contradiction as central to his account of the sign,

Peirce goes very far in the direction that I have called the deconstruction of the transcendental signi-fied, which, at one time or another, would place a reassuring end to the reference from sign to sign. I have identified logocentrism and the metaphysics of presence as the exigent, powerful, systematic, and irrepressible desire for such a signified. Now Peirce considers the indefiniteness of reference as the criterion that allows us to recognize that we are indeed dealing with a system of signs. . . . The thing itself is a sign. . . . The so-called "thing itself" is always already a representamen shielded from the simplicity of intuitive evidence. The representamen functions only by giving rise to an interpretant that itself becomes a sign and so on to infinity. . . . From the moment that there is meaning there are nothing but signs.[80]

Those who look to Peirce for pragmatic evidence of an extra-photographic real, the thing-itself, the generative source of the indexical signing that is the photographic process, will, if they look closely enough, find "nothing but signs." Accordingly, if we follow Peirce to the letter and rewrite photography as "signing of signs," we must logically include the real as but one more form of the photographic. It too is the be-coming of signs. It too is a dynamic practice of signification. Any extended notion of photography's identity must therefore concern itself with the how of this becoming, with the perennial tracing of one sign within the grain of the other. In other words, we must regard photography as the representation of a reality that is itself nothing but a play of representations. More than that, if reality is such a representational system, it is one produced within, among other economies, the *spacing* of the photographic.

Victor Burgin would be well aware of any move signaled by a Derridean reading of Peirce. Burgin in fact used the above quotation from Derrida in an essay he pub-lished back in 1975, referring approvingly to Peirce's concept of "unlimited semiosis"

and often conjuring Derrida's critique of logocentrism as part of his own argument with the discourse of modernism.[81] No doubt Burgin would be suspicious of any theory of photography that presumed a simple prerepresentational ground. His own criticism uses a Lacanian reading of psychoanalysis to describe the operations of photography in terms of a productive exercise of power. According to Burgin, the human subject is photography's illusory effect as well as its real producer. But, we should ask once again, what of that subject's body? Is the body also produced by photography, or does the brute matter of flesh and blood somehow precede its embrace by representation?

Burgin is careful to distance himself from the body-centric essentialism of a certain kind of feminism and also from what he calls "the biologistic reductionism which has tended to be the fate of psychoanalytic theory in the English-speaking world."[82] Instead he denaturalizes our assumptions about the acquisition of masculinity and femininity and stresses the inherently social character of sexed subjectivity. According to Burgin, photography has a definite role in the construction of this character: "Forms of representation such as photography don't simply express a biologically pregiven 'femininity' or 'masculinity'; sexual difference, in the totality of its effects, doesn't precede the social practices which 'represent it,' doesn't function outside such practices, but is constructed within them, through them."[83] As a consequence, we must factor into our accounts of photography "the recognition of sexuality as a *construct,* subject to social and historical change; and the recognition of the body as not simply given, as essence, in nature but as constantly reproduced, 'revised,' in discourse."[84] This argument hints at an unacknowledged contradiction. On the one hand, the body is never simply given in nature. On the other, this same body is constantly "reproduced" and "revised." This consistent choice of prefix implies the existence of a prediscursive body locatable at some originary point in time not yet subjected to the reiteration of the social. In "Tea with Madeleine," a paper first delivered in 1983, Burgin attempts to clarify what he means by referring the issue of sexed subjectivity back to just such a moment, the moment of birth. By so doing, he directly addresses the socially coded context in which sexual differences are first established and confirmed.

The most important question asked of any of us is a question we do not, at the time, understand: "Doctor, is it a boy or a girl?" "Female" and "male" are anatomical terms. "Masculine" and "femi-

nine" are sociological and psychological terms, which designate gender roles and/or psychological characteristics along a spectrum between "active" and "passive." Social roles and psychology may be assigned, by convention and institutions, on the basis of anatomy, but they are not otherwise determined by anatomy.[85]

The problem now becomes clear. Burgin's theory of photography rests on a presumed opposition of anatomy and psyche, on a chronological and conceptual division between the biology of sex and the sociology of gender. Sex (male and female) is a given. Gender (masculine and feminine) is designated by the ideology of patriarchy. The sexed body precedes a discursive context that, beginning at birth, will reinscribe it as a socialized, gendered human subject. Remember that Burgin's argument was mounted in the face of a feminist essentialism that sought to ground woman's "difference" in some shared, lived experience of her biological body. However, in his anxiety to avoid any naive reductionism, he implements what is no more than a reversal of the two terms. Where previously we were offered an account of the "origins of subjectivity" grounded entirely in the body, now we are presented with one grounded entirely in the psyche. The politically interested binary opposition of body and psyche, of the real and its representation, remains in place, its logocentric economy undisturbed. Once again, the productive effects of photography are confined to one side of this oppositional structure, to the desubstantialized realm of representation.[86]

RETHINKING PHOTOGRAPHY

This is the principal irony of the postmodern critique of photography. Convincing and insightful in so many respects, this critique nevertheless reiterates the very politics that it sets out to dispute. While postmodernism successfully reverses the nature/culture opposition erected by a modernist formalism, it neglects to displace the system of oppositions itself. By insisting that photography is not nature but culture, the postmodern view reproduces at every level the same logocentric economy that sustains both formalist analysis and broader formations of oppression such as phallocentrism and ethnocentrism. Postmodernism's retention of a structuralist logic also limits its engagement with the question of power. It allows a sophisticated form of ideology critique yet precludes the recognition that photography is always and already the mani-

festation of a distinctly modern economy of power-knowledge-subject. This in turn has led to a separation of photography from the body, the real, and any number of other entities still considered immutable, essential, and outside the play of both history and the photographic.

This real/representation split deserves a little more comment. Although postmodern criticism opposes itself to the essentialism of a transcendental nature, it nevertheless often finds itself conjuring precisely this (not culture but nature) whenever it seeks to name photography's generative source. This repressed contradiction reveals the limitation of a critical approach that is content to reduce everything to representation but is not willing to engage the economy that makes representation and the real utterly complicit and mutually constitutive. The result is an unacknowledged but tenacious investment in a foundation that always precedes both representation and difference. The problem is exemplified in Jonathan Crary's *Techniques of the Observer,* a book that has been justly praised for bringing a Foucault-inspired postmodernism to the question of vision. In wanting to make clear that all historical selection serves the interests of the present, Crary claims that "it should not be necessary to point out there are no such things as continuities and discontinuities in history, only in historical explanation." The boundary between history and fact, between discourse and "things," is similarly figured on an earlier page. "If I have mentioned the idea of a history of vision, it is only as a hypothetical possibility. Whether perception or vision actually change is irrelevant, for they have no autonomous history. What changes are the plural forces and rules composing the field in which perception occurs."[87] Why do postmodern critics always feel the need to make this sort of disclaimer? What are they so afraid of? If, as Foucault's work suggests, sex and the discourse of sexuality produce each other, why shouldn't we also presume that perception actually changes in concert with transformations in the discourse of vision?

As signaled in Derrida's discussion of semiology, cultural critics must henceforth think representation as the lived morphology of inscription in general (what Derrida calls "arche-writing").[88] This arche-writing must include the photographic. To assume that photography itself doesn't matter, as postmodernism has traditionally done, is to fail to recognize that photography *cannot not matter,* just as the social can never not be present. This shift in thinking undoubtedly complicates political analysis, but such a complication is precisely what is needed. For the politics of photography isn't some-

thing that identifies itself only when the medium is in action within obviously oppressive institutions. Rather, power inhabits the very grain of photography's existence as a modern Western event. It is reproduced within every photograph and also as the ontological field that makes any photograph possible, the very photography as such that postmodernism is so anxious to disavow. This is surely the main point to tackle here. We can no longer afford to leave the battlefield of essence in the hands of a vacuous art-historical formalism.

It might be protested that it is all too easy to accuse a given cultural discourse of retaining a conservative oppositional structure. For, whether we like it or not, every analysis is caught within the strictures of a binary metaphysical frame. However, as Derrida argues, not all ways of "not escaping" this frame are equally fecund.[89] I have sought to disrupt prevailing views of photography by deploying certain aspects of Foucault's genealogy and Derrida's deconstruction. The result is a troubling supplement, rather than a simple alternative, to established modes of discussing photography. Although neither postmodern nor formalist, my account, being true to the parasitical logic of the supplement, incorporates aspects of each. At the same time, I have tried to show how the strange and convoluted history of photography's conception strikes at the heart of all oppositional renditions of photographic identity. Such renditions look to photography's origins to provide a stable ontological foundation, an identity before which there is no photography, an identity without difference. But the story of photography's beginnings has proved disturbingly recalcitrant. Everywhere we have looked photography's origins are found inscribed within a dynamic play of differences (the play of differance) that refuses to settle at any of the available poles of identification (nature, culture, the intrinsic characteristics of the medium, the exigencies of context).

Photographic history, it seems, always carries within itself the process of its own erasure. A singular point of origin, a definitive meaning, a linear narrative: all of these traditional historical props are henceforth displaced from photography's provenance. In their place we have discovered something far more provocative—a way of rethinking photography that persuasively accords with the medium's undeniable conceptual, political, and historical complexity.

| EPITAPH |

As digitization emerges as a state-of-the-art method of encoding photographic images, the very foundation and status of the [photographic] document is challenged. The early effects of this process are accumulating and they suggest that the extent of this tremendous shift will be staggering. Whatever tenuous continuity ever existed between photography or digitized imagery and its message could be shattered, leaving the entire problematic concept of representation pulverized.[1]

In fact, the new malleability of the image may eventually lead to a profound undermining of photography's status as an inherently truthful pictorial form. . . . If even a minimal confidence in photography does not survive, it is questionable whether many pictures will have meaning anymore, not only as symbols but as evidence.[2]

In some ways we are facing the death of photography—but as in movie fiction the corpse remains and is re-animated, by a mysterious new process, to inhabit the earth like a zombie. . . . Digitization is a process which is cannibalising and regurgitating photographic (and other) imagery, allowing the production of simulations of simulations. . . . Photography loses its special aesthetic status and becomes no more than visual information and, once data is gathered exclusively by still video cameras, traditional film and paper based photography will have disappeared both as a technology and as a medium-specific aesthetic. . . . The end of photography is not the end of something that looks like photography, but the end of something which can be considered as stable.[3]

The rapid development in little more than a decade of a vast array of computer graphics techniques is part of a sweeping reconfiguration of relations between an observing subject and modes of representation that effectively nullifies most of the culturally established meanings of the terms observer *and* representation. *The formalization and diffusion of computer-generated imagery heralds the ubiquitous implantation of fabricated visual "spaces" radically different from the mimetic capacities of film, photography, and television.*[4]

We can identify certain historical moments at which the sudden crystallization of a new technology (such as printing, photography, or computing) provides the nucleus for new forms of social and cultural practice and marks the beginning of a new era of artistic exploration. The end of the 1830s— the moment of Daguerre and Talbot—was one of these. And the opening of the 1990s will be re-

membered as another—the time at which the computer-processed digital image began to supersede the image fixed on silver-based photographic emulsion. . . . From the moment of its sesquicentennial in 1989 photography was dead—or, more precisely, radically and permanently displaced—as was painting 150 years before.[5]

F aced with the invention of photography, French painter Paul Delaroche is supposed to have declared, "From today, painting is dead!"[6] Now, a little over 150 years later, everyone seems to want to talk about photography's death. This sustained outburst of morbidity stems from two related anxieties. The first is an effect of the widespread introduction of computer-driven imaging processes that allow "fake" photos to be passed off as real ones. The prospect is that, unable to spot the fake amid the real, viewers will increasingly discard their faith in the photograph's ability to deliver objective truth. Photography will thereby lose its power as a privileged conveyor of information. Given the proliferation of digital images that look exactly like photographs, photography may even be robbed of its cultural identity as a distinctive medium.[7]

These possibilities are exacerbated by a second source of concern, the pervasive suspicion that we are entering a time when it will no longer be possible to tell any original from its simulations. Thing and sign, nature and culture, human and machine—all of these hitherto dependable entities appear to be collapsing in on each other. Soon, it seems, the whole world will consist of an undifferentiated artificial nature, a hyperreal. According to this scenario, the vexed question of distinguishing truth from falsehood will then become nothing more than a quaint anachronism—as will photography itself.

So photography today faces two apparent crises, one technological (the introduction of computerized images) and one epistemological (having to do with broader changes in ethics, knowledge and culture). Taken together, these crises apparently threaten us with the death of photography, with the "end" of photography and the culture it sustains. But exactly what kind of end would this be?

It should not be forgotten that photography has been associated with death since the beginning. Photography's birth pangs coincided with the demise of a premodern episteme. In stopping or turning back time, each individual photograph appeared to embody this same perverse interweave of life and death. "Necromancy" was the lighthearted charge of some contemporary journalists. However, others took this association with black magic more seriously. The Norwegian sculptor Thorvaldsen, for example, allowed himself to be daguerreotyped in about 1842 but took no chances by forming one hand into a sign to ward off the evil eye. In similar fashion, Nadar tells us with some amusement that his friend Balzac had an intense fear of being photographed:

According to Balzac's theory, all physical bodies are made up entirely of layers of ghostlike images, an infinite number of leaflike skins laid one on top of the other. Since Balzac believed man was incapable of making something material from an apparition, from something impalpable—that is, creating something from nothing—he concluded that every time someone had his photograph taken, one of the spectral layers was removed from the body and transferred to the photograph. Repeated exposures entailed the unavoidable loss of subsequent ghostly layers, that is, the very essence of life.[8]

An excess of life was actually a bit of a problem for those early photographers trying to make portraits. Due to slow exposure times, even a slight movement of the subject's head produced an unsightly blur. Some critics complained that the strain of keeping steady made the subject's face look like that of a corpse. However, a simple solution was soon available. Those wanting their portraits taken simply had to submit to having their heads placed within a constraining device that ensured a still posture for the necessary seconds. This device transformed the lived time of the body into the stasis of an embalmed effigy. In other words, photography insisted that if one wanted to appear lifelike in a photograph, one first had to act as if dead.

Portrait photographers soon took this association a step further, developing a lucrative trade in posthumous photographs. Grieving parents could console themselves with a photograph of their departed loved one, an image of the dead as dead that somehow worked to sustain the living. This business was taken to another level in 1861, when a Boston engraver announced that he had found a successful way to photograph ghosts. Thousands of photographs showed the living consorting with the

A. C. T. Neubourg, *Portrait of Thorvaldsen*, c. 1840. Daguerreotype. Thorvaldsen Museum, Copenhagen

dead, a comfort for those inclined toward spiritualism and a financial bonanza for those prepared to manipulate the photographic technology of double exposure.[9]

Not everyone benefited from photography's commercial success. As Delaroche had predicted, photography's introduction into the capitals of Western Europe spelled doom for many established image-making industries. Miniature painting, for example, was quickly made extinct by the magically cheap appearance of the daguerreotype's exact, shiny portraits. As N. P. Willis, the first American commentator on photography, warned in April 1839, other art practices were also under threat from the new apparatus: "Vanish equatints (sic) and mezzotints—as chimneys that consume their own smoke, devour yourselves. Steel engravers, copper engravers, and etchers, drink up your aquafortis and die! There is an end of your black art. . . . The real black art of true magic arises and cries avaunt."[10]

Not only individual reproductive practices faced a photographically induced euthenasia. Walter Benjamin's famous essay "The Work of Art in the Age of Mechanical Reproduction" (1936) argues that photography would even hasten the demise of capitalism itself by inexorably transforming the aura of authenticity into a commodity form. As a mechanical manifestation of the capitalist mode of production, photography necessarily bore the seeds of capitalism's own implosion and demise. In his dialectical tale of sacrifice and resurrection, aura would have to die at the hand of photography before any authentic social relations could be brought back to life. As Benjamin put it, "One could expect [capitalism] not only to exploit the proletariat with increasing intensity, but ultimately to create conditions which would make it possible to abolish capitalism itself."[11] Capitalism is therefore projected as its own worst nightmare, for its means of sustenance is also its poison. For Benjamin, photography enjoys this same dual character. Like the daguerreotype, it is a force at once positive and negative.

Benjamin is not the only twentieth-century commentator to pursue this theme. In a 1927 essay titled simply "Photography," Siegfried Kracauer argues that "historicist thinking . . . emerged at about the same time as did modern photographic technology." In fact, he says, "Historicism is concerned with the photography of time." Therefore, "The turn to photography is the life and death game of the historical process." According to Kracauer, this game also manifests itself in actual photographs. "What the photographs by their sheer accumulation attempt to banish is the recollection of

death, which is part and parcel of every memory-image. . . . The world has become a photographable present, and the photographed present has been entirely eternalized. Seemingly ripped from the clutch of death, in reality it has succumbed to it all the more."[12]

Over half a century later, Roland Barthes describes photography in remarkably similar terms. In the process, he shifts his own analysis of the medium from a phenomenology of individual images to a meditation on the nature of death in general. As a consequence of photography's peculiar articulation of time, for Barthes every individual photograph is a chilling reminder of human mortality. This is especially poignant in photographs of himself. "Ultimately, what I am seeking in the photograph taken of me (the 'intention' according to which I look at it) is Death: Death is the eidos of the Photograph."[13]

Given that death has been part and parcel of photography's life, what does it mean to speak now of the terminal displacement of photography by digital imaging? No doubt computerized image-making processes are rapidly replacing or supplementing traditional still-camera images in many commercial situations, especially in advertising and photojournalism. Given the economies involved, it probably won't be long before almost all silver-based photographies are superceded by computer-driven processes. After all, whether by scanning in and manipulating bits of existing images in the form of data or by manufacturing fictional representations on screen (or both), computer operators can already produce printed images that are indistinguishable in look and quality from traditional photographs.

The main difference is that, whereas photography still claims some sort of objectivity, digital imaging remains an overtly fictional process. As a practice known to be nothing but fabrication, digitization abandons even the rhetoric of truth that has been such an important part of photography's cultural success. As the name suggests, digital processes actually return the production of photographic images to the whim of the creative human hand (to the digits). For that reason, digital images are actually closer in spirit to art and fiction than they are to documentation and fact.

This is perceived as a potential problem by industries that rely on photography as a mechanical and hence nonsubjective purveyor of information. Many European newspapers, anxious to preserve the integrity of their product, have discussed adding an *M* (for "manipulation") to credit lines accompanying any images that have been

digitally changed.[14] Of course, given that such credit lines will not actually tell readers what has been suppressed or enhanced, they may simply cast doubt on the truth of every image that henceforth appears in the paper. The dilemma is more rhetorical than ethical; newspapers have of course always manipulated their images in one way or another. The much-heralded advent of digital imaging simply means having to admit it to oneself and even, perhaps, to one's customers.[15]

This is an important point. The history of photography is already full of images that have been manipulated in some way or other. In fact, it could be argued that photography is nothing but that history. I am speaking not just of those notorious images where figures have been added or erased for the convenience of contemporary politics—I am suggesting that the production of any and every photograph involves intervention and manipulation. After all, what else is photography, other than the manipulation of light levels, exposure times, chemical concentrations, tonal ranges, and so on? In the mere act of transcribing world into picture, three dimensions into two, photographers necessarily manufacture the images they make. Artifice of one kind or another is therefore an inescapable part of photographic life. Photographs are no more or less "true" to the facts of the appearance of things in the world than are digital images.

This argument returns us to the dilemma of photography's ontology, to the analogical operations that supposedly give photography its identity as a medium. Remember that Barthes has already discounted resemblance to reality as a way of defining photography. In his terms, a given person may not look exactly as the photograph now portrays them, but we can at least be sure he or she was once there in front of the camera. We can be sure they were at some point present in time and space. For what makes photographs distinctive is that they depend on this original presence, a referent in the material world that at some time really did exist to imprint itself on a sheet of light-sensitive paper. Reality may have been transcribed, manipulated, or enhanced, but photography doesn't cast doubt on reality's actual existence.

Indeed, quite the opposite. Photography's plausibility has long rested on the uniqueness of its indexical relation to the world it images, a relation regarded as fundamental to its operation as a system of representation. As a footprint is to a foot, so is a photograph to its referent. It is as if objects have reached out and touched the surface of a photograph, leaving their own traces, as faithful to the contour of the original

object as a death mask is to the face of the newly departed. Photography is the world's self-produced momento mori. For this reason, a photograph of something has generally been held to be a proof of that thing's being, even if not of its truth.

Computer visualization, on the other hand, can produce photographic-style images with apparently no direct referent in an outside world. Where photography is inscribed by the things it represents, digital images may have no origin other than their own computer programs. These images may still be indices of a sort, but their referents are differential circuits and abstracted data banks of information (information that includes, in most cases, the look of the photographic). In other words, digital images are not so much signs of reality as signs of signs. They are representations of what is already perceived to be a series of representations. This is why digital images remain untroubled by the future anterior of presence, the "this has been" and "this will be" that animate the photograph. Digital images are in time but not of time. In this sense, the reality that the computer presents could be said to be virtual, a mere simulation of the analogically and temporally guaranteed reality promised by the photograph. And of course, when people seek to protect photography from the incursion of the digital, it is this reality that they are ultimately defending.

But how is reality, or photography for that matter, threatened? It should be clear to those familiar with the history of photography that a change in imaging technology will not, in and of itself, cause the disappearance of the photograph and the culture it sustains. Photography has never been any one technology; its nearly two centuries of development have been marked by numerous, competing instances of technological innovation and obsolescence, without any threat posed to the survival of the medium itself. Even if we continue to identify photography with certain archaic technologies, such as camera and film, those technologies themselves embody the idea of photography, or, more accurately, a persistent economy of photographic desires and concepts. The concepts inscribed within this economy include things like nature, knowledge, representation, time, space, observing subject, and observed object. Thus, to attempt a momentary definition, photography is the desire, conscious or not, to orchestrate a particular set of relationships between these various concepts.

While both concepts and relationships continue to endure, so will a photographic culture of one sort or another. Even if a computer does replace the traditional camera, that computer will continue to depend on the thinking and worldview of the

humans who program, control and direct it, just as photography now does. Thus, while the human survives, so will human values and human culture—no matter which image-making instrument that the human chooses to employ.

But are both "the human" and "the photographic" indeed still with us? Technology alone won't determine photography's future, but new technologies, as manifestations of our culture's latest worldview, may at least give us some vital signs of its present state of health. Digitization, prosthetic and cosmetic surgery, cloning, genetic engineering, artificial intelligence, virtual reality—each of these expanding fields of activity calls into question the presumed distinction between nature and culture, human and nonhuman, real and representation, truth and falsehood—all concepts on which the epistemology of the photographic has hitherto depended.

Back in 1982, the film *Blade Runner* looked into the near future and suggested that we will all soon become replicants, manufactured by the social-medical-industrial culture of the early twenty-first century as "more human than human," as living simulations of what the human is imagined to be. Deckard's job as a Blade Runner is to distinguish human from replicant, a distinction ironically only possible when he allows himself to become prosthesis to a viewing machine. At the start of the film he thinks he knows what a human is and isn't, but the harder he looks, the less clear the distinction becomes (the replicants even have snapshots, just like his own!). Eventually he has to abandon the attempt, unsure at the end even of the status of his own subjectivity. His dilemma is crucial; he has indeed identified the other, and it is himself.[16]

The twenty-first century is almost upon us, and already there is no one reading this who is a "natural" being, whose flesh has not been nourished by genetically enhanced corn, milk, or beef and whose body has not experienced some form of medical intervention, from artificial teeth to preventive innoculations to corrective surgery. Zucchinis are "enhanced" by human growth hormones. Pigs are bred to produce flesh genetically identical to that of humans. Who can any longer say with confidence where the human ends and the nonhuman begins? We are all already replicants.

Not that this is a new dilemma. Like any other technology, the body has always been in continual metamorphosis. Different today is the degree to which its permeability is a visible part of everyday life, a situation that insists on a rigorous questioning not only of the body but also of the very nature of humanness. We have entered an age in which the human and all that appends to it can no longer remain a stable site of

knowledge precisely because the human cannot be clearly identified. And if the human is under erasure, can photography and photographic culture simply remain as before?

Manifestations of this are all around (as well as within) us. Contemporary philosophy raises serious questions about the conceptual stability of the index on which photography's identity is presumed to rest. Photographs are privileged over digital images because they are indexical signs, images inscribed by the very objects to which they refer. This is taken to mean that, whatever degrees of mediation may be introduced, photographs are ultimately direct imprints of reality itself. But as Derrida points out, in Peirce's writing "the thing itself is a sign ... from the moment there is meaning there are nothing but signs."[17] In other words, the very Peircian semiotics upon which photography's analogical stability is founded would have us rewrite photography as a signing of signs, recognizing that it is at the same time a *digital* process.

Philosophy gives us one way to think the complication that is photography's identity. Certain developments in the art world give us another. It used to be said that photography was tormented by the ghost of painting. Used to be said. For nowadays photography is the one that's doing the haunting. Where once photography was measured according to the conventions and aesthetic values of painting, today the situation is somewhat more complicated. Who could deny that much of the most interesting art of recent years has been entirely caught up in the photographic? David Salle, Cindy Sherman, Laurie Anderson, Jeff Koons, Gerhard Richter: the work of each of these artists is inhabited by a troubling fusion of real and fictional, referent and reference, a fusion directly generated by their exploitation of photography.

Postmodern art photography, such as that produced by Sherman, is notorious for obsessively reflecting on itself, for parasitically reproducing itself as selective quotations from photography's own pictorial history. According to critics like Paul Virilio, "Photography, overcome by indifference, seems from now on incapable of finding something new to photograph."[18] However, postmodernism's photography of photography (its production of "photography" as opposed to mere photographs) has been generated not by indifference but by its opposite—by a concern for photography's own differences from itself, by a questioning of the traditional avant-garde desire for the "new" and by a somewhat anxious recognition that photography had previously neglected its own identity as worthy of serious exploration.

In a return to the strategies of the conceptual movement of the late sixties and early seventies, a lot of contemporary photographic imagery is now made to reappear as solid transfigurations of glass, timber, plaster, wax, paint, graphite, lead, paper, or vinyl. As if to mire forever the distinction between taking and making, image and thing, we confront solid photo-objects designed to be seen rather than seen through. In the process, the boundary between photography and other media like painting, sculpture, and performance has been made increasingly porous, leaving the photographic residing everywhere but nowhere in particular. With this post-photography, we enter an era after, even if not yet quite beyond photography. Like a ghost, the apparition of the photographic continues to surprise us with its presence, long after its original manifestation is supposed to have departed from the scene. In other words, even if photography as a separate entity may be fast disappearing, the photographic as a vocabulary of conventions and references lives on in ever-expanding splendor.[19]

Photography, it appears, is a logic that continually returns to haunt itself. It is its own "medium." Each of my ghost stories has pointed to the enigmatic quality of photography's death, or, more precisely, each has posed the necessity of questioning our present understanding of the very concepts of "life" and "death." Given the advent of new imaging processes, photography may indeed be on the verge of losing its privileged place within modern culture. This does not mean that photographic images will no longer be made, but it does signal the possibility of a dramatic transformation of their meaning and value, and therefore of the medium's ongoing significance. However, any such shift in significance will have as much to do with general epistemological changes as with the advent of digital imaging. Photography will cease to be a dominant element of modern life only when the desire to photograph, and the peculiar arrangement of knowledges and investments that that desire represents, is refigured as another social and cultural formation. Photography's passing must necessarily entail the inscription of another way of seeing—and of being.

I have suggested that photography has been haunted by the specter of such a death throughout its long life, just as it has always been inhabited by the very thing, digitization, that is supposed to deal the fatal blow. In other words, what is really at stake in the current debate about digital imaging is not only photography's possible future but also the nature of its past and present.

Chapter 1

1. Jacques Derrida, *Positions,* trans. Alan Bass (Chicago: The University of Chicago Press, 1981), 59.

2. For useful discussions of this development, see "Photographs and Professionals: A Discussion by Peter Bunnell, Ronald Feldman, Lucien Goldschmidt, Harold Jones, Lee Witkin and Aaron Siskind," *The Print Collectors' Newsletter* 4 (July 1973): 54–60; Allan Sekula, "The Instrumental Image: Steichen at War," *Artforum* 14, no. 4 (December 1975): 26–35; Martha Rosler, "Lookers, Buyers, Dealers, and Makers: Thoughts on Audience" (1979), in Brian Wallis, ed., *Art after Modernism: Rethinking Representation* (New York: New Museum of Contemporary Art, 1984), 310–39; Abigail Solomon-Godeau, "Calotypomania: The Gourmet Guide to Nineteenth-Century Photography" (1983) and "Canon Fodder: Authoring Eugène Atget" (1986), in *Photography at the Dock: Essays on Photographic History, Institutions, and Practices* (Minneapolis: University of Minnesota Press, 1991), 4–51; Christopher Phillips, "A Mnemonic Art?:

Calotype Aesthetics at Princeton," *October* 26 (Fall 1983): 34–62.

3. John Berger, *Ways of Seeing* (London: British Broadcasting Corporation, 1972); Susan Sontag, *On Photography* (New York: Penguin Books, 1977); Roland Barthes, *Image-Music-Text,* trans. Stephen Heath (New York: Hill and Wang, 1977). These books followed the publication in English of Walter Benjamin's much discussed 1936 essay "The Work of Art in the Age of Mechanical Reproduction," in *Illuminations,* trans. Harry Zohn (New York: Schocken Books, 1969). This was soon followed by Stanley Mitchell's translation of Benjamin's 1931 essay "A Short History of Photography" in the British magazine *Screen* 13, no. 1 (Spring 1972).

4. There is insufficient space here to explore the history and implications of postmodernism as a general critical phenomenon. The following selection of essays and anthologies provides an introduction to the field: Hal Foster, ed., *The Anti-Aesthetic: Essays on Postmodern Culture* (Port Townsend: Bay Press, 1983); Andreas Huyssen, "Mapping the

Postmodern," *New German Critique* 33 (Fall 1984): 5–52; Brian Wallis, ed., *Art After Modernism: Rethinking Representation* (New York: New Museum of Contemporary Art, 1984); John Rajchman, "Postmodernism in a Nominalist Frame: The Emergence and Diffusion of a Cultural Category," *Flash Art International Edition* 137 (November–December 1987): 49–51; Thomas Docherty, ed., *Postmodernism: A Reader* (New York: Columbia University Press, 1993): Vicki Kirby, "Viral Identities: Feminisms and Postmodernisms" in Norma Grieve and Ailsa Burns, eds., *Australian Women: Contemporary Feminist Thought* (Oxford University Press, 1994), 120–32, 314–16.

5. The Editors (Rosalind Krauss and Annette Michelson), "Photography: A Special Issue," *October* 5 (Summer 1978): 4.

6. John Tagg, "Evidence, Truth and Order: Photographic Records and the Growth of the State" (1984), in *The Burden of Representation: Essays on Photographies and Histories* (London: MacMillan Education, 1988), 63. Tagg reiterates this view of photography in virtually identical terms in another essay, "God's Sanitary Law: Slum Clearance and Photography in Late Nineteenth-Century Leeds" (1988), in *Burden,* 118. A similar set of claims also appears in a later essay, "Totalled Machines: Criticism, Photography and Technological Change," *New Formations* 7 (Spring 1989): 31: "Even this cursory mapping is enough to dislodge the idea that the territory of photography is a unity. There turns out to be no meaning to photography as such. The meaning and value of photographies cannot be adjudicated outside specific language games, whose playing-fields piece out a topography we must trace."

For critiques of Tagg's work, see Geoffrey Batchen, "Photography, Power, and Representation," *Afterimage* 16, no. 4 (November 1988): 7–9; David Phillips, "The Subject of Photography," *The Oxford Art Journal* 12, no. 2 (1989): 115–21; Naomi Schor, "*Cartes Postales*: Representing Paris 1900," *Critical Inquiry* 18 (Winter 1992): 191–95.

7. Tagg, "The Currency of the Photograph" (1979), in *Burden,* 165–66.

8. Tagg, "Evidence, Truth and Order" (1984), in *Burden,* 64.

9. Tagg, "A Means of Surveillance" (1980), in *Burden,* 71

10. Tagg, "Evidence, Truth and Order" (1984), in *Burden,* 65.

11. Allan Sekula, introduction, in *Photography Against the Grain: Essays and Photo Works 1973–1983* (Halifax: Press of the Nova Scotia College of Art and Design, 1984), xv.

12. Sekula, "The Traffic in Photographs" (1981), in *Photography Against the Grain,* 78.

13. Ibid., 96.

14. Ibid., 93.

15. Allan Sekula, "The Body and the Archive," *October* 39 (Winter 1986): 4.

16. Allan Sekula, "Photography Between Labour and Capital," in Benjamin H. D. Buchloh and Robert Wilkie, eds., *Mining Photographs and Other Pictures 1948–1968: Photographs by Leslie Shedden* (Halifax: Press of the Nova Scotia College of Art and Design, 1983), 201.

17. Sekula, "The Traffic in Photographs" (1981), in *Photography Against the Grain,* 79.

18. Sekula, "The Body and the Archive," *October,* 6.

19. Sekula, "Photography Between Labour and Capital," *Mining Photographs,* 218.

20. Victor Burgin, introduction, in *Thinking Photography* (London: MacMillan, 1982), 9.

21. Burgin, "Photography, Phantasy, Function" (1980), in *Thinking Photography,* 215–16.

22. Victor Burgin, "Something About Photography Theory," *Screen* 25, no. 1 (January–February 1984): 65.

23. Burgin, "Looking at Photographs" (1977), in *Thinking Photography,* 144.

24. Ibid., 145.

25. Ibid., 150.

26. Ibid., 152.

27. Ibid., 153.

28. Victor Burgin, "Tea with Madeleine" (1984), *The End of Art Theory: Criticism and Postmodernity* (London: MacMillan Education, 1986), 98.

29. Although these writers by no means constitute a "group," essays by Tagg, Sekula, and Burgin were reproduced together (along with contributions from Walter Benjamin, Umberto Eco, and Simon Watney) in *Thinking Photography,* an influential anthology of critical writings on photography edited by Burgin and published by MacMillan in 1982.

30. Abigail Solomon-Godeau, introduction, in *Photography at the Dock,* xxi–xxxiv.

31. All of the critics discussed so far have at some point positioned themselves in direct opposition to an art-historical approach to photography, which they often identify specifically with John Szarkowski and his formalist exhibition practice. In the introduction to the 1988 anthology *The Burden of Representation,* John Tagg mentions Szarkowski as continuing a "programme for a peculiar photographic modernism" that his own work sets out to dispute (14–15). In "Photography, Phantasy, Function" (1980), Victor Burgin offers an extended critique of Szarkowski's formalism, contrasting it with a photographic discourse (like his own) that attends to the seeing subject and its social ramifications (*Thinking Photography,* 208–11).

Allan Sekula similarly asks his readers to "reject" Szarkowski's "triumphalist but also rather mournful crypto-Hegelian teleology." See Allan Sekula, "Walker Evans and the Police," in Jean-Francois Chevrier, Allan Sekula, and Benjamin H. D. Buchloh, *Walker Evans and Dan Graham* (New York: Whitney Museum of American Art, 1992), 193–94. Of all of these writers, Abigail Solomon-Godeau is perhaps Szarkowski's most vociferous critic. Indeed, in her introduction to *Photography at the Dock* (which she describes as a "chronicle of photographic discourse of the 1980s"), she admits that "reference to and criticism of the activities of the Museum of Modern Art's Photography Department and its enormously powerful director, John Szarkowski, constitute a refrain—a veritable leitmotif—in the essays" (Ibid., xix, xxv). In her book on the recent championing of Marcel Duchamp, Amelia Jones points to how postmodern art criticism in general has positioned itself as a counterdiscourse to formalism. "As defined in discussions of contemporary art, postmodernism takes form precisely in relation to a conception of modernism that is reductively Greenbergian: outmoded, formalist, masculinist, and critically bankrupt. In the theatrical terms of Oedipus, postmodernism is implicated in modernism precisely through its desire to overthrow it—working to kill the (Greenbergian) father and blinding itself in the process." See Amelia Jones, *Postmodernism and the En-Gendering of Marcel Duchamp* (Cambridge University Press, 1994), 1.

32. Clement Greenberg, "Modernist Painting" (1961), as reproduced in Francis Frascina and Charles Harrison, eds., *Modern Art and Modernism: A Critical Anthology* (London: Harper & Row, 1982), 5.

33. Ibid., 5.

34. Clement Greenberg, "Four Photographers" (1964), *History of Photography* 15, no. 2 (Summer 1991), 131.

35. Ibid., 131.

36. André Bazin, "The Ontology of the Photographic Image" (1945), in Peninah R. Petruck, ed., *The Camera Viewed: Writings on Twentieth-Century Photography Vol. 2* (New York: E. P. Dutton, 1979), 142. See also Rudolph Arnheim, "On the Nature of Photography," *Critical Inquiry* 1, no. 1 (1974), 149–61.

37. Bazin, ibid., 145–46.

38. John Szarkowski, as quoted in Maren Stange, "Photography and the Institution: Szarkowski at the Modern," in Jerome Liebling, ed., *Photography: Current Perspectives* (*Massachusetts Review* 1978): 69. See also John Szarkowski, "A Different Kind of Art," *The New York Times Magazine,* April 13, 1975, 16, 64–68; and Virginia Dell, "John Szarkowski's Guide," *Afterimage* 12, no. 3 (October 1984): 8–11.

39. Szarkowski, as quoted in Liebling, ed., *Photography,* 73.

40. Ibid., 74. In this statement, Szarkowski comes closer to the "situational" formalism of Michael Fried. As Fried has argued: "The essence of painting is not something irreducible. Rather, the task of the modernist painter is to discover those conventions which at a given moment, alone are capable of establishing his work's identity as painting." See Michael Fried, "How Modernism Works: a response to T. J. Clark," in Francis Frascina, ed., *Pollock and After: The Critical Debate* (New York: Harper & Row, 1985), 69, as well as his

earlier "Three American Painters" (1965), in *Modern Art and Modernism,* 115–21.

41. Ibid., 72.

42. John Szarkowski, *The Photographer's Eye* (New York: Museum of Modern Art, 1966), unpaginated.

43. John Szarkowski, *Photography Until Now* (New York: Museum of Modern Art, 1989). For a scathing critique of this exhibition, see Abigail Solomon-Godeau, "Mandarin Modernism: Photography Until Now," *Art in America* 78, no. 12 (December 1990): 140–49, 183.

44. Szarkowski, *The Photographer's Eye,* unpaginated. For more on Szarkowski's approach to photographic history, see Christopher Phillips, "The Judgment Seat of Photography" (1982), in Annette Michelson, Rosalind Krauss, Douglas Crimp, and Joan Copjec, eds., *October: The First Decade* (Cambridge: MIT Press, 1987), 257–93; Jonathan Green, "Surrogate Reality," *American Photography: A Critical History 1945 to the Present* (New York: Harry N. Abrams, 1984), 94–103; Joel Eisinger, "Formalism," *Trace and Transformation: American Criticism of Photography in the Modernist Period* (Albuquerque: University of New Mexico Press, 1995), 210–44.

45. Szarkowski, Ibid.

46. For some background on the writing of this book, see Marta Braun, "A History of the History of Photography," *Photo Communiqué* 2, no. 4 (Winter 1980–81): 21–23; Mary Warner Marien, "What Shall We Tell the Children?: Photography and Its Text (Books)," *Afterimage* 13, no. 9 (April 1986): 4–7; Barbara L. Michaels, "Behind the Scenes of Photographic

History: Reyher, Newhall and Atget," *Afterimage* 15, no. 10 (May 1988): 14–17; and Beaumont Newhall, *Focus: Memoirs of a Life in Photography* (Boston: Bulfinch Press, 1993).

47. Newhall's book has been extraordinarily influential on subsequent attempts to write the history of photography. Most have reiterated the basic structure of his art-historical model, concentrating on certain endlessly reproduced masterworks, usually photographs that are exceptional rather than typical of their genre and on a narrative organized around individual biographies and stylistic developments. Important (but often anonymous) photographic genres such as pornography, snapshots, or advertising, three of the largest in terms of sheer volume of production, are given scant attention (except when they can be tied into an art history). A few examples include: Peter Pollack, *The Picture History of Photography* (New York: Harry N. Abrams, 1969); Ian Jeffrey, *Photography: A Concise History* (London: Thames and Hudson, 1981); Naomi Rosenblum, *A World History of Photography* (New York: Abbeville Press, 1984); Jean-Claude Lemagny and André Rouillé, eds., *A History of Photography: Social and Cultural Perspectives* (Cambridge: Cambridge University Press, 1987); Gael Newton, *Shades of Light: Photography and Australia 1839–1988* (Canberra: Australian National Gallery, 1988); Sarah Greenhough, Joel Snyder, David Travis, and Colin Westerbeck, *On the Art of Fixing a Shadow* (Washington: National Gallery of Art and the Art Institute of Chicago, 1989); Mike Weaver, ed., *The Art of Photography* (London: The Royal Academy of the Arts, 1989); Michel Frizot, ed., *Nouvelle Histoire de la Photographie* (Paris: Bordas, 1994). One notable exception to this tendency is Heinz Henisch and Bridget

Henisch, *The Photographic Experience 1839–1914: Images and Attitudes* (University Park: Pennsylvania State University Press, 1994).

48. Szarkowski, *Photography Until Now*, 9.

49. Peter Galassi, *Before Photography: Painting and the Invention of Photography* (New York: Museum of Modern Art, 1981).

50. Ibid., 12.

51. Ibid., 14.

52. Ibid., 18, 28, 18.

53. Ibid., 25.

54. Ibid., 29.

55. Abigail Solomon-Godeau, "Tunnel Vision," *The Print Collector's Newsletter* 12, no. 6 (January–February 1982): 175. For a further critique of *Before Photography*, see Joel Snyder, "Review of Peter Galassi's *Before Photography*," *Studies in Visual Communication* (Winter 1982): 110–16.

56. Abigail Solomon-Godeau, "Calotypomania," in *Photography at the Dock*, 25. Interestingly, Galassi himself describes Beaumont Newhall's account of photography's history as "a tautology which in effect remands the interpretive burden to the scientific tradition" (*Before Photography*, 12). Galassi sees himself revising this "scientific tradition" in *Before Photography*. This is the same tradition that Eugenia Parry Janis contests in *The Art of French Calotype*, the exhibition and catalogue being reviewed (negatively, because she sees it as yet another formalist exercise in connoisseurship) in Solomon-Godeau's essay "Calotypomania." See Eugenia Parry Janis, "To Still the Telling Lens: Observations on the Art

of French Calotype," *The Creative Eye: Essays in Photographic Criticism* (Occasional Papers of the Conneticut Humanities Council, no. 4, 1981), 53–64, and André Jammes and Eugenia Parry Janis, *The Art of French Calotype* (Princeton: Princeton University Press, 1983).

57. Jacques Derrida, "LIMITED INC..abc," *Glyph* 2 (1977): 236.

58. Ibid.

59. Szarkowski, "Before Photography," *Photography Until Now*, 11–19.

60. Victor Burgin, "Photography, Phantasy, Function" (1980), *Thinking Photography*, 187.

61. John Tagg, "A Democracy of the Image" (1984), *The Burden of Representation*, 40–41.

62. Allan Sekula, "Traffic in Photographs" (1981), *Photography Against the Grain*, 97.

Chapter 2

1. My opening paragraph is a photographic paraphrase of a passage on the history of writing from Jacques Derrida's *Of Grammatology*, trans. Gayatri Chakravorty Spivak (Baltimore: The Johns Hopkins University Press, 1976), 28.

2. Helmut Gernsheim, *The Origins of Photography* (London: Thames and Hudson, 1982), 6.

3. From "Motives and particulars of the Bill presented by the Minister of the Interior (sitting of 15th June, 1839)," in *An Historical and Descriptive Account of the various Processes of the Daguerreotype and the Diorama by Daguerre* (London: McLean, 1839; reprint: New York: Krauss Reprint Co., 1969), 1, 3. François Arago's "Report" of July 6, 1839 to the

Chamber of Deputies was keen not only to distinguish Daguerre's invention from that of Niépce but also to repel foreign claiments (and particularly Talbot) to the title of first inventor of photography.

Had it been possible to disavow the importance of the Daguerreotype, and the place which it cannot fail to hold in the esteem of all men, all hesitation on our part would have ceased when we should have beheld the pressing avidity of foreign nations in endeavouring to profit by an erroneous date, a fact held in doubt, pretexts of the most frivolous nature, to substantiate a claim to priority, to try to add the brilliant ornament which will always be formed by photographical processes, to the crown of discoveries which every one of these nations is wont to wear. (as reproduced in Daguerre, *Account*, 30–31)

Arago's statement to the Académie des Sciences on January 7 is reproduced in Helmut and Alison Gernsheim, *L. J. M. Daguerre: The History of the Diorama and the Daguerreotype* (New York: Dover Publications, 1968), 82–84. Arago's official statement was in turn preempted by newspaper reports, such as that written by H. Gaucheraud for the *Gazette de France* of January 6, 1839 (reproduced in Aaron Scharf, *Pioneers of Photography: An album of pictures and words* [London: British Broadcasting Corporation, 1975], 37).

4. Victor Fouque, *The Truth concerning The Invention of Photography: Nicéphore Niepce* (sic) *his Life, his Endeavours, his Works* (Paris: Library of Authors and of the Academy of Booklovers, 1867; reprint, New York: Arno Press, 1973), 1. Fouque's vehement support of Niépce as photography's "true inventor" is supported by recent essays by Jack Naylor, "The Truth Concerning the Invention of Photography," and Jean-Louis Marignier, "Photography: The

Invention of Nicéphore Niépce," in *The Journal: New England Journal of Photographic History,* nos. 144 and 145 (1995): 30–46.

5. Gernsheim, *The Origins of Photography,* 6. For more on his discovery of Niépce's "first photograph" see Helmut Gernsheim, "The 150th Anniversary of Photography," *History of Photography* 1, no. 1 (January 1977): 3–8.

6. Marcel Bovis, "Technical Processes," *A History of Photography: Social and Cultural Perspectives,* Jean-Claude Lemagny and André Rouillé, eds. (Cambridge: Cambridge University Press, 1987), 269.

7. Josef Maria Eder, *History of Photography* (New York: Columbia University Press, 1890; revised 1945), 60, 62. See also the section of Eder's chapter on Schulze, headed in typically forthright fashion "Rejection of the erroneous presentation of Schulze's merits by Potonniée in his *Histoire de la Photographie,* 1925" (62–63).

8. Lynn White, Jr., *Machina Ex Deo: Essays in the Dynamism of Western Culture* (Cambridge: MIT Press, 1968), 111–12.

9. Humphry Davy, "An Account of a Method of Copying Paintings Upon Glass etc," *Journals of The Royal Institution,* vol. 1 (London, 1802), as reproduced in R. B. Litchfield, *Tom Wedgwood: The First Photographer, an Account of his Life, his Discovery and his Friendship with Samuel Taylor Coleridge including the Letters of Coleridge to the Wedgwoods, and an Examination of Accounts of alleged earlier Photographic Discoveries* (London: Duckworth and Co., 1903), 189, 192, 194.

10. Litchfield, ibid., 201.

11. For more details on the milieu in which Wedgwood studied and experimented, see my

"Tom Wedgwood and Humphry Davy: 'An Account of a Method,'" *History of Photography* 17, no. 2 (Summer 1993): 172–83.

12. The full title of Fulhame's self-published book was *An Essay on Combustion, with a view to a New Art of Dying and Painting, wherein the Phlogistic and Antiphlogistic Hypotheses are Proved Erroneous.* It was republished in Germany in 1798 and in the United States in 1810. Fulhame's work is discussed in more detail in Larry Schaaf, "The First Fifty Years of British Photography: 1794–1844," in Michael Pritchard, ed., *Technology and Art: The Birth and Early Years of Photography* (Bath: Royal Photographic Society Historical Group, 1990), 11–12, and in Larry Schaaf, *Sun Gardens: Victorian Photograms by Anna Atkins* (New York: Aperture, 1985), 23, 100.

13. See Larry Schaaf, "Sir John Herschel's 1839 Royal Society Paper on Photography," *History of Photography* 3, no. 1 (January 1979): 47–60.

14. Humphry Davy, "An Account of a Method of Copying Paintings Upon Glass etc," in Beaumont Newhall, eds., *Photography: Essays & Images* (New York: Museum of Modern Art, 1980), 16.

15. Henry Talbot (1844), as quoted in Scharf, *Pioneers of Photography,* 17.

16. Newhall, *Photography: Essays & Images,* 23.

17. An example of this ware is reproduced in Eliza Meteyard, *The Life of Josiah Wedgwood, Vol. II* (London: Hurst & Blackett, 1866), 585. The name "silvered ware" comes from a letter by Tom Wedgwood written in February 1791. It was also sometimes known as "silver lustre ware."

18. Anthony Carlisle, as quoted in Gail Buckland, *Fox Talbot and the Invention of Photography* (St. Lucia, Australia: University of Queensland Press, 1980), 41.

19. As quoted in R. B. Litchfield, *Tom Wedgwood,* 185–86.

20. Georges Potonniée, *The History of the Discovery of Photography,* trans. Edward Epstean (New York: Tennant and Ward, 1936), 42.

21. See Martin Gasser, "Histories of Photography 1839–1939," *History of Photography* 16, no. 1 (Spring 1992): 52. It is reproduced for example in Newhall, ed., *Photography: Essays & Images,* 13–14, under the title "Photography Predicted." Newhall dates Tiphaigne's "remarkable prophecy" at 1760. For a discussion of the date see Potonniée, *The History of the Discovery of Photography,* note 5, page 46. In *The Origins of Photography,* Helmut Gernsheim refers to Tiphaigne's book as "a remarkable forecast of photography" (22–23). He also refers to a 1699 fable by Fénelon and a tale by E.T.A. Hoffman as other early "Phantoms of Photography."

22. Tiphaigne de la Roche, *Giphantie* (1760), as reproduced in Potonniée, *The History of the Discovery of Photography,* 44.

23. Potonniée, ibid.

24. As quoted in Eder, *History of Photography,* 145. See also Gernsheim, *The Origins of Photography,* 28, and my "Tom Wedgwood and Humphry Davy," 183. Young was asked in 1828, the year before he died, by Sir Everard Home to comment on the potential utility of the heliographic experiments of Nicéphore Niépce. He made no connection between the aspirations of Niépce and those of Wedgwood and Davy (and himself?) as published twenty-six years before. After examining some of Niépce's plates, Young replied: "Mr. Nepcés [sic] invention appears to me to be very neat and elegant and I have no knowledge of any similar method having been before employed. How far it may become practically useful thereaf-

ter, is impossible for me to judge, especially without knowing the whole of the secret. But I see no reason to doubt of its utility, except that all novelties are liable to unforeseen difficulties" (as quoted in Torichan Pavlovich Kravets, ed., *Documents on the History of the Invention of Photography* [New York: Arno Press, 1979], document no. 69). In 1839 John Herschel described an experiment similar to the one Young undertook in 1803 as "a strictly photographic process." In the process he added Arago and Fresnel to the list of potential proto-photographers: "The blackening of Chloride of Silver had already been employed by Mssrs. Arago and Fresnel for the purpose of exhibiting by a strictly photographic process, the fringes of interference formed by the Chemical rays and thus demonstrating their susceptibility of Polarization. But for the present purpose it was necessary not only to *produce,* but to *preserve* the blackened traces" (John Herschel, "Note on the Art of Photography or The Application of the Chemical Rays of Light to the Purposes of Pictorial Representation" [March 14, 1839], as reproduced in Larry Schaaf, "Sir John Herschel's 1839 Royal Society Paper on Photography," *History of Photography* 3, no., 1 [January 1979]: 57–58).

25. Pierre Harmant, "Paleophotographic Studies: Was Photography Born in the 18th Century?," *History of Photography* 4, no. 1 (January 1980): 39–45. Gernsheim (*Origins,* 29) also lends some credence to a 1796 date.

26. As declared in *An Historical and Descriptive Account of the Daguerréotype and the Diorama by Daguerre,* 39.

27. Letter from Claude to Nicéphore Niépce, February 24, 1824, as quoted in Fouque, *The Truth Concerning the Invention of Photography,* 57.

28. Gernsheim, *The Origins of Photography,* 42.

29. H. and A. Gernsheim, *L. J. M. Daguerre,* 81.

30. Talbot, *The Pencil of Nature* (1844–46), unpaginated. Larry Schaaf has suggested that Talbot's thinking on photography in 1833 was actually prompted by his subconscious memory of an 1831 experiment by John Herschel: "I believe that what he was trying to recall was an 1831 demonstration that Herschel had made in Talbot's presence to Charles Babbage and Sir David Brewster. Herschel showed that one could form images in a test tube using light sensitive salts of platinum. . . . Using light to effect a chemical change was, of course, the basis of Talbot's inspiration just two years later, and Herschel's demonstration must have been at least a component of Talbot's subconscious underpinnings for the idea" (Larry Schaaf, "The First Fifty Years of British Photography: 1794–1844," in *Technology and Art,* 11).

31. Pierre Harmant, "Anno Lucis 1839: 1st Part," *Camera* no. 5 (May 1977): 39.

32. See Martin Gasser, "Histories of Photography 1839–1939," *History of Photography.* The sexualized economy of this process of historical claim and counterclaim is made explicit by W. Jerome Harrison, author of *The History of Photography* (1887), in a statement printed in the *British Journal of Photography* (October 12, 1888): "Inventing is like making love; no man can feel sure of having been 'the first.'" (As quoted in John Hammond, *The Camera Obscura: A Chronicle* [Bristol: Adam Hilgar Ltd, 1981], 131).

33. See for example *History of Photography* 1, no. 4 (October 1977), which reproduces a watercolor held in the Lacock Abbey Collection with the remarkable caption "W. H. Fox Talbot (b. 1800), Father of Photography, aged 3, From a watercolour, (artist unknown)." John Werge suggests an even

more crowded patrilineal genealogy for photography: "If we consider such men as Niépce, Reade, Daguerre, and Fox Talbot the fathers of photography, we cannot but look upon Thomas Wedgwood as the Grand Father, and the centenary of his first achievement should be celebrated with becoming honour as the English centenary of photography" (John Werge, *The Evolution of Photography* [New York: Arno Press, 1890, 1973], 125).

34. The tone of these cries of triumph is exemplified in Talbot's self-consciously learned choice of quotation for the title page of his first book of photographs, *The Pencil of Nature* (1844–46). Taken from Virgil's *Georgics* (III, 293), the Latin inscription reads: *Juvat Ire Jugis Qua Nulla Priorum Castaliam Molli Devertitur Orbita Clivo* (roughly translated, "It is a joyous thing to be the first to cross a mountain"). Talbot took out a patent on his Calotype process on February 8, 1841. (For a reproduction of this patent, no. 8842, see Gail Buckland, *Fox Talbot and the Invention of Photography* [Boston: David R. Godine, 1980], 204–6.) Daguerre had already sought to patent his daguerreotype process "within England, Wales, and the town of Berwick-upon-Tweed, and in all Her Majesty's Colonies and Plantations abroad" on June 1, 1839 and succeeded in doing so on July 15 of that year. See H.&A. Gernsheim, *L. J. M. Daguerre,* 143–49, and R. Derek Wood, "The Daguerreotype Patent, The British Government, and The Royal Society," *History of Photography* 4, no. 1 [January 1980]: 53–59. There was almost immediate opposition to both of these patents and a number of subsequent injunctions and court cases took place. For a detailed discussion of two of these from 1852 and 1854, both involving Talbot, see R. Derek Wood, "J. B. Reade, F. R. S., and the Early History of Photography: Part II. Gallic Acid and Talbot's Calotype Patent," *Annals of Science* 27, no. 1 (March 1971): 47–

83., and R. Derek Wood, "The Involvement of Sir John Herschel in the Photographic Patent Case, Talbot v. Henderson, 1854," *Annals of Science* 27, no. 3 (September 1971): 239–64. See also the chapter headed "Photography: Of Priority, Plagiarism and Patents" in H. J. P. Arnold, *William Henry Fox Talbot: Pioneer of Photography and Man of Science* (London: Hutchinson Benham, 1977), 175–216.

35. Vincent Descombes has even argued that "Foucault's theory of history must be sought in his manner of detailing these births and deaths." See Descombes, *Modern French Philosophy,* trans. L. Scott Fox and J. M. Harding (Cambridge: Cambridge University Press, 1980), 115.

36. Michel Foucault, *The Archaeology of Knowledge,* trans. A. M. Sheridan Smith (New York: Pantheon Books, 1972), 144.

37. Pierre Harmant, "Anno Lucis 1839: 3rd part," *Camera,* no. 10 (October 1977): 42.

38. *The Athenaeum,* no. 606, 435–36, as quoted in R. Derek Wood, "J. B. Reade, F. R. S., and the Early History of Photography: Part I. A Reassessment of the Discovery of Contemporary Evidence," *Annals of Science* 27, no. 1 (March 1971): 13–45. *The Athenaeum* was not the only English journal to be sent such claims. On February 9, 1839, *The Literary Gazette* published a letter from an experimenter who claimed that he and two friends had, some thirty years previously, devised a process similar to Talbot's. They had given up, however, when they found "that the effects produced were the reverse of true—that which ought to have been black remaining white, and that which ought to have been white becoming black." It had not occurred to them at that time to make "an image of the image on a fresh field of muriate of silver, introduced into the cam-

era obscura for the purpose." The letter is quoted in Keith I. P. Adamson, "1839–The Year of Daguerre," *History of Photography* 13, no. 3 (July–September 1989), 194.

39. The general desire to photograph that its invention both answered and induced is evidenced by its remarkably rapid spread around the globe. The daguerreotype was publicly available in France from August 19, 1839; a survey of other countries shows that daguerreotypes were first taken in England on September 13, in Germany on September 15, in the United States on September 16, in Poland on October 13 (with a "photogenic drawing" being produced there on July 9), in Egypt in November, and in Spain on November 18. Other countries quickly to experience the daguerreotype include Brazil (January 1840), Uraguay (February 29, 1840), Canada (September 17, 1840), Romania (1840), and Australia (May 13, 1841).

40. Contrary to the information given in some histories of photography, Davy's "Account" was in fact widely read and discussed. After appearing in the first issue of the *Journals of the Royal Institution of Great Britain* in June 1802, the "Account" was subsequently reproduced either in full, in translation, or as an abstract in a number of other journals. These included *Nicholson's Journal of Natural Philosophy, Chemistry and the Arts* (London [November 1802]), the *Annale di chimica e storia naturale* (Pavia [1802]), the *Annalen der Physik* (Halle [1803]), the *Magazin for naturvidenskaberne* (Berne [1824]), the *Annales de chimie, ou recuil de mémoires concernant la chimie et les arts qui en dépendent* (Paris [1802]), the *Journal für die Chemie, Physik und Mineralogie* (Berlin [1807]), *Annals of Philosophy* 3 ([1802]), *Bibliotheque Britanique* 22 (Geneva [January 1803]), William Henry's *Epitome of Experimental Chemistry* (Boston [1810]), *Ackerman's*

Repository 2 ([October 1816]), John Webster's *Manual of Chemistry* (Boston [2nd ed., 1828]), and the *Bulletin des sciences* (Paris [c. 1820]). See June Z. Fullmer, *Sir Humphry Davy's Published Works* (Cambridge: Harvard University Press, 1969), 36, and Schaaf, "The First Fifty Years of British Photography: 1794–1844," 18. Moreover David Brewster, later to be a close friend of Henry Talbot's, published a review of the "Account" in the December 1802 issue of the *Edinburgh Magazine,* and extensive extracts were included in Frederick Accum's *System of Theoretical and Practical Chemistry* and John Imison's *System of Theoretical and Practical Chemistry,* both published in 1803. The French were obviously also aware of Wedgwood and Davy's experiments. In a "Report" to the Chamber of Deputies of July 3, 1839, Arago includes the "Account" in his story of the daguerreotype's prehistory but disparagingly describes Wedgwood and Davy's experiments as "unsatisfactory and insignificant." See *An Historical and Descriptive Account of the various Processes of the Daguerréotype and the Diorama by Daguerre,* 15–16.

41. Daguerre had first publicly announced his invention, prematurely as it turned out, in a statement printed in *Journal des Artistes* on September 27, 1835 (H. & A. Gernsheim, *L. J. M. Daguerre,* 73). As a consequence, his experiments were known among the Parisian elite. For example, Violet-le-Duc's father wrote to his son in Italy in 1836 to tell him about the purported marvels of the new process (André Jammes and Eugenia Parry Janis, *The Art of French Calotype* [Princeton: Princeton University Press, 1987], 146). However, Charles Chevalier would have it that as early as 1824 Daguerre had proclaimed to his friends (the Chevaliers, Paul Carpentier, Peron, "and others") that "I have found a way of fixing the images of the camera! I have seized the fleeting light

and imprisoned it! I have forced the sun to paint pictures for me!" (See H. & A. Gernsheim, *L. J. M. Daguerre,* 49.) As a consequence of these exclamations and Daguerre's promotional efforts, including his publication of a subscription brochure in late 1838, his experiments were apparently familiar to a certain echelon of Parisian society prior to Arago's announcement in January of 1839. A manuscript, written by Jules Pelletan and dated 1838, begins by asserting as much: "For some time there has been much talk in the circles of savants and artists of the fine discovery which M. Daguerre has made." This manuscript was published, with some minor revisions, in the Paris journal *La Presse* on January 24, 1839. See Peter J. Mustardo, "Early Impressions of the Daguerreotype from the Notebook of an Anonymous Frenchman: A Translation," *History of Photography* 9, no. 1 (January–March 1985): 53–56, and some correspondence between Pierre Harmant and Mustardo in *History of Photography* 9, no. 3 (July–September 1985): 260. An article on the invention of the daguerreotype in *The Spectator* of February 2, 1839 also confirms that there had been some pre-1839 talk of Daguerre's experiments. This article claimed that rumors of his researches had "been the talk of the ateliers in Paris for several years; but no artist having seen any results, it was regarded as a delusion, like the search for the philosophers' stone, or perpetual motion." The article is quoted in Adamson, "1839–The Year of Daguerre," *History of Photography,* 191.

42. Henry Brougham, *The Life and Times of Henry Lord Brougham written by himself in three volumes,* vol. 1 (Edinburgh and London: William Blackwood and Sons, 1871), 69–70.

43. Samuel Morse, as quoted in Richard Rudisill, *Mirror Image: The Influence of the Daguerreotype on*

American Society (Albuquerque: University of New Mexico Press, 1971), 35. The letter was first published in the *New York Observer* (where Morse's two brothers were editors) on April 20, 1839 and then in many other American newspapers.

44. Habersham's recollection was first published in 1914 in Edward Lind Morse, ed., *Samuel F. B. Morse: His Letters and Journals,* vol. 1 (Boston: Houghton Mifflin, 1914), 421. It seems likely that Habersham's account was solicited in the early 1850s, along with a testimony from Silliman, as evidence to be used in Morse's favor during a court case in Philadelphia. See Carleton Mabee, *The American Leonardo: A Life of Samuel F. B. Morse* (New York: Octagon Books, 1943), 309.

45. Mabee, *The American Leonardo,* 82.

46. Benjamin Silliman had met Davy and Accum in London in 1805, having himself been taught chemistry in Philadelphia by a man who had been working with Davy in London in 1802. Following these meetings Silliman returned to the United States to teach chemistry at Yale and subsequently, between 1808 and 1810, taught Samuel Morse in that subject. During this same time he would have been writing his "Notes on various subjects," including "an account of the New Discoveries of Professor Davy" for the second American edition of William Henry's *An Epitome of Experimental Chemistry* (Boston: William Andrews, 1810). This publication promised, among other things, "to facilitate the acquisition of chemical knowledge, by minute instructions for the performance of experiments." It would seem from this evidence that Silliman and Morse could hardly have been unaware of Wedgwood and Davy's own prior experiments. However, William Henry not Silliman wrote up Davy and Wedgwood's photographic experiments for the book

in question. Henry gave them no more than a short paragraph on page 196, repeating certain phrases used in the "Account" itself and concluding that "this property [of silver nitrate] furnishes a method of of copying paintings on glass, and transferring them to leather or paper." He then referred to the description provided by "Mr. T. Wedgwood, in *Nicholson's Journal,* 8vo. iii. 167." Silliman added notes to the pages before and after Henry's reference to the "Account" but, significantly, made no comments on the photographic experiments. He instead spoke at length about Davy's later experiments with galvanism. So Silliman may have tried to replicate Wedgwood and Davy's experiments in 1809–10, but the details of Henry's publication provide no evidence of this. As a consequence, 1821 seems the more reliable date for the first photographic experiments on the American continent.

47. Mabee, *The American Leonardo,* 406.

48. For more details, see my "'Some Experiments of Mine': The Early Photographic Experiments of Samuel Morse," *History of Photography* 15, no. 1 (Spring 1991): 37–42.

49. Henry Hunt Snelling, *The History and Practice of the Art of Photography; or the Production of Pictures Through the Agency of Light* (New York G. P. Putnam, 1849), 9. I am grateful to Joan E. Hostetler for sending me a working draft of her as yet unpublished 1995 essay on Wattles, entitled "James Miles Wattles: A Footnote in Photographic History." See also the accounts of Wattles given in William Welling, *Photography in America: The Formative Years 1839–1900* (New York: Thomas Y. Crowell, 1978), 4, and in Rudisill, *Mirror Image,* 35–36.

50. Hubert, as quoted in H. & A. Gernsheim, *L. J. M. Daguerre,* 73–74.

51. For more on Hubert, see Jammes and Janis, *The Art of French Calotype,* 9–11, 16, 110–11.

52. This report is reproduced as "Annexe 3" in Jean-Claude Gautrand, eds., *Hippolyte Bayard: Naissance de l"image photographique* (Amiens: Trois Cailloux, 1986), 193 (my translation, with the assistance of Marina Lvoss and Julian Perfanis).

53. The information in this quotation, and the previous one, is taken from Boris Kossoy, "Hercules Florence, Pioneer of Photography in Brazil," *Image* 20, no. 1 (March 1977): 12–21, and Kossoy, *Hercules Florence, 1833: a descoberta isolada de Fotografia no Brasil* (São Paulo: Livraria Duas Cidades, 1980). See also Kossoy's *Origens e Expansao de Fotografia no Brasil: seculo XIX* (Rio de Janeiro: Edicao FUNARTE, 1980). In a review of another of Kossoy's books, *Hercules Florence 1833; a descoberta isolada de Fotografia no Brasil* (1977), H. K. Henisch refers to Florence's inventions and states that "there is no reasonable doubt of their authenticity." See this review in *History of Photography* 2, no. 1 (January 1978): 89–91.

54. Eder, *History of Photography,* 181–83, and Pierre Harmant, "Anno Lucis 1839: 2nd Part," *Camera,* no. 8 (August 1977): 37.

55. As quoted in Harmant, ibid., 38. See also Gernsheim, *The Origins of Photography,* 71. Most of the following information comes from either Harmant or Gernsheim, with, where their information is in conflict, the latter being regarded as the more reliable source.

56. As quoted in Gernsheim, *The Origins of Photography,* 71.

57. Ibid.

58. Ibid., 72.

59. Helmut Gernsheim, *Incunabula of British Photo-*

graphic Literature (London: Scholar Press, 1984), 16.

60. Welling, *Photography in America,* 4.

61. As quoted in Harmant, "Anno Lucis 1839: 2nd Part," *Camera* 8, 37. See also my "José Ramos Zapetti," *History of Photography* 17, no. 2 (Summer 1993): 215.

62. As quoted in Marie-Loup Sougez, *Historia de la fotografia* (Madrid: Ed. Cátedra, 1981), 208–9 (my translation, assisted by Gail and Hilda Tighe). On Zapetti's claims see also Lee Fontanella, *La Historia de la Fotografia en Espagna: desde sus origenes hasta 1900* (Madrid: El Viso, 1981), 24.

63. Vernon Heath, *Vernon Heath's Recollections* (London, Paris, and Melbourne: Cassell & Co., 1892), 47–49. For more on Heath, see my "Vernon Heath's *Recollections* (1892)," *History of Photography* 16, no. 1 (Spring 1992): 78. Further useful information on the camera lucida is provided in Larry Schaaf, *Tracings of Light: Sir John Herschel & the Camera Lucida* (San Francisco: The Friends of Photography, 1989), and John H. Hammond and Jill Austin, *The Camera Lucida in Art and Science* (Bristol: Adam Hilger, 1987).

64. Talbot, as reproduced in Newhall, *Photography: Essays & Images,* 23–24.

65. *The Literary Gazette* (February 9, 1839), 90, as quoted in Adamson, "1839–The Year of Daguerre," *History of Photography,* 194.

66. *Chambers' Edinburgh Journal,* October 19, 1839, as quoted in Floyd Rinhart and Marion Rinhart, *The American Daguerreotype* (Athens: University of Georgia Press, 1981), 429.

67. Niépce wrote to Claude on September 16, 1824, as quoted in Beaumont Newhall, *Latent Image: The Discovery of Photography* (Albuquerque: Uni-

versity of New Mexico Press, 1967), 27. Niépce wrote to Daguerre on June 4, 1827, as quoted in Victor Fouque, *The Truth Concerning the Invention of Photography,* 72. Daguerre sent Niépce his letter on February 3, 1828, as quoted in Newhall, *Latent Image,* 34.

68. Arago, in his speech to the Academie des Sciences on January 7, 1839, as reproduced in H. & A. Gernsheim, *L. J. M. Daguerre,* 82.

69. Arago, in his report to the Chamber of Deputies on July 6, 1839, as reproduced in Daguerre's *An Historical and Descriptive Account,* 14.

Chapter 3

1. Michel Foucault, "Nietzsche, Genealogy, History" (1971), in *Language, Counter-Memory, Practice,* ed. Donald Bouchard (Ithaca: Cornell University Press, 1977), 142.

2. Louis Daguerre, *An Historical and Descriptive Account of the various Processes of the Daguerréotype and the Diorama,* (London: McLean, 1839), 60.

3. Henry Talbot, "Some Account of the Art of Photogenic Drawing, or, The Process by Which Natural Objects May Be Made to Delineate Themselves without the Aid of the Artist's Pencil" (January 31, 1839), as reproduced in Beaumont Newhall, ed., *Photography: Essays & Images* (New York: Museum of Modern Art, 1980), 23–30.

4. Michel Foucault, *The Order of Things: An Archaeology of the Human Sciences* (New York: Vintage Books, 1970), ix, xi.

5. Michel Foucault, *Power/Knowledge: Selected Interviews and Other Writings 1972–1977,* ed.

Colin Gordon (Brighton: The Harvester Press, 1980), 211.

6. Raymond Williams, *Keywords: A vocabulary of Culture and Society* (Glasgow: Fontana, 1976), 184, 186. For a general history of the idea of nature up to about 1800, see Clarence J. Glacken, *Traces on the Rhodian Shore: Nature and Culture in Western Thought from Ancient Times to the End of the Eighteenth Century* (Berkeley: University of California Press, 1967).

7. For a more detailed discussion of this issue, see L. J. Jordanova, introduction, in L. J. Jordanova, ed., *Languages of Nature: Critical Essays on Science and Literature* (London: Free Association Books, 1986), 15–47. As she writes, "Ways of writing about nature are thus bound up with ways of knowing about nature, and hence with questions of scientific method" (28).

8. James Thompson (1700–1748), as quoted in Jane Clark, *The Great Eighteenth Century Exhibition* (Melbourne: National Gallery of Victoria, 1983), 89.

9. Linnaeus, as quoted in Bernard Smith, *European Vision and the South Pacific 1768–1850: A Study in the History of Art and Ideas* (London: Oxford University Press, 1960), 5. For more on the Linnaean method see also Frans A. Stafleu, *Linnaeus and the Linnaeans* (Utrecht: A. Oosthoek's Uitgeversmaatschappij N.V., 1971), and Peter Salm, *The Poem as Plant: A Biological View of Goethe's Faust* (Cleveland: Press of Case Western Reserve University, 1971).

10. Foucault, *The Order of Things,* 75–76.

11. Marjorie Nicholson, *The Microscope and English Imagination* (Northampton, Mass.: Department of Modern Languages of Smith College, 1935), 81–82.

12. This sketch of the Enlightenment concept of nature is taken from William Powell Jones, *The Rhetoric of Science: A Study of Scientific Ideas and Imagery in Eighteenth-Century English Poetry* (Berkeley: University of California Press, 1966), 28–29.

13. See for example Madeleine Barthélemy-Madaule, *Lamarck the Mythical Precursor: A Study of the Relations between Science and Ideology,* trans. M. H. Shank (Cambridge, Mass.: MIT Press, 1982). As Barthélemy-Madaule says in her second chapter, headed "Nature": "The end of the eighteenth century and the beginning of the nineteenth century is a period of disjunction between what had been the 'natural history' dominated by the illustrious Buffon, and what would be called 'biology' by Lamarck in France and Treviranus in Germany, among others. . . . Thinkers did not seem conscious very often (let alone necessarily) of the twofold movement in which they participated and the contradiction they embodied" (22).

14. See Derek Gjertsen, *The Newton Handbook* (London: Routledge & Kegan Paul, 1986), 7–8.

15. Coleridge, as quoted in Raimonda Modiano, *Coleridge and the Concept of Nature* (London: MacMillan, 1985), 8.

16. Ibid., 208. Modiano shows that Coleridge's statement is closely based on a passage from Herder's *Kalligone,* which Coleridge was annotating at the time, and was also closely related to a description of nature provided by Goethe in 1783.

17. Coleridge, as quoted in H. W. Piper, "Coleridge and the Unitarian Consensus," in R. Gravil and M. Lefebure, eds., *The Coleridge Connection: Essays for Thomas McFarland* (London: MacMillan, 1990), 287.

18. Coleridge, as quoted in T. E. Thorpe, *Humphry Davy: Poet and Philosopher* (London: Cassell & Co., 1896), 74.

19. Carleton Mabee, *The American Leonardo: A Life of Samuel F. B. Morse* (New York: Octagon Books, 1943), 29.

20. Earl K. Wasserman, "The English Romantics: The Grounds of Knowledge," *Studies in Romanticism,* no. 4 (1964): 26.

21. Ibid., 25.

22. Owen Barfield, *What Coleridge Thought* (London: Oxford University Press, 1971), 22, 198, 199.

23. For a more detailed discussion of this concept see Barfield's chapter "Two Forces of One Power," in ibid., 27–40.

24. Modiano, *Coleridge and the Concept of Nature,* 141.

25. Barfield, *What Coleridge Thought,* 52.

26. See, for example, Earl Wasserman, "The English Romantics: The Grounds of Knowledge," *Studies in Romanticism,* 33–34.

What Wordsworth, Coleridge, Keats, and Shelley chose to confront more centrally and to a degree unprecedented in English literature is a nagging problem in their literary culture: How do subject and object meet in a meaningful relationship? By what means do we have a significant *awareness of the world? . . . The four Romantics, it is clear, are sharply at odds with each other. . . . But the very fact that their positions do clash so directly . . . instead of being merely unrelated, confirms that they all face the central need to find a significant relationship between the subjective and objective worlds. We may conceive of poetry as made up superficially of features, such as nature images,*

melancholy, or lyricism; but it is made by *purposes, and epistemology is poetically constitutive. All the Romantics, it is true, give extraordinary value to a faculty they call the imagination because they must postulate an extraordinary faculty that bridges the gap between mind and the external world; but no two of them agree on a definition of this faculty, any more than they do on the mode of existence of the external nature they so commonly write about.*

27. As quoted in Gail Buckland, *Fox Talbot and the Invention of Photography* (St. Lucia, Australia: University of Queensland Press, 1980), 31.

28. Nicéphore Niépce, as quoted in Victor Fouque, *The Truth Concerning the Invention of Photography: Nicephore (sic) Niépce, His Life, Letters and Works* (New York: Tennant and Ward, 1867, 1935), 161.

29. Daguerre, *An Historical and Descriptive Account of the various Processes of the Daguerréotype and the Diorama,* 41.

30. This note is reproduced in Russian and French in T. P. Kravets, ed., *Dokumenty Po Istorii Izobretniia Fotografii* (New York: Arno Press, 1944, 1979), 401–2. A not always faithful transcription/translation is provided by Scharf, *Pioneers of Photography,* 35.

31. As quoted in Helmut and Alison Gernsheim, *L. J. M. Daguerre: The History of the Diorama and the Daguerreotype* (New York: Dover, 1968), 54, 57.

32. Niépce, as quoted in ibid., 67.

33. Daguerre, as quoted in ibid., 79–81.

34. Ibid., 81.

35. Talbot, "Some Account of the Art of Photogenic Drawing" (1839), in Newhall, *Photography: Essays & Images,* 25.

36. See the complete document in ibid., 23–30.

37. Talbot, as quoted in Larry Schaaf, *Out of the Shadows: Herschel, Talbot & the Invention of Photography* (New Haven: Yale University Press, 1992), 48.

38. Ibid., 65.

39. Ibid., 66.

40. Talbot, "Some Account of the Art of Photogenic Drawing," in Newhall, *Photography: Essays & Images,* 23.

41. Georges Potonniée, *The History of the Discovery of Photography* (New York: Tenant and Ward, 1936), 97.

42. Claude Niépce, February 24, 1824, as quoted in Fouque, *The Truth Concerning the Invention of Photography,* 57.

43. Nicéphore Niépce, September 16, 1824, as quoted in Beaumont Newhall, *Latent Image: The Discovery of Photography* (New York: Doubleday, 1967), 27.

44. Nicéphore Niépce, June 4, 1827, as quoted in H. & A. Gernsheim, *L. J. M. Daguerre,* 56–57.

45. Ibid., 186.

46. David, as quoted in ibid., 7.

47. As quoted in ibid., 31.

48. Schaaf, *Out of the Shadows,* 11.

49. Ibid., 12.

50. Ibid., 12.

51. Talbot, as quoted in H. J. P. Arnold, *William Henry Fox Talbot: Pioneer of Photography and Man of Science* (London: Hutchinson Benham, 1977), 48.

52. William Gilpin (1768), as quoted in Luke Herrmann, *British Landscape Painting of the Eighteenth Century* (London: Faber & Faber, 1973), 112.

53. William Gilpin, *Three Essays on Picturesque Beauty; on Picturesque Travel; and on Sketching Landscape: to which is added a poem, on Landscape painting* (2nd ed., 1794; reprint: Westmead: Gregg International Publishers, 1972), 28.

54. Herrmann, *British Landscape Painting of the Eighteenth Century,* 26. Christopher Hussey tells us that "later in the century Thomas West (*A Guide to the Lakes,* 1778) recommended the use of two glasses, one on dark foil for sunny days and one on silver for dull days." See Christopher Hussey, *The Picturesque: Studies in a Point of View* (London: Archon Books, 1927, 1967), 107. In a later publication, *A Guide to the Lakes in Cumberland, Westmorland, and Lancashire* (1784), West gave the following description of the Claude Glass.

The landscape mirror will also furnish much amusement, in this tour. Where the objects are great and near, it removes them to a due distance, and shews them in the soft colours of nature, and in the most regular perspective the eye can perceive, or science demonstrate. The mirror is of the greatest use in sunshine; and the person using it ought always to turn his back to the object that he views. It should be suspended by the upper part of the case, and the landscape will then be seen in the glass, by holding it a little to the right or left (as the position of the parts to be viewed require) and the face screened from the sun. A glass of four inches, or four inches and a half diameter is a proper size.

As quoted in Doug Nickel, "The Camera and Other Drawing Machines," in Mike Weaver, ed., *British Photography in the Nineteenth Century: The Fine Art Tradition* (Cambridge: Cambridge

University Press, 1989), 5. The most notoriously enthusiastic advocate for the Claude Glass was the English poet Thomas Gray; as a result they were sometimes known as Gray Glasses. In a letter from November 1769, Gray described to a friend his view from the Crosthwaite Vicarage garden. "(I) saw in my glass a picture, that if I could transmitt to you, & fix it in all the softness of its living colours, would fairly sell for a thousand pounds, this is the sweetest scene I can yet discover in point of pastoral beauty. the rest are in a sublimer style" (as quoted in Malcolm Andrews, *The Search for the Picturesque: Landscape Aesthetics and Tourism in Britain, 1760–1800* [Aldershot: Scolar Press, 1989], 187).

55. A. Walker (1792), as quoted in Andrews, *The Search for the Picturesque,* 68.

56. Gilpin, *Forest Scenery* (1791), as quoted in ibid., 69. Elsewhere in his book, Gilpin refers to the flattening, theatrical effect that the Claude Glass mirror image had on landscape forms, making them look "something like the scenes of a playhouse, retired behind each other" (Ibid., 29).

57. Robison was writing in *The Atheneaum* in May 1839, as quoted in Newhall, *Latent Image,* 84. His comparison is understandable in that the Claude Glass also closely resembled the daguerreotype in size and packaging. William Mason described the glass in 1827 as "a Plano-convex Mirror of about four inches diameter on a black foil, and bound up like a pocket book" (as quoted in John Dixon Hunt, "Picturesque Mirrors and the Ruins of the Past," *Art History* 4, no. 3 [September 1981]: 257). Sometimes the glass was rectangular, but a circular mirror was more usual. Daguerre's

early daguerreotypes also sometimes varied in format between circular and rectangular images.

58. Gilpin, as quoted in John Murdoch, "John Constable in the Lake District, September–October 1806," in *The V & A Album 3* (London: De Montford Publishing, 1984), 97.

59. As quoted in Carole Fabricant, "The Aesthetics and Politics of Landscape in the Eighteenth Century," in Ralph Cohen, ed., *Studies in Eighteenth-Century British Art and Aesthetics* (Berkeley: University of California Press, 1985), 71.

60. William Gilpin Jr., 1788, as quoted in Carl Paul Barbier, *William Gilpin: His Drawings, Teaching and Theory of the Picturesque* (Oxford: Clarendon Press, 1963), 111.

61. Dr. William Wollaston took out a patent for his camera lucida in 1806. The idea for such an instrument had apparently come to him during a walking tour with a friend, Henry Hasted, in late 1800. See John H. Hammond and Jill Austin, *The Camera Lucida in Art and Science* (Bristol: Adam Hilger, 1987), 4–5. There are two versions of the camera lucida as a drawing instrument, the "see-through" and the "split-pupil." In the first, the artist sees his or her paper and pencil by means of a reflection while in the other the reflection is observed with half the pupil while the other half sees the paper and pencil. In this second type, the brain fuses the two images so that the scene being viewed on the back of the retina *appears* to be on the paper, thus enabling the hand to trace its features. For an extensive discussion of the camera lucida, see Larry J. Schaaf, *Tracings of Light: Sir John Herschel & The Camera Lucida* (San Francisco: The Friends of Photography, 1989),

and my "Detours: Photography and the Camera Lucida," *Afterimage* 18, no. 2 (September 1990): 14–15.

62. Rosalind Krauss, "The Originality of the Avant-Garde" (1981), in *The Originality of the Avant-Garde and Other Modernist Myths* (Cambridge: MIT Press, 1985), 162.

63. Krauss, ibid., 163, 166.

64. Barbier, *William Gilpin,* 104.

65. This, for example, is a structuring theme of Goethe's 1809 novel *Elective Affinities,* trans. Elizabeth Mayer and Louise Bogan (South Bend, Ind.: Gateway Editions, 1963).

66. Barbier, *William Gilpin,* 103, 106, 72, 143.

67. Gilpin, as quoted in Wendelin A. Guentner, "British Aesthetic Discourse, 1780–1830: The Sketch, the *Non Finito,* and the Imagination," *Art Journal* 52, no. 2 (Summer 1993): 44.

68. See Hussey, *The Picturesque,* 4, and Samuel H. Monk, *The Sublime: A Study of Critical Theories in XVIII-Century England* (Chicago: University of Chicago Press, 1935, 1960), 155.

69. See Modiano, *Coleridge and the Concept of Nature,* 20.

70. Coleridge, as quoted in ibid. Coleridge was himself familiar with picturesque theory, having read the work of Gilpin and having written an anonymous review of Knight's poem "Landscape" in 1796; he also owned a copy of Price's *Essay on the Picturesque* and with Wordsworth annotated a copy of Knight's *An Analytical Inquiry into the Principles of Taste* (Ibid., 5).

71. The picturesque is described as an "unstable term" in Martin Price, "The Picturesque Moment," in Frederick W. Hilles and Harold Bloom, eds., *From Sensibility to Romanticism: Essays Presented to Frederick A. Pottle* (New York: Oxford University Press, 1965), 259–92. Walter Hipple also describes it as acquiring a "systematic ambiguity" around this time. See Walter Hipple, *The Beautiful, The Sublime & The Picturesque in Eighteenth-Century British Aesthetic Theory* (Carbondale: The Southern Illinois University Press, 1957), 188.

72. Richard Payne Knight (1805), as quoted in Manwaring, *Italian Landscape in Eighteenth Century England,* 198–99.

73. As quoted in John Dixon Hunt and Peter Willis, eds., *The Genius of the Place: The English Landscape Garden 1620–1820* (London: Paul Elek, 1975), 350. Knight's long *Inquiry* covers many issues and debates, among them the question of novelty, expressed in terms of the irregularity, intricacy, and variety needed to achieve this particular quality in a picturesque scene. This concern broaches the difficult topic of transience and fixity. Knight addresses the art of gardening as much as painting, and this caused him some problems of definition. Gardens, like scenes in nature, offered a sequence of ever-changing novelties that required a mobile viewer and a passage of time in which to look. Painted landscapes, by contrast, were composed from a single, fixed point of view, demanding a static viewing position and representing a more stable and singular conjunction of time and space. No wonder that Knight had difficulty reconciling these two picturesques. As one commentator has written, "Knight was confused by the inevitable difficulty of distinguishing between space and time; of novelties which succeed one another at relatively distinct intervals, and novelties which are juxtaposed; of what is

apprehended in measured sequence and what is apprehended at a glance." See Peter Collins, *Changing Ideals in Modern Architecture 1750–1950* (London: Faber and Faber, 1965), 55.

74. Newton's *Opticks* opens with the following passage: "In a very dark Chamber, at a round Hole, about one third Part of an Inch broad, made in the Shut of a Window, I placed a Glass Prism, whereby the Beam of the Sun's Light, which came in at that Hole, might be refracted upwards toward the opposite Wall of the Chamber, and there form a colour'd Image of the Sun" (as quoted in Marjorie Hope Nicolson, *Newton Demands the Muse: Newton's 'Opticks' and the 18th Century Poets* [Princeton: Princeton University Press, 1946], 5). Nicolson provides copious detail about the influence of Newton's thinking about optics and light on the epistemology (and especially the poetry) of the eighteenth century.

75. Darwin, as quoted in McNeil, "The Scientific Muse: The Poetry of Erasmus Darwin," in Jordanova, ed., *Languages of Nature*, 185.

76. Ibid., 185–86.

77. This tendency toward modification even led one mid-eighteenth-century instructional book on drawing to warn its readers about the camera obscura.

It cannot be denied that certain general lessons can in fact be drawn from it of broad masses of shadows and light: and yet too exact an imitation would be a distortion; because the way in which we see natural objects in the camera obscura is different from the way in which we see them naturally. This glass interposed between objects and their representation on the paper intercepts the rays of the reflected light which render shadows visible and pleasantly

coloured, thus shadows are rendered darker by it than they would be naturally. Local colours of objects being condensed in a smaller space and losing little of their strength seem stronger and brighter in colour. The effect is indeed heightened but it is false.

M. G. J. Gravesande, in Charles-Antoine Jombert's instructional book on drawing, as quoted in Aaron Scharf, *Art and Photography* (Harmondsworth: Penguin, 1974), 21.

78. Knight, *The Landscape*, a *Didactic Poem* (1794), as quoted in Stephen Daniels, "The political iconography of woodland in later Georgian England," in Cosgrove and Daniels, eds., *The Iconography of Landscape*, 65.

79. Jean Hagstrum, *The Sister Arts: The Tradition of Literary Pictorialism and English Poetry from Dryden to Gray* (Chicago: University of Chicago Press, 1958), 141–42.

80. See, for example, John Dixon Hunt, "Picturesque Mirrors and the Ruins of the Past," in *Art History,* 258:

It was the privileged metaphor of artistic representation, authorizing—according to one's emphasis—either accuracy of vision or the capture of the belle nature. To the picturesque tourist and amateur artist it reflected the real world, yet also collected carefully chosen images within the oval or rectangular frame and coloured them with its one, co-ordinating, tint. It was both an objective, cognitive activity and a private, creative one, as the mirror's user turned his back upon the scene and withdrew into his own reflection. The reversed images in the glass, paralleling of course the upside-down images we receive upon our retinas, were a visible token of that joint world of optical and mental reflections, *the latter being what Locke called "the notice which the mind takes of its own operations, and the manner of them." This doubleness of* re*flection is likewise announced in the relationship of* speculation *and* speculum, *the Latin for mirror.*

81. Niépce, March 12, 1816, as quoted in Fouque, *The Truth Concerning the Invention of Photography*, 29.

82. Niépce, May 5, 1816, as quoted in ibid., 30.

83. Talbot, as quoted in Gail Buckland, *Fox Talbot and the Invention of Photography*, 81.

84. Biot, as quoted in H. & A. Gernsheim, *L. J. M. Daguerre*, 84.

85. Jonathan Crary, "Modernizing Vision," in Hal Foster, ed., *Vision and Visuality: Dia Art Foundation Discussions in Contemporary Culture Number 2* (Seattle: Bay Press, 1988), 42.

86. Jonathan Crary, *Techniques of the Observer: On Vision and Modernity in the Nineteenth Century* (Cambridge: MIT Press, 1990), 3, 4. It is interesting to compare Goethe's supposedly "stunning" suggestion with the sensory experience described by that staid English gentleman William Gilpin in his 1792 essay "On Picturesque Travel":

We are, in some degree, also amused by the very visions of fancy itself. Often, when slumber has half-closed the eye, and shut out all the objects of sense, especially after the enjoyment of some splendid scene; the imagination, active, and alert, collects its scattered ideas, transposes, combines, and shifts them into a thousand forms, producing such exquisite scenes, such sublime arrangements, such glow, and harmony of colouring, such brilliant lights, such depth, and clearness of shadow, as equally foil description, and every attempt of artificial colouring.

As quoted in Alasdair Clayre, ed., *Nature and Industrialization* (Oxford: Oxford University Press, 1977), 28.

87. Talbot, as quoted in Buckland, *Fox Talbot and the Invention of Photography*, 21.

88. Crary, "Techniques of the Observer," *October* 45 (Summer 1988): 4. Although he here uses the term *post-Kantian,* Crary includes Kant among his pioneers of modern vision. Indeed he argues that "clearly Kant's 'Copernican revolution' (*Drehung*) of the spectator, proposed in the preface to the second edition of the *Critique of Reason* (1787), is a definitive sign of a new organization and positioning of the subject" (5). Crary projects Hegel as an even more significant figure. "In the preface to his *Phenomenology* (1807), Hegel makes a sweeping repudiation of Lockean perception and situates perception within an unfolding that is temporal and historical. While attacking the apparent certainty of sense perception, Hegel implicitly refutes the model of the camera obscura" (10).

89. Crary, *Techniques of the Observer,* 5, 10.

90. Crary, "Techniques of the Observer," *October,* 14.

91. Crary, "Modernizing Vision," *Vision and Visuality,* 36. In the discourses of biology, themselves only recently constituted as a distinctive discipline, the convenient separation of psychology and physiology was now bridged by a third term that was not so much a thing as a "system" of communications between the first two. See Karl M. Figlio, "Theories of Perception and the Physiology of Mind in the Late Eighteenth Century," *History of Science* 13 (1975): 177–78.

92. Cowper, as quoted in Hagstrum, *The Sister Arts,* 139.

93. Coleridge, as quoted in Jack David, ed., *Discussions of William Wordsworth* (Boston: D. C. Heath & Co., 1964), 7.

94. John Clare, "Autobiography" (c. 1824–25), as quoted in Brownlow, *John Clare and Picturesque Landscape,* 13.

95. An extract from Talbot's 1830 poem "The

Magic Mirror" is published in Mike Weaver, ed., *The Art of Photography* (London: The Royal Academy of the Arts, 1989), 15–17.

96. Talbot, "Brief Historical Sketch of the Art," *The Pencil of Nature* (London: Longman, Brown, Green, & Longman's, 1844–46), unpaginated.

97. M. H. Abrams, *The Mirror and the Lamp: Romantic Theory and the Critical Tradition* (New York: Oxford University Press, 1953), viii, 57.

98. Ibid., 58.

99. Stephen J. Spector, "Wordsworth's Mirror Imagery and the Picturesque Tradition," *English Literary History,* no. 44 (1977): 87.

100. Coleridge, as quoted in (and deleting Coleridge's own erasions), Kathleen Coburn, "Reflections in a Coleridge Mirror: Some Images in His Poems," in Frederick W. Hilles and Harold Bloom, eds., *From Sensibility to Romanticism: Essays presented to Frederick A. Pottle* (New York: Oxford University Press, 1965), 423. Coburn mentions that Coleridge had considered writing an "Ode to a Looking Glass" in 1795–96 and claims that "the mirror, the looking-glass of Narcissus, is in obvious and also in less obvious ways connected with the search for the self" (417).

101. Coleridge, in a letter to his wife, November 16, 1802, in Earl Leslie Griggs, ed., *Collected Letters of Samuel Taylor Coleridge, Vol. II 1801–1806* (Oxford: Clarendon Press, 1956), 883.

102. R. B. Litchfield, *Tom Wedgwood: The First Photographer* (London: Duckworth & Co., 1903), 122.

103. An illustration of Aristotle's observation is found in John Hammond, *The Camera Obscura: A Chronicle* (Bristol: Adam Hilgar, 1981), ii, and also in Gaston Tissandier, *A History and Handbook of Photography* (London: Sampson, Low, Marston, Searle, and Rivington, 1878), 3.

104. As quoted in Owen Barfield, "The Harp and the Camera" (1977), in Thomas Barrow, Shelley Armitage and William Tydeman, eds., *Reading into Photography: Selected Essays 1959–1980* (Albuquerque: University of New Mexico Press, 1982), 103.

105. Abrams, *The Mirror and the Lamp,* 61.

106. Coleridge, as quoted in ibid., 346.

107. Coleridge, as quoted in Hans Aarsleff, *From Locke to Saussure: Essays on the Study of Language and Intellectual History* (Minneapolis: University of Minnesota Press, 1982), 205. See also the letters to the Wedgwoods in Griggs, ed., *Collected Letters of Samuel Taylor Coleridge, Vol. II 1801–1806,* 677–709.

108. Coleridge, in Griggs, ibid., 709.

109. Talbot, "Some Account of the Art of Photogenic Drawing" (1839), in Newhall, *Photography: Essays & Images,* 25.

110. Talbot, *The Pencil of Nature,* unpaginated.

111. Hubertus von Amelunxen, *Die aufgehobene Zeit: die Erfindung der Photographie durch William Fox Talbot* (Berlin: Nishen, 1988), 44 (translation by Olav Westphalen).

112. Ibid., 40.

113. As quoted in Beaumont Newhall, "Eighteen Thirty-Nine: The Birth of Photography," in Weston Naef, ed., *Photography: Discovery and Invention* (Malibu: The J. Paul Getty Museum, 1990), 22.

114. *The Athenaeum,* August 2, 1845, as quoted in Larry Schaaf, "'A Wonderful Illustration of Modern Necromancy': Significant Talbot Experimental Prints in the J. Paul Getty Museum,' ibid., 31.

115. Ibid., 44.

116. Hayden White, "Foucault's Discourse: The Historiography of Anti-Humanism," *The Content*

of the Form: Narrative Discourse and Historical Representation (Baltimore: The Johns Hopkins University Press), 124.

117. Linda Nochlin, *Realism* (Harmondsworth: Penguin, 1971), 31.

118. William Gilpin, as quoted in Timothy Brownlow, *John Clare and Picturesque Landscape* (Oxford: Clarendon Press, 1983), 12. Brownlow argues that in this passage Gilpin, "uses his eye like a cine-camera."

119. Gilpin, *Forest Scenery* (1791), as quoted in Spector, "Wordsworth's Mirror Imagery and the Picturesque Tradition," *English Literary History,* 89.

120. Krauss, "The Originality of the Avant-Garde," in *The Originality of the Avant-Garde,* 164–65.

121. Malcolm Andrews, "Claude Glasses and Rosa-Tinted Spectacles," a lecture delivered as part of a conference titled "Landscape and the Arts I: Europe 1700–1900" (Canberra, July 1984), unpaginated.

122. See J. J. C. Smart, *Problems of Space and Time* (New York: MacMillan, 1964), and Mark Kipperman, *Beyond Enchantment: German Idealism and English Romantic Poetry* (Philadelphia: University of Pennsylvania Press, 1986).

123. For more details of these experiments and of Coleridge and Wedgwood's involvement in them, see note 44 in my "Tom Wedgwood and Humphry Davy: 'An Account of a Method,'" *History of Photography* 17, no. 2 (Summer 1993): 182–83.

124. Trevor Levere, *Affinity and Matter: Elements of Chemical Philosophy 1800–1865* (Oxford: Clarendon Press, 1971), 31.

125. Ibid., 29–34.

126. Coleridge (1803), as quoted in Patricia S. Yaeger, "Coleridge, Derrida, and the Anguish of Writing," *SubStance* 12, no. 2 (1983): 91. According to Brownlow (*John Clare and Picturesque Landscape,* 5), the English poet Clare shared Coleridge's interest in this problem; he claims that in Clare's writing "the mobile and the static are fused together, as if his eye had a special lens."

127. Ross Gibson, "This Prison This Language: Thomas Watling's Letters from an Exile at Botany-Bay (1794)," in Paul Foss, ed., *Island in the Stream: Myths of Place in Australian Culture* (Sydney: Pluto Press, 1988), 27. Gibson argues that Coleridge's "anxiety" arises from the fact that he is a subject "struggling to understand the significance of science and its observational methods."

128. Coleridge, in a letter to Southey, as quoted in Raimonda Modiano, "Spatial and Sensory Modes of Experience in Coleridge" (Ph.D. dissertation, University of California, San Diego, 1973), 8.

129. Coleridge, in *The Statesman's Manual, or The Bible: the Best Guide to Political Skill and Foresight* (December 1816), in R. J. White, ed., *The Collected Works of Samuel Taylor Coleridge: Lay Sermons* (London: Routledge & Kegan Paul, 1972), 30.

130. Coleridge, as quoted in Richard Holmes, *Coleridge: Early Visions* (New York: Viking, 1989), 344.

131. Kathleen Coburn, ed., *The Notebooks of Samuel Taylor Coleridge: Notes, Vol. 1, 1794–1804* (London: Routledge & Kegan Paul, 1957), note 1705 [i]. According to Coburn, "When Coleridge's reservations about Kant's moral philosophy are becoming clearer to himself, he thinks of Schiller who shared his reservations on similar psycholog-

ical grounds. . . . It was also natural that Tom Wedgwood, who had abetted and sympathized with those interests, should come into his mind at this point too." For more on Wedgwood's various interests, see Margaret Olivia Tremayne, ed., *The Value of a Maimed Life: Extracts from the Manuscript Notes of Thomas Wedgwood* (London: C. W. Daniel, 1912).

132. Josiah Wedgwood (1800), in a letter to Thomas Poole, as quoted in Litchfield, *Tom Wedgwood,* 207.

133. Coleridge, as quoted in Richard Haven, *Patterns of Consciousness: An Essay on Coleridge* (Amherst: University of Massachusetts Press, 1969), 145–46.

134. Eliza Meteyard, *A Group of Englishmen (1795 to 1815) being records of the Younger Wedgwoods And Their Friends embracing the history of the Discovery of Photography and a Facsimile Of The First Photograph* (London: Longmans, Green, and Co., 1871), 295. See also Coburn, *The Notebooks of Samuel Taylor Coleridge,* note 838, page 842.

135. See Michael J. Morgan, *Molyneaux's Question: Vision, Touch and the Philosophy of Perception* (Cambridge: Cambridge University Press, 1977).

136. Coburn, *The Notebooks of Samuel Taylor Coleridge,* note 1039.

137. Wedgwood, in Meteyard, *A Group of Englishmen,* 402–3.

138. Coleridge, as quoted in Litchfield, *Tom Wedgwood,* 181.

139. Constable, (May 1833), as reproduced in R. B. Beckett, ed., *John Constable's Discourses* (Suffolk Records Society, vol. 14, 1970), 9–10.

140. Corot, as quoted in Jean-Luc Daval, *Photography: History of an Art* (New York: Rizzoli, 1982), 14.

141. See Peter Galassi, *Before Photography: Painting and the Invention of Photography* (New York: Museum of Modern Art, 1981).

142. See Guentner, "British Aesthetic Discourse, 1780–1830," *Art Journal,* 40–47.

143. As quoted in William Vaughan, *Romantic Art* (London: Thames and Hudson, 1978), 203.

144. Constable, as quoted in ibid., 197.

145. This was made manifest with the widespread introduction of railways (the Paris-St. Germain line opened in 1837). A person who had perhaps previously measured the relations of time and space according to how far an individual could walk or ride in a day could now sit in a still space and witness the world outside racing by in discontinuous fragments. Daumier's painting *A Third-Class Carriage* (c. 1865), beautifully captures this new experience. The relativity of appearance and time was of course at the heart of impressionist painting from the mid-1860s on. See, in particular, Virginia Spate, *Claude Monet: Life and Work* (New York: Rizzoli, 1992).

146. Ann Bermingham, "Reading Constable," *Art History* 10, no. 1 (March 1987): 38–58.

147. For an extensive history of the debate surrounding the term *photography,* see my "The Naming of Photography: 'A Mass of Metaphor,'" *History of Photography* 17, no. 1 (Spring 1993): 22–32.

148. Talbot was the first to use the word *fix* in relation to photography. On January 25, 1839, Talbot wrote to Herschel about "the possibility of fixing upon paper the image formed by a Camera Obscura, or rather, I should say, causing it to fix itself." On February 8, he wrote again, this time using the word more specifically and self-consciously ("my method of 'fixing'") to refer to

the method whereby the induced image was to be made permanent. As it happened, Talbot's method of fixing was never totally successful and was eventually replaced by Herschel's "washing out" process. Thus "fixed" in my sentence suggests only a momentary and untrustworthy stability. See Larry Schaaf, "Herschel, Talbot, and Photography: Spring 1831 and Spring 1839," *History of Photography* 4, no. 3 (July 1980): 185, 190.

149. For more on discussions of light in this period, see Vasco Ronchi, *The Nature of Light: An Historical Survey* (London: Heinemann, 1970); David Lindberg and Geoffrey Cantor, *The Discourse of Light from the Middle Ages to the Enlightenment* (Los Angeles: University of California Press, 1985); Geoffrey N. Cantor, "Weighing Light: the role of metaphor in eighteenth-century optical discourse," in A. Benjamin, G. Cantor and J. Christie, eds., *The Figural and the Literal: Problems of Language in the History of Science and Philosophy 1630–1800* (Manchester: Manchester University Press, 1987), 124–46; G. N. Cantor, "Henry Brougham and the Scottish Methodological Tradition," *Studies in History and Philosophy of Science,* vol. 2 (1971–72), 69–89; G. N. Cantor and M. J. S. Hodge, eds., *Conceptions of Ether: Studies in the History of Ether Theories 1740–1900* (Cambridge: Cambridge University Press, 1981); Eugene Frankel, "Corpuscular Optics and the Wave Theory of Light: The Science and Politics of a Revolution in Physics," *Social Studies of Science,* no. 6 (1976): 141–84; and Jed Z. Buchwald, *The Rise of the Wave Theory of Light: Optical Theory and Experiment in the Early Nineteenth Century* (Chicago: University of Chicago Press, 1989).

150. For more on the changing conception of writing in this period, see Otto Jespersen, *Language: Its Nature, Development and Origin* (London: George Allen & Unwin, 1922); Maurice Pope, *The Story of Decipherment* (London: Thames & Hud-

son, 1975); Scott Elledge, "The Naked Science of Language 1747–1786," in Howard Anderson and John S. Shea, eds., *Studies in Criticism and Aesthetics, 1660–1800: Essays in honour of Samuel Holt Monk* (Minneapolis: University of Minnesota Press, 1967), 266–95; Barbara Stafford, *Voyage into Substance: Art, Science, Nature, and the Illustrated Travel Account, 1760–1840* (Cambridge: MIT Press, 1984), 537.

151. Jacques Derrida, *Positions,* trans. Alan Bass (Chicago: The University of Chicago Press, 1972, 1981), 106.

152. See the etymology of "-graph" provided by the *Oxford English Dictionary,* 822.

CHAPTER 4

1. Jean-Claude Lemagny and André Rouillé, eds., *A History of Photography: Social and Cultural Perspectives* (Cambridge: Cambridge University Press, 1987).

2. Lemagny, introduction, ibid., 9. In a review of this book, David Phillips points out that the finished product largely resembles traditional aesthetic histories of photography. He also argues that "the book's distinctly Hegelian narrative of the progression of the subject of photography towards self-knowledge is no more than a reworking of a dominant modernist paradigm of photography's history" (David Phillips, "The Subject of Photography," *The Oxford Art Journal* 12, no. 2 [1989]: 115–21).

3. Bernard Marbot, "Towards the discovery (before 1839)," in Lemagny and Rouillé, *A History of Photography,* 12.

4. Peter Galassi, *Before Photography: Painting and the Invention of Photography* (New York: Museum of Modern Art, 1981), 12.

5. Victor Burgin, "Photography, Phantasy, Function" (1980), in Victor Burgin, ed., *Thinking Photography* (London: MacMillan, 1982), 187.

6. Christian Metz, *Psychoanalysis and Cinema: The Imaginary Signifier* (London: MacMillan, 1982), 49.

7. Joseph Koerner has also remarked on the sexual politics of this image. "Dürer has articulated the various zones of representation—artist, model, image, and viewer—classifying them through a system of antitheses: female and male, supine and upright, naked and clothed, rounded and square. . . . In the woodcut of the reclining nude, the eye is retained, yet it is controlled and stabilized, able to reenter the paradise of beauty only through the renunciation of desire." See Joseph Leo Koerner, *The Moment of Self-Portraiture in German Renaissance Art* (Chicago: University of Chicago Press, 1993), 444–46.

8. Leon Battista Alberti, *On Painting,* trans. John Spencer (New Haven: Yale University Press, 1966), 68. See also James Elkins, *The Poetics of Perspective* (Ithaca: Cornell University Press, 1994), especially his opening chapter "Into the Maelstrom of Metaphor."

9. William Ivins, *Prints and Visual Communication* (Cambridge: MIT Press, 1953), 65.

10. Dürer, (c. 1506), as quoted in Wolfgang Stechow, ed., *Northern Renaissance Art 1400–1600* (Englewood Cliffs, N.J.: Prentice-Hall, 1966), 109.

11. Derrida discusses the potential complexities of the *spacing* being conjured here ("the index of an irreducible exterior, and at the same time of a *movement,* a displacement that indicates an irreducible alterity") in *Positions,* 27–28, 40, 43, 81, 94. In a 1988 article about perspective, "Geometry and Abjection," *Public,* no. 1 (Winter 1988): 12–30, Victor Burgin presents a critique of his own earlier readings of perspective. He argues that "the metaphor of the 'cone of vision,' predominant in theories of representation over the past twelve years, is itself responsible for a reductive and simplistic equation of looking with objectification." Burgin suggests that we can no longer remain entirely faithful to the "Euclidean geometrical-*optical* metaphors of the modern period" and should instead explore the possibilities of other, alternative models of analysis to account for the power exercised within photo-scopic looking. He shows a particular interest in Kristeva's notion of the "abject," as he describes it, "the means by which the subject is first impelled towards the possibility of constituting itself as such." He thereby shifts critical attention from the "subject/object 'standoff' of Euclidian perspective," with its attendant "modern" articulation of space as "horizontal, infinitely extensible, and therefore in principle boundless." He investigates instead that patriarchal positioning of the (female) subject "perpetually at the boundary, the borderline, the edge, the 'outer limit'" of a postmodern space he sees as being "in the process of imploding, infolding—to appropriate a Derridean term, it is a space in process of 'intravagination.'" Another possible reference to Derrida makes its appearance when Burgin adds that: "As a concept, the 'abject' might fall into the gap between 'subject' and 'object.' The abject however is, in the history of the subject, prior to this dichotomy."

Can we equate Derrida's *spacing* with Burgin's version of a Kristevan abject? It seems unlikely, given that Burgin persists in punctuating his account with moments of origin that somehow precede the abject (when the subject is "first impelled" by the "first object of abjection ... the pre-Oedipal mother") and with a series of binary oppositions (between the "lost object of psychoanalysis" and "some real object," between "unconscious wishes and the fantasies they engender (as) psychical reality" and a "material reality"). In other words his "intervention" within what he calls "1970s theory" retains without apparent qualification the same logocentric psychoanalytic investments and narrative structure that has informed his previous formulations. As a consequence, while purporting to give us a history of space, he continues to avoid addressing its necessary corollary, a *history* (as opposed to a hermeneutics) of the subject.

12. See Thomas Wedgwood and Humphry Davy, "An Account of a Method of Copying Paintings Upon Glass, and of Making Profiles, by the Agency of Light Upon Nitrate of Silver" (1802), in Beaumont Newhall, ed., *Photography: Essays & Images* (New York: Museum of Modern Art, 1980), 15–16.

13. Anthony Carlisle, as quoted in Gail Buckland, *Fox Talbot and the Invention of Photography* (St. Lucia: University of Queensland Press, 1980), 41.

14. See our discussion in Geoffrey Batchen, "For an Impossible Realism: an Interview with Victor Burgin," *Afterimage,* 16, no. 7 (February 1989): 4–9.

15. For more details on the education of Tom Wedgwood, see my "Tom Wedgwood and Humphry Davy: 'An Account of a Method,'" *History of Photography* 17, no. 2 (Summer 1993): 172–83.

16. See David Fraser, "'Fields of radiance': The Scientific and Industrial Scenes of Joseph Wright," in Denis Cosgrove and Stephen Daniels, eds., *The Iconography of Landscape: Essays on the Symbolic Representation, Design and Use of Past Environments* (Cambridge: Cambridge University Press, 1988), 121. The relation of Wright's work to contemporary developments in science is also discussed in Michel Serres, "Turner Translates Carnot," in Norman Bryson, ed., *Calligram: Essays in New Art History from France* (Cambridge: Cambridge University Press, 1988), 154–65, and in David Fraser, "Joseph Wright of Derby and the Lunar Society: An Essay on the Artist's Connections with Science and Industry," in Judy Egerton, ed., *Wright of Derby* (New York: Metropolitan Museum of Art, 1990), 15–23.

17. Josiah Wedgwood Sr. in a letter to his friend Bentley, as quoted in Ann Finer and George Savage, eds., *The Selected Letters of Josiah Wedgwood* (London: Cory, Adams & Mackay, 1965), 234–35. Stubbs did eventually paint a portrait of the family "in or about 1780" under the title *The Wedgwood Family at Etruria Hall*. It is reproduced in R. B. Litchfield, *Tom Wedgwood: The First Photographer, an account of his life, his discovery and his friendship with Samuel Taylor Coleridge including the letters of Coleridge to the Wedgwoods, and an examination of accounts of alleged earlier photographic discoveries* (London: Duckworth and Co., 1903), 6. For more on the fruitful relationship between Wedgwood and Stubbs see Neil McKendrick, "Josiah Wedgwood and George Stubbs," *History Today* 7, no. 8 (August 1957): 504–14.

18. Robert Rosenblum, "The Origin of Painting: A Problem in the Iconography of Romantic Clas-

sicism," *The Art Bulletin* 39, no. 4 (December 1957): 279–90.

19. See Ann Bermingham, "The Origin of Painting and the Ends of Art: Wright of Derby's Corinthian Maid," in John Barrell, ed., *Painting and the Politics of Culture: New Essays in British Art 1700–1850* (Oxford: Oxford University Press, 1992), 135–65. "The legend's popularity in the eighteenth century's revival of classicism did not coincidentally anticipate the dawn of a new relationship between image, object, and beholder that was photographic. Rather, it virtually established this relationship by setting the terms in advance whereby photography would be discovered, understood, and assimilated" (164).

20. As quoted in Edgerton, *Wright of Derby,* 132–34.

21. Jacques Derrida, *Of Grammatology,* trans. Gayatri Chakravorty Spivak (Baltimore: The Johns Hopkins University Press, 1976), 234.

22. Jean-Jacques Rousseau, "Essay on the Origin of Languages which treats of Melody and Musical Imitation," in John H. Moran and Alexander Gode, eds., *On the Origin of Language* (Chicago: University of Chicago Press, 1966), 6.

23. Ibid., 12. See also Bernard Vouilloux, "Drawing between the Eye and the Hand: (On Rousseau)," *Yale French Studies,* no. 84 (1994): 175–97.

24. See the catalogue entry on this painting in Edgerton, *Wright of Derby,* 116–18.

25. See Derrida, *Of Grammatology,* 230–31.

26. Ibid., 157.

27. Ibid., 159.

28. Jacques Derrida, *Mémoires d'aveugle: L'autoportrait et autres ruines* (Paris: Réunion des musées

nationeaux, 1990), 54 (my translation). This catalogue has been published in English as *Memoirs of the Blind: The Self-Portrait and Other Ruins,* trans. Pascale-Anne Brault and Michael Naas (Chicago: University of Chicago Press, 1993). In a review of the exhibition, Meyer Raphael Rubinstein reports that "Joseph-Benoit Suvée's *Dibutades, or the Origin of Drawing,* from the Groeningemuseum in Belgium was the only borrowed work, and it was the only painting in the show—ironically enough, given the work's title" (47). See Rubinstein, "Sight Unseen," *Art in America* 79, no. 4 (April 1991): 47–53.

29. As Derrida points out, the maid has no name of her own, always being referred to as Dibutade or Dibutades (i.e., "of Butades," her father's name). Thus, despite being honored as the first to exercise the power of representation, she is allowed no identity other than as a shadow of her father or as the *répétiteur* for the shadow of her (potential) husband. On this theme, see also Ewa Kuryluk, *Veronica and Her Cloth: History, Symbolism, and Structure of a "True" Image* (Oxford: Basil Blackwell, 1991), 143–44.

30. Rubinstein, "Sight Unseen," *Art in America,* 47.

31. As reported by a special correspondent for the *New York Star* who attended Daguerre's public demonstration at the Grand Hôtel on the Quai d'Orsay on September 17, 1839 (as quoted in Beaumont Newhall, *The History of Photography, from 1839 to the Present Day* [New York: Museum of Modern Art, 1964], 19).

32. Derrida, *Memoirs of the Blind,* 65.

33. Most of these are reproduced in Paul Jay, *Niépce: Genèse d'une Invention* (Chalon-sur-Saône: Société des Amis du Musée Nicéphore Niépce, 1988).

34. Nicéphore Niépce, February 2, 1827, as quoted in Victor Fouque, *The Truth Concerning the Invention of Photography: Nicéphore Niepce (sic), His Life, Letters and Works* (New York: Arno Press, 1973), 66–67.

35. Niépce, December 8, 1827, as quoted in Fouque, ibid., 81.

36. Niépce, as quoted in Helmut and Alison Gernsheim, *L. J. M. Daguerre: The History of the Diorama and the Daguerreotype* (New York: Dover, 1968), 56–57.

37. Niépce, as quoted in Fouque, *The Truth Concerning the Invention of Photography,* 66.

38. Lemaître, as quoted in ibid., 67.

39. Claude Nori, *French Photography: From its Origins to the Present* (New York: Pantheon, 1979), facing page 1.

40. Helmut Gernsheim, *The Origins of Photography* (London: Thames and Hudson, 1982), 35.

41. Louis-Alphonse Davanne (1824–1912) was a French photographer, critic, and chemist who in the 1850s returned to bitumen of Judea as a potential medium for photo-engraving. He called his process *litho-photographie.* His own photographs were sometimes signed "A. Davanne." For more on Davanne, see André Jammes and Eugenia Parry Janis, *The Art of French Calotype* (Princeton: Princeton University Press, 1983), 163–64.

42. Gernsheim, *The Origins of Photography,* 34.

43. Niépce, as quoted in Georges Potonniée, *The History of the Discovery of Photography* (New York: Arno Press, 1973), 82.

44. In a letter to his brother dated September 3, 1824, Claude Niépce affirmed that "the engraving of views from nature is still more magical than the other" (as quoted in Gernsheim, *The Origins of Photography,* 33).

45. Ibid., 34.

46. Helmut Gernsheim, "The 150th Anniversary of Photography," *History of Photography* 1, no. 1 (January 1977): 3–8.

47. Gernsheim's watercolor is reproduced as the "first photograph" in the following publications: Gernsheim, *The Origins of Photography,* 32; Lemagny and Rouillé, eds., *A History of Photography,* 16; Peter Pollack, *The Picture History of Photography* (New York: Harry N. Abrams, 1969), 38–39; Naomi Rosenblum, *A World History of Photography* (New York: Abbeville Press, 1984), 19; Pierre Bonhomme, ed., *Les Multiples Inventions de la Photographie* (Paris: Association française pour la diffusion du Patrimoine photographique, 1989), 93; Paul Jay, *Niépce: Premiers Outils, Premiers Resultats* (Chalon-sur-Saône: Musée Nicéphore Niépce, 1978), 26; Peter Turner, *History of Photography* (New York: Exeter Books, 1987), 13; Paul Jay and Michel Frizot, *Nicéphore Niépce* (Paris: Centre National de la Photographie, 1983), cover; André Rouillé, *La Photographie en France: Textes & Controverses: une Anthologie 1816–1871* (Paris: Macula, 1989), 26; Michel Frizot et al., *Nouvelle Histoire de la Photographie* (Paris: Bordas, 1994), 21. The Harry Ransom Humanities Research Center, which owns Niépce's "first photograph," is bound by an agreement made with Gernsheim and therefore refuses to provide any reproduction of this heliograph other than copies of their benefactor's watercolor. Beaumont Newhall reproduces this watercolor in the 1964 edition of *The History of Photography* (16) but replaces it with an enhanced, unauthorized reproduction of the "greatly distorted" Kodak version for the 1982 edition (15).

48. Like Davy (in 1802) and Niépce (in 1816), it seems that Daguerre made use of the solar microscope as a means of producing a concentrated image capable of being photographed. He certainly discussed the operations of this instrument with Niépce, sending him a diagram and instructions in a letter dated February 21, 1831. This is reproduced in Jay, *Niépce: Genèse d'une Invention,* 302. In 1841 German newspapers reported that Daguerre attempted to take a daguerreotype portrait of the French King, Louis-Philippe, in the garden of the Tuileries. It was a complete failure. See Helmut Gernsheim, introduction, in Stefan Richter, *The Art of the Daguerreotype* (New York: Viking, 1989), 6.

49. Daguerre, 1835, as quoted in H. & A. Gernsheim, *L. J. M. Daguerre,* 73.

50. Daguerre (1838), as quoted in ibid., 80–81.

51. Louis Daguerre, *Historique et Description des procédés du Daguerréotype et du Diorama* (Paris: Alphonse Giroux, 1839), plate 6, opposite page 68.

52. This image is titled *Still Life* in Janet E. Buerger, *French Daguerreotypes* (Chicago: University of Chicago Press, 1989), 20–21 (but she dates it 1839). Newhall calls it *The Artist's Studio* in *The History of Photography* (1964 edition), 12. The same image is titled *Intérieur d'un Cabinet Curiosité* in Turner, *History of Photography,* 13.

53. See the entries on Jean Goujon in Bernard Ceysson et al., *Sculpture: The Great Tradition of Sculpture from the Fifteenth to the Eighteenth Century* (New York: Rizzoli, 1987), 142–43, and Geneviève Bresc-Bautier and Anne Pingeot, *Sculptures des jardins du Louvre, du Carrousel et des Tuileries,* vol. 2 (Paris: Ministère de la Culture, 1986), 224–26. Thanks to Sheldon Nodelman for the identification of this sculptor's work.

54. See Pierre du Colombier, *Jean Goujon* (Paris: Editions Albin Michel, 1949), 135–36 and plate 47. The panel is listed as "After Jean Goujon" and titled *Nymphe Fluviale* in the Louvre's *Description raisonnée des sculptures de la Renaissance française* (Paris: Louvre, 1978), 102–3. Hippolyte Bayard also made a photograph of a related work by Goujon: *La Vénus à la coquille de Jean Goujon* (French Society of Photography 24.291).

55. Cailleux had held various positions at the Louvre since 1821, including curator of drawings from 1827 to 1832. He was made *directeur-général* of the museum on March 13, 1841. See J. J. Marquet de Vasselot, *Répertoire des Catalogues du Musée du Louvre (1797–1917) suivi de la liste des Directeurs et Conservateurs du Musée* (reprint: New York: Burt Franklin, 1968), 126, 147. Helmut Gernsheim implies that Daguerre presented his *Still Life* to Cailleux in 1837, "in the hope that his influence might bring the invention to the notice of artists." Not having any success in this regard, Daguerre then began taking daguerreotypes in the streets around Paris in order to attract publicity. Gernsheim reproduces one of the images, *View of the Ile de la Cité and Notre Dame taken before the public announcement of his discovery in 1839.* See Gernsheim in Richter, *The Art of the Daguerreotype,* 2–4. Arago mentions several more early pictures during his speech to the Académie des Sciences on January 7, 1839; "a view of the long gallery connecting the Louvre with the Tuileries; a view of the Ile de la Cité with the towers of Notre-Dame; several views of the Seine with some of its bridges; also views of the [Customs] barriers of the capital." He also mentions witnessing Daguerre's attempt to photograph the moon. See Gernsheim, *L. J. M. Daguerre,* 82–83. On July 7, 1839, Daguerre showed a number of his daguerreotypes to members of the Chamber of Deputies.

As reported in the British *Literary Gazette* of July 13, these included "views of three of the streets of Paris, of the interior of M. Daguerre's studio, and of a group of busts from the Musée des Antiques." The view of Daguerre's studio featured a bust of Homer. See this report in Newhall, *Photography: Essays & Images,* 18.

56. Julia Ballerini, "Recasting Ancestry: Statuettes as Imaged by Three Inventors of Photography," in Anne Lowenthal, ed., *The Object as Subject: Essays on the Interpretation of Still Life* (Princeton: Princeton University Press, 1996), 44, 48.

57. Daguerre, 1838, as quoted in H. & A. Gernsheim, *L. J. M. Daguerre,* 81.

58. Ibid., 192.

59. Eugenia Parry Janis has also commented on this image. "Thus Daguerre, in choosing fossils among the first things photographed, recorded objects that not only encapsulate immeasurable time, but allude to the essence of the photographic process by showing other ways in which nature managed to imprint itself" (20). See Eugenia Parry Janis, "Fabled Bodies: Some Observations on the Photography of Sculpture," in Jeffrey Fraenkel, ed., *The Kiss of Apollo: Photography & Sculpture 1845 to the Present* (San Francisco: Fraenkel Gallery, 1991), 9–23.

60. See H. & A. Gernsheim, *L. J. M. Daguerre,* 193.

61. As reported in ibid., 194.

62. Alexander von Humboldt, writing to a friend on February 7, 1839, as quoted in Beaumont Newhall, introduction in *An Historical & Descriptive Account of the Various Processes of the Daguerreotype & the Diorama by Daguerre* (New York: Winter House, 1971), 16.

63. Duchâtel, as quoted in Louis Daguerre, *An Historical and Descriptive Account of the various Processes of the Daguerréotype and the Diorama* (London: McLean, 1839), 3.

64. *Le Commerce,* January 13, 1839, as quoted in H. & A. Gernsheim, *L. J. M. Daguerre,* 86.

65. H. Gaucheraud, *Gazette de France,* January 6, 1839, as quoted in ibid., 85.

66. Samuel Morse, in a letter dated March 9, 1839, as quoted in ibid., 89.

67. Hubert, as quoted in ibid., 104.

68. See R. Derek Wood & Pierre G. Harmant, "Daguerre's Demonstrations in 1839 at the Palais d'Orsay," *History of Photography* 16, no. 4 (Winter 1992): 400–1.

69. This is how it is described, for example, in Gail Buckland, *First Photographs: People, Places, and Phenomena as Captured for the First Time by the Camera* (New York: MacMillan, 1980), 177.

70. Samuel Morse, in a letter dated March 9, 1839, as quoted in H. &. A. Gernsheim, *L. J. M. Daguerre,* 89.

71. Arago, from his statement to the Académie des Sciences on January 7, 1839, as quoted in ibid., 82.

72. Gaucheraud, *Gazette de France,* January 6, 1839, as quoted in ibid., 85.

73. Auguste Comte (1798–1857), as quoted in Dennis P. Grady, "Philosophy and Photography in the Nineteenth Century: A Note on the Matter of Influence" (1977), in T. Barrow, S. Armitage, and W. Tydeman, eds., *Reading into Photography: Selected Essays 1959–1980* (Albuquerque: University of New Mexico Press, 1982), 147.

74. D. G. Charlton, *Positivist Thought in France, dur-*

ing the Second Empire 1852–1870 (Westport: Green-
wood Press, 1959), 5. Charlton says in the
introduction that "almost every writer to be dis-
cussed, in fact, is, whether consciously or not, the
victim of a divided mind. They are attempting, in
differing ways and to differing extents, to recon-
cile aspirations and convictions that are incompat-
ible" (2).

75. American philosopher Stanley Cavell is one
recent scholar who, while casting his analysis of
photography in terms of desire and power, simul-
taneously projects a universal positivist ideal as
the medium's determining ontology.

*So far as photography satisfied a wish, it satisfied a wish
not confined to painters, but the human wish, intensifying
since the Reformation, to escape subjectivity and meta-
physical isolation—a wish for the power to reach this
world, having for so long tried, at last hopelessly, to mani-
fest fidelity to another. . . . Photography overcame subjec-
tivity in a way undreamed of by painting, one which does
not so much defeat the act of painting as escape it alto-
gether: by automatism, by removing the human agent
from the act of reproduction.*

Stanley Cavell, *The World Viewed* (1971), as
quoted in Joel Snyder and Neil Walsh Allen, "Pho-
tography, Vision, and Representation" (1975), in
Barrow, Armitage, and Tydeman, eds., *Reading
into Photography,* 63.

76. Hippolyte Taine (1828–1893), as quoted in
Jean-Luc Daval, *Photography: History of an Art*
(New York: Rizzoli, 1982), 18. Charlton describes
Taine as espousing a contradictory fusion of En-
glish positivism and German idealism, a merger
"of Mill and Hegel." See Charlton, *Posivitist
Thought in France,* 133–34.

77. Reese Jenkins, "Science, Technology, and the
Evolution of Photography, 1790–1925," in Eu-
gene Ostroff, ed., *Pioneers of Photography: Their

Achievements in Science and Technology (Springfield:
The Society for Imaging Science and Technology,
1987), 20.

78. Janet E. Buerger, "The Genius of Photogra-
phy," in John Wood, ed., *The Daguerreotype: A Ses-
quicentennial Celebration* (Iowa City: University of
Iowa Press, 1989), 43, 48, 49. Buerger is not the
only historian to locate photography's origins in a
desire for a kind of pictorial realism. Svetlana Alp-
ers, for example, argues that photography should
be properly seen as part of a Dutch or Keplerian
mode of descriptive representation rather than as
the "logical culmination of the Albertian tradi-
tion of picture-making." Alpers' argument is a
product of her more general thesis in *The Art of
Describing,* in which she claims that there is a
definite distinction between Albertian and north-
ern pictorial modes of representation. To sup-
port her argument, Alpers seeks to persuade
readers that photographic conventions are some-
how generically different from those found in the
Albertian picture.

*Many characteristics of photographs—those very charac-
teristics that make them so real—are common also to the
northern descriptive mode: fragmentariness; arbitrary
frames; the immediacy that the first practitioners ex-
pressed by claiming that the photograph gave Nature the
power to reproduce herself directly unaided by man. . . .
The ultimate origins of photography do not lie in the
fifteenth-century invention of perspective . . . but rather
in the alternative mode of the north.*

See Svetlana Alpers, *The Art of Describing: Dutch
Art in the Seventeenth Century* (Chicago: University
of Chicago Press, 1983), 243, 43, 244.

79. Daguerre, 1835, as quoted in H. & A. Gerns-
heim, *L. J. M. Daguerre,* 73.

80. Daguerre and Bouton, from *Notice explicative
des tableaux exposés au Diorama* (Paris, 1822), as

quoted in Newhall's introduction to *An Histori-cal & Descriptive Account,* 10.

81. For more on the work and influence of de Loutherbourg, see Francis D. Klingender, *Art and the Industrial Revolution,* ed. and rev. Arthur Elton (London: Evelyn, Adams and MacKay, 1947, 1968), 96–100. The patent for the Diorama, estab-lished only on February 10, 1823, described it as "an improved mode of publicly exhibiting pic-tures or painted scenery of every description, and of distributing or directing daylight upon or through them, so as to produce many beautiful effects of light and shade." As quoted in Arthur T. Gill, "The London Diorama," *History of Photog-raphy* 1, no. 1 (January 1977): 31. The Diorama was so successful in Paris that it was soon repli-cated elsewhere. The London Diorama for ex-ample first opened October 6, 1823 and continued under various managements until April 1851. For further discussions of the Di-orama, see Eric de Kuypre and Emile Poppe, "Voir et regarder," *Communications,* no. 34 (1981): 85–96; Jonathan Crary, "Techniques of the Ob-server," *October* 45 (Summer 1988): 22; and Wil-liam H. Galperin, "The Panorama and the Diorama: Aids to Distraction," in *The Return of the Visible in British Romanticism* (Baltimore: The Johns Hopkins University Press, 1993), 34–71.

82. *The Times,* October 4, 1823, as quoted in H. & A. Gernsheim, *L. J. M. Daguerre,* 17.

83. Niépce, as quoted in ibid., 57–58.

84. Niépce, as quoted in Fouque, *The Truth Con-cerning the Invention of Photography,* 94.

85. Olive Cook, *Movement in Two Dimensions: A Study of the Animated and Projected Pictures which Pre-ceded the Invention of Cinematography* (London: Hutchinson, 1963), 42. To add extra veracity to one Swiss scene, Daguerre also included sound;

the audience could hear Alpine horns and folk songs coming from offstage. See Newhall, intro-duction, in *An Historical & Descriptive Account,* 11–12.

86. Linda Nochlin, *Realism* (Harmondsworth: Penguin, 1971), 14. For more on the difficulty of the word *realism* see Raymond Williams, *Keywords: A Vocabulary of Culture and Society* (Glasgow: Fon-tana, 1976), 216–21.

87. See T. J. Clark, *Image of the People: Gustave Cour-bet and the 1848 Revolution* (London: Thames and Hudson, 1973) and Linda Nochlin, "Courbet's Real Allegory: Rereading *The Painter's Studio,*" in Sarah Faunce and Linda Nochlin, eds., *Courbet Re-considered* (Brooklyn: Brooklyn Museum, 1988), 17–41, 222–26. In the posthumously published *Lettres à L'Etrangère,* Honoré de Balzac claimed that he had foreshadowed daguerreotypy in the final pages of his 1832 novel *Louis Lambert* (where he speaks, for example, of "the mirror or means of estimating a thing by seeing it in its en-tirety"). George Parsons explains Balzac's realist aspirations in his 1892 introduction to the En-glish translation: "Balzac undertook to describe the society of his time. . . . His vast plan involved the photographing, the analysis, the classifica-tion, of every social element." See Balzac, *Lettres à L'Etrangère 1842–1844 Tome Deuxième* (Paris: Calmann-Lévy, 1906), 38, and Balzac, *Louis Lam-bert* (Boston: Roberts Brothers, 1892), 143, ix.

88. Daguerre included a "Description of the Pro-cess of Painting and Effects of Light invented by Daguerre and applied by him to the Pictures of the Diorama" in his booklet *An Historical and De-scriptive Account of the various Processes of the Da-guerreotype and the Diorama* (1839). These passages (which open and close his description) have been taken from pages 81 and 86 of the English edi-tion. Note that Bouton gets even less credit from

Daguerre for this invention than Niépce received for his work toward the daguerreotype. Daguerre was right to emphasize light as his real medium. "He illuminated certain areas of the canvas with colored lights and painted details in the complementary color. Parts painted red, for example, would disappear when red light shone on them; blue-green areas, on the other hand, would appear black." Newhall, introduction, in *An Historical & Descriptive Account,* 12.

89. Constable, writing to Archdeacon Fisher in 1823, as quoted in Cook, *Movement in Two Dimensions,* 37–38.

90. See Daguerre's 1838 broadsheet, as quoted in Gernsheim, *L. J. M. Daguerre,* 80–81.

91. Henry Talbot, "Brief Historical Sketch of the Art," *The Pencil of Nature* (London: Longman, Brown, Green & Longman's, 1844–46), unpaginated.

92. Henry Talbot, "Some Account of the Art of Photogenic Drawing" (1839), as reproduced in Newhall, *Photography: Essays & Images,* 23–30.

93. Laura Mundy, as quoted in Larry Schaaf, *Out of the Shadows: Herschel, Talbot, & the Invention of Photography* (New Haven: Yale University Press, 1992), 40.

94. See Michael Gray, "Secret Writing," in Mike Weaver, ed., *Henry Fox Talbot: Selected Texts and Bibliography* (Oxford: Clio Press, 1992), 72. Morse had also experimented with a secret writing process early in his career. See my "'Some Experiments of Mine': The Early Photographic Experiments of Samuel Morse," *History of Photography* 15, no. 1 (Spring 1991), 38.

95. As reproduced in Michael Gray, "Zunächst verbogen, erscheine ich schlie lich doch: Zu den Versuchen von William Henry Fox Talbot," in Hubertus von Amelunxen, *Die Aufgehobene Zeit:*

Die Erfindung der Photographie durch William Henry Fox Talbot (Berlin: Nishen, 1988), 147.

96. See Eugene Ostroff, "Talbot's Earliest Extant Print, June 20, 1835, Rediscovered," *Photographic Science and Engineering* 10, no. 6 (November–December 1966): 350–54.

97. Talbot (March 1839), as quoted in Schaaf, *Out of the Shadows,* 40.

98. See Schaaf, ibid., 47, 38, 39. The J. Paul Getty Museum also lists several prints by Talbot that it dates circa 1835. These include a negative of a piece of floral-patterned lace and another negative titled *Rooftop and Chimneys, Lacock Abbey.* See Weston Naef, *Handbook of the Photographs Collection* (Malibu: The J. Paul Getty Museum, 1995), 9–10.

99. See Ian Jeffrey, *The Real Thing: An Anthology of British Photographs 1840–1950* (London: Arts Council of Great Britain, 1975), 6–7. A similar reading of the knowing sophistication of Talbot's early photographs is found in Mike Weaver's *The Photographic Art: Pictorial Traditions in Britain and America* (New York: Harper & Row, 1986) and in his essay "Henry Fox Talbot: Conversation Pieces" in Mike Weaver, ed., *British Photography in the Nineteenth Century: The Fine Art Tradition* (Cambridge: Cambridge University Press, 1989), 11–23.

100. See Schaaf, *Out of the Shadows,* 41. See also my review of this book, "Out of the Shadows," *The Photo-Historian,* no. 102 (London: The Royal Photographic Society [Autumn 1993]): 15–20.

101. See Schaaf, ibid., 89.

102. Reese Jenkins, "Science, Technology, and the Evolution of Photography, 1790–1925," *Pioneers of Photography,* 19–20.

103. Coleridge, as quoted in Owen Barfield, *What Coleridge Thought* (Oxford: Oxford University Press, 1971), 31.

104. Mesmer (1766), as quoted in Brian Inglis, *Natural and Supernatural: A History of the Paranormal from Earliest Times to 1914* (London: Hodder and Stoughton, 1977), 141.

105. For more on mesmerism and its European reception see Inglis, *Natural and Supernatural,* 141–58, and Nigel Leask, "Shelley's 'Magnetic Ladies': Romantic Mesmerism and the Politics of the Body," in Stephen Copley and John Whale, eds., *Beyond Romanticism: New Approaches to Texts and Contexts 1780–1832* (London: Routledge, 1992), 53–78.

106. Davy, as quoted in Trevor Levere, *Affinity and Matter: Elements of Chemical Philosophy 1800–1865* (Oxford: Clarendon Press, 1971), 26.

107. Schelling (1799), as quoted in Thomas Kuhn, *The Essential Tension: Selected Studies in Scientific Tradition and Change* (Chicago: University of Chicago Press, 1977), 97–98.

108. Taken from Davy's lectures on electrical science between 1810 and 1826, as quoted in John Davy, *Memoirs of the Life of Sir Humphry Davy, Bart.,* vol. 1 (London: Longman, Rees, Orme, Brown, Green, & Longman, 1836), 326–27. See also Levere, *Affinity and Matter,* 31.

109. See David D. Ault, *Visionary Physics: Blake's Response to Newton* (Chicago: University of Chicago Press, 1974), 6–17.

110. John Herschel, *A Preliminary Discourse on the Study of Natural Philosophy* (Philadelphia: Lea & Blanchard, 1831, 1840), 253.

111. See Richard Olson, *Scottish Philosophy and British Physics 1750–1880: A Study in the Foundations of the Victorian Scientific Style* (Princeton: Princeton University Press, 1975), 171.

112. See H. J. P. Arnold, *William Henry Fox Talbot: Pioneer of Photography and Man of Science* (London: Hutchinson Benham, 1977), 51.

113. See D. M. Turner, *Makers of Science: Electricity and Magnetism* (London: Oxford University Press, 1927), 57–58.

114. See Arnold, *William Henry Fox Talbot,* 220–26.

115. The most comprehensive selection of Bayard's photography can be found reproduced in Jean-Claude Gautrand and Michel Frizot, *Hippolyte Bayard: Naissance de l'image photographique* (Amiens: Trois Cailloux, 1986). For further reproductions see also Joseph-Marie Lo Ducco, *Bayard* (New York: Arno Press, 1943, 1979); Otto Steinert and Pierre Harmant, *Hippolyte Bayard ein Erfinder der Photographie* (Essen: Museum Folkwang Essen, 1959); André Jammes, *Hippolyte Bayard, Ein verkannter Erfinder und Meister der Photographie* (Lucerne: Bucher, 1975); and Nancy Keeler, "Souvenirs of the Invention of Photography on Paper: Bayard, Talbot, and the Triumph of Negative-Positive Photography," in Weston Naef, ed., *Photography: Discovery and Invention* (Malibu: The J. Paul Getty Museum, 1990), 47–62.

116. As quoted in Jammes and Janis, *The Art of French Calotype,* 3.

117. Wey, as quoted in ibid., 4.

118. For more on Antinous and Hadrian, see Royston Lambert, *Beloved and God: The Story of Hadrian and Antinous* (London: Weidenfeld and Nicolson, 1984). Bayard's statuette was a miniature copy of the so-called "Farnese" Statue of Antinous, a reproduction of which was part of the Jean Baptiste Giraud museum of casts from antiquity at the Place Vendôme. Bayard used the statuette in at least four of his still life photographs. In a recent lecture ("Freud and the Culture of

Late 19th-Century Homosexuality," delivered at the University of California San Diego on March 13, 1996), Whitney Davis argued that Antinous represented an unmistakable homoerotic reference point for the intelligentsia of the eighteenth and nineteenth centuries, providing a classical model for the expression of a contemporary homosexual desire. For further evidence of the use of such models, see Whitney Davis, "Winkelmann's 'Homosexual' Teleologies," in Natalie Boymel Kampen, ed., *Sexuality in Ancient Art: Near East, Egypt, Greece, and Italy* (Cambridge: Cambridge University Press, 1996), 262–76, and Whitney Davis, "The Renunciation of Reaction in Girodet's *Sleep of Endymion*," in Norman Bryson, Michael Ann Holly, and Keith Moxey eds., *Visual Culture: Images and Interpretations* (Hanover, NH: University Press of New England, 1994), 168–201.

119. Julia Ballerini, "Recasting Ancestry: Statuettes as Imaged by Three Inventors of Photography," *The Object as Subject,* 47. See also Michel Frizot, 'Bayard et son jardin,' *Hippolyte Bayard,* 77–105.

120. One of Bayard's closest friends was Jules-Claude Ziégler, a painter who in 1839 founded a ceramics factory. Perhaps this ubiquitous vase is one of his? For more on Bayard's circle of friends and associates, see Jammes and Janis, *The Art of French Calotype,* 144–48.

121. See Michel Frizot, "The Parole of the Primitives: Hippolyte Bayard and the French Calotypists," *History of Photography* 16, no. 4 (Winter 1992): 358–70, and Jammes and Janis, *The Art of French Calotype,* 20.

122. Photography's historians have offered a number of interpretations of Bayard's *Le Noyé.* André Jammes and Eugenia Parry Janis suggest that the photograph is a "bizarre" parody of David's *Death of Marat.* Michel Frizot has called it "a timid threat," "a portrait of defeat," the *Defeated Self-Portrait.* Nancy Keeler disagrees with this reading, pointing out the humor of the image and its ironic treatment of what was then a popular romantic theme. See Jammes and Janis, *The Art of French Calotype,* 20, 109–10; Michel Frizot, "Bayard et son jardin," *Hippolyte Bayard: Naissance de l'image photographique,* 98–103; and Nancy Keeler, "Hippolye Bayard: aux origines de la photographie et de la ville moderne," *La Recherche Photographie,* no. 2 (May 1987): 7–17. See also my own earlier reading in "Le Petite Mort: Photography and Pose," *San Francisco Camerawork Quarterly* 15, no. 1 (Spring 1988): 3–6.

123. For extensive commentaries on the production and meanings of David's *Death of Marat,* see Dorothy Johnson, *Jacques-Louis David: Art in Metamorphosis* (Princeton: Princeton University Press, 1993); T. J. Clark, "Painting in the Year Two," *Representations* 47 (Summer 1994): 13–63; Thomas Crow, *Emulation: Making Artists for Revolutionary France* (Yale University Press, 1995).

124. E. J. Delécluze, *Louis David, son école et son temps* (Paris: Macula, 1855, 1983), 153.

125. See Antoine Schnapper and Arlette Serullaz, eds., *Jacques-Louis David 1748–1825,* exhib. cat. (Paris: Editions de la Réunion des musées nationaux, 1989), 219–21.

126. This mention of an offensive smell may well be yet another reference to the figures of Marat and Le Peletier. Both of these martyrs were given elaborate funerals designed by David in which their carefully posed, semi-nude and rapidly decomposing bodies were put on public display. Marat's body was a particular problem, as it was decaying from disease while he was still alive and had to be displayed in hot weather when dead. The body, already green by the day of the funeral,

NOTES

TO PAGES 153–171

253

was therefore embalmed, painted with white makeup, drenched in perfume, and swathed in flowers. It still stank. For contemporary images and an account of these funerals, see Crow, *Emulation: Making Artists for Revolutionary France,* 156–59, 162–65.

127. For an undated print showing Bayard's father harvesting an apple marked with a *B,* see Paul Jay, *Les Conserves de Nicéphore: Essai sur la nécessité d'inventer la photographie* (Chalon-sur-Saône: Société des Amis du Musée Nicéphore Niépce, 1992), 19. For an account of this harvest, see Potonniée, *The History of the Discovery of Photography,* 183. This story is repeated as a legend by Gautrand, who traces its first publication to 1868. See Gautrand, ed., *Hippolyte Bayard,* 17.

128. Derrida, as quoted in Rubinstein, "Sight Unseen," *Art in America,* 48.

129. This seems to confirm Michel Frizot's argument that Bayard's constant subject was "photography in the process of constructing itself, the how and the why of its making, the conception and materialisation confounded in a single gesture" (as quoted in Elizabeth Anne McCauley, "The Amateur Aesthetic: Bayard, Lesecq and the Victorians," *Afterimage* 15, no. 3 [October 1987], 6).

130. Eduardo Cadava, "Words of Light: Theses on the Photography of History," *Diacritics* 22, no. 3–4 (Fall–Winter 1992): 110.

CHAPTER 5

1. Jacques Derrida, *Positions,* trans. Alan Bass (Chicago: University of Chicago Press, 1972, 1981), 28.

2. Jacques Derrida, *Of Grammatology,* trans. Gayatri Chakravorty Spivak (Baltimore: The Johns Hopkins University Press, 1967, 1976), 36.

3. See, for example, Barbara Johnson, translator's introduction, in Jacques Derrida, *Dissemination* (Chicago: University of Chicago Press, 1972, 1981), vii–xxxiii; Jacques Derrida, "Différance" (1968), in *Margins of Philosophy,* trans. Alan Bass (Chicago: University of Chicago Press, 1982), 1–27; Irene Harvey, *Derrida and the Economy of Différance* (Bloomington: Indiana University Press, 1986); and David Wood and Robert Bernasconi, eds., *Derrida and Différance* (Evanston, Ill.: Northwestern University Press, 1988).

4. Derrida, *Of Grammatology,* 143.

5. Ibid., 158.

6. Derrida, *Positions,* 43.

7. Ibid., 26.

8. In a review of Peter Galassi's exhibition *Before Photography,* American critic Joel Snyder carefully lists a series of scientific discoveries without which, he argues, the invention of photography would not have been possible.

The solvent properties of sodium thiosulphate on silver halides, an absolute necessity for photography as we know it, were not discovered until 1819 by John Herschel. Wedgwood and Davy failed in their attempts to make pictures by means of the camera (thus, they admitted that they could not combine Galassi's two "simple principles" [i.e., optics and chemistry]). The Niépce brothers did not use silver salts as the basis of their photographic system. Their motivation was initially to make lithographic stones and plates that were engraved by the action of the sun on certain oily substances. Their work could not

have commenced until after the publication of the principles of lithography in 1813. Daguerre's system is absolutely dependent upon the use of elemental iodine, which was not discovered until 1813 by Gay-Lussac and Humphry Davy and which did not go into commercial production until 1821. Talbot's system required his own discovery (made in 1834) that silver halides (eg. silver chloride) were highly light-sensitive if made with an excess of silver nitrate and a small amount of halides, and that the same silver halides were barely sensitive to light if made with low-concentration silver nitrate and high concentrations of halide salts. Talbot's major discoveries concerning the salts of silver could not have been made prior to the early 1830s because many of the compounds he used were not available before then. From a technical perspective, the invention of photography was an extraordinary achievement that could not possibly have been accomplished before it, in fact, was.

Joel Snyder, "Review of Peter Galassi's 'Before Photography,'" *Studies in Visual Communication* 8, no. 1 (Winter 1982): 116. See also Joel Snyder, "Inventing Photography, 1839–1879," in Sarah Greenough, Joel Snyder, David Travis, and Colin Westerbeck, *On the Art of Fixing a Shadow: One Hundred and Fifty Years of Photography* (Washington: National Gallery of Art, 1989), 8. Snyder's argument, although well taken, nevertheless assumes that the desire to invent photography was an automatic product of the technical ability to do so. Yet the archive of this desire, as opposed to an account focusing on experimental failure and success, indicates that in many cases (including those of both Talbot and Daguerre) its onset in fact preceded the dates that Snyder presents as an "absolute necessity" to photography. Certainly the desire to photograph, and the empirical experiments

it induced, consistently outstripped prevailing chemistry theory. As Henry Talbot admitted in his "Some Account of the Art of Photogenic Drawing" of January 1839: "As to the theory, I confess that I cannot as yet understand the reason why the paper prepared in one way should be so much more sensitive than another" (Talbot, in Beaumont Newhall, ed., *Photography: Essays & Images* [New York: Museum of Modern Art, 1980], 27). Furthermore, Talbot, writing to Herschel in 1839, had this to say about his own process: "But upon what chemical reasons does the process depend, or why it should be at all possible, to obtain fixation in this manner? Nothing that is said in chemical works concerning chloride of silver has any bearing on the subject, nor do they even mention its insensible state" (H. J. P. Arnold, *William Henry Fox Talbot: Pioneer of Photography and Man of Science* [London: Hutchinson Bentham, 1977], 110–11). The same problem applied to the invention of the daguerreotype. *The Athenaeum's* report of the joint meeting of the French Académie des Sciences and Académie des Arts, held on August 19, 1839, had this to say: "M. Arago, however, formally declared the positive inability of the combined wisdom of physical, chemical, and optical science, to offer any theory of these delicate and complicated operations, which might be even tolerably rational and satisfactory" (as quoted in M. Susan Barger, "Delicate and Complicated Operations: The Scientific Examination of the Daguerreotype," in John Wood, ed., *The Daguerreotype: A Sesquicentennial Celebration* [Iowa City: University of Iowa Press, 1989], 97). The English edition of Daguerre's *An Historical and Descriptive Account of the Daguerréotype and the Diorama* of 1839

contained an essay titled "Theory of the Daguerreotype Process." It was written by William E. A. Aikin, professor of chemistry and pharmacy at the University of Maryland, and was originally published in the *Maryland Medical and Surgical Journal.* Among other comments, Aikin admits that "the action of light in the camera is quite inexplicable at present, and a very long time may elapse before the secret is revealed" (3).

Faced with this evidence, one has to go beyond the search for some sort of scientific "cause" of photography and come back to why people wanted to photograph at all. "Both the camera and the necessary chemistry had coexisted for some time. It was the motivation to produce a photograph that was the most important factor in this equation. The crucial question is *why,* rather than *how,* photography was finally invented" (Larry Schaaf, *Out of the Shadows: Herschel, Talbot, and the Invention of Photography* [New Haven: Yale University Press, 1992], 1).

9. Derrida, "Différance," *Margins of Philosophy,* 11.

10. Michel Foucault, "Foreword to the English Edition," *The Order of Things: An Archaeology of the Human Sciences* (New York: Vintage Books, 1966, 1973), xi.

11. Ibid., xxii.

12. Michel Foucault, preface, in Gilles Deleuze and Félix Guattari, *Anti-Oedipus: Capitalism and Schizophrenia,* trans. Robert Hurley, Mark Seem, and Helen R. Lane (Minneapolis: University of Minnesota Press, 1983), xiii. A number of commentators have noted the correspondence of Foucault's conception of power and the positive, rhyzomatic desire figured in the work of Deleuze and Guattari. As Jean Baudrillard

puts it: "One can't help but be struck by the coincidence between this new version of power and the new version of desire proposed by Deleuze and Lyotard: no longer lack or interdiction, but the apparatus and positive dissemination of flows or intensities. This coincidence is not accidental: it is quite simply that in Foucault power takes the place of desire" (Jean Baudrillard, "Oublier Foucault," *Theoretical Strategies* [Sydney: Local Consumption Publications 2/3 (August 1982)], 192). For similar comparisons, see also Paul Patton, "Notes for a Glossary," *Ideology & Consciousness,* no. 8 (1981): 41–48; and Pamela Major-Poetzl, *Michel Foucault's Archaeology of Western Culture: Toward a New Science of History* (Chapel Hill: University of North Carolina Press, 1983), 47–49.

13. Gilles Deleuze and Félix Guattari, as quoted in Patton, "Notes for a Glossary," *Ideology & Consciousness,* 42.

14. Deleuze and Guattari, *Anti-Oedipus,* 26–27, 29.

15. See Jacques Derrida, "Force and Signification" (1963), in *Writing and Difference,* trans. Alan Bass (Chicago: University of Chicago Press, 1967, 1978), 27, and Derrida, "White Mythology: Metaphor in the Text of Philosophy" (1971), *Margins of Philosophy,* 207–71.

16. Eduardo Cadava, "Words of Light: Theses on the Photography of History," *Diacritics* 22, no. 3–4 (Fall–Winter 1992): 87.

17. Foucault, *The Order of Things,* xxii. Elsewhere in this book Foucault puts the "chronological frontier" of the classical period at "around 1800–10" (57) and describes the shift into the modern as taking place "within

a few years (around 1800)" (xii): "The phenomenon as a whole can be situated between easily assignable dates (the outer limits are the years 1775 and 1825); but in each of the domains studied we can perceive two successive phases, which are articulated one upon the other more or less around the years 1795–1800" (221). In a 1967 interview with Raymond Bellour, Foucault is similarly precise about the timing of the modern period, stating that it "began about 1790–1810" (as quoted in Alan Sheridan, *Michel Foucault: The Will to Truth* [London: Tavistock Publications, 1980], 196).

18. Foucault, *The Order of Things,* xxii.

19. Ibid., 238.

20. Michel de Certeau, "The Black Sun of Language: Foucault" (1969), in *Heterologies: Discourse on the Other,* trans. Brian Massumi (Minneapolis: University of Minnesota Press, 1986), 176.

21. In *The Order of Things* Foucault describes the radical mutation from Classical to Modern in terms of three particular sets of relationships: philology, biology, and political economy on the one hand, and general grammar, natural history, and the analysis of wealth on the other.

It would be false—and above all inadequate—to attribute this mutation to the discovery of hitherto unknown objects, such as the grammatical system of Sanskrit, or the relation between anatomical arrangements and organic functions in living beings, or the economical role of capital. And it would be no more accurate to imagine that general grammar became philology, natural history biology, and the analysis of wealth political economy, because all these modes of knowledge corrected their methods, came

closer to their objects, rationalized their concepts, selected better models of formalization—in short, because they freed themselves from their prehistories through a sort of auto-analysis achieved by reason itself. What changed at the turn of the century, and underwent an irremediable modification, was knowledge itself as an anterior and indivisible mode of being between the knowing subject and the object of knowledge. (252)

22. Foucault, *The Order of Things,* 50.

23. Ibid., 207.

24. Michel Foucault, *The Archaeology of Knowledge,* trans. A. M. Sheridan Smith (New York: Pantheon Books, 1972), 173.

25. De Certeau, "The Black Sun of Language: Foucault," *Heterologies,* 178. Hayden White has also commented on Foucault's methodological complexity, arguing against some of the Frenchman's critics that "there *is* a transformational system built into Foucault's conception of the succession of forms of the human sciences, even though Foucault appears not to know that it is there." This system is, according to White, a "projective or generational aspect of language," specifically a rhetorical/historical cycle comprised of four tropes—metaphor, metonomy, synecdoche and irony. See Hayden White, "Foucault Decoded" (1973), *Tropics of Discourse: Essays in Cultural Criticism* (Baltimore: The Johns Hopkins University Press, 1978), 251, 254–55. In a later essay, White argues that the rhetorical trope of catechresis is fundamental to Foucault's style of discourse, a style notable for its perverse reversals and its mode of "circular negation." See Hayden White, "Foucault's Discourse: The Historiography of Anti-Humanism" (1978), in *The Content of the Form: Narrative Discourse and*

Historical Representation (Baltimore: The Johns Hopkins University Press, 1987), 104–41. White reads Foucault's own discourse in terms of a rhetorical tropology that strategically breaks down the traditional distinction between the literal and figural meanings of words.

This rhetorical trope is catachresis, and Foucault's style not only displays a profusion of the various figures sanctioned by catachresis, such as paradox, oxymoron, chiasmus, hysteron, proteron, metalepsis, prolepsis, antonomasia, paronomasia, antiphrasis, hyperbole, litotes, irony, and so on; his own discourse stands as an abuse of everything for which "normal" or "proper" discourse stands. It looks like history, like philosophy, like criticism, but it stands over these discourses as ironic antithesis.

Hayden White, "Michel Foucault" in John Sturrock, ed., *Structuralism and Since: From Levi-Strauss to Derrida* (Oxford: Oxford University Press, 1979), 93. Speaking of catechresis ("wrong naming"), it is worth noting how Foucault consistently employs terms that are made to double parasitically and paradoxically upon themselves; examples include "event" ("an incorporeal materialism"), "genealogy" (a strategic play of continuity with discontinuity, presence within absence), "positive unconscious" (a conjunction of negative and positive, conscious and unconscious), "bio-power" (a productive interaction of sex and sexuality), "apparatus" (an intersection of the discursive and nondiscursive), "panopticism" (in which the subject is both prisoner and warder, vehicle and target), "man" ("an empirico-transcendental doublet"), and so on.

26. Foucault, *The Order of Things,* 220.

27. Ibid., 120.

28. De Certeau describes Foucault's method in the following terms:

The internal instability of cycles and the ambiguity of their connections do not constitute two problems. Rather, it is in these two forms—the relation to other and the relation to self—that a single unending confrontation agitates history; it can be read in the ruptures that topple systems, and in the modes of coherence that tend to repress internal changes. There is both continuity and discontinuity, and both are deceptive, because each epistemological age, with its own "mode of being of order," carries within itself an alterity every representation attempts to absorb by objectifying. None will ever succeed in halting its obscure workings, or in staving off its fatal venom.

De Certeau, "The Black Sun of Language: Foucault," *Heterologies,* 181. Foucault replicates the paradoxical play described above in various discussions of his own historical method.

I"ll say this, that for me the whole business of breaks and non-breaks is always at once a point of departure and a very relative thing. In The Order of Things, *I took as my starting point some very manifest differences, the transformations of the empirical sciences around the end of the eighteenth century. It calls for a degree of ignorance (which I know isn't yours) to fail to see that a treatise of medicine written in 1780 and a treatise of pathological anatomy written in 1820 belong to two different worlds.* Michel Foucault, *Power/Knowledge: Selected Interviews and Other Writings 1972–1977,* ed. Colin Gordon [Brighton: The Harvester Press, 1980], 211.

It seemed to me that in certain empirical forms of knowledge like biology, political economy, psychiatry, medicine etc., the rhythm of transformation doesn't follow the smooth, continuist schemas of development

which are normally accepted. *The great biological image of a progressive maturation of science still underpins a good many historical analyses; it does not seem to me to be pertinent to history. In a science like medicine, for example, up to the end of the eighteenth century one has a certain type of discourse whose gradual transformation, within a period of twenty-five or thirty years, broke not only with the "true" propositions which it had hitherto been possible to formulate but also, more profoundly, with the ways of speaking and seeing, the whole ensemble of practices which served as supports for medical knowledge. These are not simply new discoveries, there is a whole new "regime" in discourse and forms of knowledge. And all this happens in the space of a few years. This is something which is undeniable, once one has looked at the texts with sufficient attention.* (Foucault, *Power/Knowledge,* 113).

Foucault, seemingly anxious to avoid the charge of structuralism, softens the edges of the definite periodization consistently suggested above when he writes, for example, *The Archaeology of Knowledge.* As he says there,

Nothing would be more false than to see in the analysis of discursive formations an attempt at totalitarian periodization, whereby from a certain moment and for a certain time, everyone would think in the same way, in spite of surface differences, say the same thing, through a polymorphous vocabulary, and produce a sort of great discourse that one could travel over in any direction. (148)
The idea of a single break suddenly, at a given moment, dividing all discursive formations, interrupting them in a single moment and reconstituting them in accordance with the same rules—such an idea cannot be sustained. The contemporaneity of several transformations does not mean their exact chronological coincidence.... Archaeology disarticulates the synchrony of breaks,

just as it destroyed the abstract unity of change and event. The period is neither its basic unity, nor its horizon, nor its object: if it speaks of these things it is always in terms of particular discursive practices, and as a result of its analyses. (175, 176)

Foucault repeats this line of auto-critique in other commentaries and interviews from this period. In an interview conducted during 1968, for example, he puts forward a complex list of criteria (described in terms of rules of formation, transformation, and correlation) as a substitute for an undesirable totalizing history.

They allow us to describe, as the episteme *of a period, not the sum of its knowledge, nor the general style of its research, but the deviation, the distances, the oppositions, the differences, the relations of its multiple scientific discourses: the* epistemic *is not a sort of grand underlying theory, it is a space of dispersion, it is an open field of relationships and no doubt indefinitely specifiable.... I do not seek to detect, starting from diverse signs, the unitary spirit of an epoch, the general form of its consciousness.*

Michel Foucault, "Politics and the Study of Discourse," *Ideology & Consciousness,* no. 3 (Spring 1978): 10. After May 1968 Foucault himself "definitively abandons" the strict rules of formation that he outlines with such thoroughness in this article and in *The Archaeology of Knowledge.* On this shift in orientation see Hubert Dreyfus and Paul Rabinow, *Michel Foucault: Beyond Structuralism and Hermeneutics* (Chicago: University of Chicago Press, 1983), 108.

29. This explains the confusion that sometimes attends the work of those who claim to be employing a Foucauldian method. Jonathan Crary, for example, argues in *Techniques of the*

Observer: On Vision and Modernity in the Nineteenth Century (Cambridge: MIT Press, 1990) that "my discussion of the camera obscura is founded on notions of *discontinuity* and difference." However, his account insists that the camera obscura and the photographic camera are "radically dissimilar," even as it positions photography as a continuation of the Cartesian logic of the camera obscura. For a more detailed analysis of this confusion, see Geoffrey Batchen, "Seeing Things: Vision and Modernity," *Afterimage* 19, no. 2 (September 1991): 5–7.

30. Jacques Derrida, "Freud and the Scene of Writing" (1966), in *Writing and Difference,* 196–231, 329–31.

31. Sigmund Freud, *The Interpretation of Dreams,* trans. James Strachey (New York: Avon Books, 1965), 574.

32. Sigmund Freud, "A Note Upon the 'Mystic Writing Pad' (1925)," *General Psychological Theory: Papers on Metapsychology* (New York: Collier Books, 1963), 212.

33. In a footnote to "Freud and the Scene of Writing," Derrida points out that in Freud's work, "the metaphor of a photographic negative occurs frequently. . . . the notions of negative and copy are the principal means of the analogy." In 1913, for example, Freud explicitly compared the relations between the conscious and unconscious to a photographic process (Derrida, "Freud and the Scene of Writing," *Writing and Difference,* 330).

34. Derrida, *Positions,* 43, 94.

35. Gayatri Chakravorty Spivak, translator's preface, in *Of Grammatology,* xl.

36. Derrida, *Of Grammatology,* 158. In the face of a common misunderstanding, I must reiterate that Derrida's "text" and "writing" go well beyond the marks on the page traditionally associated with these terms. He himself has pointed this out on numerous occasions.

I have often insisted on the fact that "writing" or the "text" are not reducible either to the sensible or visible presence of the graphic or the "literal."
 Derrida, *Positions,* 65.

An hour's reading, beginning on any page of any one of the texts I have published over the last twenty years, should suffice for you to realize that text, as I used the word, is not the book. No more than writing or trace, it is not limited to the paper which you cover with your graphism.
 Derrida, "But Beyond. . . . [Open letter to Anne McClintock and Rob Nixon])," trans. P. Kamuf, *Critical Inquiry* 13, no. 1 (1986): 167.

Strategic reasons . . . have motivated the choice of this word to designate "something" which is no longer tied to writing in the traditional sense any more than it is to speech or to any other type of mark. . . . What is at stake is precisely the attempt to put this concept into question and to transform it.
 Derrida, 'LIMITED INC . . . abc,' trans. Samuel Weber, *Glyph,* no. 1 (1977), 191.

37. Derrida, "Scene," *Writing and Difference,* 226.

38. Without wanting to ignore the differences, this book has tried to think the work of Foucault and Derrida together. In this regard, see Gayatri Spivak on Derrida and Foucault in the translator's preface in *Of Grammatology,* lx–lxii, and her "More on Power/Knowledge" in Thomas E. Wartenberg, ed., *Rethinking Power* (Albany: SUNY Press, 1992), 149–73. Certain differences were made public in an exchange of articles between the two philosophers regarding Foucault's early book *Madness and Civilization:* see Derrida, "Cog-

ito and the History of Madness" (1964), in *Writing and Difference,* 31–63; Foucault, "My Body, This Paper, This Fire" (1971), trans. Geoff Bennington, *Oxford Literary Review* 4, no. 1 (Autumn 1979): 9–28; Derrida, "'To Do Justice to Freud': The History of Madness in the Age of Psychoanalysis," *Critical Inquiry* 20 (Winter 1994): 227–66. This passionate exchange has tended to obscure the many sources, aspirations, and practices that the two philosophers share. For commentaries on this aspect of their work, see Tom Keenan, "The 'Paradox' of Knowledge and Power: Reading Foucault on a Bias," *Political Theory* 15, no. 1 (February 1987): 5–32; Gregory S. Jay, "Values and Deconstructions: Derrida, Saussure, Marx," *Cultural Critique* no. 8 (Winter 1987–88): 153–96; Alan D. Schrift, "Genealogy and/as Deconstruction: Nietzsche, Derrida and Foucault on Philosophy as Critique," in Hugh Silverman and Donn Welton, eds., *Postmodernism and Continental Philosophy* (Albany: State University of New York Press, 1988), 193–13; Roy Boyne, *Foucault and Derrida: The Other Side of Reason* (London: Unwin Hyman, 1990).

39. Compare Tagg's project with Foucault's, as described by the latter in a 1975 interview.

I think I would distinguish myself from both the Marxist and the para-Marxist perspectives. As regards Marxism, I'm not one of those who try to elicit the effects of power at the level of ideology. Indeed, I wonder if it wouldn"t be more materialist to study first the question of the body and the effects of power on it. Because what troubles me with these analyses which prioritise ideology is that there is always presupposed a human subject on the lines of the model provided by classical philosophy, endowed with a consciousness which power is then thought to seize on.

Michel Foucault, "Body/Power," *Power/Knowledge,* 58.

40. Foucault, *Power/Knowledge,* 98.

41. Ibid., 97.

42. Ibid., 186.

43. Michel Foucault, *The History of Sexuality, Volume 1: An Introduction,* trans. Robert Hurley (New York: Vintage, 1978), 157. Foucault has more to say on the vexing question of the relationship of sex and sexuality in *Power/Knowledge* (190):

This question was the central difficulty with my book. I had begun to write it as a history of the way in which sex was obscured and travestied by this strange life-form, this strange growth which was to become sexuality. Now, I believe, setting up this opposition between sex and sexuality leads back to the positing of power as law and prohibition, the idea that power created sexuality as a device to say no to sex. My analysis was still held captive by the juridical conception of power. I had to make a complete reversal of direction. I postulated the idea of sex as internal to the apparatus of sexuality, and the consequent idea that what must be found at the root of that apparatus is not the rejection of sex, but a positive economy of the body and of pleasure.

44. Jacques Derrida, "Scribble (writing-power)" (1977), trans. Cary Plotkin, *Yale French Studies* 58 (1979): 117.

45. Foucault, *Power/Knowledge,* 52.

46. Ibid., 195–96.

47. The phrase, representing a typically narrow reading of Foucault, comes in this instance from Patricia R. Zimmerman, "Our Trip to Africa: Home Movies as the Eyes of the Empire," *Afterimage* 17, no. 8 (March 1990): 4.

48. Michel Foucault, *Discipline and Punish: The Birth of the Prison,* trans. Alan Sheridan (Harmondsworth: Penguin, 1977), 201, 202–3.

49. Foucault, *The Order of Things,* 318.

50. Ibid., 312.

51. Foucault, *The Order of Things,* 312, 313, 316, 320–21. Faced with the complexities articulated by this collection of quotations, it is well to repeat the commentary of Paul Rabinow and Hubert Dreyfus: "Although this may sound Hegelian, it is radically opposed to all dialectic thought. Foucault has absolutely no sense that the truth is the whole and that these archaeological and genealogical transformations are stages in a process converging on an ideal community" (Paul Dreyfus and Hubert Rabinow, *Michel Foucault: Beyond Structuralism and Hermeneutics,* 263). See also David Carroll, *Paraesthetics: Foucault.Lyotard.Derrida* (New York: Methuen, 1987), 67; Michael S. Roth, *Knowing and History: Appropriations of Hegel in Twentieth-Century France* (Ithaca: Cornell University Press, 1988), 204–5. Both Derrida and Foucault attended Jean Hippolyte's classes on Hegel in the 1950s. For Foucault's own commentary on the distinctions between his practice and a Hegelian history, see Michel Foucault, "The Discourse on Language," *The Archaeology of Knowledge,* 215–37.

52. Foucault, *The Archaeology of Knowledge,* 49.

53. Ibid., 47–48.

54. Roland Barthes, "Rhetoric of the Image" (1964), in *Image-Music-Text,* trans. Stephen Heath (New York: Hill and Wang, 1977), 36.

55. Roland Barthes, *Camera Lucida: Reflections on Photography,* trans. Richard Howard (New York: Hill and Wang, 1980).

56. Roland Barthes, *The Pleasure of the Text,* trans. Richard Miller (New York: Hill and Wang, 1975), 9. See also Jane Gallop, "The Pleasure of the Phototext," *Afterimage* 12, no. 9 (April 1985): 16–18.

57. Barthes, *Camera Lucida,* 73.

58. Barthes, "Rhetoric of the Image," *Image-Music-Text,* 44.

59. Barthes, *Camera Lucida,* 96.

60. Jacques Derrida, "The Deaths of Roland Barthes" (1981), trans. Pascale-Anne Brault and Michael Naas, in Hugh Silverman, ed., *Philosophy and Non-Philosophy since Merleau-Ponty* (New York: Routledge, 1988), 266–67. For a challenging commentary on this text see Gayatri Chakravorty Spivak, "A Response to John O"Neill" in Gary Shapiro and Alan Sica, eds., *Hermeneutics: Questions and Prospects* (Amherst: University of Massachusetts Press, 1984), 183–98. See also the commentary on photography in Marie-Françoise Plissart and Jacques Derrida, "Right of Inspection," trans. David Wills, *Art & Text* no. 32 (Autumn 1989): 20–97, and especially 90–91.

61. Allan Sekula, "Photography Between Labour and Capital," in Benjamin H. D. Buchloh and Robert Wilkie, eds., *Mining Photographs and Other Pictures 1948–1968: A Selection from the Negative Archives of Shedden Studio, Glace Bay, Cape Breton* (Halifax: Press of the Nova Scotia College of Art and Design and the University College of Cape Breton Press, 1983), 218.

62. Allan Sekula, "Dismantling Modernism, Reinventing Documentary (Notes on the Politics of Representation)" (1978), in *Photography Against the Grain: Essays and Photo Works 1973–1983* (Halifax: Press of the Nova Scotia College of Art and Design, 1984), 57.

63. Sekula, "The Body and the Archive" (1986), in Richard Bolton, ed., *The Contest of Meaning: Critical Histories of Photography* (Cambridge: MIT Press, 1989), 372.

64. Rosalind Krauss, "Notes on the Index: Part

1" (1977), in *The Originality of the Avant-Garde and Other Modernist Myths* (Cambridge: MIT Press, 1985), 203.

65. Ibid.

66. Rosalind Krauss, "Notes on the Index: Part 2" (1977), in *The Originality of the Avant-Garde,* 211.

67. Ibid., 211–12.

68. Ibid., 216.

69. Rosalind Krauss, "In the Name of Picasso" (1981), in *The Originality of the Avant-Garde,* 33.

70. Ibid., 33.

71. Ibid., 37.

72. Ibid., 38. Krauss has also discussed the question of origins in a more recent essay.

This is . . . merely an evasion of the challenge to the very concept of authorial origin that poststructuralist theory poses, for while the strategy I've just described redraws the profile of the author—making it now a sect, or a class, or a cult—it leaves the idea of the origin intact; which is to say, it acts as though it goes without saying that "everything has to begin somewhere." But what if there were no beginning uncorrupted by a prior instance—or what in much of poststructuralist writing is rendered as the "always already"—and what if this somewhere, this localizable origin, were fractured at its very core—and thus were always already self-divided? . . . To capture this movement of an always already self-divided origin was, I realized, to carry out the examination of the very tools and categories of art history at a level that seemed to me extremely telling.

Rosalind Krauss, "Originality as Repetition: Introduction," *October* 37 (Summer 1986): 36, 40.

73. Rosalind Krauss, "The Photographic Conditions of Surrealism" (1981), in *The Originality of the Avant-Garde,* 110.

74. Ibid., 112.

75. Ibid., 112, 118. On Krauss's use of Derrida, see Matthew Biro, "Art Criticism and Deconstruction: Rosalind Krauss and Jacques Derrida," *Art Criticism* 6 (1990): 33–47. See also her essays on surrealist photography in Rosalind Krauss and Jane Livingstone, *L'Amour Fou: Photography and Surrealism* (Washington: The Corcoran Gallery of Art, 1985). For an earlier deployment of Derrida's work in American photographic criticism, see Craig Owens, "Photography *en abyme," October* 5 (Summer 1978): 73–88.

76. For a general critique of Krauss's work, see Craig Owens, "Analysis Logical and Ideological," *Art in America* 73, no. 5 (May 1985): 25–31. Owens castigates Krauss for adhering to what he calls "logical" (according to Owens, a structuralist and hence modernist mode of criticism) rather than "rhetorical" (or poststructuralist) art-historical analysis. The result, he says, is that "Krauss has effectively produced a monolithic modernism which denies all difference, heterogeneity, contradiction." This is the same Owens who just five years earlier had himself argued that "postmodernist art may in fact be identified by a single, coherent impulse," namely allegory. Thus, just like Krauss, he is anxious to return history to order, only this time it is to the order of disorder; to precisely the difference, heterogeneity, and contradiction that Krauss's account has supposedly denied. This simple reversal of oppositional terms is of course a standard structuralist move. And despite calling himself a Derridean (and translating Derrida's "The Parergon"), Owens wants to draw a sharp distinction between logical and rhetorical that is exactly the sort of binary recuperation that Derrida questions (see Geoffrey Batchen, "Recognizing Owens," *Art & Text* 45 [1993]: 66–67).

77. Sekula, "Photography Between Labor and Capital," *Mining Photographs*, 264. This unfashionably utopian phrase appears as the conclusion to Sekula's essay, and in the context of a discussion of the different meanings that might be drawn from group photographs of the Dosco workers. "The group photograph, then, harbours another meaning, a meaning that contradicts the logic of management. Here, posed confidently around the instruments and materials of production, are people who could quite reasonably control those instruments and materials. Therein lies a promise and a hope for the future."

78. See Allan Sekula, "The Body and the Archive," *The Contest of Meaning*, 342–88.

79. Derrida, *Of Grammatology*, 48.

80. Ibid., 49–50.

81. See Victor Burgin, "Photographic Practice and Art Theory" (1975), in Victor Burgin, ed., *Thinking Photography* (London: MacMillan Education, 1982), 54–55.

82. Victor Burgin, "Rereading *Camera Lucida*" (1982), *The End of Art Theory: Criticism and Postmodernity* (London: MacMillan Education, 1986), 84. Burgin also speaks of the problems of a biological account of the body in another essay in this collection, "Tea with Madeleine" (1984). Again, he condemns "biologism" even as he himself returns to masculine anatomy as the "prerepresentational" foundation of his narrative.

The question of precisely how "men" and "women" emerge from an initially undifferentiated pre-Oedipal sexuality has provoked storms of confusion, and biologism is the port in which many seek shelter. To deny that biology determines psychology is not, however, to deny that the body figures. . . . The body figures, is represented, in psychic life. In male psychic life these representations turn between the poles of having/not having the phallus. This is so for the female too, but the male has the means of representing the phallus, as an integral part of his body, in the form of the penis. (100)

83. Burgin, in an interview with Tony Godfrey, recorded 1979, published in *Block,* no. 7 (London) (1982), and reprinted in Victor Burgin, *Between* (London: Basil Blackwell and ICA, 1986), 59–60.

84. Burgin, in an interview with John Bird, originally published in *Block,* no. 7 (London) (1982) and reprinted in *Between,* 84.

85. Burgin, "Tea with Madeleine" (1984), in *The End of Art Theory,* 96.

86. For a sophisticated analysis of the essentialism debate within feminism, see Vicki Kirby, "Corporeal Habits: Addressing Essentialism Differently," *Hypatia* 6, no. 3 (Fall 1991): 4–24. As Kirby puts it in her abstract: "The spectre of essentialism means that the biological or anatomical body, the body that is commonly understood to be the "real" body, is often excluded from this [feminist] investigation. The increasingly sterile debate between essentialism and antiessentialism has inadvertently encouraged this somatophobia. I argue that these opposing positions are actually inseparable, sharing a complicitous relationship that produces real effects" (4).

87. Crary, *Techniques of the Observer,* 6.

88. Derrida, *Of Grammatology,* 56.

89. Derrida, "Structure, Sign and Play in the Discourse of the Human Sciences," *Writing and Difference,* 282.

1. Timothy Druckrey, "L'Amour Faux," *Digital Photography: Captured Images, Volatile Memory, New Montage,* exhib. cat. (San Francisco Camerawork, 1988), 4.

2. Fred Ritchin, "Photojournalism in the Age of Computers" in Carol Squiers, ed., *The Critical Image: Essays on Contemporary Photography* (Seattle: Bay Press, 1990), 28, 37.

3. Anne-Marie Willis, "Digitisation and the Living Death of Photography," in Philip Hayward, ed., *Culture, Technology & Creativity in the late Twentieth Century* (London: John Libbey, 1990), 197–208.

4. Jonathan Crary, *Techniques of the Observer: On Vision and Modernity in the Nineteenth Century* (Cambridge: MIT Press, 1990), 1.

5. William J. Mitchell, *The Reconfigured Eye: Visual Truth in the Post-Photographic Era* (Cambridge: MIT Press, 1992), 20. For further commentaries on the purported death of photography, see Fred Ritchin, "The end of photography as we have known it," in Paul Wombell, ed., *Photo Video* (London: Rivers Oram Press, 1991), 8–15, and Kevin Robins, "Will image move us still?" in Martin Lister, ed., *The Photographic Image in Digital Culture* (London: Routledge, 1995), 29–50.

6. Helmut Gernsheim (*The Origins of Photography* [Thames and Hudson, 1982], 45) repeats this exclamation as fact. However there is no evidence that the French painter Paul Delaroche ever actually made such a statement. On the contrary, he enthusiastically supported photography, recording that he considered the daguerreotype "an immense service rendered to art." See Beaumont Newhall, *Latent Image: The Discovery of Photography* (New York: Doubleday, 1967), 88.

7. Portions of the argument that follows have previously appeared in my essays: "Post-Photography: Digital Imaging and the Death of Photography," and "Post-Fotografie: Digitale Bilderstellung und der Tod der Fotografie," *BE Magazin,* no. 1 (Berlin) (May 1994): 7–13; "Phantasm: Digital Imaging and the Death of Photography," *Aperture,* no. 136 (Summer 1994): 47–50; "Post-Photography: Digital Imaging and the Death of Photography," trans. Huang Shaohua, *Chinese Photography* 15, no. 5 (Beijing, May 1994): 10–12; "Ghost Stories: The Beginnings and Ends of Photography," in N.W.M. Ko, ed., *Art Catalogue of the First International Conference on Flow Interaction* (Hong Kong: Fung Ping Shan Museum, University of Hong Kong, September 1994), 5–13; "Ghost Stories: The Beginnings and Ends of Photography," *Art Monthly Australia* no. 76 (December 1994): 4–8; "Ghost Stories: The Beginnings and Ends of Photography," trans. Keun-Shik Chang, *Sajinyesul: The Monthly Photographic Art Magazine* (Korea, June 1995): 62–66.

8. Nadar, "My Life as a Photographer" (1900), *October* 5 (Summer 1978): 9.

9. For more on this genre of photography, see Fred Gettings, *Ghosts in Photographs: The Extraordinary Story of Spirit Photography* (New York: Harmony Books, 1978); Dan Meinwald, *Memento Mori: Death in Nineteenth Century Photography* (*CMP Bulletin* 9, no. 4 [1990]); Jay Ruby, *Secure the Shadow: Death and Photography in America* (Cambridge: MIT Press, 1995).

10. N. P. Willis, "The Pencil of Nature" (April 1839), as quoted in Alan Trachtenberg,

"Photography: The Emergence of a Keyword,"
in Martha A. Sandweiss, ed., *Photography in
Nineteenth-Century America* (Fort Worth: Amon
Carter Museum of Western Art, 1991), 30.

11. Walter Benjamin, "The Work of Art in the
Age of Mechanical Reproduction" (1936), in
John Hanhardt, ed., *Video Culture: A Critical
Investigation* (Rochester: Visual Studies
Workshop, 1986), 27.

12. See Siegfried Kracauer, "Photography"
(1927), trans. Thomas Y. Levin, *Critical Inquiry*
19, no. 3 (Spring 1993): 421–36.

13. Roland Barthes, *Camera Lucida: Reflections
on Photography* (New York: Hill and Wang,
1981), 15.

14. See Keith Kenney, "Computer-Altered
Photos: Do Readers Know Them When They
See Them?," *News Photographer* (January 1993):
26–27.

15. See Martha Rosler, "Image simulations,
computer manipulations: some considerations,"
*Digital Dialogues: Photography in the Age of
Cyberspace* (*Ten.8 Photo Paperback* 2, no. 2
[Autumn 1991]): 52–63.

16. For more on the role of the photograph
within *Blade Runner* (Ridley Scott, 1982), see
Giuliana Bruno, "Ramble City: Postmodernism
and Blade Runner," *October* 41 (Summer 1987):
61–74; Elissa Marder, "Blade Runner's Moving
Still," *Camera Obscura* no. 27 (September 1991):
88–107; and Kaja Silverman, "Back to the
Future," *Camera Obscura* no. 27 (September
1991): 108–33.

17. Jacques Derrida, *Of Grammatology,* trans.
Gayatri Chakravorty Spivak (Baltimore: The
Johns Hopkins University Press, 1976), 48–50.

18. Paul Virilio, *The Aesthetics of Disappearance*
(New York: Semiotext[e], 1991), 47.

19. For further elaborations of this argument,
see my "On Post-Photography," *Afterimage* 20,
no. 3 (October 1992): 17; "Post-Photography:
after but Not Yet Beyond," *Photofile* 39 (July
1993): 7–10; "Reflexions: Life and Death in
the Age of Post-Photography," in Stuart Koop,
ed., *Reflex* exhib. cat. (Melbourne: Centre for
Contemporary Photography, 1993), 32–39.

Index

Buerger, Janet, 139, 141–142, 143
Burgin, Victor, 9–11, 19, 107, 111, 113, 117, 118,
 194, 198–200, 220n31, 243n11, 264n82

Cadava, Eduardo, 172, 183
Cailleux, Alphonse de, 132, 133, 247n55
Camera lucida, 34, 49–50, 72, 73, 75, 85, 94, 144,
 235n61
Camera obscura, 18, 19, 24, 25, 26, 27, 31, 33, 34,
 39, 41, 42, 43, 44, 45, 46, 48, 49, 51, 52,
 53, 56, 63, 66, 68, 70, 73, 78–90, 94, 95,
 100, 101, 112, 113, 119, 126, 128, 135,
 139, 144, 149, 158, 183
Carlisle, Anthony, 30–31, 32, 50, 60, 112, 153,
 155
Cavell, Stanley, 249n75
Certeau, Michel de, 185, 258n28
Chisholm, Alexander, 27
Clare, John, 84
Claude (Lorrain), 59, 73, 120
Claude glass, 73–74, 80–81, 93–94
Clericus, 35, 38
Coburn, Kathleen, 97, 239n100, 240n131
Coleridge, Samuel Taylor, 30, 59, 60–62, 76, 84,
 86–90, 95–97, 98, 101, 152, 153, 181, 191
Constable, John, 59, 98, 99–100, 142, 143, 181

Corot, Jean-Baptiste-Camille, 98
Courbet, Gustave, 142
Cowper, William, 84
Crary, Jonathan, 82–83, 201, 238n88, 259n29

Daguerre, Louis-Jacques-Mandé, 25, 33–34, 35,
 36, 38, 39, 40, 43, 46, 47, 48, 49, 50, 51,
 52, 53, 56, 62, 63, 64–66, 70, 71, 78, 82,
 90, 92, 107, 113, 119, 121, 123, 127–136,
 138, 139–143, 149, 157, 158, 167, 177,
 187, 191, 206, 228n41
 Boulevard du Temple, 133, *134,* 135, 136, 142
 Still life, 128–133, *129*
Daguerre, Madame, 33
Darwin, Erasmus, 58, 80, 117
Davanne, A., 123, 246n41
David, Jacques-Louis, 71, 166–167
 Death of Marat, 166, *168*
 Lepeletier de Saint-Fargeau, 166–167, *169*
Davy, Humphry, 26–29, 30, 31, 32, 38, 41, 48, 50,
 51, 60, 61, 87, 88, 91, 95, 112, 113, 120,
 153–154, 155
Deconstruction, 179, 181, 187, 202
Delaroche, Paul, 207, 210, 265n6
Delécluze E. J., 166
Deleuze, Gilles, 182